# Parting at the Shore

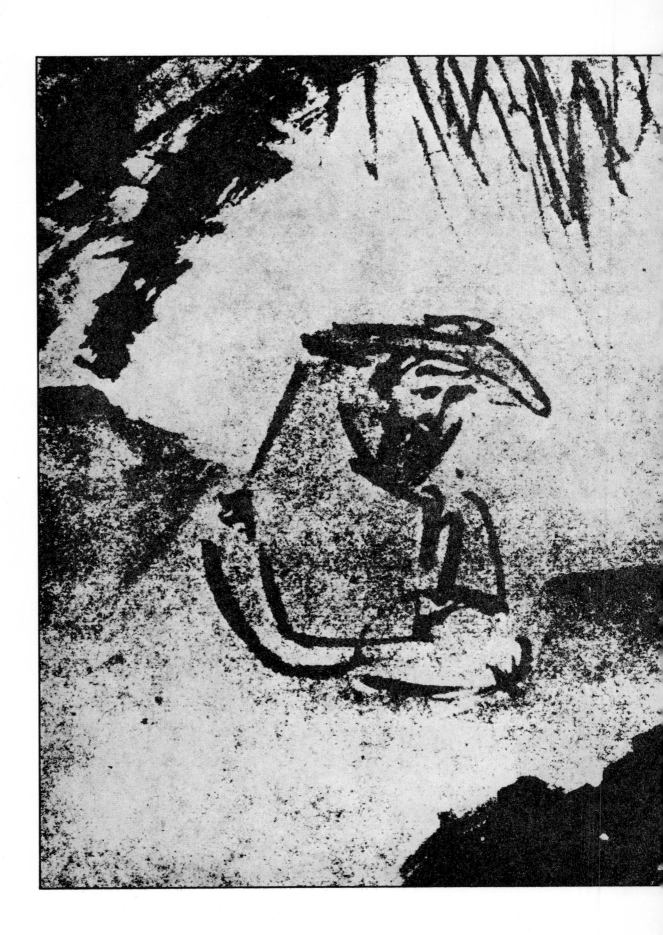

JAMES CAHILL

# PARTING AT THE SHORE

Chinese Painting of the
Early and Middle Ming Dynasty,
1368–1580

New York · WEATHERHILL · Tokyo

This is the second in a projected series of five volumes by James Cahill
under the series title "A History of Later Chinese Painting, 1279–1950."
Published to date:

> Volume 1. *Hills Beyond a River: Chinese Painting of the Yüan
> Dynasty, 1279–1368*
>
> Volume 2. *Parting at the Shore: Chinese Painting of the Early and
> Middle Ming Dynasty, 1368–1580*

A NOTE ON THE DECORATIONS. The seal on the front cover shows the au-
thor's studio name in Chinese characters reading Ching Yüan Chai. The
title page shows a section from Shih Chung's "Solitary Fisherman" (Plate
69) reproduced with high contrast effect.

FIRST EDITION, 1978

Published by John Weatherhill, Inc., of New York and Tokyo, with editorial offices at 7–6–13 Roppongi,
Minato-ku, Tokyo 106, Japan. Protected by copyright under terms of the International Copyright Union;
all rights reserved. Printed and first published in Japan.

*Library of Congress Cataloging in Publication Data:* Cahill, James Francis, 1926– / Parting at the shore. /
Bibliography:p.    / Includes index. / 1. Painting, Chinese—Ming-Ch'ing dynasties, 1368–1912. / I.
Title. / ND1043.5.C33 / 759.951 / 77–8682 / ISBN 0–8348–0128–0

# Contents

*Maps  appear  on  pages  xv  and  xvi*

# Plates

# Preface

This is the second volume in a projected series of five that will make up a history of later Chinese painting. They are planned so that they may be read either in sequence or independently. The first, *Hills Beyond a River*, was devoted to painting of the Yüan dynasty (1279–1368), the period of Mongol domination of China and the great watershed between earlier and later Chinese painting. The present book takes up where that one left off and treats the first two centuries of the Ming dynasty. Like the previous one, it covers a segment of the development of Chinese painting that has in itself a beginning and an end, opening with the foundation of the Ming and closing with that moment in the late sixteenth century when all the leading movements in Ming painting seemed to have lost their impetus and the time was ripe for radical change. The succeeding volume, which should follow this one by about a year, will deal with painting of the late Ming period and with the radical changes that did in fact occur.

The major themes of *Hills Beyond a River* were: the stylistic innovations of the Yüan masters; their uses of past traditions; the effects of historical events and circumstances on developments in painting; the emergence of the scholar-amateur movement in painting and the theories and attitudes that accompanied it. The Ming continuations of those themes will occupy our attention in this book, along with a few new ones. There will be more emphasis on local schools and traditions and on the relationship between the social and economic status of the artists and the styles in which they worked—between, that is, the patterns of their lives and the pictures they painted. Because more information is available about these later artists and more of their works survive, we are better able to look for correlations of this kind. We can also present the painters more fully as artistic personalities and will find some of them to have been very colorful characters indeed.

Once more, I owe a great debt to a number of colleagues who have done valuable work on Ming painting: Richard Edwards, Harrie Vanderstappen, Yoshiho Yonezawa, Kei Suzuki, Chiang Chao-shen, and Anne Clapp, to begin with; others are credited in the Notes and Bibliography. Louise Yuhas provided me with useful notes on Lü Chih. Studies of Ming history and culture have been immensely facilitated by the publication in 1976 of the monumental *Dictionary of Ming Biography*, and its editors, L. C. Goodrich and Chaoying Fang, are to be congratulated and thanked, as are the many contributors to that work.

I want to thank the owners and custodians of the paintings reproduced for permissions and for supplying photographs; also Mr. Chiang Chao-shen, Mr. Toshio Ebine, Mr. Hiroshi Kanazawa, Mr. Fumio Hatano of Kodansha, and Mr. Norikatsu Suzuki of Chuo Koron-sha

for helping me obtain color transparencies. The National Palace Museum in Taipei again merits special thanks for its cooperation, particularly Dr. Chiang Fu-tsung, Director; Mr. Chiang Chao-shen, Curator of Painting and Calligraphy; and Mr. Wang Chi-wu, Chief of the Publication Division. Theirs is the greatest collection of Ming painting (as well as of Yüan and Sung painting), and any study of the subject must begin with many hours spent in their exhibition halls and study rooms. That those hours have been pleasant as well as fruitful is due to their unfailing hospitality. I also want to thank once again the officials and curators of museums in the People's Republic of China for their kindness in showing paintings to the delegation of which I was a member, and especially the Kuang-chou Provincial Museum for special permission to reproduce for the first time two sections of the sole surviving work of the early Ming Cantonese master Yen Tsung.

Howard Rogers and Richard Vinograd made useful comments and criticisms on my text, which led to a number of improvements. Marsha Weidner made many editorial corrections, compiled the bibliography, plate captions, and index, and is generally responsible for making the book really usable; to her I owe a special debt of gratitude. Students in my 1974 seminar on Che-school painting contributed to this book both through their own papers—among others, Mary Anne Matteson's on Tai Chin, Holly Holtz's on Wu Wei, Geebee Hsu's on Tu Chin—and by obliging me to organize and sharpen my own thoughts.

Adrienne Morgan again prepared the maps. (It should be noted here that both in the text and in the maps, we have mostly used modern boundaries and place names to avoid the confusion that would result if such names and boundaries were not consistent throughout the series. I hope that specialist colleagues will pardon this lapse from strict scholarly scrupulousness.) The History of Art office staff, especially Nancy Grimsley and Wanda Mar, helped again with typing and in many other ways. Once again Meredith Weatherby and the Weatherhill editorial staff deserve my thanks for careful but light-handed editing of the text and for the handsome design of the book.

This volume is dedicated to Max Loehr, who taught me that style has meaning. Everything else that matters followed from that.

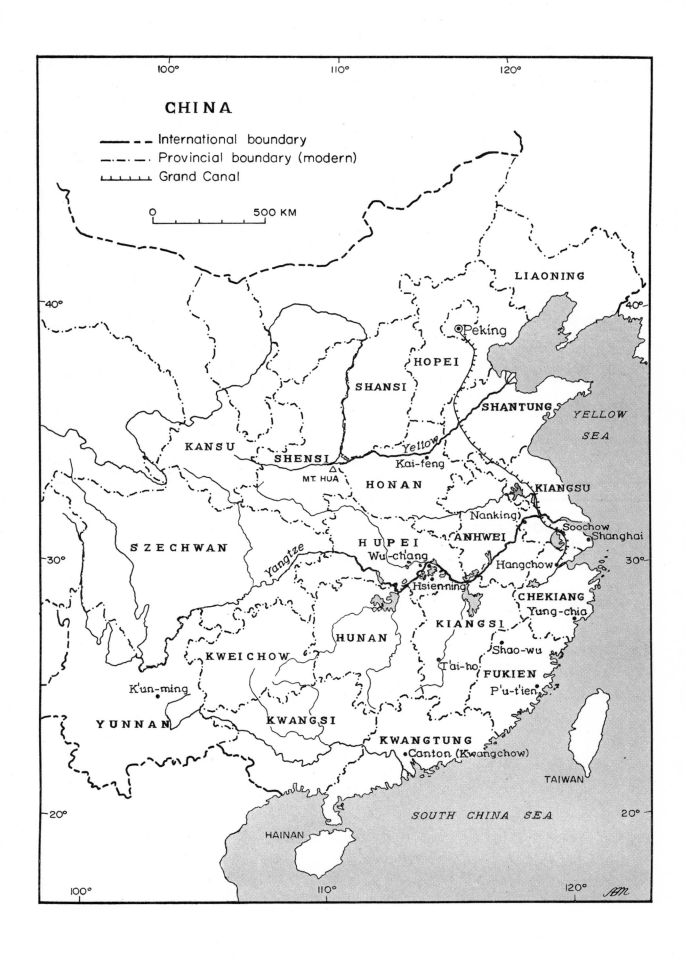

CHINA

International boundary
Provincial boundary (modern)
Grand Canal

0          500 KM

LIAONING

40°                                                                40°

Peking

HOPEI

SHANSI

SHANTUNG

YELLOW

SEA

KANSU                    Yellow

SHENSI            Kai-feng

MT. HUA            HONAN                    KIANGSU

Nanking

Soochow

SZECHWAN            HUPEI        ANHWEI            Shanghai

Wu-ch'ang

30°                        Yangtze                    Hangchow            30°

Hsien-ning

CHEKIANG

KIANGSI            Yung-chia

HUNAN

Shao-wu

KWEICHOW            T'ai-ho        FUKIEN

K'un-ming                                P'u-t'ien

YUNNAN            KWANGSI

KWANGTUNG

Canton (Kwangchow)

TAIWAN

20°                                                                20°

SOUTH CHINA SEA

HAINAN

100°                        110°                        120°

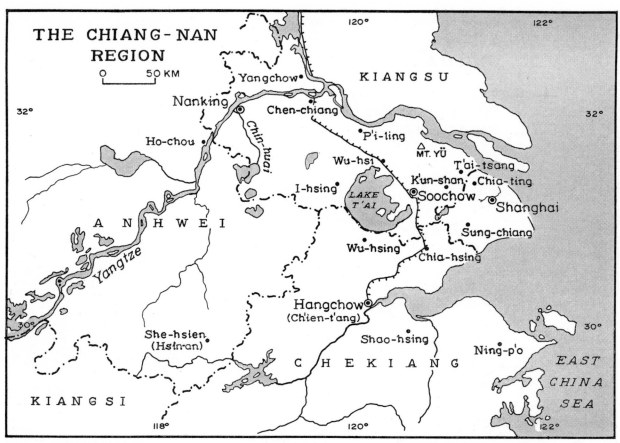

## THE CHIANG-NAN REGION

0    50 KM

KIANGSU

Yangchow

Nanking

Chen-chiang

P'i-ling

Ho-chou

Wu-hsi

MT. YÜ

T'ai-tsang

Chin-huai

Kun-shan

Chia-ting

I-hsing

LAKE T'AI

Soochow

Shanghai

ANHWEI

Sung-chiang

Yangtze

Wu-hsing

Chia-hsing

Hangchow
(Ch'ien-t'ang)

She-hsien
(Hsin-an)

Shao-hsing

Ning-p'o

EAST
CHINA
SEA

C H E K I A N G

KIANGSI

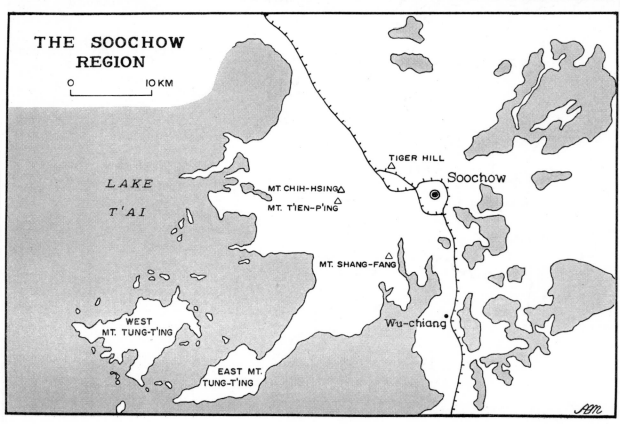

## THE SOOCHOW REGION

0    10 KM

LAKE

T'AI

TIGER HILL

MT. CHIH-HSING

Soochow

MT. T'IEN-P'ING

MT. SHANG-FANG

WEST
MT. TUNG-T'ING

Wu-chiang

EAST MT.
TUNG-T'ING

# Parting at the Shore

Dimensions are given, when available, in centimeters (first the height and then the width) and apply to an entire painting, not, in the case of a detail or section, to just the portion shown. Chinese titles are given, in parentheses, when they are particularly well known, having usually been written on the painting by the artist.

# CHAPTER ONE

# The Early Ming "Academy" and the Che School

## 1. THE REIGN OF HUNG-WU

The founding of the Ming dynasty in 1368 began another of China's long-lasting, relatively stable periods under native rule, like the Han, T'ang, and Sung before it. Such dynasties had regularly alternated with periods, usually shorter, in which China was at least partly under foreign domination, as nomadic peoples or Tartars from the steppe regions of northern Asia took advantage of the weakening of native regimes to invade North China, or the whole of China, and set up their own states and dynasties. The most recent of these invaders, immediately preceding the Ming, had been the Mongols, who ruled China for nearly a century as the Yüan dynasty (1279–1368). The last decades of the Yüan were beset with famines, economic collapse, misrule by incompetent Mongol emperors, and revolts in several parts of the country led by warlord-patriots who aspired to the imperial throne and fought with each other as well as with the remnants of Mongol forces. The political and social disorder of the late Yüan, and its effect on painters and painting, were outlined in the first volume of this series (*Hills Beyond a River*—referred to hereafter simply as *Hills*—Chapter 3 passim).

The one among these contenders who succeeded in defeating both the Mongols and his rivals, and who was proclaimed emperor of the new dynasty in 1368, was Chu Yüan-chang, better known by his reign title Hung-wu (which designates also his thirty-year rule, the first era of the Ming dynasty, 1368–98). A peasant who had lived for a time in a Buddhist monastery as a youth, Chu was only forty when he assumed the throne of all China. The Mongol capital had been in the northern city of Peking; Chu, whose base of power was in the south, established his capital at Nanking, on the Yangtze River. (Nanking means "southern capital," Peking "northern capital.") Early in his reign he adopted a number of policies that seemed to promise a return to traditional, Confucian patterns of government: a legal code based on that of the T'ang; the state veneration of Confucius and promotion of Neo-Confucian thought; the reinstitution of an examination system for staffing the bureaucracy based on knowledge of the classics and literary ability; the reorganization of the Han-lin Academy of scholars and the National University.

All these measures, along with the transfer of the capital to the south and the restoration of Chinese rule itself, encouraged educated men who had been living in retirement in the south to emerge into public life and take their normal roles as officials under the new dynasty. Their optimistic expectations did not last long. As we saw in the preceding volume, many of them came to tragic ends, including some of the leading late Yüan poets and painters. As the emperor grew older, he became more and more distrustful, especially of southerners and the educated class, and

had thousands of people arrested and put to death for suspected plots and sedition. His support of Confucianism proved empty, since his later policies and actions were based rather on the opposing school of political thought, the antihumanist and amoral theories of the Legalists, which allowed, even encouraged, the most violent repression so long as it achieved the desired end of eliminating all opposition to the state. In this way, at terrible cost, China returned to political stability after decades of turbulence.

Restoration and oppression: the situation could only induce an atmosphere of conservatism. It is reflected in a cessation of the innovative and progressive tendencies to be seen in late Yüan painting and in an officially sponsored revival of Sung painting styles, especially those of the Southern Sung Academy, which by this time represented the conservative current in painting.

## 2. Two Landscape Traditions: The Che and Wu Schools

A brief account of the landscape traditions practiced in the Yüan and early Ming must be introduced here, as background for our treatment of Ming artists and paintings. While these traditions and artistic issues, so suddenly presented, may for the moment seem confusing to readers not already familiar with them through our foregoing volume or some other treatment of Yüan painting, they should become clear as we proceed.

We have spoken here of a "revival" of Sung painting styles in the early Ming, although, properly speaking, they had never quite dropped into total disuse during the intervening Yüan dynasty. A few Yüan painters such as Sun Chün-tse and Chang Yüan (*Hills*, Color Pl. 4 and Pl. 29) had carried on, in works of high quality, the elegant, highly finished styles of Ma Yüan and Hsia Kuei, the two leading landscapists of the Imperial Academy during the Southern Sung period (i.e., the last half of the Sung dynasty, 1127–1279, when the capital was at Hangchow in the south). But for the most part, these styles had been scrupulously avoided by the scholar-amateur artists of the Yüan, who made up the progressive current of painting in that age; they were considered to be too open in their emotional appeal, too closely associated with the political debility and effeteness (as the Yüan scholars saw it) of the Southern Sung court. They were, moreover, associated with professionalism, and the Yüan was the age of the ascendancy of the scholar-amateur artist. The leading painters of the Yüan were scholars by vocation, sometimes government officials, and painted—at least in theory—as an avocation, not to make money, and never on commission or on demand. (For a discussion of this important amateur-professional distinction, see *Hills*, pp. 4–6 ff.)

In rejecting the styles of Ma Yüan and Hsia Kuei (in the Chinese abbreviation, the Ma-Hsia styles), the scholar-artists of the Yüan turned instead to older landscape traditions, especially to one that had been inaugurated by two painters active in Nanking in the tenth century, Tung Yüan and his follower Chü-jan. This was known as the Tung-Chü mode of landscape and was a less polished, more earthy way of painting; it was commonly used for depicting the lush scenery of the region south of the Yangtze River (the Chiang-nan, "South-of the-River," region), which featured low hills and numerous waterways. (For good examples of works in this tradition, see *Hills*, Pls. 13, 26, 38, 90.) Most of the leading landscapists of the late Yüan period worked in variants of the Tung-Chü mode. (Besides the Ma-Hsia and Tung-Chü there was a third tradition, the Li-Kuo, named after two of the greatest landscapists of early Sung, the northerners Li Ch'eng of the tenth century and Kuo Hsi of the eleventh; but this tradition plays a relatively small part in Ming painting, although we will encounter it later in this chapter as one of the styles popular in the Ming "Academy.")

Yüan painting reveals already a phenomenon that is observable in much of later Chinese painting, which will occupy our attention often in this book: a correlation between the social-economic status of the artist and the stylistic tradition he follows. Painters of some standing in

the gentry-literati society, those who make up the scholar-amateur current of painting known as *wen-jen hua*, or literati painting, tended to favor the Tung-Chü tradition, which fitted both their expressive purposes, by lending itself to effects of poetic "blandness," and their amateurism, by making fewer technical demands on the artist. The Ma-Hsia tradition, along with the style of the early-twelfth-century master Li T'ang (on which those of Ma Yüan and Hsia Kuei were based) and others of the Sung Academy, were carried on chiefly by professionals, especially those of the local school of Hangchow, in Chekiang Province, who were relegated, however unjustly, to the status of craftsmen, "artists on hire," and whose achievements as painters did little to elevate them on the social ladder.

These correlations of status and style persist into the early Ming and are recognized in the conventional division of fifteenth- and early-sixteenth-century painting into two dominant movements or "schools" which are known (loosely in the case of the first) as the Che and Wu schools. These names are meant fundamentally as designations of locale, the first referring to Chekiang Province (chiefly the Hangchow region) and the second to the Soochow area in Kiangsu Province, of which the ancient name was Wu, located to the east of the T'ai-hu, or Great Lake. Hangchow and its environs, as we have noted already, had long been a center for artists following the conservative direction in painting that depended on Southern Sung Academy styles; Soochow had been in the late Yüan, and continued to be for most of the Ming, the main area of concentration for literati artists.

Thus are the issues set up, and thus they are discussed by the Ming critics and theorists: Che vs. Wu, Sung vs. Yüan, professional vs. amateur—issues by no means identical, but so interlocked in critical discussions as to be all but inseparable. With considerable imprecision, that is, the situation in early and middle Ming painting was seen as one in which professional artists of the Che school working in Sung styles were opposed to scholar-amateur artists of the Wu school working in Yüan styles. This bipolar formulation of the history of Ming painting was to culminate in the late-Ming theory of the "Northern and Southern schools" propounded by Tung Ch'i-ch'ang (1555-1636). Without accepting such formulations as more than they are—attempts to organize a complex development and to give historical sanction to critical judgments—we will use them as convenient and partly valid distinctions of stylistic currents, and will try to point out as we proceed where they clarify the true development and where they are inadequate, even misleading. We will consider the Wu school in our second chapter and again in the last; the Che school will be treated in this chapter and the third. Before turning, however, to the artists of the Ming Academy and the Che school, we will consider three works that illustrate in different ways the resurgence of interest in the Ma-Hsia landscape manner in the early Ming.

## 3. PAINTING IN THE HUNG-WU ERA, 1368-98

WANG LI  An interesting exception to the pattern that associates the Ma-Hsia style with professionalism is the late Yüan and early Ming artist Wang Li. Born in 1322 at K'un-shan in Kiangsu Province, he studied medicine, made his living as a doctor, and was the author of several medical texts. He was also conversant with the classics and composed both prose essays and poetry. He thus belongs, as a painter, firmly in the scholar-amateur camp. However, he is said to have studied the landscape style of Hsia Kuei while he was young, and later that of Ma Yüan. Critics praised him for combining, "in his firm but supple brushwork and densely rich compositions, the professional spirit with the scholarly."[1]

At the beginning of the Ming period, when he was about fifty, he climbed to the summit of Hua-shan, the towering mountain in Shensi Province that drew pilgrims both as a Taoist holy place and for its awesome scenery. The experience was apparently overwhelming, transforming his life and his painting style. On Hua-shan he encountered a strange beauty in nature that tran-

scended all he had known in art, and he realized that in thirty years of studying painting he had never freed his works from the "paper and silk quality" of the artifact, nor from being identifiable as "school of so-and-so." When asked later who his teacher had been, he replied (consciously echoing an often-quoted statement by the early Sung landscapist Fan K'uan): "My teacher is my mind; its teachers are my eyes; their teacher is Hua-shan. That's all."

Truth to an external nature or truth to one's inner nature and feelings: this was yet one more issue, interlocked with the others. The literati artists were inclined to argue in favor of the second kind of truth and to try to embody it in their works. Wang is not totally committed to the first—in his formulation, his eyes and mind intervene between Hua-shan and his pictures of it—but he insists on fidelity to nature as the fundamental requirement for a good painting: "Although painting is a matter of forms, its main concern is the conception. If the conception is deficient, it might be said that the forms are false. But the conception lies in the forms; if you discard the forms, where can you look for the conception? Therefore, when you capture the forms, the conception will pervade them. But if you lose the [true] forms, are they forms at all? A painting of an object must resemble that object; how can you make it unrecognizable? Those who become famous in the world by 'returning to the ancients' really achieve their effects by groping in the dark. . . ."

The words quoted above form the opening passage of the long preface that Wang Li composed for his album of "Scenes of Hua-shan," his sole surviving (and sole recorded) work as a painter, represented here by two leaves (Pl. 1, 2). It is not at all coincidental that this statement, made in direct and conscious opposition to attitudes current among the literati artists (contrast statements by T'ang Hou and Ni Tsan, *Hills*, pp. 164, 175), accompanies a series of paintings done in a style that similarly flouts the scholar-painters' assertions about which traditions were proper and which improper for them and their peers to follow. Wang Li in fact praises Ma Yüan, Hsia Kuei, and their followers in another essay, "On Models for Painting," as the ones among "the numerous painters" whose works he particularly esteems: "Even when coarse [in brushwork] they don't fall into banality; even when fine and detailed, they don't slip into prettiness. They have the distant harmony of a pure vastness, transcending the commonplace; they are free of the vulgarity of cloddish dullness." Wang is defending these painters against the very vices with which they had been charged by critics and crediting them with the very virtues that those critics had denied them.[2]

The album is painted, as one would expect after reading these sentiments, in a style clearly derived from the lineage of Fan K'uan, Li T'ang, Ma Yüan, and Hsia Kuei. It is the very album that Wang painted after his trip to Hua-shan, based on sketches made while traveling. It originally included over forty leaves; by the eighteenth century there were only about twenty; today, only fourteen can be traced.[3]

The surviving leaves exhibit a remarkable variety in theme and composition; if we were to ascribe this variety to an extraordinary inventiveness in the painter and remark on his nonadherence to existing compositional formulae and type forms, he would doubtless answer that he was only depicting the scenery of Hua-shan as he saw it. Nevertheless, one may question whether the actual landscape offers any such powerfully overhanging formations of strangely twisted and pitted rock as the album does.

In one of the leaves (Pl. 1), such a mass occupies almost the whole space of the picture, leaving only narrow ravines at the sides, in which travelers are visible on paths, climbing always upward. Wang Li is conveying the impression the landscape made on him, using his sketches as starting points for imaginative constructions. He draws in heavy lines that taper at the ends and thicken where they bend; it is the interrelationships of these bent lines, together with sparse texture strokes and a limited use of ink wash, that define the shapes of the rocks and the hollows in and around them. Bushes and trees grow from crevices or on the tops of boulders and ridges.

Presenting such a massive escarpment full face to the viewer may recall some Northern Sung landscapes, but Wang Li remains essentially independent of such precedents; the animation of his forms is very different from, for instance, Kuo Hsi's, although it similarly seems to endow the landscape with an unearthly inner life more than it portrays the effects of natural geological processes. Sung landscape had never exhibited such bold linearity—that is part of the heritage of Yüan—nor violated so freely the dictates of naturalism. For all his warnings against losing the "true forms," Wang in fact exploits almost as fully as his scholar-artist contemporaries the increased degree of subjectivity possible in his time.

Another leaf (Pl. 2) depicts the peaks of a winding mountain ridge, with groves of low pine trees, appearing above a sea of fog. Here it is Southern Sung landscapes that may be recalled as precedents for this presentation of evanescent phenomena, but again Wang Li refuses to be bound to tradition, embodying in his picture a personal interpretation of his visual and emotional experience. Perhaps it is the artist himself who is seen, just left of center, resting on the path and contemplating the mist-filled depths out of which he has climbed; but whomever the tiny figure is intended to represent, its diminutive scale within the landscape conveys the artist's apprehension of the vastness of his surroundings far better than he could have conveyed it by following the standard formula of the Ma Yüan school, which would have placed the figure in the foreground and drawn him large, forcing his importance on the viewer and implicitly reducing the vista beyond him to a function of his feeling.

TWO ANONYMOUS PAINTINGS    Wang Li seems to have had little or no following, and the old conventions continued to rule, in pictures devoted to generalized rather than specific and personal themes. If we wonder what a more orthodox, straight-line follower of the Ma-Hsia tradition would have been painting around this time, an answer may be found in such a picture as the anonymous "Scholars on a Lakeshore" (Pl. 3), which probably dates from the beginning of Ming. It is a good example of the compositional type we have just described as typical of the Ma Yüan school. Two men, with an attendant, sit under leafy trees gazing out into the light fog that hangs over the rippled surface of water. Brushwork is restrained and adapts closely to its subjects; ink washes are subtly used to create a play of light and shadow that recalls Sun Chün-tse's treatment of rocks (*Hills,* Color Pl. 4). The old diagonal division of the picture area still prevails but here adjusts itself to stronger horizontal (foreground) and vertical (right side) emphases, the latter broken, in the stream, path, tree, and rock that occupy the lower part of the composition, into short diagonal thrusts that carry the eye upward on a zigzag course. All this reads as surface movement, working against any pull into depth; in spite of the penetration into limitless distance intended at the left, nothing in the picture actually seems so far away as does the farther shore in Sun Chün-tse's painting. Nevertheless, even though "Scholars on a Lakeshore" lacks the haunting depths of romantic Southern Sung works, it is successful to a degree rare for its time in recapturing some of the most attractive features of that mode: a richness of sensitively presented detail, an elegance of execution, an invitation to the viewer to participate in the emotions of the figures in the painting and respond with them to their surroundings.

Another anonymous work of about the same period, titled "Quietly Sitting in a Study Beneath Pines" (Pl. 4), points more clearly the direction that painting of this stylistic tradition was to take in the Ming. It is organized in a similar way, with strong vertical and horizontal elements countered by shorter diagonals; even more than "Scholars on a Lakeshore," it is composed on the surface through a geometric division of the picture area. An allover evenness of tonality, within which sudden dimmings of ink values create limited pockets of space, makes the forms adhere to the picture plane; they are not only presented as distinct shapes as in the other work but are also bounded (as are Wang Li's) by heavy outlines. (A particular linear

mannerism seen here, the addition of a rounded bump at some points where the rock outline changes direction, appears also in Wang Li's landscapes, and even earlier in Sun Chün-tse's; this becomes an almost obsessive mannerism in the paintings of the Japanese artist Sesshū, who presumably learned it, with much of the rest of his style, from the Che-school masters during his stay in China in 1468–69.) These outlines set up jerky, angular movements across the surface, apparently guided more by inherent laws of linear motion than by the necessity to define natural forms, creating an impression of dash rather than delicacy. In spite of the title and the solitary, quiescent figure visible in the study, a stock symbol of seclusion, the painting is not tranquil in mood. The texture strokes on the rocks have taken on the sharp, scratchy character that had already begun to be evident in the work of Sun Chün-tse.

THE EARLY MING "ACADEMY"    The differences between these two anonymous pictures, and the new tendencies to be seen in the second—toward tighter, more geometric composition on the picture plane, a more linear mode of brushwork that features prominent and energetic drawing, and a consequent loss of convincing depth—can be taken as indications of the direction that painting of this school was to take in the first half of the Ming and as introduction to stylistic issues and innovations within the movement we are to consider next. That movement is the painting of the so-called Ming "Academy." If we begin by trying to outline the historical circumstances in which it occurred, we are immediately brought up against the problem of the Ming "Academy" itself. A good deal of discussion, perhaps more than the subject merits, has focused on the question of whether there was an "academy" in the Ming—whether, that is, the term "academy" can be correctly applied to any phenomenon that occurred then. It seems more useful, here as elsewhere, to define the phenomenon, and show how it differed from related or corresponding ones in other periods, than to worry over whether the common term for it is correctly used.

In the Southern Sung period, a well organized Painting Academy (T'u-hua Yüan) had existed at the imperial court within the Han-lin, the academy of scholars, and many of the best painters of the age had served in it. The Yüan emperors, as we have noted, apparently employed no organized group of court painters, although some artists (such as Liu Kuan-tao) served in the court, and others (such as Chao Meng-fu) were active there in other official capacities. The practice of summoning noted painters to court and giving them official titles and imperial commissions was reinstituted in the Ming. A number of painters were active under the first emperor, Hung-wu. As we have noted, an examination system for the selection of officials had been re-established at the beginning of the dynasty; scholars who attained chin-shih ("presented scholar," a kind of doctorate degree) were eligible for appointment to the Han-lin Academy, and several who received such appointments were painters. It is probable, however, that they were employed mainly in other functions, as scholars and calligraphers, poets and astrologers and diviners. At the same time, the establishment of Nanking as the new capital and the building or restoration of palace halls created a need for wall paintings, and portraitists were in demand to produce, for instance, state portraits of meritorious officials. For these functions, professional artists were employed. The impression one receives from a variety of written sources is of a loose, scarcely organized body of artists of varying skills and a diversity of stylistic backgrounds, creating paintings as the need arose or the whim of the emperor and his ministers dictated.

Among these artists were a follower of the Ma-Hsia tradition; a nephew of Sheng Mou named Sheng Chu; several specialists in figure compositions and portraits; and one survivor of the late Yüan literati school of Soochow, Chao Yüan—who, as related earlier (Hills, pp. 129–30), did not survive for long: he was beheaded at the order of the emperor, who found him incompetent as a portraitist. Sheng Chu suffered the same fate, for representing a Taoist fairy riding a dragon (a theme interpreted as insulting to the emperor), and so did Chou Wei, a figure painter and

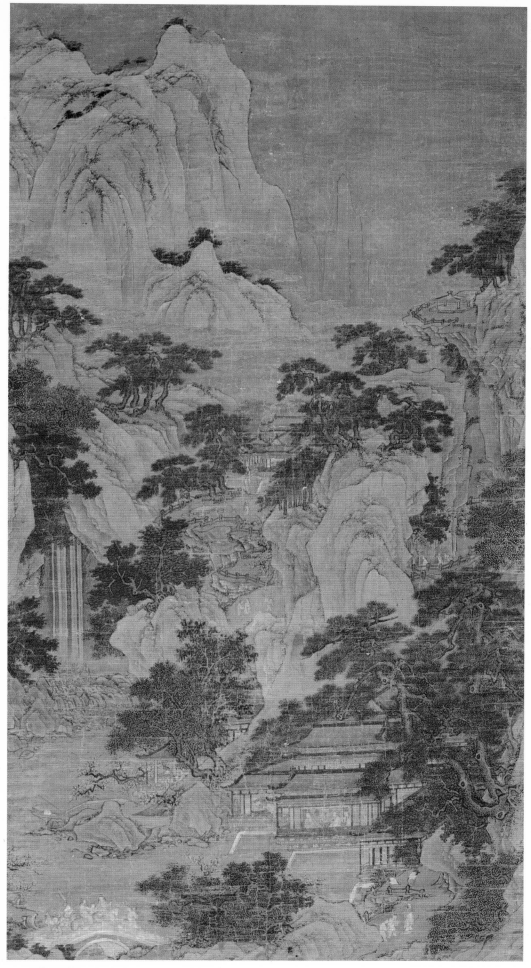

Color Plate 1. Shih Jui: ''Landscape with Buildings and Figures, in the Blue-and-Green Manner.'' *Hanging scroll, ink and colors on silk, 142.8 × 74.8 cm. Private collection, Japan.*

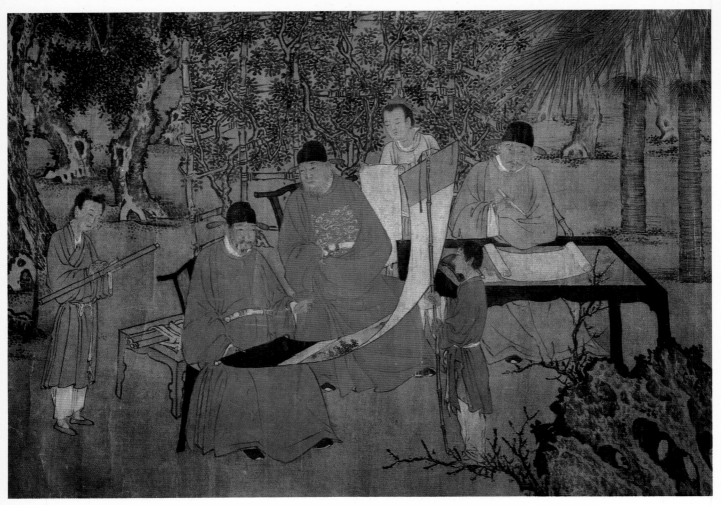

Color Plate 2. Hsieh Huan: "A Literary Gathering in the Apricot Garden." *Dated 1437. Section of a handscroll, ink and colors on silk, 36.6 × 240.6 cm. Collection of H. C. Weng, New York.*

Color Plate 3. Tai Chin: "Fishermen on the River." *Section of a handscroll, ink and colors on paper, 46 × 740 cm. Courtesy of Smithsonian Institution, Freer Gallery of Art, Washington, D.C.*

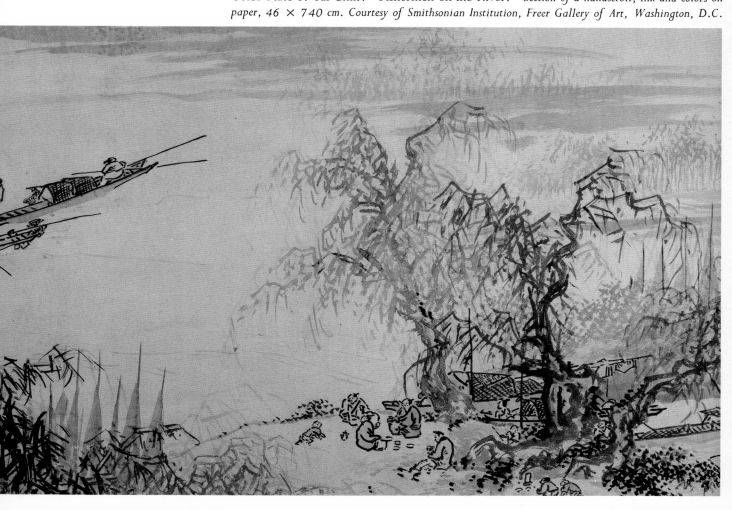

Color Plate 4. Shen Chou: from ''Album of Landscapes with Figures, for Chou Wei-te.'' *Dated 1482. Album leaf, ink and light colors on paper, 31.8 × 59.7 cm. Chung Hsing Lu collection.*

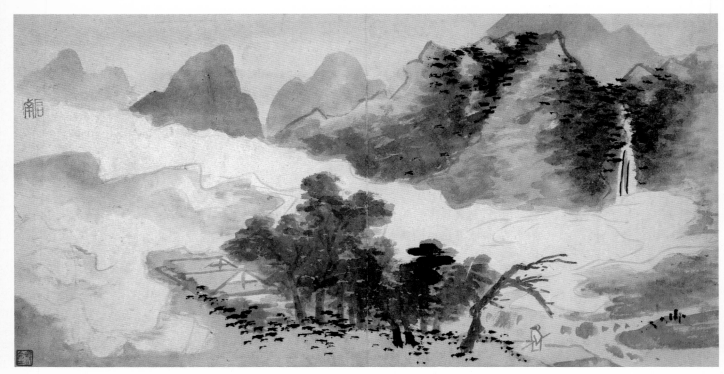

Color Plate 5. Shen Chou: from ''Album of Landscapes with Figures, for Chou Wei-te.'' *Dated 1482. Album leaf, ink and light colors on paper, 31.8 × 59.7 cm. Chung Hsing Lu collection.*

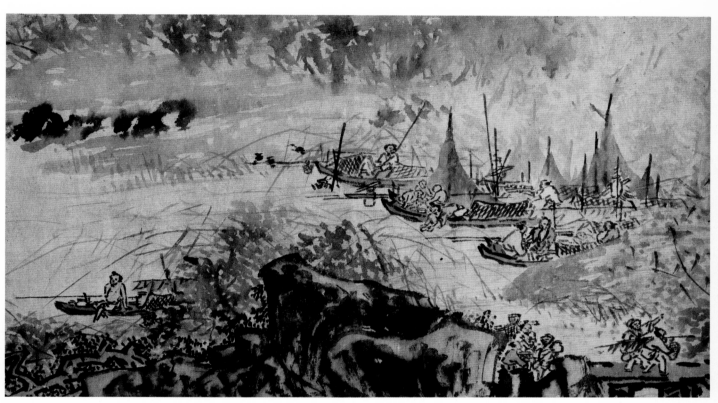

Color Plate 6. Wu Wei: ''Pleasures of Fishermen.'' *Section of a handscroll, ink and colors on paper, 27.2 × 243 cm. Ching Yüan Chai collection.*

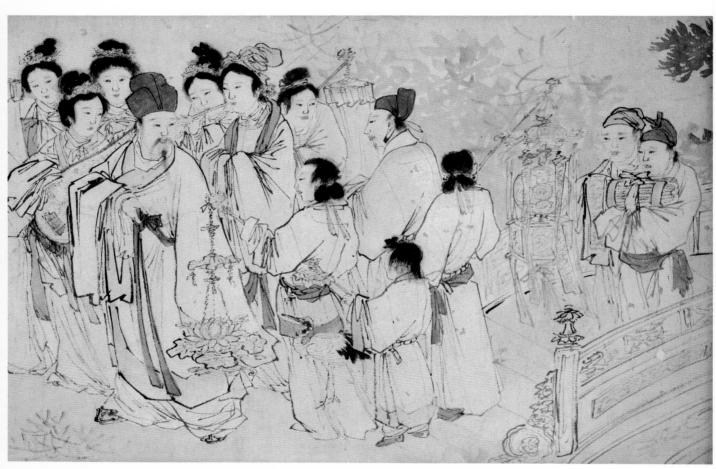

Color Plate 7. Chang Lu, attributed to: "Su Tung-p'o Returning
to the Han-lin Academy." *Section of a handscroll, ink and light
colors on paper, 31.8 × 121.6 cm. Ching Yüan Chai collection.*

Color Plate 8. Anonymous, Ming dynasty ("Ch'ien Hsüan"): "Early Autumn." *Section of a handscroll, ink and colors on paper, 26.7 × 120 cm. Detroit Institute of Arts, General Membership and Donations Fund.*

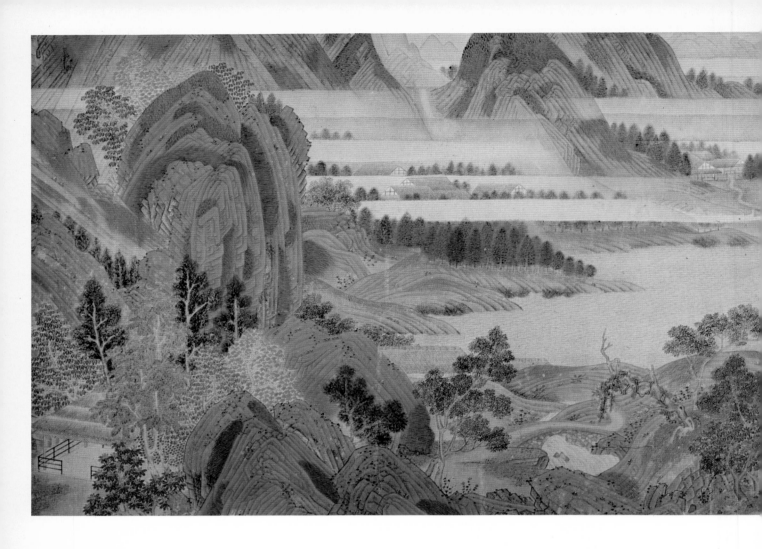

Color Plate 10. Tu Chin: "The Scholar Fu Sheng in a Garden." *Detail from a hanging scroll, ink and colors on silk, 157.7 × 104.5 cm. Yamaguchi collection, Ashiya.*

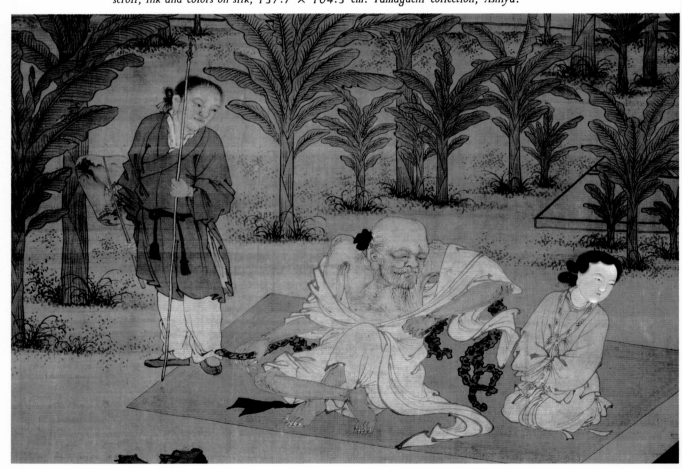

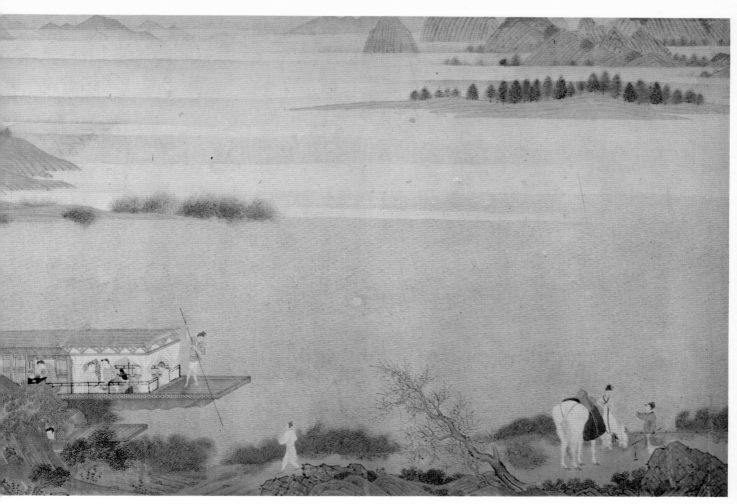

Color Plate 9. Ch'iu Ying: "The Lute Song." *Section of a handscroll, ink and colors on paper, 33.7 × 400.7 cm. Nelson-Atkins Gallery, Kansas City.*

Color Plate 11. *Detail from Color Plate 10.*

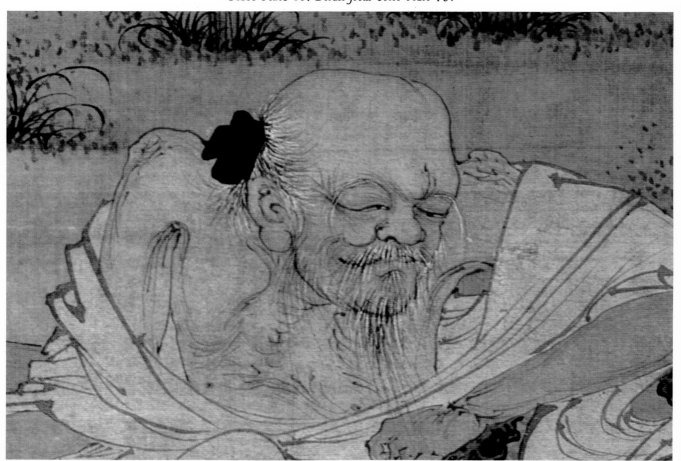

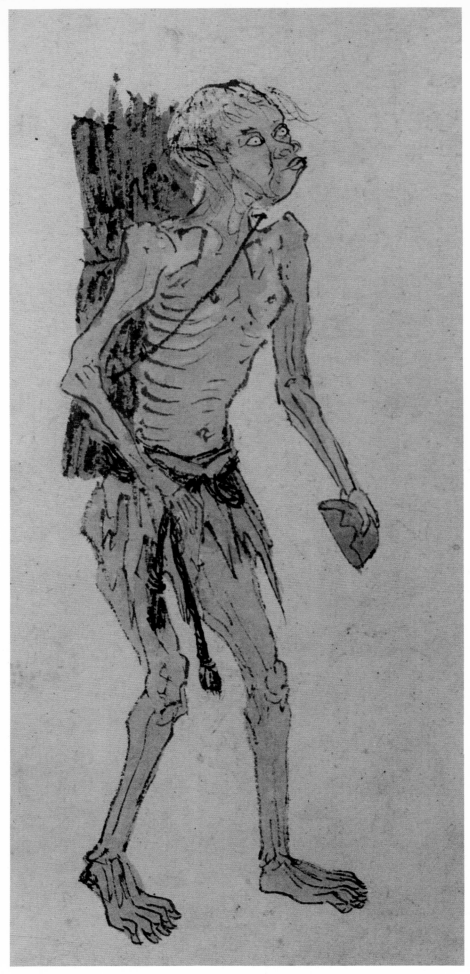

Color Plate 12. Chou Ch'en: from "Beggars and Street Characters." *Dated 1516. Portion of an album leaf mounted in a handscroll, ink and colors on paper, 32.9 × 843.9 cm. Honolulu Academy of Art, gift of Mrs. Carter Galt, 1956.*

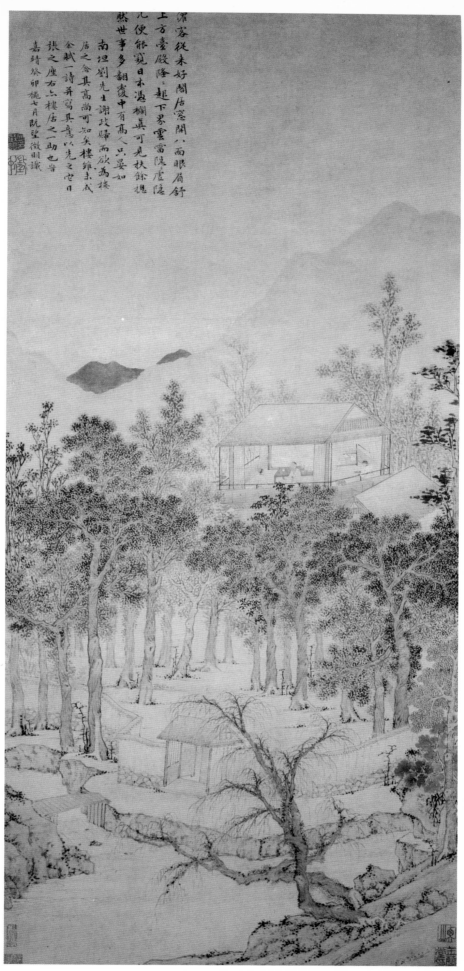

居客從未好閣居落開八面眼眉舒
上方臺殿隆：趨下界雲雷隱虚隱
几便郤覗日本憑欄真可見扶餘提
然世事多嘲褒中有高人只要如
南坦劉先生謝玭歸而欲為樓
居之舍其高尚可知矣樓雖未成
余試一詩并寫其意以先之世曰
張之座右点樓居之一助也皆
嘉靖癸卯槐七月既望微明識

Color Plate 13. Wen Cheng-ming: "Living Aloft" *(Lou-chü t'u)*.
*Dated 1543. Hanging scroll, ink and light colors on paper, 95.3 ×*
*45.7 cm. Collection of Mr. and Mrs. David Spelman, Great Neck, N.Y.*

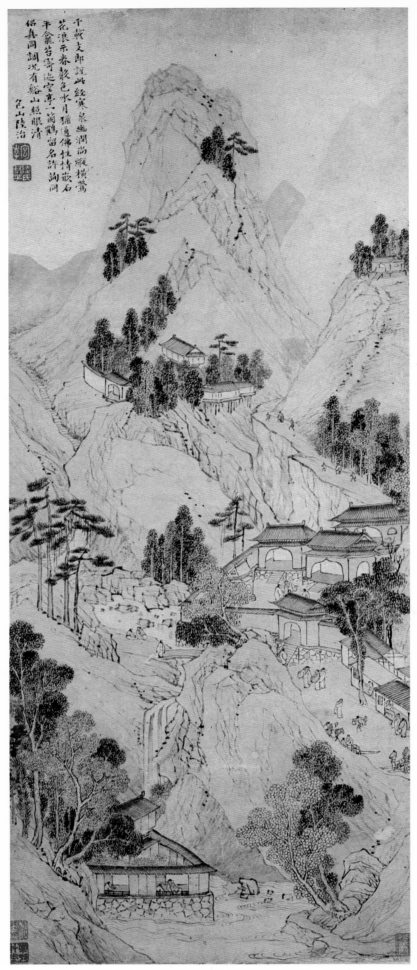

Color Plate 14. Lu Chih: "Mount Chih-hsing." *Hanging scroll, ink and colors on paper, 83.6 × 34.7 cm. National Palace Museum, Taipei.*

landscapist who executed many of the wall paintings in the new palace. Chou had once managed to escape the emperor's displeasure in a clever way: ordered to paint "all the rivers and mountains of the empire" on a palace wall, he pleaded insufficient acquaintance with the topography of the whole of China and asked the emperor, who (as he flatteringly pointed out) knew it from his brilliant conquests, to do a preliminary sketch on the wall. When Hung-wu had completed the sketch, Chou bowed his head and declared that he would never dare to touch it, for fear of spoiling it. In the end, however, even this resourceful man was executed "through the envy and slander of his colleagues."

Obviously, conditions were not right for the emergence of any tightly knit body, on the Sung model, that could properly be called an "academy." Moreover, not enough reliable work by these masters survives (except that of Chao Yüan, which antedates the fall of the Yüan) to allow any detailed investigation of court painting during the first Ming reign.[4]

## 4. PAINTING IN THE YUNG-LO ERA, 1403–24

Hung-wu's designated successor—one of his sons—died in 1391; with the death of Hung-wu himself in 1398, a sixteen-year-old son of this late heir-apparent was enthroned. However, another son of Hung-wu, Chu Ti, who as prince had established himself in the old Mongol capital of Peking, marched south and sacked Nanking, killing supporters of the boy-emperor and seizing the throne for himself. He ruled with the reign title Yung-lo ("Perpetual Happiness") from 1403 until his death in 1424. In 1421 he transferred the capital to Peking, keeping Nanking as a secondary capital.

The removal of the seat of government to the north was in part a response to the continuing threat of the Mongols, against whom Yung-lo organized a series of punitive campaigns. He also brought much of Southeast Asia under Chinese control and launched seven great maritime expeditions, most of them directed by a Moslem eunuch named Cheng Ho. These expeditions reached India, the Persian Gulf, and the east coast of Africa, opening a sea route and exploring potential sources and markets for Chinese trade, bringing back exotic commodities and strange animals. This remarkable beginning was not followed up, however, and by the middle of the fifteenth century China had settled into the isolationism that was to persist for the rest of the dynasty. The end of this age of expansion and exploration seems to have been brought about by the same anticommercial, ethnocentric conservatism among the Confucian bureaucracy and gentry classes that we can see manifested in much of the art of the Ming; it is therefore worth noting in an account of Ming painting.

THE PERSISTENCE OF CONSERVATIVE SOUTHERN SUNG STYLES   In writing of a resurgence of Ma-Hsia landscape styles, we may have given the false impression that these made up the main heritage of the Southern Sung Academy for artists of later periods. In fact, the styles of Ma Yüan and Hsia Kuei were themselves individual departures from the basic conservative Academy style. That style had been formed in the early twelfth century in the Painting Academy of the emperor Hui-tsung (reigned 1101–25) and was continued by Academy artists in the twelfth and thirteenth centuries, as well as by professional masters outside court. While individual variants and historical change can of course be recognized within it, the body of painting produced by these masters, great and small, exhibits more homogeneity and commonness of purpose than any other in Chinese painting.

In the late twelfth and early thirteenth centuries, in particular, the Academy style attained a point of classical equilibrium that established the basic conservative manner and canonical models for professional artists in all the centuries to follow. In landscape it is represented by tradition-

alist followers of Li T'ang; in flower, bird, and animal painting by such artists as Lin Ch'un and Li Ti; in figures-and-landscapes or figures-in-architecture compositions, by Liu Sung-nien, Li Sung, and others in the Academy. We can trace its continuation in the works of late Sung painters such as Lou Kuan; it was practiced by Yüan court painters such as Liu Kuan-tao (*Hills*, Pl. 68); and it becomes, as we shall see, the basic manner for artists of the early Ming "Academy." Later in the Ming it is taken up again as the point of departure for the professional masters of early-sixteenth-century Soochow, notably Chou Ch'en, T'ang Yin, and Ch'iu Ying. Even in the Ch'ing dynasty it underlies the productions of some painters in the Manchu court, as well as others outside it, such as Yüan Chiang. And all through these centuries, this style was practiced constantly, in relatively pure form although on a qualitatively lower level, passed on from master to pupil in local ateliers, by the myriad minor artists who continued always to supply pleasing, decorative pictures for hanging in houses or for the enjoyment of people of conservative taste. Their works survive by the thousands, in most cases divested of their signatures and reattributed misleadingly to the Sung masters by hopeful dealers and collectors, and make up the bulk of many old museum collections, as anyone knows who has spent days going through storage-room cabinets and drawers. It is important, as we go on to consider the progressive movements and individual contributions that must occupy us in any art-historical treatment of later Chinese painting, that we always remember this great undercurrent of conservative styles. It is important also to recognize these styles when they rise occasionally to the surface, elevated once more to the level of significant art by painters who can be highly skilled without aspiring to any notable originality, as happens in the early Ming "Academy."

PIEN WEN-CHIN  Of the few court artists recorded as having been active in Yung-lo's reign, only two, Pien Wen-chin and Hsieh Huan, can be studied in extant paintings. Both were conservative masters of the type we have just defined. We shall consider Pien here and Hsieh in the following section.

Pien Wen-chin (also called Pien Ching-chao) was born in the southern coastal province of Fukien, where he must have received his early training as a painter of bird-and-flower subjects. Nothing is clearly known of any local Fukienese school of painting in the early and middle Ming, but a number of artists from that province served at court, and both their surviving works and what is recorded about them suggest that a somewhat backward pocket of Sung traditions persisted in Fukien while more progressive movements arose in the major centers farther to the north. We can also suppose, although again without clear documentary evidence, that the early Ming rulers, in keeping with their aim of restoring pre-Mongol institutions in government and society, probably favored Sung styles as a matter of official policy. They probably did so also as men of conservative artistic tastes, who besides had no reason or occasion to become acquainted with the revolutionary achievements of the Yüan literati painters. Whatever the reason, artists drawn from the local traditions of Chekiang and Fukien, primarily commercial traditions that had never quite been penetrated by Yüan attitudes and remained committed to Sung modes, dominated court painting circles both in their numbers and in their styles during the first half of the fifteenth century, and continued to exert a powerful influence into the early sixteenth.

Pien Wen-chin was invited to court during the Yung-lo period and made a *tai-chao* (painter-in-attendance), serving in a palace building called the Wu-ying Tien. This and another building nearby called the Jen-chih Tien, both located in the palace compound at Peking, were the quarters where painters worked; one late Ming source says that the Wu-ying Tien housed a school of painting and calligraphy, while the Jen-chih Tien housed the studios, but this information is not confirmed by other evidence. Both buildings were under the administration of an office, staffed by court eunuchs, which supervised the work of painters, calligraphers, and artisans. Pien Wen-chin, however, probably began his service as a court artist in Nanking; his well-known picture

titled "The Three Friends and Hundred Birds" in the Palace Museum, Taipei,[5] is dated 1413 and inscribed as having been painted in an "official residence," so he had already taken up his career at court by then, eight years before the move to Peking. Pien was still active as a court artist at the beginning of the Hsüan-te era (1426–35), by which time he was over seventy years of age. Some time during that era he was stripped of his cap and sash, the emblems of official rank, and made a commoner for having accepted bribes in recommending two scholars to the court—the emperor spared him from more severe punishment because of his advanced age.

Pien's painting of "Two Cranes and Small Birds, with Bamboo and Blossoming Plum" (Pl. 5), which bears his signature and three of his seals, is typical of his surviving output. The form and materials—a hanging scroll done in ink and heavy colors on silk—are standard for works of artists of an academic bent, and the asymmetrical composition, with flowering plants and bamboo disposed vertically up one side, a sloping bank of earth below, and the birds perched or walking on both, had become orthodox already in the Yüan (cf. Meng Yü-chien's picture, *Hills*, Color Pl. 8). Most of Pien's paintings are variations on this simple formula, which was followed as well by hundreds of later bird-and-flower masters of the Ming in thousands of pleasantly decorative, usually undistinguished works.

It would be difficult to define an individual style for Pien, who offers a straightforward, workman-like performance in the Sung outline-and-color manner. Somewhat distinctive are the postures of his smaller birds, heads turned sharply or tucked down, depicted with an attempt at animation that does not quite succeed—neither they nor the two stalking cranes convey the sense of organic life that Meng Yü-chien's birds had, and those, in turn, represented a loss in liveliness over Sung works of the type. Both birds and plants, in this and other works by Pien, seem static and arranged, and the neat drawing does little to enliven them. Paintings of other subjects by early Ming court artists are for the most part similarly static, and much of the later stylistic experimentation within the school, as we will find, seems directed at overcoming this failing by one means or another.

## 5. THE HSÜAN-TE ACADEMY, 1424–35

Before turning to a consideration of artists active at court in the Hsüan-te era, we had best pause to consider the Hsüan-te Academy itself. (We will hereafter use the term Academy without quotation marks; having pointed out that no organization for the training of artists comparable to the Sung Academy can be proved to have existed in the Ming, we mean the term to refer to the groups of painters active in the imperial court in the successive periods.) The era was one of retrenchment. Failing to follow up the bolder imperial exploits of Yung-lo, Hsüan-te pulled back the Chinese forces in Southeast Asia, allowed the situation on the northern frontier with the Mongols to deteriorate, and put a stop to the maritime expeditions. He inherited a situation of serious monetary inflation brought about by his predecessor's grand-scale building in Peking and military campaigns. Like the emperor Hui-tsung three centuries earlier, he was himself a painter of modest talent, specializing in animals, especially cats and dogs in garden settings, and must have exerted some influence on the painters in his court; but his own works are so eclectic in style that it is hard to guess what the influence can have been. In any case, whether by design or through laxer control, he effected no stylistic or aesthetic domination comparable to Hui-tsung's (which, as noted above, set a whole new direction for court-academy painting in the Sung).

The masters of Hsüan-te's Academy, although they mostly came from the conservative centers in Fukien and Chekiang provinces and were trained in the "basic" Sung styles described earlier, do not simply perpetuate those old styles but, together with a master who may never really have

been one of them, Tai Chin, accomplish the true beginning of Ming Academy painting as a distinct movement. In contrast to their predecessors in the Hung-wu and Yung-lo courts, who had represented little more than an aftermath of Sung-Yüan painting and were apparently regarded more as performers of useful functions than as artists of individual stature, the Hsüan-te Academy masters, or some of them, created a new and significant stylistic current, based on Sung styles (and to a lesser degree on those of the Yüan) but not stultifyingly bound to them.

HSIEH HUAN    Another painter who, like Pien Wen-chin, served at court under both the Yung-lo and Hsüan-te emperors was Hsieh Huan, or Hsieh T'ing-hsün (the name he used in his later years). Born in Yung-chia in Chekiang Province, he acquired somehow an education that went beyond that of the ordinary professional painter, and some literary ability as well. In his later years he was, moreover, a connoisseur and collector of paintings himself and reportedly painted, on occasion, in the styles associated with the scholar-artists.[6] His career at court was unusually long-lasting and successful: the Hsüan-te emperor had a particularly high regard for Hsieh and "kept him close to his side" as an adviser on matters of painting. One Ming writer reports that he played *wei-ch'i* (a game like Japanese *go*) with the emperor every day. Because there was no regularized system for bestowing commendation or promotion on painters, they were commonly given purely symbolic titles and, especially, pseudomilitary rank in the so-called Embroidered Uniform Guard, the personal guard of the emperor. Established by Hung-wu in 1382, this became a kind of secret service, sometimes employed by the emperor for political espionage and other covert operations. We do not know whether painters took part in such operations, but since some of them were confidants to the emperors, they may well have done so. Hsieh Huan was appointed Platoon Commander and later, in the Ching-t'ai era (1450–56), Battalion Commander in the Embroidered Uniform Guard. How far his elevation was in recognition of his excellence as a painter and how far the result of his closeness to the emperor and of cultivating friends among high officials and the eunuchs, whose political influence had risen sharply since the Yung-lo era, we cannot know. Other officials resented the exemption of painters from the normal channels of official promotion; the practice of giving high rank to them for (as the others saw it) trivial skills, and the practices of favoritism and bribery in their promotion, were criticized severely by two censors in the fifteenth century, but without result. Painters continued to be among the favorites of the art-loving emperors, receiving salaries much higher than court painters in the Sung had received, and sometimes, as we will see, they took extraordinary advantage of their status.

Hsieh Huan's best surviving work, "A Literary Gathering in the Apricot Garden" (Color Pl. 2), testifies to his associations with people in high places: it portrays a gathering held in the spring of 1437 in the garden of the villa of Yang Jung, one of the "Three Yangs" who as members of the Grand Secretariat were the most trusted and honored advisers to the emperors of this period.[7] All three Yangs are portrayed in the painting, along with seven other scholar-officials, one of them Hsieh Huan himself. Inscriptions by Yang Shih-ch'i (1365–1444) and others accompany the painting, identifying the occasion and the participants.

In the section we reproduce, the old man in the center is Yang P'u (1372–1446). He and a man named Wang Ying (1376–1450) are admiring a scroll painting suspended from a bamboo hanging rod held by a boy servant; another boy at the left is untying the fastening string on another scroll. To their right, a Mr. Ch'ien Hsi-li, seated at a table, raises a brush above a spread-out roll of paper, his head cocked thoughtfully as if he were completing a poem in his mind before inscribing it. In portraying these men, Hsieh Huan uses conventions that were well established in formal and state portraiture, thus making a pictorial statement of their eminent status as court officials. At the same time, by investing them with the attributes of the scholar-aesthete, he tells us that they were intellectuals and connoisseurs as well. Perhaps they

were; but we may be reminded of portraits of weighty figures of other times and places—princes, corporation executives—that present these subjects as men of both worldly power and intellectual-artistic prowess. That is the image they want to project, and there are always "establishment" artists who will oblige them by making paintings that project it.

Behind the figures, wisteria vines grow on a bamboo trellis; also framing the scene are palm and cypress trees, and in the foreground a garden rock and low apricot trees in bloom. The enclosed setting, the massiveness of the main figures in their heavy official robes, and their impassive faces speak of a comfortable security that was partly real (the controlled environment of a high official's garden, where he and his friends could indulge in time-honored aesthetic pastimes, surely offered as much of security as Ming China could afford) and partly, as had been the case with Southern Sung court painting and its relationship to reality, a Confucian ideal enshrined in a glorious past and never quite realizable in the present.

The style of the painting suits its theme in being traditional and unadventurous, fully accepting the Southern Sung Academy mode in only slightly altered form. Paintings by Liu Sungnien, Li Sung, and other masters of that age provide such close sources for Ming works in this style that we are sometimes at a loss over whether to date them, in the absence of trustworthy signatures or other evidence, to the twelfth century or to the fifteenth. The contour lines of rocks and tree trunks have taken on, in this later work, a slightly crotchety character, with small bumps and points protruding at close intervals, produced by pushing down and raising the brush rhythmically as it moves; such line drawing is typical of the most conservative academic paintings of early Ming. The forms are compact, distinctly set off, neatly spaced, heavily and individually textured. This clear division of the picture surface into dense and empty areas as a basic means of composition had begun, probably, with Li T'ang in the early twelfth century and characterized the academic styles thereafter.

SHANG HSI   An artist with whom this tight, restrained style is especially associated in the second quarter of the fifteenth century is Shang Hsi, who was born at P'u-yang in Kiangsu Province. Called to court in the Hsüan-te era, he eventually became Commander in the Embroidered Uniform Guard. His subjects included tigers and other animals, flowers, and figures in landscapes. A good example of the last category is his painting of "Lao-tzu Passing the Barrier" (Pl. 6). It is unsigned, but an inscription mounted above, by a writer of the later fifteenth century, identifies Shang as the artist. The picture illustrates one of the didactic anecdotes or events from history and legend that the Chinese call ku-shih, "events of antiquity," which supply the themes for a great number of Ming academic paintings, even many of those that seem at first glance to be pure landscapes or landscapes with purely conventional figure groups. Such painting, favored by Academy or academic painters (and their patrons) in all periods, is the Chinese equivalent of "history painting" in Europe.

Here it is a story from the late Chou period that is illustrated: Lao-tzu, the semilegendary Taoist philosopher, leaving China in an ox-drawn cart on his way to the Western Regions, delivers the text of his Tao-te ching ("The Way and Its Power" in Waley's rendering) to the keeper of the barrier, Yin Hsi. Lao-tzu is presented in his traditional image, with bulging forehead and white beard, his yoga-like seated posture an expression of his quietist thought. Yin Hsi, kneeling before him holding a scepter of office, wears the costume of a Ming official—the artist makes no attempt at historical accuracy, or even at a general air of antiquity. The cart is also, we may suppose, an up-to-date Ming model. Where the serious professional excelled in scenes of this kind—and this is why the amateurs seldom tried their hands at them, and were usually out of their depth when they did (cf. Ch'en Ju-yen's picture, Hills, Pl. 71)—was in giving an impression of precision by means of firm-lined, detailed drawing; actual fidelity to either history or nature was beside the point. The landscape elements in Shang Hsi's picture are similar to those in

Hsieh Huan's in being firmly bounded and heavily textured and are similarly used to enclose a shallow stage for action.

SHIH JUI    Another of the backward-looking court painters of the period was Shih Jui, a native of the Hangchow region in Chekiang who was called to court in the Hsüan-te era and served as a painter-in-attendance (tai-chao) in the Jen-chih Tien. He is said to have used the style of the Yüan master Sheng Mou in some of his landscapes and to have worked in the blue-and-green manner; he was also a specialist in chieh-hua, or "boundary painting," the meticulous delineation of architectural subjects. Among his surviving pictures are three illustrations to ku-shih, and two handscrolls and two hanging scrolls in the blue-and-green manner.[8] One of the hanging scrolls, probably his finest surviving work (Color Pl. 1), bears two seals of the artist.

The blue-and-green mode of landscape painting originated in the T'ang dynasty or earlier but was probably not thought of as a distinct manner, or given a name, until the Sung period. It took its name from the blue and green mineral pigments, the copper carbonates azurite and malachite, finely ground and held by a glue binder, that were applied heavily in coloring earth surfaces and rocks. Sometimes gold was added (brushed on as a pigment) along the edges of rocks and elsewhere to render a glow of sunlight; an alternative name for the manner was "gold-and-green landscape." In the Sung period and especially the twelfth century, when ink monochrome or lightly colored styles were most popular, the blue-and-green landscape was revived as an archaistic manner, with deliberate reference to antiquity; but at the same time, the heavy mineral coloring was used in styles that otherwise represented, along with other works of that period, the apogee of naturalism in Chinese painting. Yüan-period blue-and-green landscapes, by contrast, emphasize the element of decorative archaism and move consciously away from naturalism in their flat coloring and highly conventionalized drawing (see the example by Ch'ien Hsüan, Hills, Color Pl. 1).

The early Ming Academy, in this mode of painting as in others, reverts to Sung practice, restoring a degree of naturalism to the style by providing enough space within the paintings for houses to be set and figures to move around, and offering the careful, descriptive delineation of detail that makes the picture believable in the viewer's eyes. To accomplish this, to recapture so much of the Sung manner, the Ming artists must have had actual paintings of that period to study. We know that the great landscape handscroll ascribed to the mid-twelfth-century Chao Po-chü, now in the Peking Palace Museum, was in the imperial collection in the early Ming period, since the Hung-wu emperor wrote a long inscription for it, and this was probably a principal model for Shih Jui's essays in the blue-and-green mode.[9] A crucial factor in the formation of the court painters' styles, or in the transforming and refining of their styles after they came to court, was their access to early works in the imperial collection. Ordinary painters, unless they had some special entree to good private collections, could hope for no such familiarity with the masterworks of the past.

Shih Jui's painting follows Chao Po-chü's in many features but reflects its own age and the intervention of Yüan in others. The blue and green pigments are not laid on so flatly or so separately within the outlines as in Ch'ien Hsüan's version of the style, but neither do they model the masses through subtle shading as in Chao's. Figures are spotted about the scene as they are in Chao's scroll, admiring the vistas, climbing the paths, approaching the houses or resting inside; but when we view them close up they are seen to be less individualized, more conventional. The mountain ridges, like Chao's, are represented as winding upward and back, and yet in the end are read as flat and frontal. Chao's composition is unified by a hierarchical ordering of forms, while Shih's trees, rocks, figures, etc., are more or less uniform in size and tone and are dispersed evenly throughout the picture space. The proliferation of composition elements is obvious if the picture is compared with Sun Chün-tse's (Hills, Color Pl. 4), which begins with a

similarly arranged foreground but is far simpler as a whole. This tendency to overelaboration and the episodic treatment of figures and architecture are characteristic of large-scale landscapes of the Academy and the Che school. Later examples, however, in pursuing bolder effects, were to lose the refinements of execution that can still be admired in this one. The Ming re-creation of Sung style as an elegant, courtly art is seen here in its truest, and in some respects its finest, form.

An impressive and hitherto unpublished landscape, signed by the artist, can be added to Shih Jui's small oeuvre (Pl. 8). Painted in ink and fairly heavy colors on silk, it represents a river shore with a steep mountain rising in the distance. Three men sit at a table in a foreground pavilion, attended by servants; beyond the farther shore is a villa among leafy trees. Here, the composition in its scale and plan recalls Yüan-period evocations of Northern Sung and earlier landscapes: the nearest land mass is already in middle distance and is separated from the viewer by water; there is no clear focus to the composition; the shores and mountain slopes are treated in an archaistic manner derived from the Five Dynasties and early Sung mode that combined schematic parallel-fold divisions of the surface with a heavy, graded application of texture strokes. The furry appearance given to the earth masses by this method may remind us of Wang Meng's "Fisherman-Recluse at Hua-ch'i" (*Hills*, Pl. 52) and of the schematic archaisms of Ch'ien Hsüan's "Dwelling in the Floating Jade Mountains" (*Hills*, Pl. 7), but comparison with either work reveals immediately that Shih Jui is after all the academician: nothing in his painting seems arbitrary or spontaneous; there is nothing of the partly intentional awkwardness of the amateur nor much sense of original creation to counter the uneventfulness of a performance in an established style. Like Shang Hsi's picture or Shih's own blue-and-green landscape, this one is neat, stable, clearly readable, involving more the eye with richly tactile forms than the mind with any emotions or concepts that might underlie them.

LI TSAI   The two leading landscapists among Hsüan-te's court painters were Li Tsai and (insofar as he was ever a court painter at all) Tai Chin. Li was born in Fukien Province, where he presumably learned painting from some local master. For reasons not recorded he moved to K'un-ming in Yünnan Province, in the far southwest. Written accounts go on to say that he was summoned to the capital and installed as a painter-in-attendance in the Jen-chih Tien during the Hsüan-te era; but his collaboration with two other painters of whom the same is reported, Hsia Chih and Ma Shih, on a handscroll[10] dated 1424, two years before the beginning of that era, suggests that he and the others were already in the capital by that year, perhaps hoping for appointments at court. The growth of Nanking and Peking, and the concentration in both cities of money and patronage, must have attracted artists from faraway places; and when we read of one who was "invited to court," the truth may well be that he had come to the capital on his own, still little known but ambitious, or perhaps at the invitation of some official from his home province who was serving in the capital, and there won a name for himself and eventually come to the attention of some higher official or eunuch who recommended him to the emperor. It was in such channels of recommendation that the possibility of regional favoritism and bribery arose. This is, of course, speculation, but is a more likely pattern of events than the idealized one suggested by standard accounts written long afterwards, in which the emperor hears of the fame of some painter in far-off Fukien and calls him to his side.

Concerning Li Tsai's landscape style, written sources and extant works agree in indicating that he followed two traditions: that of Kuo Hsi and that of Ma Yüan and Hsia Kuei. Beyond this simple observation, however, they diverge. The critics write that he used the Kuo Hsi manner for his refined or careful works, the Ma-Hsia for his rough or coarse ones; surviving paintings seem to say just the opposite.

Good examples of his work in the Ma-Hsia manner are the three pictures he contributed to the handscroll mentioned above, painted in 1424 and representing scenes from the "Home-coming Ode" by T'ao Yüan-ming. The one from which we reproduce the central section (Pl. 9) illustrates the line: "I sit by a limpid stream composing poems." The poet is seated on the bank, beneath a pine tree, his brush poised, head tilted (like that of the calligrapher in Hsieh Huan's scroll, Color Pl. 2—such expressiveness of posture and arrested movement was a feature of the Academy figure style). His boy servant stands behind him, careful not to block his view, and grinds his ink. On the opposite shore are two herons. The stream banks are rendered in smoothly graded ink washes, which set off the river elegantly and then fade into fog above.

All this is very old-fashioned, in a somewhat homogenized, late-romantic Ma-Hsia manner. The same could be said of the anonymous "Scholars on a Lakeshore" (Pl. 3), but there the execution was more polished and meticulous. Li Tsai has effected some interesting alterations in the manner. The figures are larger, the trees not so attenuated or so impressive. In Sung compositions of this type, and even in "Scholars on a Lakeshore," foreground figures are set in one corner and gaze into distance, directing the attention of the viewer outward to the landscape. Here, by contrast, the figure of the poet is drawn large and located centrally, while the surrounding landscape is reduced to a minimal role (instead of gazing into misty space, the poet looks at a nearby pair of birds); one's attention cannot easily escape from the figures themselves. The matter-of-fact pose and action of the servant (whose facial expression and crumpled garment assign him to a lower social order—we will see a superlative exploitation of this means of indicating status by style in a later chapter, in "Beggars and Street Characters" by Chou Ch'en) work also to deprive the picture of the air of ideal perfection, and of mystery, that the style had originally carried with it. For all its elevated theme, the untrammeled pleasures of the country gentleman, the painting seems rather mundane, as do the others in the scroll. This effect is partly due to the absence of all ambiguities from the composition, partly to the heavier, more mannered drawing of the figures in jagged brushstrokes. Such drawing was intended, no doubt, to recapture the figure style of the Southern Sung masters Ma Yüan and Liang K'ai but falls far short of their reconciliation of sensitivity and sureness. (Among the heirs to this more heavy-handed Ming derivative of Sung styles were the painters of Muromachi-period Japan and the Kano-school masters of still later periods.)

We begin to perceive the dilemma faced by the Hsüan-te court painters: while some of them seem to have been content to continue in old styles, others felt the necessity to break out of them, if only because they recognized that anyone trying to compete with the Sung masters on their own ground could be sure of losing the competition. However, attempts to move into a new style raised new dangers. The inclination of any good painter of any school in this period, with the examples of the great Yüan masters behind him, must have been toward the more in-dividual and expressive kinds of brushwork practiced by the scholar-artists of the Yüan. But the history of Chinese painting offers numerous instances of what happened, typically, when one of the professionals, trained in the technically disciplined and precise modes of drawing, tried to "loosen up" and join the amateurs: unable to break easily the ingrained habits of tightly con-trolled movement, to relax and "trust the hand" or "trust the brush" (Chinese phrases referring to spontaneous acts of creation) so as to attain the nuances of touch and the implications of a lighter, slightly capricious approach that characterized the scholar-artists' drawing, they tended to slip into nervous mannerisms, obtrusive and obsessive eccentricities of brushline that seem too obviously aimed at effects of animation. On the one hand, then, the safe but deadening option of academicism; on the other, alternatives that involved serious risks—beyond, that is, the normal ones that a painter runs when he departs from the style in which he feels secure, and which he knows will please his patrons. But good artists do not avoid risks, and the best of the Academy artists did not; their experiments proved rewarding, in ways we will see. By under-

standing their dilemma we are better prepared to understand the later development of this branch of Ming painting, in both its successes and its failures.

Li Tsai's best-known work, "Landscape in the Manner of Kuo Hsi" (Pl. 11), is a good introduction to the new direction within Academy painting. It is undated but must represent the style of his later years, when he was probably influenced by Tai Chin, the artist most responsible for that new direction. Comparison with T'ang Ti's "Traveling in the Autumn Mountains" (*Hills*, Pl. 31) and with the masterpiece on which that is based, Kuo Hsi's "Early Spring" of 1072 (*Hills*, Pl. 92), reveals at once that this is still another reworking of that famous composition.[11] It seems to be based more on T'ang Ti's version, or some other intermediary, than on Kuo's original, which Li Tsai may never have seen (although he could have, since it was in the early Ming palace collection): the temple-in-the-valley passage, for instance, is again located in the left center. The distant mountains that T'ang inserted at the opposite side, to block off the deep recession, have been enlarged to fill the whole space, allowing no penetration at all. Li Tsai's masses have lost even the degree of rotundity that T'ang Ti's preserved. Moreover, he treats complex masses neither as organic wholes in the Kuo Hsi manner nor as composites of lumpy units in that of T'ang Ti but as overlapping flat shapes, set off from each other by simple contrasts of light and dark, the smaller shapes superimposed upon the larger. The ridge that zigzagged into depth at the summit of Kuo Hsi's central mountain survives only as a two-dimensional zigzag pattern on the front face of Li Tsai's.

All this represents a general abandonment of concern with illusionistic rendering of space and mass, light and shadow; and by giving these up, acknowledging that he is no Sung painter and exploiting the characteristics of a new style, Li Tsai achieves a far more pleasing work than T'ang Ti's, a work that in relinquishing Northern Sung monumentality conveys a monumentality of its own, in powerful forms rendered with sureness of purpose but also with an air of semi-spontaneity. Untroubled by the need to define relative distance, he can construct his picture out of blocky units that interlock for compositional tightness; content with creating a generalized effect of sunlight and shade (in which, following probably the lead of Tai Chin, he is quite successful), he is relieved of the task of trying to portray their interaction on individual forms. The effect of fussiness (from which T'ang Ti does not escape) he avoids through broader, more dashing brushwork that sacrifices much of its form-defining properties to gain a sense of ease, a degree of relaxation.

The roughness of the brushwork which is more visible in details (and more pronounced in other works by Li), gives us a clue to why his style was described by Yüeh Cheng (1418–72) as "wild and disorderly." Brushwork of this kind tends to flatten whatever it depicts, but the flatness is here accepted, presented as an aspect of an interesting new style. The implications of impulsiveness and temperament that this style carries signal at least a partial liberation of the court painter from the servile position of a maker of images, allowing him the status of a creator of works of art. Here style corroborates history: the greater prestige that court painters enjoyed in the Hsüan-te period and afterward is evident even from the meager biographical material that we have for them. The artist who probably deserves most credit for raising the qualitative level and prestige of the Academy was Tai Chin.

## 6. TAI CHIN

The events and circumstances of Tai Chin's life, and his influence on contemporary and later artists, have recently become clearer through the research of Kei Suzuki.[12] Tai was born in 1388 in Ch'ien-t'ang (the region of Hangchow) in Chekiang Province and presumably learned painting

from some master of the local school. He made at least one trip, and perhaps two, to the capital (then Nanking) while still in his twenties. One later Ming source relates an anecdote that has him arriving there in the early Yung-lo era: a porter disappears with his luggage, whereupon Tai sketches the man from memory so accurately that the townspeople recognize him and conduct Tai to his house, where the luggage is retrieved. Another source, the biography of Tai by Lang Ying (b. 1487), which is the fullest account of Tai Chin's life that we have, tells of his coming to Nanking late in the Yung-lo period with his father, who had received an official appointment (? the text is not clear). Although Tai was already a painter of uncommon ability, he failed to make a name for himself, even with his father's support, and returned to Ch'ien-t'ang to work on perfecting his skill. His fame grew, and early in the Hsüan-te era, probably around 1425, he was recommended at court by a eunuch named Fu, who submitted four of Tai's paintings, landscapes of the four seasons, for the emperor's appreciation. The viewing was held in the Jen-chih Tien.

There are several varying accounts of what happened at this viewing, but they agree that Tai fell victim to the envy of other painters in the Academy, especially of Hsieh Huan. In Lang Ying's version, Hsieh (who was, we should recall, the emperor's trusted artistic adviser) unrolled first the spring and summer scenes, and expressed admiration for them: "These are beyond what your subject [i.e., I myself] could attain." But when Hsieh looked at the autumn scene, he expressed anger. The emperor asked why, and Hsieh replied that the fisherman portrayed in the picture was not suitably humble in appearance. Other accounts are more specific about his objection: the figure wore a red coat, which, Hsieh maintained, was proper garb for gentlemen-officials but not for a common fisherman. Gentlemen garbed as fishermen-recluses had often appeared in Yüan paintings, where they suggested a high-minded avoidance of public life and service under the Mongols; perhaps Hsieh meant to read such an antigovernment implication into Tai Chin's picture.

That possibility is strengthened by his response to Tai's winter scene: upon examining it, Lang Ying goes on to relate, Hsieh Huan exclaimed that the "Seven Worthies Passing the Barrier" (a ku-shih of unclear origin which was evidently the theme of the picture) was "an incident from a disorderly age"—it represented seven men fleeing from some unsettled, ergo badly ruled, state and hence could be interpreted, however forcedly, as a slur directed at the emperor and his regime. Hsüan-te concurred and waved the paintings away; Tai Chin had lost, at least for the time, all chance of an appointment to the Academy. Lang Ying tells us that the emperor ordered the eunuch Fu executed (which would seem an excessive punishment if this were not Ming China, when executions for trivial offenses were common) and that Tai Chin and his student Hsia Chih escaped to Hangchow, leaving at night to escape notice.

This bitter episode is so crucial to Tai Chin's career that it must be assessed and somehow understood. It would be a mistake to interpret it as indicating that Tai's contact with Hsüan-te court painting circles was so brief as to be inconsequential. A more plausible interpretation, suggested but not developed by Suzuki, is that it represents the climax, but not the entirety, of a serious conflict between Tai and the conservative artists at court, of whom Hsieh Huan was the eldest and most powerful. The young Tai Chin, coming from the same Chekiang background as Hsieh and following the same stylistic tradition but already (we may assume) engaged in a creative reworking of it, could be seen only as a potential rival; as one outside the established hierarchy of age and rank but at least implicitly challenging it, he may well have represented a real threat. The court artists described in the texts as envious of Tai cannot have known his work only through this single showing at court; he may have been at the capital for some time before this, as was suggested above in the case of Li Tsai, looking for high-level patronage and eventually a position at court. The same artistic excellences that raised his reputation in Hangchow and Peking may have provoked alarm in the Academy.

Lu Shen (1477–1545), our earliest source on the life of Tai Chin, introduces his account of the incident with this: "Serving at court under Hsüan-te were Hsieh Huan, Ni Tuan, Shih Jui,

and Li Tsai, all of whom were famous; but when Tai Chin came to the capital, they were all jealous of him.''[13] Hsieh Huan, as the most powerful spokesman for this point of view, probably invented his objections to the fisherman's red coat and the Seven Worthies theme on the spot to mask a deeper opposition; and his choosing issues of subject rather than style to discredit Tai before the emperor suggests another gap between old and new. Court painters up to this time had devoted a great deal of attention to depicting specific subjects, historical, legendary, or contemporary (Shang Hsi, for instance, painted a huge picture of Hsüan-te and his courtiers on a hunt, which still survives). They accepted the fact that their works would be evaluated, as those of Sung academicians had been, on the "correctness" of their portrayal of the chosen or assigned themes. Later painters in this tradition are much less concerned with such subjects and the correct portrayal of them. The transition seems to have been in the period of Tai Chin, whose early works sometimes contain *ku-shih* but whose fully mature works seldom if ever do.

At Hangchow, Tai hid out in Buddhist temples and made his living painting images for them. He had not yet escaped, however, from the enmity of Hsieh Huan, who employed an agent to seek him out, forcing him to flee once more, this time to Yünnan, where he entered the service of an art-loving nobleman named Mu Ch'en (1368–1439). Another painter favored by Mu Ch'en was Shih Jui, who, presumably on a visit to Mu's residence, saw and admired paintings of gate guardians that Tai had done for him and, ascertaining that the artist was a fellow townsman (both were from Ch'ien-t'ang), housed and fed him for some time. Shih was apparently not one of the painters hostile to Tai during his brief appearance at court, or else had relented afterwards.

Later, probably around 1440, Tai returned at last to Peking.[14] The Hsüan-te emperor had died in 1435 and was succeeded by his son, who was only eight at the time. The Yangs (who were portrayed in Hsieh Huan's scroll of 1437, Color Pl. 2) and later a eunuch named Wang Chen were the effective rulers. Tai received the favor and support of two high officials, Yang Shih-ch'i (1365–1444) and Wang Ao (1384–1467), who considered him to be the equal of the old masters. His life in this period, Lang Ying tells us, was "well ordered and contented"; people took pleasure in having him for a friend, and his works were in great demand. There is no evidence that he entered service in the Imperial Academy—in fact, since it is difficult to identify much activity in court painting circles between the Hsüan-te and Ch'eng-hua reigns, i.e., 1435–65, we may wonder to what extent there *was* an Academy, even in the loose sense in which we have used the term. But Tai's patrons were on the highest levels of the government, and he was probably the most esteemed and influential painter in the capital during his years there. Nevertheless, he eventually returned to his home in Hangchow, as we are told by, among others, Tu Ch'iung (whom we will encounter as an amateur painter in the next chapter): "Late in life he begged to return to Hangchow, where his fame had increased." He died there in 1462; a number of sources state that he died in poverty, but none takes the trouble to tell us why.

Only a few of Tai Chin's surviving works are dated, and whatever development we may trace in them must accordingly be on the basis of their style. It is natural to begin with paintings that preserve most faithfully the Ma-Hsia mode, on the assumption that this was what he learned as a youth in Ch'ien-t'ang and practiced in his early years. There are a number that seem to represent that stage, among them a landscape with figure recently acquired by the Cleveland Museum of Art (Pl. 12). The composition, like some others treated in this chapter, is a compromise between the diagonally divided plan of late Sung, with free-flowing spaces, and a new tendency to locate the focus of the picture centrally, constructing the remainder around it in a tight, even rigid relationship to the frame. The theme may at first recall a famous work by Ma Lin dated 1246, "Listening to the Wind in the Pines,"[15] and parts of the setting, including trees and rocks, resemble those of Ma Lin, except that they have lost the suppleness of Ma Lin's delineation to become harder and more angular in the Ming manner. The figure is framed by them but not comfortably set in them—the branches projecting inward toward him and the harshness of the

sharp-cut banks with their nail-like texture strokes preclude that. He is shown as a weary traveler who sprawls gracelessly on a path, resting his weight on one arm, his walking stick laid starkly before him, and looks out at the viewer. Unidealized, his head sunk between his shoulders, he seems to assert himself as a modern man inhabiting, or passing through, a Sung world gone slightly wrong. Granting that this is unlikely to have been the conscious expressive intent of the artist, we can still sense in the painting a degree of disillusionment with the Sung artistic ideal to which it ostensibly conforms.

Wai-kam Ho has recently proposed a more specific theme for the painting. He notes the similarity in size and style to another work by Tai Chin representing "Emperor Wen-wang Visiting T'ai Kung-wang"[16] and suggests that the two may have belonged to a series depicting virtuous recluses of legend. When the Chou-dynasty emperor Wen-wang came to visit T'ai Kung-wang on the shore of the Wei River, where the hermit was fishing, to invite him to serve as a minister at court, T'ai loftily refused. Wai-kam Ho identifies the figure in the Cleveland picture as Hsü Yu, another legendary recluse of even mistier antiquity, who, when the sage-emperor Yao offered to yield the throne to him, not only refused but washed his ears to remove the contamination they had suffered. On another occasion Hsü Yu said: "When the water is clean I wash my cap; when it is muddy I wash my feet." The fact that the cap and feet of the figure are prominently displayed in the Cleveland picture supports this suggestion, which is especially interesting in view of the possibility that related themes (cases of seclusion or withdrawal to avoid involvement with official or court service) may have been portrayed in the two paintings denounced by Hsieh Huan. Hsieh's patronage, if we can take the "Apricot Garden" scroll of 1437 as indicative, was from among established officials and men of high ministerial rank. Were Tai Chin's patrons, in the early period probably represented by these works, men somehow out of office, who found in such paintings flattering suggestions that they were so by their own choice? While we can only speculate, the paintings of the two clearly express opposite attitudes toward government service, and for painters active in the capital the choice of such themes was surely significant with respect to the status of their patrons.

A handscroll by Tai Chin portraying the first six patriarchs of the Ch'an Buddhist sect in a mountainous landscape must be another relatively early work, perhaps done during his period as a painter for the Buddhist temples of Hangchow, although this scroll, as we know from the dedication, was done for an individual patron or friend named P'u-hsün. The scroll opens with the scene of the First Patriarch, Bodhidharma, seated in meditation in a cave facing a stone wall (Pl. 10). Hui-k'o, who was to become the Second Patriarch but who at this point was still aspiring to disciplehood, stands behind him, ankle-deep in snow. Bodhidharma ignores him; a moment afterward, in a desperate and totally convincing demonstration of his seriousness, Hui-k'o was to draw a knife and cut off his left arm. The best known illustration to the story is of course the one painted in 1496 by Sesshū, who, as noted already, took much of his stylistic and thematic repertory from the Che school.[17] Sesshū's picture is simpler but quite similarly composed; it may be based on this one, or both on a still older model.

To those familiar with Sesshū's austere work, Tai Chin's will seem busy, even cluttered—he shows us the furnishings of Bodhidharma's cave, even to a bamboo water conduit emptying into a large pot, with a towel hanging over it. Again, an elevated theme is brought down to the mundane level: one could scarcely imagine a treatment of it further removed in spirit from what we are accustomed to think of as Ch'an painting. The outline drawing of trees and rock masses exemplifies that kind of nervous mannerism, referred to above, to which the academically trained artist was prone when he attempted to escape, through experiments in calligraphic activation, from the stiffness of the style he had inherited. Tai Chin is here pushing to the point of absurdity—as, apparently, an artist sometimes must before discarding entirely an outworn feature of style—the linear mode we have associated with the most conservative masters of the

early Ming, turning it into a sort of dotted line. The landscape forms are otherwise close to those in the other picture, which must in an ideal chronology antedate this one, both preceding the artist's full maturity.

The records of Tai's life are too spotty to give us clues as to how the crucial alterations in style came about; we have no information, for instance, on what he saw and studied in painting of the past. But on his trips to the capitals, and later during his stay with Mu Ch'en, he must have had opportunities to see Sung and Yüan works that expanded the range of styles on which he could draw, and his increasing fame in Chekiang art circles doubtless opened doors to collections there. Some of his extant paintings suggest that in his break from the hardened Sung manner he was inspired by the more conservative Yüan artists, especially Sheng Mou, Wu Chen, and Kao K'o-kung; the first two were of course Chekiang painters themselves. As examples of his essays in these Yüan manners we may consider two works that, standing somewhat outside whatever development we can postulate for him, are difficult to assign even provisionally to any particular stage in his career.

One is a hanging scroll painted in ink and light colors on paper, titled "Listening to the Rain" (Pl. 13). The title has been inscribed by the artist at the upper right and is followed by: "Tai Chin of Ch'ien-t'ang drew this in an official residence at Yü-ho." Yü-ho (Jade River) is located in the western environs of Peking; the picture must have been painted during one of Tai's stays there. It is clearly based on the style of Sheng Mou—compare, for instance, Sheng's "Singing While Boating on an Autumn River" (*Hills*, Pl. 25)—in both composition and rendering of motifs: the foreground and distant hills are strikingly similar, as is the device of framing the boat between the shore and overhanging tree branches. So successfully is the style recaptured, in fact, that little besides the composition—vertically disposed at left, horizontally at right (cf. Pl. 15)—reveals the Ming date of the picture or the hand and taste of Tai Chin.

Imitating Sheng Mou was in itself nothing unusual for an Academy or academic painter of the early Ming; as we have already noted, the artist's nephew Sheng Chu was a painter in the Hungwu court, and a number of extant early Ming works testify that Sheng's style was practiced in hardened form by academic artists of that period, for whom it was, along with the landscape manner of Kao K'o-kung, among the few exceptions to their general rejection of the Yüan masters. But Tai Chin's use of the Sheng Mou style is fresh and direct—it must have been based on familiarity with good originals—and avoids the crotchety mannerisms that had crept into standard Ming renderings of it. His brushwork is as soft and sensitive as Sheng's own, re-creating not merely the superficials but the expressive essence of his model, making one more conscious of the scene and its poetic flavor than of the style. A man lies in his boat, sheltered by a woven canopy, listening to the patter of raindrops on the water. The rain is suggested only in a sky darkened with washes of dilute ink and in an agitated river surface.

A more problematic and controversial work is "Five White Deer Beneath Pines" (Pl. 14). It is unsigned, but an inscription by Wen Cheng-ming (1470–1559) attributes it to Tai Chin. Both the authenticity and the quality of the painting have been repeatedly called into question, and it has been little published or discussed. Part of the problem has been identifying the stylistic tradition it follows and understanding how a master of the Che school could come to do such an odd picture. The tradition is in fact that of Kao K'o-kung, whose landscape of 1309 (*Hills*, Pl. 19), however dissimilar in whole effect, provides a parallel for the basic plan and some motifs: a stream separating the foreground into two banks, on which trees grow; cottony fog in the middle ground (which Tai Chin otherwise eliminates by increasing the sizes of his trees and bringing the mountains closer); the mountain itself, made up of steep-sided, round-topped pinnacles, which are already split apart by deep fissures in Kao's work and in Tai's scarcely cohere as a single mass. Several landscapes by followers of Kao K'o-kung could be introduced to fill the

stylistic gap between the two pictures;[18] they corroborate what we learn from written sources: that the following of that arch-amateur Kao K'o-kung, after the end of Yüan, was not so much among the scholar-artists as (somewhat surprisingly) among the Academy painters and other professionals.

Five deer, white with brown spots, have come to drink at a stream in a pine grove. Deer are auspicious symbols in China, because the word for deer (*lu*) is a homonym with that for good fortune. Wen Cheng-ming's poem underlines this symbolic content in the painting, which was probably commissioned for presentation on some occasion such as the birthday of an official; it speaks of the "five auspicious [symbols] assembled" and of "deities and immortals on earth." The artist, perhaps aiming at an impression of otherworldliness, dematerializes his mountain peaks until, descendants though they are of Kao K'o-kung's ponderous masses, they seem quite weightless. He transforms the horizontal *tien* ("dots," or small strokes) that lined the edges of Kao's slopes into elongated grassy strokes that are repeated by vertical piling throughout the picture, as if threaded on the long, wavering contour lines. He adds to the visual ambiguities of clouds and hilltops by drawing both with the same curling outlines. Throughout, most of all, he denies solid substance by setting up vibrating movements, interweavings of restless line, flickering plays of light and dark. Where Kao K'o-kung presented us with a basically stable construction of strangely plastic but inert matter, Tai Chin (if it is indeed he) gives us a vision of shimmering mountains, fluidly twisting pines, shifting mists, and mysterious deer that seem suitably unearthly denizens of such a world. The picture is worthy of Tai Chin, and Wen Cheng-ming's attribution can provisionally be credited until more evidence either substantiates or disproves it.

The four Tai Chin paintings we have considered fall either prior to or somehow outside his typical mature style. Enough of his work survives, and with enough consistency within it, for us to define that style clearly and see how it developed out of the harder, tighter manner of his early period, a development that set the direction for the whole Che school. A good starting point is a large, signed painting representing "Men in a House over a Stream" (Pl. 17). Three men sit in a room opening onto the water, while another approaches on a path along the river. The lower part of the composition is roughly symmetrical and fairly stable, but the placing and drawing of the beetling bluff that rises above offsets both symmetry and stability. Since some features of style to be seen here will affect powerfully the later phases of the school, it is worthwhile to identify them now, at first encounter (or, for some of them, second, since they were noted already in Li Tsai's landscape, Pl. 11):

1) The scale of figures to their setting belongs neither to the monumental landscape type (Shih Jui, Li Tsai: Pl. 8, 11), in which figures were small and inconspicuous, nor to the narrative or anecdotal figures-in-landscape type (Shang Hsi, Li Tsai: Pl. 7, 9) in which they were the center of attention. Here they are large enough and numerous enough to enliven the scene without dominating it, while the mountains are scaled down to modest proportions by the relative sizes of trees, building, waterfall, etc. The scale, to put the matter simply, is closer to that of Yüan painting than to that of Sung.

2) The painting is composed in large units, none dominant; they lock together and echo each other in shape for a unity that does not depend on well-defined spatial relationships—there is little sense of separation in depth—or on any flow of force or forms from one part to the next, but on an effective organization of the painting surface.

3) The landscape masses, and especially those in the upper part, are not treated as truly plastic or tactile forms; the artist neither models them nor renders their texture with the patiently repeated strokes called *ts'un*. Instead, washes and broad overlapping strokes of dilute ink create an impression of light and shadow, conveying the corporeality of a mass by distinguishing

simply its sunlit and shaded sides, and its weathered, irregular surface through highlights (standing out as reserve in the areas of wash) and dark strokes that read as recesses.

4) Landscape forms are dynamically conceived; they push and lean, like those in Yüan paintings, thrust answered by counterthrust, and overhang at some points for effects of instability.

5) All this is accomplished in brushwork that is itself dynamic and achieves something of the quasi-improvisatory character of the late Yüan scholar-artists' works. Outlines meander fluidly across the surface, and scratchy, split-brush configurations have taken the place of texture strokes. Tai Chin is venturing into the alluring, perilous realm of style that we referred to, in discussing Yüan painting, as the transformation of mass into movement; it is a relatively cautious venture so far, but is already successful in several respects. It communicates to the viewer a sense of swiftness and ease of execution, thus involving him visually in the making of the picture; it allows the artist (since the swiftness was no doubt real) to produce more quickly a work that is no less formally strong or decoratively beautiful than he could achieve with the older, more painstaking methods.

Another way of characterizing this direction in style has been suggested by Sherman Lee, who speaks (in describing Yüan departures from Sung practice) of pictures that are "written" rather than (in the old sense) painted.[19] Tai Chin's pictorial "writing" is the brush-idiom of the semicursive "running" script, *hsing-shu*, or even of the cursive *ts'ao-shu* in some of its brusquer manifestations. Tai's most extreme excursion into this manner is also his most brilliant: the celebrated handscroll in the Freer titled "Fishermen on the River" (Color Pl. 3). Here the influence of Wu Chen seems obvious: in the thick-line, cartoon-like drawing, in the depiction of shoals with reeds stretching into distance, and in the placing of boats as bold diagonals against the river, which in some sections fills the entire height of the scroll, as in Wu Chen's own "Fishermen" scroll of 1342 (also in the Freer Gallery).[20] But these stylistic borrowings are used in a context that is fundamentally different from Wu Chen's.

Tai Chin's fishermen are not the gentlemen-recluses whom Wu depicted, out on the river for quiet contemplation; some of them, at least, are actively earning their living by catching fish. Others pole their boats, sit in them conversing in gregarious groups, or gather on the bank to drink wine, surrounded by their wives and children. All are highly animated, both by their postures (turned heads, bent knees) and by the drawing itself, done in short, jerky strokes. Trees and rocks (seen elsewhere in the scroll) seem animated as well, not so much by any dynamism in the forms themselves as by a nervous energy in the brushwork that brings them into being. Tai Chin works with an air of unrestraint or even abandon, but a rigorous technical training underlies his seeming looseness, preventing him from ever really losing control; the effect is one of spontaneity, but everything is in place. We can admire this nice balance that he strikes between freedom and discipline; few later artists were to strike it so successfully. The energetic and decisive execution of this scroll might be condemned by the more fastidious literati critics as showy, but it impresses us today as a dazzling virtuoso performance by a master whose technical brilliance is as apparent in his spontaneous works as in his careful ones, perhaps even more so.

The few dated works of Tai Chin that survive are clustered in the period 1439–46, with a single painting, a hard-edged and severe winter landscape dated 1452, standing apart from these. They all belong to a period, probably during his later stay in Peking, when he worked confidently, in well-mastered styles, producing works that were not too demanding of his time or taxing of his inventiveness, to supply a demand created by his new popularity. A hanging scroll dated 1445 in the Shanghai Museum and a handscroll dated 1446 in the Berlin Museum are both made up of fairly conventional Ma-Hsia school motifs rendered in a blunt "shorthand" manner.

More admirable are two hanging scrolls dated 1444, autumn and winter scenes from a set of

landscapes of the four seasons, which are known only through reproductions in an old Japanese book (Pl. 15–16). They are handsome, strongly decorative pictures that retain little of the old academicism, and the fact that the style they display became in time the basis of a new academicism is of course irrelevant to their quality. Both can serve to establish for us compositional types that were probably original with Tai Chin (cf. his "Listening to the Rain," Pl. 13) and were endlessly repeated by later artists. In the autumn scene (Pl. 16), an overhanging cliff rises the entire height of the picture, with trees and bushes growing out from it, and fishermen's boats placed below and beyond the cliff define simply a horizontal extension into depth to counter the dominant vertical. Variants of this type were to become the stock in trade of later artists such as Chang Lu. The winter scene (Pl. 15) is similarly vertical in its main emphasis, with rocks, trees, and peaks piled up on the left side; the river stretches to a high horizon at right, with stages in the recession marked only in the foreground, by a bank and bridge with a group of travelers, and in the background by a boat and the distant shore. Both formulas provide means for the easy contrivance of effects of deep space, which are neither so rationally achieved as in Northern Sung painting nor so visually as in Southern Sung but rely on long-established conventions that are effective because they are familiar. Similarly, the profusion of trees, diverse in their branch patterns and leafage, affords an impression of rich textural variety to compositions that would otherwise seem very stark.

The drawing adapts sensitively to the nature of the objects it portrays: supple for the trees of autumn, stubby and stiffer for those of winter; firmly bounding for the rocks, compact and sure for the figures and boats; everywhere with the right degree of tension for its function; clean and exact, with none of the sloppiness or hardness that were to afflict later imitations. When we add to these excellences the attractiveness of the subjects, with their bucolic nostalgia, to officials and other residents of the capital, we are at no loss to understand Tai Chin's popularity; and these two pictures alone would prove that it was well merited.

Chinese writers of later ages credit Tai with founding the Che school, named after his native province, Chekiang, where he began and ended the ups and downs of his career. Many later artists, court painters and others, were his followers; whether or not we can properly call them a school is another of those questions of definition on which it seems fruitless to spend one's time. (The designation "Che school" is commonly expanded, as we noted at the beginning of this chapter, to cover court painters and others stylistically related to them as a group, including those who neither came from Chekiang nor followed Tai.) The decline of this school (or whatever we choose to call it), which will be traced in a later chapter, affected also Tai Chin's reputation. In his time and shortly after, he was praised by some as the finest painter of his age. Lu Shen (1477–1545), quoted earlier, says: "Of the painters of this dynasty, Tai Chin of Ch'ien-t'ang must be considered the foremost"; and Lang Ying writes: "After the master died, there were dozens who became illustrious through their paintings—Li Tsai and Chou Ch'en in landscape, Lin Liang and Lü Chi in birds and animals, Tu Chin and Wu Wei in figures . . . but they each attained only one branch [of his art]. Who was there who combined beauties and skills as the master did? He was truly a sage among painters." Others in the sixteenth century, however, felt obliged to praise him a bit defensively as "the best among the Academy masters" or as having been more than a mere academician, an artist whose styles contained elements of Yüan painting as well as Sung and of the amateur tradition as well as the professional.

Wang Shih-chen (1526–90), a highly influential critic of literature as well as painting, says of him (Sirén's translation): "Tai Chin from Ch'ien-t'ang painted incessantly during his whole life, yet he could never buy a full meal. This was his minor misfortune. After his death he was famous in Wu [Soochow], but when a hundred years had passed he was no longer considered equal to Shen Chou. This was his greater misfortune. But in the eyes of real connoisseurs he will be considered the foremost of all Ming painters." Wang's further defense of Tai Chin, how-

ever, betrays in itself some prejudice: he tells of seeing a series of seven landscapes by him, which he mistook at first sight for works by the slightly later scholar-artist Shen Chou (who is hailed as founder of the Wu school, as Tai is of the Che); there was, he said, "no trace of the Ch'ien-t'ang feeling in them."[21]

It was already difficult, a century after Tai's death, to reconcile an admiration for his paintings with an all-but-obligatory condemnation of the tradition he belonged to. By the late Ming, the issues had become even more polarized and doctrinaire. Tung Ch'i-ch'ang, the most powerful of all the later critic-theorists, writes equivocally about Tai Chin, perhaps in recognition of his inescapable excellence; but still later authorities (e.g., Hsieh Chao-che, ca. 1600) include him in the despised lineage of the "Northern school" and speak of the "low quality" of his works.

## 7. PAINTING DURING THE "INTERREGNUM," 1436–65

For the period between the Hsüan-te and Ch'eng-hua reigns, 1436–65, records of painters at court are scant. Hsieh Huan was still alive and presumably active as a painter in the Ching-t'ai era (1450–56), and Lin Liang, to whom we will turn shortly, probably entered service at court during this period; but for the most part the period is a blank. The same is true in the production of blue-and-white porcelains for imperial use; the absence of pieces datable by reign marks to this intervening period has led scholars of Ming porcelains to refer to it as an "interregnum." The explanation usually given is that the country was impoverished by the necessity of launching further campaigns against the Mongols (who dealt the Chinese a disastrous defeat in 1449); although this view has recently been questioned,[22] some significant falling-off of imperial patronage of the arts seems to have occurred.

CHOU WEN-CHING    A single work datable to the end of this period is a landscape by Chou Wen-ching dated 1463 (Pl. 18), which is said to represent the eleventh-century philosopher Chou Tun-i (1017–73) gazing at water lilies from a waterside pavilion. The artist was born, like Li Tsai, in P'u-t'ien in Fukien and entered court service in the Hsüan-te era—not at first, it would appear, as a painter but as a diviner or geomancer of the Yin-Yang school. He rose to prominence as a painter when the emperor awarded first prize, in some competition, to his picture of "Wintry Crows in an Old Tree." He is said to have revered Hsieh Huan, whose support may have contributed to his success at court.

Chou Wen-ching signs the 1463 work as "Painter in the Jen-chih Tien" but dedicates the painting to an individual—it was not, that is, done for the emperor. It is an impressively old-fashioned work, which, if it lacked the dated inscription, would doubtless be assigned by its style to an earlier period. Influence from Tai Chin is minimal if present at all. The forms of the picture are incompletely defined and suggestive, their contours subdued, like those in paintings by Hsia Kuei (cf. *Hills*, Pl. 87); they appear successively, overlapping in a slanting echelon, separated by hollows of misty space, back into deep distance. The artist paints as if nothing of significance had occurred in this style between the Southern Sung and 1463. The statement that he "revered Hsieh Huan" agrees with the conservative outlook he evidences here. One Ming source says that he followed Hsia Kuei and Wu Chen; two other signed works that (in contrast to this one) are done in thick-line drawing must represent his debt to the Yüan master.[23]

YEN TSUNG    A surprisingly large number of professional painters in the Ming period came from port cities on the central and southern coast—P'u-t'ien and others in Fukien, Hangchow and Ningp'o to the north, Kuang-chou (Canton) farther to the south. Artistic production in these

centers perhaps began as a byproduct, on a higher level, of handicraft industries located in these ports to supply the foreign and coastal trade in which they were actively engaged. It must also have been, as elsewhere, nurtured by the presence of affluent patrons. The importance of Hangchow as an artistic center is commonly explained as the survival of a local school there since the Southern Sung, when it was the capital, and this is of course part of the reason; but another part was surely its importance as a center of trade. Less is known about any local school in Fukien, as we have noted, and still less about any in Canton, for this period.

The earliest Cantonese artist whose work can still be seen is Yen Tsung, painter of a landscape handscroll preserved in the Kuang-chou Provincial Museum (Pl. 19–20). Born around 1393, Yen Tsung became a second-degree graduate (*chü-jen*) in 1423 and by the early 1450s was a minor official in the Board of Military Affairs; he served earlier as magistrate of Shao-wu District in Fukien. He probably died in 1454.[24] Lin Liang, a more famous Cantonese master to whom we will turn presently, reportedly praised Yen's landscapes as having "a naturalness unattainable by others."

Naturalness is not the quality that comes first to mind when we view Yen's landscape, a thoroughly eclectic work with elements of both the Li-Kuo and the Ma-Hsia traditions. That the artist was following old traditions instead of painting what he saw around him is evident also in the kind of scenery represented, which does not resemble the lush terrain around Canton so much as the valley of the Yellow River, far in the north, Kuo Hsi's homeland. Yen Tsung conceives it in silhouettes that are skillfully graded in tonal value according to their placement in space. The middle ground is pervaded by a light fog, which dims the objects within it—bushes, temple roofs, a farmer plowing with an ox. The rusticity of the scene may have been what Lin Liang found so admirably "natural" in Yen's style, along with a pleasant disorder in the tangled clumps of trees and a looseness both in brushwork and in composition.

LIN LIANG   Lin Liang, who may have known Yen and even studied with him at some time, seems to have learned painting in Canton when he was young. According to an anecdote, he was employed as a youth in the Provincial Administration Office. On one occasion the commissioner, whose name was Ch'en Chin, undertook to make a copy, as a forgery, of a famous painting he had borrowed. Lin Liang, watching from the side, criticized Ch'en's performance—whether on moral or aesthetic grounds is unclear. Ch'en became enraged and wanted to have him flogged. Lin, in his defense, claimed some ability as a painter; Ch'en tested this claim by having the young man make the copy and was amazed by his "divine talent." While it does not specifically say so, the story opens the possibility that Lin himself was employed as a forger.

From this time on, his fame increased among the local officials. Later he was given a post at the capital as vice-administrator of the Bureau of Construction in the Board of Works; from this he moved to the position of court artist in the Jen-chih Tien, eventually reaching the honorary rank of Commander in the Embroidered Uniform Guard. He was probably working as a painter at court by the late 1450s or early 1460s; the dates of his activity are not well established.[25] He could, then, have known Tai Chin, or at least seen his works; and even in the absence of any firm evidence, we may hypothesize that his exposure in the capital to the new landscape style probably inspired him to attempt a corresponding transformation of the old, by now unexciting, mode of painting birds and their habitats which he had presumably learned in Canton.

A few of Lin Liang's paintings are in a heavily colored, very traditional manner that suggests (as does at least one written source) that he began as an imitator of Pien Wen-chin; but most of them, and the best, are done in ink monochrome with broad, characterizing brushwork—brushstrokes that adapt in shape to the subject, that is, a single stroke describing (rather than delineating) a bamboo leaf or feather. A late Ming source, *Hua-shih hui-yao*, makes this distinction: "His colored pictures, done in a highly detailed and skillful style, do not escape [the vices

of] hardness and stiffness, while in his ink-monochrome works, where he pursues his conceptions using fewer brushstrokes, as if he were writing in the cursive script, he has been able to get rid of all sense of banality." The association of the former style with descriptive realism and concern for the outward appearance of the subject, and of the latter with a more spontaneous "setting down the idea" (hsieh-i), goes back to Sung-period theoretical discussions of two tenth-century flower-and-bird specialists, Huang Ch'üan and Hsü Hsi; centuries later, when no one could be quite sure how those two masters had really painted, the issue was still presented in the same way, and the preference of literary critics was still consistently on the side of the less meticulous, less colorful manner associated with Hsü Hsi.

It is not surprising, therefore, that these scholar-critics accord far more praise to Lin Liang than to either Pien Wen-chin or Lü Chi, Lin's successor in the Academy. Many laudatory poems composed as inscriptions for Lin's pictures are preserved in Ming literary collections. Li Meng-yang (1475–1531), for example, writes:[26]

> Of painters of birds, over more than a hundred years,
> He is followed [only] by Lü Chi and preceded by Pien Wen-chin.
> Those two were skilled at likeness, but not at conveying ideas;
> Sucking their brushes and straining their eyes, they worked with
>     hair-splitting care.
> Lin Liang draws his birds using only ink;
> He spreads the silk and, with a half-sweep, evokes black clouds and wind.
> Water birds and land birds, all of the utmost wonder—
> Hanging his picture fills the hall, moving us to passion.

This "moving" quality of Lin's works was in their subjects as well as their style: instead of the small, chirpy, decorative birds favored by other painters, or those that had served for so long as symbols (cranes for immortality, pairs of mandarin ducks for connubial harmony, etc.) that they could scarcely elicit any more direct response, Lin chose to paint large, strong, sometimes fierce birds that asserted their particular natures independently of charm or literal symbolism. Hawks and eagles, often shown attacking their prey; wild geese on marshy shores; crows, cormorants, and peacocks (the last excellently represented by a painting in the Cleveland Museum of Art): these are Lin's favorite ornithological subjects. Their environment consists more often of rocks, bare trees, and bamboo than of flowering bushes and blossoming plum; and autumn and winter are more often the seasons than spring and summer. In short, Lin inclines toward toughness rather than prettiness; and since the same inclination underlay the critical attitudes of the literati, their praise for him is not based simply on a preference for bold brushwork.

A unique painting by Lin Liang preserved in a Zen temple in Kyoto (Pl. 21) portrays a phoenix standing on a projecting boulder, silhouetted against morning fog and staring off at the rising sun, which is colored with a wash of red (the painting is otherwise in ink monochrome). The mythical bird stands on one leg in a stately and static pose, its talons locked tightly to the rock, its single splendid tail feather balancing the twisting neck and head. Like the dragon, the phoenix in China had sustained such a vivid existence in artistic images for so many centuries that one can almost speak of a "realistic" representation of it. Lin Liang's phoenix is not an exception to what was said above concerning his subjects; it is not presented as a symbol but as a living creature, with nothing especially bizarre or fanciful about it. Its powerful presence dominates the picture, which must indeed have "filled" any room in which it was hung. The ink-monochrome medium permits strong tonal contrasts, which, with the bold diagonals of rock and bird, increase the dramatic, arresting quality of the work. It also permits the virtuoso brushwork for which Lin Liang is famous, here seen at its most versatile, modulating in all its aspects to convey the texture, pliancy, and structure of the things it describes.

There is little more evidence for court painting in the Ch'eng-hua era (1465–87) than there is for the "interregnum." Some of the older painters, such as Ni Tuan, were still alive, and a few others, mostly from Fukien, are recorded as having entered court service then, but none of their works seem to have survived. The only major figure to appear on the scene in this period is Wu Wei (1459–1508), who began his extraordinary career as a painter in and out of court in the latter part of the Ch'eng-hua reign, as a favorite of Emperor Hsien-tsung. His career and his paintings will be treated in a later chapter, where we will find in them the features that will bring about a second flowering of Ming Academy painting as well as those that will bring about its decay.

# CHAPTER TWO

# The Beginnings of the Wu School:
# Shen Chou and His Predecessors

## 1. THE WU SCHOOL IN THE FIFTEENTH CENTURY

The city of Soochow and the region surrounding it, known as Wu-hsien, had by the late Yüan period become the main center of the literati current in painting. The purges that scholars and intellectuals of that city underwent during the reign of the first Ming emperor, however, nearly extinguished the cultural brilliance of Soochow. Moreover, the most lively developments in painting during the first century and a half of the Ming seem to have taken place in other centers, chiefly the capitals, Nanking and Peking, but also in Hangchow and other cities of Chekiang and farther south, where traditions from the Sung dynasty still survived. Imperial and official patronage was bestowed principally on professional artists from those centers, the ones treated in the preceding chapter and in the two that follow. The interval of nearly a century from the destruction of Soochow artistic circles in the 1370s until the maturity of the first great Wu-school master of the Ming, Shen Chou, around 1470, represents a hiatus not only in the local development but also in the whole course of literati painting.

Standing forth as modest eminences from this otherwise flat expanse are a few artists of interest who work in styles derived closely from the Yüan masters. In some of their works they imitate particular painters and paintings more closely, and more consciously, than artists before them had done. Yüan artists themselves, such as Chao Meng-fu and Wu Chen, had of course advocated and practiced the imitation of the past; but with them it was a matter of reviving and utilizing styles they admired either in a conscious evocation of the past or for the betterment of their own works and the cleansing (as they saw it) of their own tradition. In the Ming something different begins: the institutionalization of such imitation as a normal part of the activity of the scholar-painter, who could assume the persona of some earlier master for one work, then shift easily, as an actor changes roles, to another for the next work. Wang Fu, the first artist we shall consider in this chapter, was probably the earliest to exemplify this phenomenon.

More often, however, these early Ming masters combine elements of style from different masters, often suppressing those stylistic features of their models that we now find most distinctive and stimulating, eliminating tensions and dissonances, reducing individual modes to more manageable stylistic systems. Neither manner of utilizing the past encouraged originality, and originality is not among the strengths of these artists. (One can make a qualified exception to this judgment in the case of one of them, Liu Chüeh, as we will see.) Even their eclecticism was in a sense secondhand: the process of homogenization of Yüan styles had begun already in the works of secondary late Yüan masters such as Chao Yüan, Ma Wan, Ch'en Ju-yen (*Hills,*

pp. 128–30); the painters now to be considered are the heirs of these lesser, as well as of the greater, masters.

WANG FU    The earliest of them was Wang Fu (1362–1416). He was not from Soochow prop-er but from nearby Wu-hsi, distinguished already in the history of painting as the birthplace of Ku K'ai-chih and Ni Tsan. He took his *chü-jen* degree ("recommended man," the second de-gree) in 1376, and two years later he went to Nanking in search of employment. However, through some unfortunate circumstance—perhaps suspicion of involvement with the same Hu Wei-yung who was responsible for Wang Meng's tragic end—Wang Fu was banished, with his wife and two sons, to the far northern frontier. There he served, with considerable hardship, as a frontier guard. He finally returned to the south around 1400 and spent a few years there painting and writing. He was fond of composing songs and poems in old styles. This literary bent and his skill as a painter, together with his dignified bearing and severe manner of speech, made him an admired personage. Around 1403 he was given a post as a calligrapher in the Wen-yüan-ko, one of the halls in the Nanking palace where the imperial library was housed and where noted scholars, members of the Han-lin Academy, were assembled. In 1412 he became a drafter in the Central Drafting Office. Two years later he moved to Peking, and died there in 1416.[1]

Literary accounts tell of his painting only infrequently, while traveling, and especially after drinking; at such times he would "let the ink flow freely . . . splashing and soaking with the brush." This has the ring, however, of a conventional pronouncement: scholar-painters were supposed to be free souls. The nature and quantity of Wang's surviving work suggest instead a serious, hard-working dedication to the art. Wen Cheng-ming, the great Soochow master of the early sixteenth century, offers this more sober characterization: "The quality of his painting is above [mere] competence; the critics say that the artisan's [technique] and the scholar's spirit are both provided by his works. His personal quality was superior, and he was not used by his art. He would not give away even his small works to anyone whom he did not consider to be the right kind of man."

Wang Fu's inscriptions on his paintings do in fact indicate, in many cases, that they were oc-casional works, done for his hosts at banquets and parties or for people in whose homes he stayed. Often the pictures bear poems composed for the occasion and inscribed by other schol-ars present at such gatherings. His "River Landscape in the Manner of Ni Tsan" (Pl. 22) was painted in 1401 as a parting present for a certain Mr. Wu Shun-min, at whose riverside retreat Wang had stayed. Wu brought out a piece of paper and asked Wang for a painting; the two had not met for ten years, Wang says, and now, recalling their old friendship, he painted the pic-ture and composed the poem to "express the emotions of parting."

The mood, then, is one of somewhat conventionalized sadness and nostalgia, and it is a mood to which the Ni Tsan landscape mode was perfectly suited (cf. *Hills*, pp. 114–20 and Pl. 47–50). Ni Tsan's own works had carried that connotation, partly through the sense of loneliness (phys-ical and emotional distance) attaching to the wide separation of river shores; the use of a bor-rowed set of expressive means implied another degree of detachment from simple feeling; and such a painting subtly complimented the recipient by assuming in him an appreciation for the spare style of Ni Tsan, which was already considered a mark of elevated connoisseurship. With those aims, the painter clearly set out to paint "a Ni Tsan" rather than a river landscape or a Wang Fu (although, of course, the painting is both of those as well). He immerses himself in the Ni Tsan manner so completely, so self-effacingly, that the painting could, if Wang's inscription was removed and a false one of Ni Tsan added, deceive anyone not thoroughly familiar with the brushwork of the two artists. Far from adding to Ni Tsan's compositional plan, Wang subtracts: Ni Tsan seems always to have worked interesting variations on the basic formula; what Wang Fu

gives us is the formula itself. The painting is thus an early and extreme example of what Max Loehr has termed "art-historical art."

Other works by Wang Fu imitate Wang Meng, although not quite so closely as this one follows Ni Tsan. Still others, the most numerous—and these represent as much of a distinctive style as Wang can be said to have—follow that eclectic mode best exemplified in the previous generation by Chao Yüan (*Hills*, Pl. 63). The softly irregular forms and their earthy, tactile textures, built up with dry-brush *ts'un*, the suppression of washes and richness of dotting, are staples of late Yüan landscape and reappear now in Wang's works little changed.

The undated "Farewell Meeting at Feng-ch'eng" (Pl. 23) was painted to commemorate a gathering of some thirteen scholars held on the occasion of the departure of one of their number for his home town, Wu-sung, where he meant to live in retirement. All thirteen have inscribed farewell poems in the sky. Several of the writers identify themselves in signatures or seals as members of the Han-lin Academy, so the painting can probably be dated to the period when Wang was serving in the Wen-yüan-ko; its stylistic similarity to his well-known "Literary Gathering" of 1404, also in the Palace Museum, Taipei,[2] supports that assumption. The painting is done in slow-moving, unexcited brushwork that builds the softly contoured masses firmly, without ever becoming heavy or assertive. The integration of brushwork and ink tone blends the forms together, rooting the trees stably in the earth, smoothing the transitions from shoreline to shoals to water. The composition has the same qualities of stability and assurance. The flat recession displays an easy mastery of distance and is underscored by a systematic diminution in the trees; this is countered by a rapid increase in the heights of hills, until the scale drops off at last to the farthest, low hills marking the horizon. In his handling of space, Wang Fu feels no compulsion to go beyond what had already been accomplished; no more, generally, did later artists of the Ming, who seldom retain so much as this of what the Yüan had achieved in rendering far distance and a continuous ground plane.

Wang Fu was also a capable painter of bamboo, in which he followed the style of Wu Chen; his best extant work in this genre is a long handscroll in the Freer Gallery of Art, dated 1410. He was in turn followed as a bamboo painter by Hsia Ch'ang (1388–1470), whose handsome compositions, in both hanging-scroll and handscroll form, survive in greater numbers. The absence of significant innovations from the works of both artists suggests that this branch of painting was already, at a relatively early stage in its development, nearing a point of exhaustion of its limited capacities. The subject and the technique continued to be favored by amateur artists, but in the later centuries, ink-bamboo was usually more a performing than a creative art.

SOOCHOW AND ITS GENTRY-LITERATI CULTURE   The artistic career of Wang Fu might be better regarded as an aftermath of late Yüan painting than as initiating the renewed activity of the literati-painting movement in the Ming. That revival began shortly before the middle of the fifteenth century. By this time, the part of present-day Kiangsu Province below the Yangtze River, with Soochow as its principal city, was the richest area of China and the home of the largest number of men of letters. Soochow itself had recovered the position of cultural prominence that it had held in the late Yüan.

The vicissitudes of Soochow and its citizens in the late Yüan period were recounted briefly in the preceding volume (*Hills*, pp. 115, 120–21, 128–31). It had been the seat of a short-lived government under Chang Shih-ch'eng, one of Chu Yüan-chang's chief rivals, between 1356 and 1367, when Chang was defeated by Chu's forces after a long siege of the city. Chu's punitive actions against Soochow when he became emperor included the banishment of thousands of its people and the execution of hundreds of officials and others on suspicion of treason. But the prosperity of Soochow, based on its geographical position and its commerce and industry, was

largely restored by the mid-fifteenth century. Located on the Grand Canal near the point where it crosses the Yangtze River, Soochow was the center of a network of transportation canals that bound together the communities of the agriculturally rich Yangtze delta region. In China it was the leading producer of textiles, both silk and cotton, and in addition had a thriving handicraft industry that supplied luxury goods of many kinds to the whole country. The wealth that accumulated in the hands of families of merchants and gentry was used for buying land, developing estates and gardens, and also for cultural pursuits. The arts flourished along with the commercial activity: literature, music, and the theater, calligraphy and painting.[3]

One advantage of wealth was that its possessors could give good educations to their sons, who could then, by entering official service and pursuing careers that were both prestigious and lucrative, further enrich their families. But government service was not so rewarding as the educated class had hoped it would be when Chinese rule was re-established under the Ming: the suspicion and prejudice that Chu Yüan-chang felt toward scholars did not entirely disappear under the reigns of his successors. The strong emperors ruled despotically, the weak ones inefficiently; they tended to favor and trust their court eunuchs instead of (as tradition dictated) their Confucian ministers. Sometimes it was the eunuchs who in fact held the power and controlled the emperor. Imperial rule during the remainder of the Ming was continually rendered unstable and ineffective by the influence of these eunuchs, by dissensions over the succession of emperors, and by court intrigues and struggles between cliques. Scholar-officials who came to the capital with high intentions frequently found some excuse to retire early and return to their homes. These, and other educated men who for various reasons never entered official service at all, made up a class of "retired scholars" whose affluence, either inherited or acquired during their periods of service, enabled them to spend their leisure in elegant and aesthetic ways: building gardens and libraries, collecting books and works of art, exchanging invitations to literary banquets, practicing calligraphy and painting.

Soochow painting in this period, then, as in the late Yüan, was created in an atmosphere of scholarly intercourse, coteries, poetry clubs, exchanges of visits and poems; like poems, the paintings served as a kind of social currency, of accepted value because they embodied accepted values. But the Soochow scholars now enjoyed also a feeling of security that the warfare of the last decades of the Yüan had precluded for their predecessors, and that sense of security permeates their paintings, which tend, like themselves, toward the mild-mannered and stable.

## 2. PREDECESSORS OF SHEN CHOU

TU CH'IUNG   Three older contemporaries of Shen Chou prepared the way for his revitalization of the Soochow painting tradition. The oldest was Tu Ch'iung (1396–1474), who does not in fact fit the pattern of affluence described above. A native of Soochow, he was orphaned and impoverished early in life. He learned to read by severe self-discipline and in time gained such a reputation for learning and literary composition that he was repeatedly recommended by the famous K'uang Chung, who served as prefect of Soochow from 1430 to 1443, for official appointments, which Tu repeatedly refused. The brief treatments of him in Chinese books give no indication of how he made his living; they state that he "amused himself with painting," but, like Wu Chen and others, he may also have supported himself with it, at least partially, and probably earned money by writing as well. He built a small "Garden of the Eastern Plain" in an orchard near the city and settled there peacefully, eating simple food, planting bamboo and flowers, living to be nearly eighty.

As a landscapist he is said to have followed the tradition of Tung Yüan; by his time, to say this meant only that he took his natural place in the lineage established by the "imitators of Tung Yüan" in the Yüan dynasty, a lineage now firmly dominant within literati painting and approach-

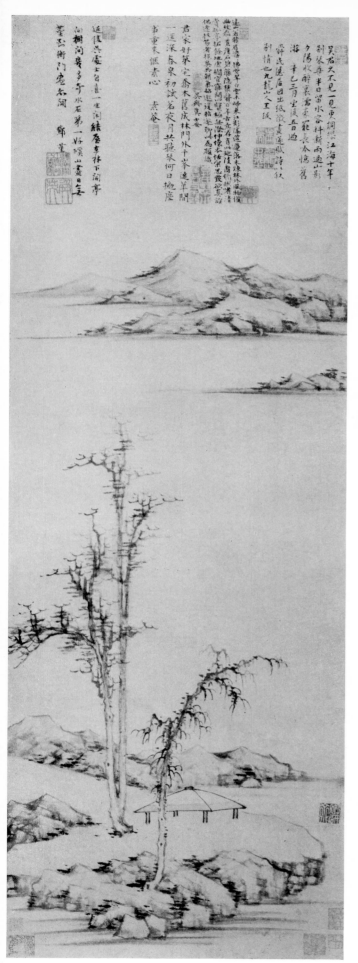

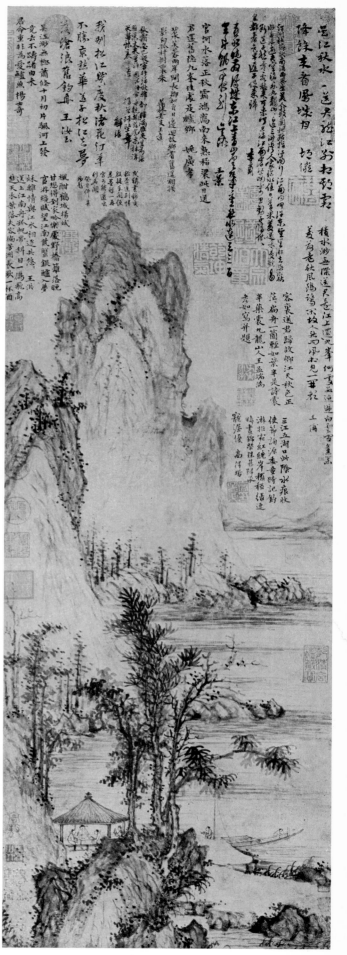

22. Wang Fu: "River Landscape in the Manner of Ni Tsan." *Dated 1401. Hanging scroll, ink on paper, 95 × 32 cm. Private collection, Tokyo.*

23. Wang Fu: "Farewell Meeting at Feng-ch'eng." *Hanging scroll, ink on paper, 91.4 × 31 cm. National Palace Museum, Taipei.*

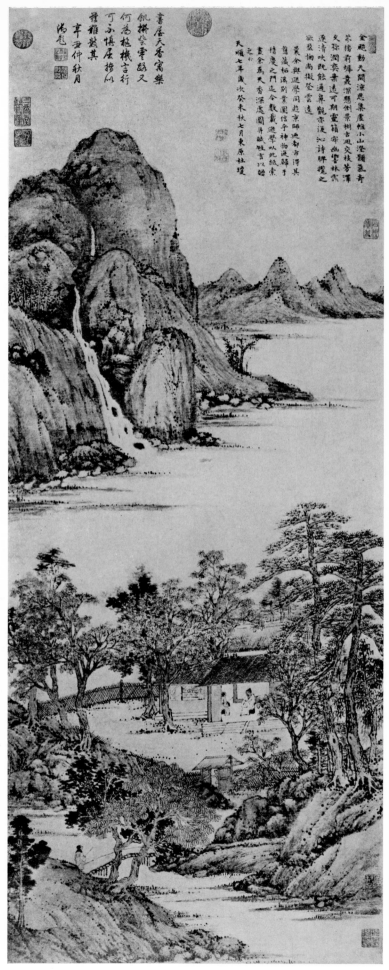

24. Tu Ch'iung: "Heavenly Fragrance in a Secluded Place."
*Dated 1463. Hanging scroll, ink and light colors (?) on paper,
133.9 × 50.9 cm. Collection unknown.*

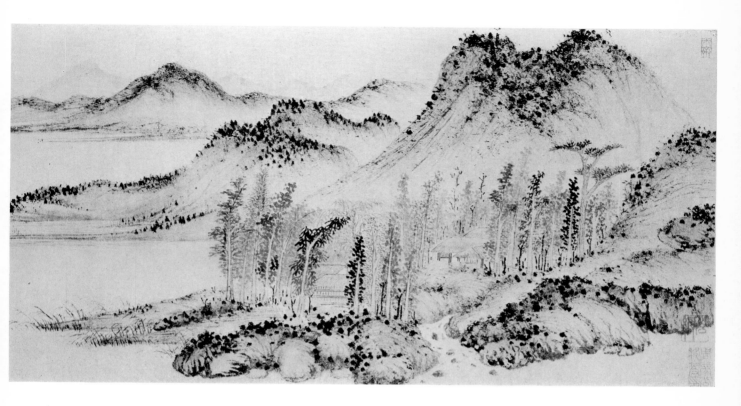

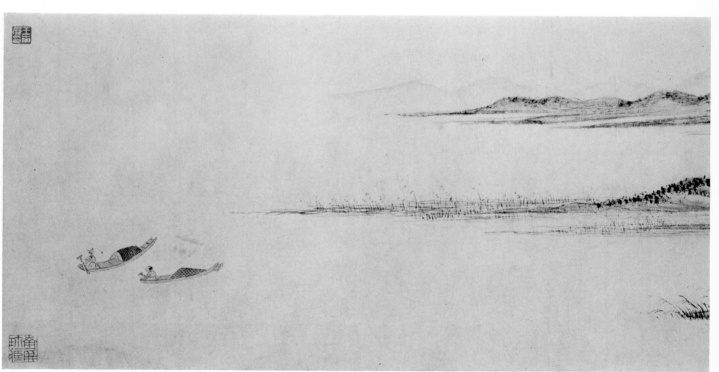

25. Yao Shou: "Landscape for Wen Kung-ta's Retirement." *Dated 1479. Hand-scroll, ink and colors on paper, 27.9 × 99 cm. Collection of N. P. Wong, Hong Kong.*

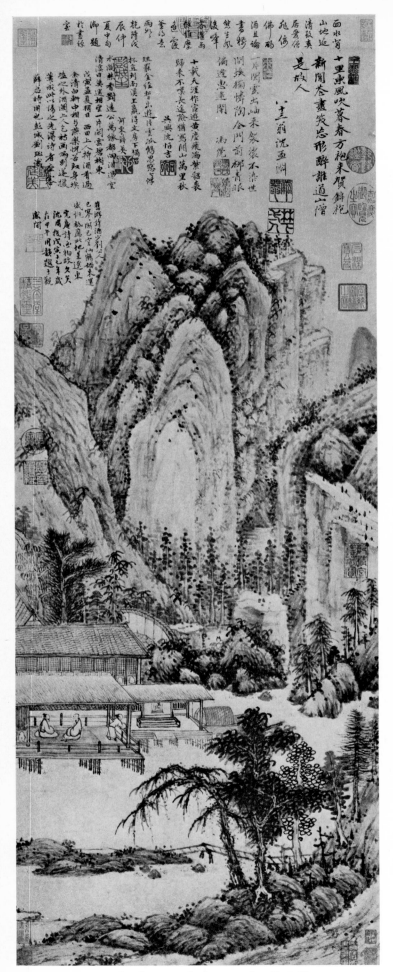

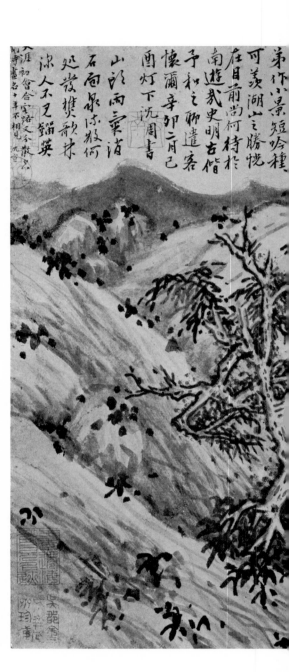

26. Liu Chüeh: "Pure and Plain Pavilion" (Ch'ing-pai Hsüan). Dated 1458. Hanging scroll, ink on paper, 97.2 × 35.4 cm. National Palace Museum, Taipei.

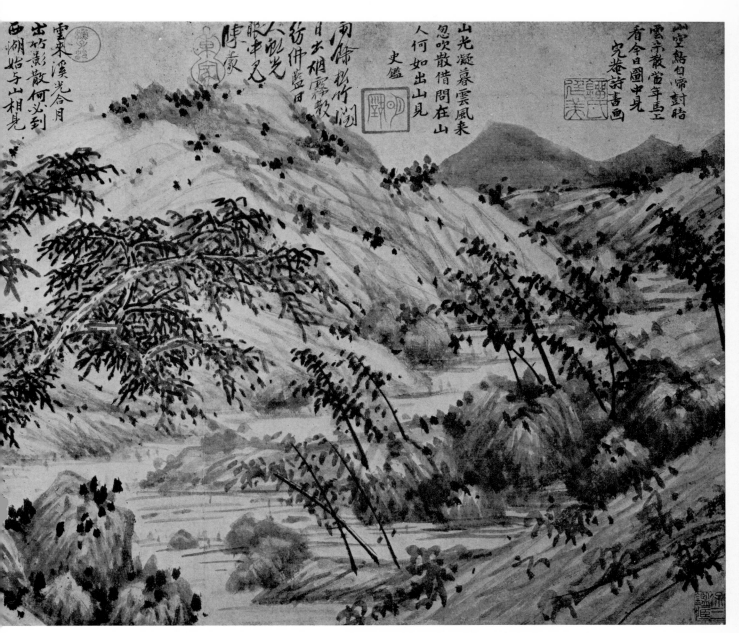

山空鳥自啼對暗<br>
雲平散當年烏上<br>
看今日圖中見<br>
完養詩書畫

山光凝暮雲風來<br>
忽吹散借問在山<br>
人何如出山見<br>
史鑑

南餘松竹湖<br>
日出湖霧散<br>
紛佛藍日

雲來溪光含月<br>
出竹影散何必到<br>
西湖始与山相見

27. Liu Chüeh: "Landscape." *Dated 1471. Handscroll, ink on paper, 33.6 ×*
*57.8 cm. Courtesy of Smithsonian Institution, Freer Gallery of Art, Washington, D.C.*

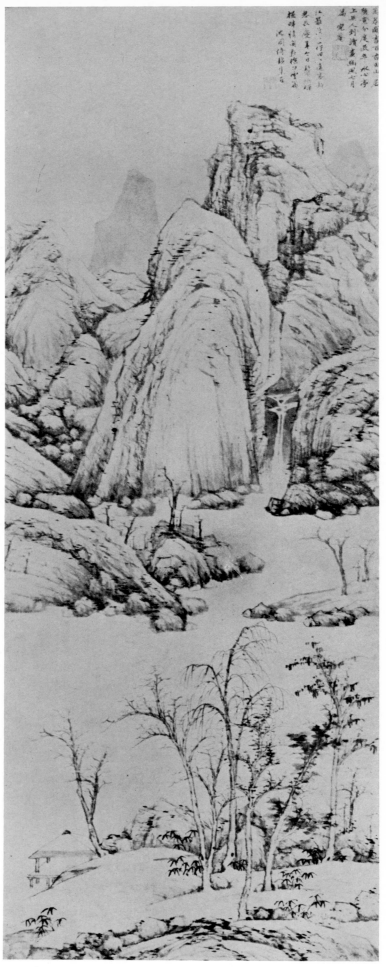

28. Liu Chüeh: "Landscape in the Manner of Ni Tsan." *Hanging scroll, ink on paper, 148.9 × 54.9 cm. Musée Guimet, Paris. Photo Musées Nationaux, Paris.*

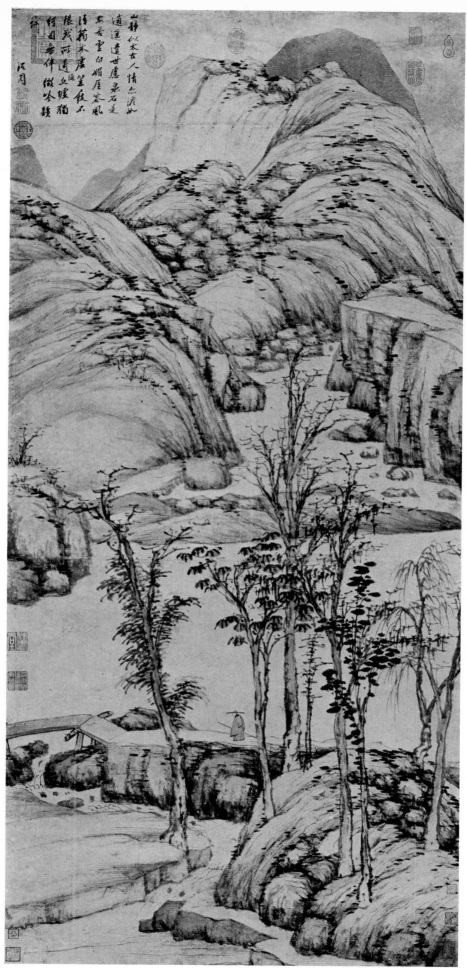

29. Shen Chou: "Walking with a Staff." *Hanging scroll, ink on paper, 159.1 × 72.2 cm. National Palace Museum, Taipei.*

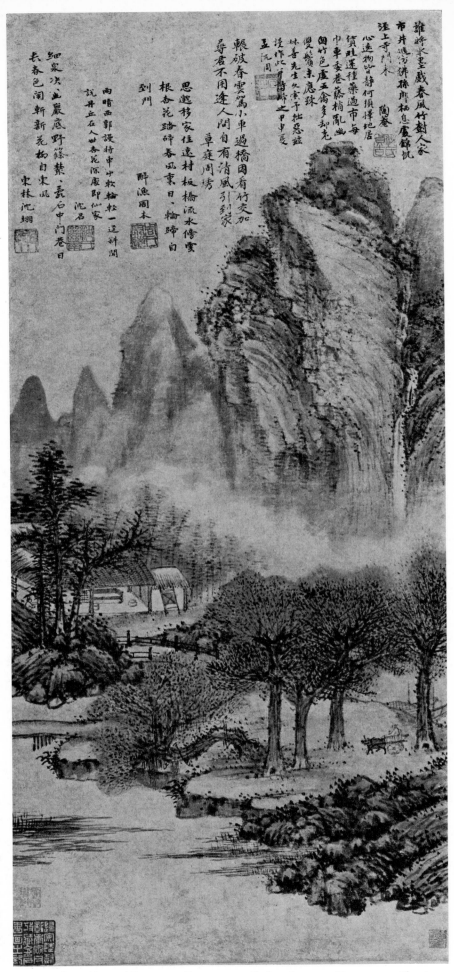

雜將水墨戲春風竹對人家
市井塵坊彿鄰郎柚息廣錦帆
汪上寺門木

心遠物皆靜何須擇地店每
貨雖遠種藥適市毎
中車委巷藤桷鳳幽
園竹色塵五禽多卻老
慇賞東應珠
林善先生久客于拙惡茲
漫作此可靜飾之甲申夏
孟沈周

陶菴

轍破春雲駕小車過橋因有竹交加
尋君不用逢人問自有清風引到家

思邀移家住遠村板橋流水傍雲
根杏花踏碎春風束日、輪蹄自
草庭周诱
到門

醉漁周木

細泉决山巖底野篠犛、蒼石中問巷日
長春色闌新荒枸自束風
束林沈翊

肉暗西郭設持申中軟輪松一逕斜開
說丹丘石人世杏花深處即仙家
沈召

30. Shen Chou: "Living in Retirement." *Dated 1464. Hanging scroll, ink on paper, 77 × 34 cm. Osaka Municipal Museum of Fine Arts, Abe Collection.*

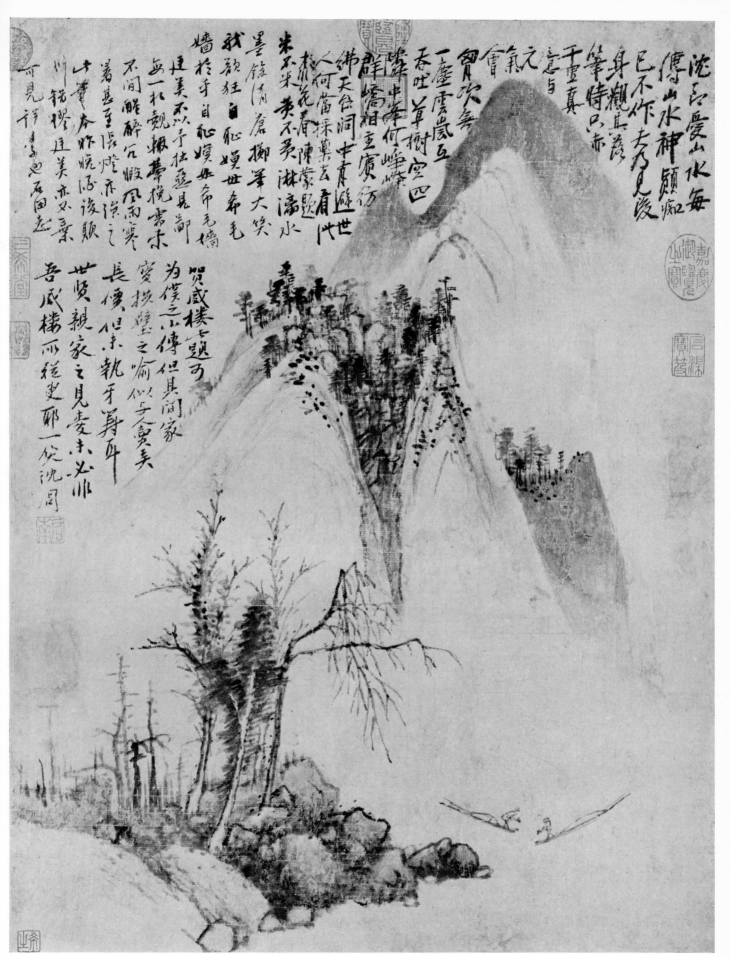

31. Shen Chou: "Landscape for Liu Chüeh." *Hanging scroll, ink on paper, 59.7 × 43.1 cm. National Palace Museum, Taipei.*

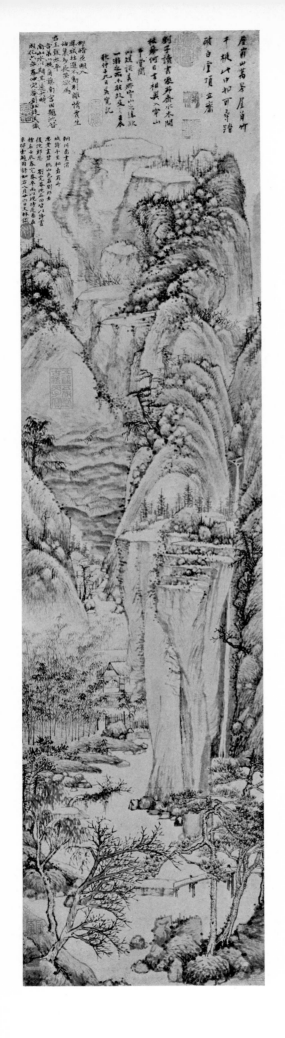

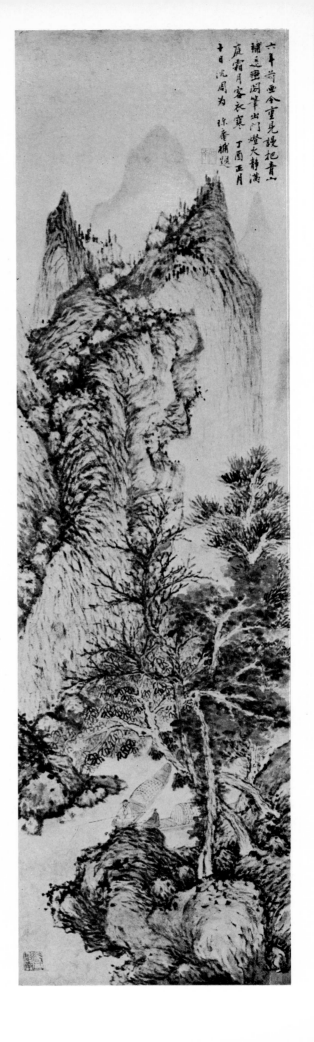

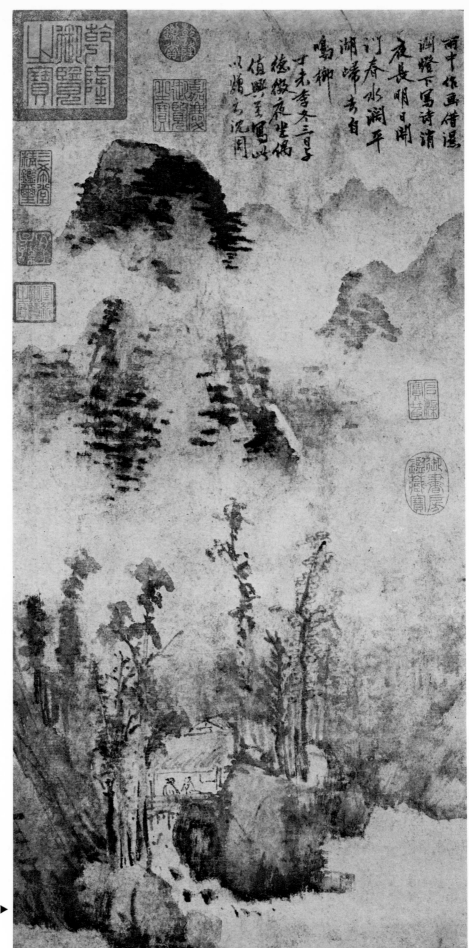

雨中作画借遇
淵燈下写詩清
夜長明日間
汀春水涸平
湖端青自
鳴榔
甘未李冬三旦子
德徵夜坐偶
值興聿寫以
以瑞為沈周

32. Shen Chou: "Towering Mountains Above a Retreat." *Dated 1470. Hanging scroll, ink on paper, 112.5 × 27.4 cm. National Palace Museum, Taipei.*

33. Shen Chou: "Fishermen on a River in Autumn." *Painted in 1471, according to inscription dated 1477. Hanging scroll, ink and colors on paper, 233.7 × 54 cm. Honolulu Academy of Art, Gift of Mrs. Robert P. Griffing, Jr., in memory of her mother, Mrs. William H. Fraser, 1961.*

34. Shen Chou: "Rainy Thoughts." ▶ *Dated 1487. Hanging scroll, ink on paper, 67.1 × 30.6 cm. National Palace Museum, Taipei.*

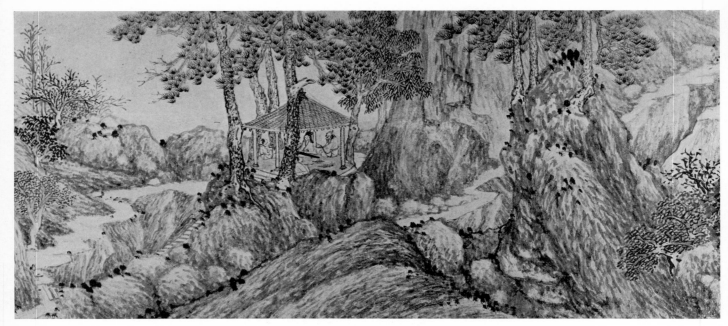

35. Shen Chou: "Landscape for Wu K'uan." *Dated 1479. Section of a hand-scroll, ink on paper, 31.1 × 1093.2 cm. Collection of Gengi Kadokawa, Tokyo.*

36. Shen Chou: "Crab and Shrimp." *Dated 1494. Album leaf, ink on paper, 34.7 × 55.4 cm. National Palace Museum, Taipei.*

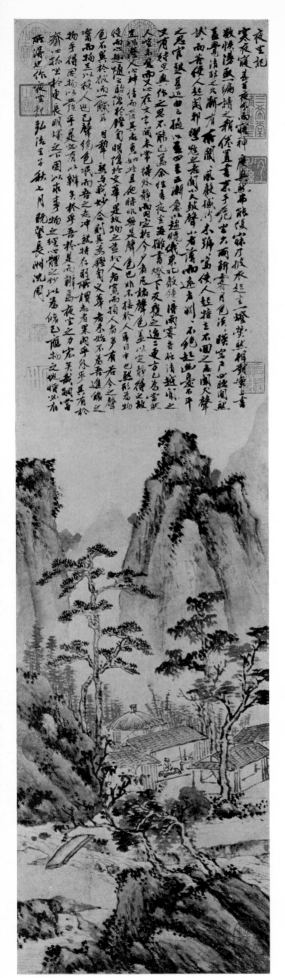

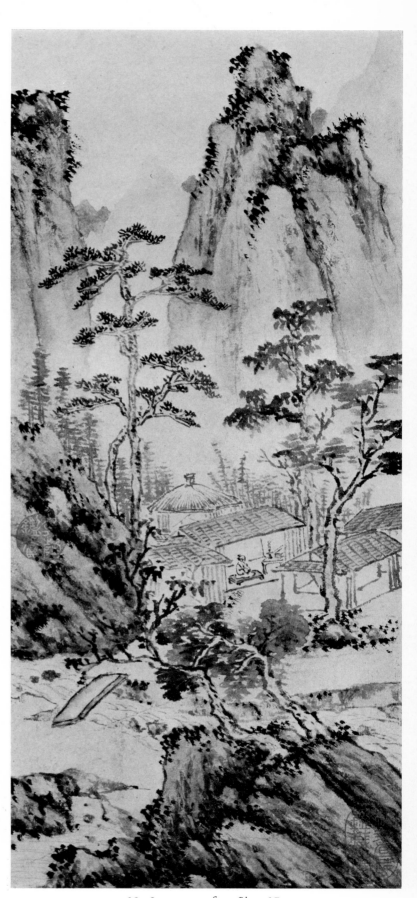

37. Shen Chou: "Night Vigil." *Dated 1492.*
*Hanging scroll, ink and colors on paper, 84.8*
*× 21.8 cm. National Palace Museum, Taipei.*

38. *Picture area from Plate 37.*

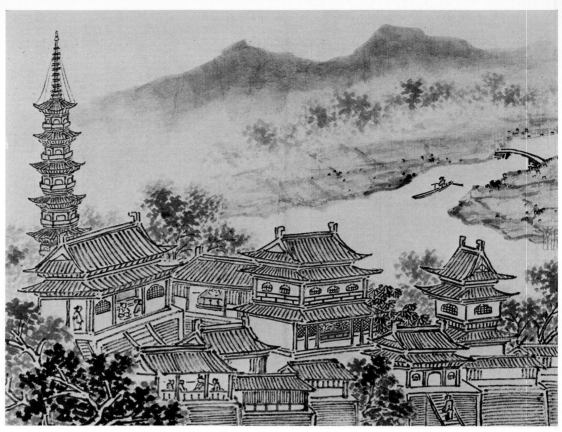

39–40. Shen Chou: from "Twelve Views of Tiger Hill." *Left*, "Thousand Buddha Hall and the Pagoda"; *right*, "Drought Demon Spring."

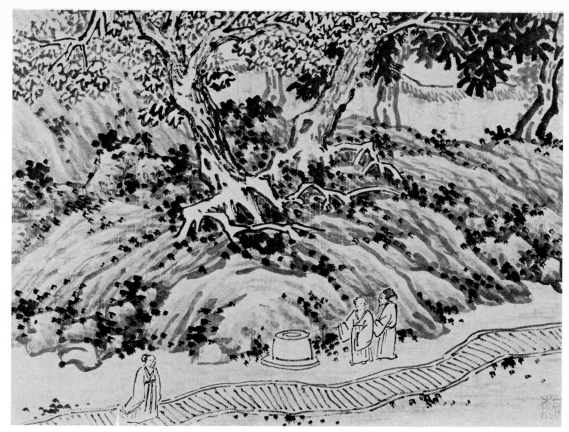

*Album leaves, ink and light colors on paper, 31.1 × 40.1 cm. Cleveland Museum of Art, purchased under the Leonard C. Hanna, Jr., bequest.*

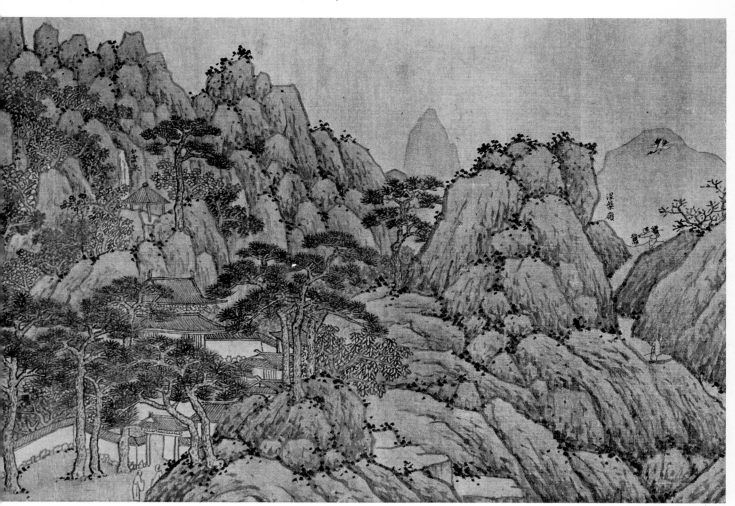

41. Shen Chou: "The White Cloud Spring." *Section of a handscroll, ink and light colors on silk, 37.3 × 936 cm. Collection of George J. Schlenker, Piedmont, California.*

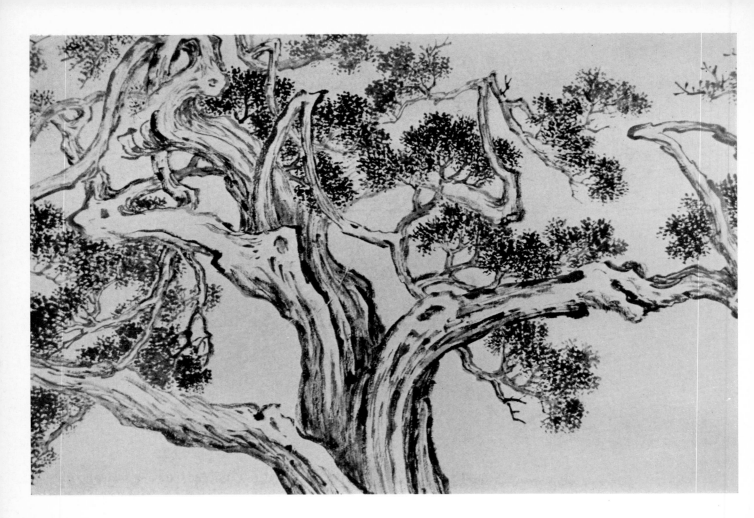

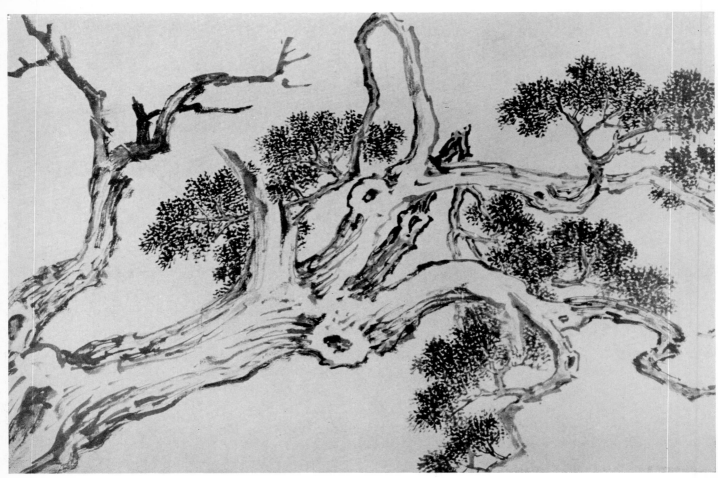

42–43. Shen Chou: "Three Juniper Trees." *Dated 1484. Sections of a handscroll, ink on paper, 11.5 × 120.6 cm. Nanking Museum.*

ing already the status of an orthodoxy. Tu Ch'iung himself, in a rather turgid piece of verse (an example of the Chinese scholar's often unhappy practice of versifying where expository prose would have better served his purpose), provides an early statement of a manner of formulating the history of painting that would later be codified in Tung Ch'i-ch'ang's theory of the Northern and Southern schools (to be discussed in a later volume):[4]

> The "gold-and-green" landscape manner goes back to the two Lis [Ssu-hsün and
>     Chao-tao];
> The high antiquity of ink monochrome, to Wang Wei. . . .
> The Assistant Commissioner of the Rear Park was called Master Tung Yüan.
> His use of ink was deep and antique; his texture strokes, hemp fibers.
> Chü-jan, in his luxuriant and moistly-rich style, carried on the true lineage. . . .
> Then we come to Li T'ang, who was particularly outstanding. . . .
> The Mis, father and son, were peers in excellence, equal in fame.
> Ma Yüan and Hsia Kuei formed their own iron-hard manner,
> But this cannot be compared with these other schools.
> Chao Meng-fu of the Crystal Palace
> Walks alone in Yüan times, a figure from Heaven.
> Old Ch'ien Hsüan from Cha-ch'uan emphasized delicacy.
> The one who gave rein to his ideas and captured moods was Huang Kung-wang.
> Ni Tsan, the "Foolish Old Fellow," was excessively pure and simple.
> The Plum Blossom Taoist, Wu Chen, was quite without fetters.
> [Kao K'o-kung from] Ta-liang and Ch'en Lin captured the styles of calligraphy [in their
>     painting]. . . .
> Wang Meng and Chao Yüan were not inferior to them.
> In many houses, on screens their paintings shine with scattered brilliance.
> All these worthies stemmed from the school of Wang Wei of Wang-ch'uan;
> Others are dispersed in disorder, not meriting inclusion.
> I have been born too late, and am too addicted to painting—
> I could not receive the guidance [of the masters] to assuage my starvation.
> Wang Fu and Shen Yü truly had "Immortals' bones";
> When they wielded their brushes they immediately transcended the common herd. . . .
> I have tried to learn from all their strengths, as well as from the old masters,
> But however much I wave [the brush] and splash [the ink], I cannot catch up.

Ignoring the expected (and probably insincere) expression of modesty at the end, we may note in Tu's listing and assessment of painters the slighting reference to the Ma-Hsia school and the marked emphasis on the scholar-artist tradition, a lineage that he traces to the T'ang dynasty master Wang Wei (699–759), who, as a great poet and amateur painter, had come to be revered as the founding father of literati painting. This "true lineage" runs through Tung Yüan, Chao Meng-fu and the artists associated with him, the Four Great Masters of the late Yüan (not yet grouped under that designation, and joined here by Chao Yüan), and the early Ming followers of that tradition, down to Tu Ch'iung himself. Later literati theorists, while keeping in the main the contents of Tu's list, emphasize even more the separation of the lineages within it and extend it successively to include themselves and their friends. It was an art-historical formulation, that is, continually invoked to establish the writer's own, or his favorite painter's, privileged place in art history. Tu Ch'iung's strong praise for the Yüan masters, moreover, can be seen as providing a historical basis for the pursuit of a quality of "Yüan-ness" in painting, as opposed to the "Sung-ness" of the Che-school works. In Tu's paintings, and those of other fifteenth-century literati masters, this aim in part supplants the older aims of creating beautiful, or powerfully expressive, or strikingly original, pictures. The same is of course true of much contempo-

rary Academy and Che-school work, except there it is "Sung-ness" that is pursued, in a similarly deliberate way.

Tu Ch'iung's finest surviving work (judging from a reproduction—the present whereabouts of the original is unknown) is a river landscape, titled "Heavenly Fragrance in a Secluded Place," which he painted in 1463 for a friend named Sun-hsüeh (Pl. 24). A diagonally disposed foreground, within which a visitor is about to cross a bridge to reach a house where two men are already conversing, is echoed in the middle distance by a diagonally placed slope, down which a waterfall pours. The farther distance is marked by a conventional row of conical hills. The pleasures of cultivated seclusion are suggested by the comfortable enclosure of the house within a woven bamboo fence and luxuriant trees; and the marshy fertility of the Chiang-nan terrain by dotting the earthy forms for a generalized effect of vegetation. Nothing in the picture or its style is especially distinctive, or striking, or stimulating; the excellence of the work lies rather in the skill and assurance with which it incorporates established materials into a stable, pleasing composition.

YAO SHOU    Another of these epigones of the Yüan masters was Yao Shou (1423–95). He was from Chia-hsing and liked to pay tribute in his paintings, partly no doubt for reasons of local pride, to artists from that area: Chao Meng-fu, Wu Chen, Wang Meng. He took his *chin-shih* degree around 1464 and held positions as an investigating censor and, in the late 1460s, as a prefect. Eventually, probably in the early 1470s, he "hung up his cap" (retired from official service) and went home. His dated paintings begin around this time, suggesting that he may have begun painting seriously only after his retirement. He was excessively, possessively, attached to his own paintings, the story goes, and would sometimes buy them back at high prices from people who had somehow succeeded in acquiring them. Most Chinese writers praise him for his faithful imitations of Yüan styles. Wen Cheng-ming, whose opinion of Wang Fu we quoted above, writes that painting was for Yao the "overflow" of his refined and skillful literary production; no one seems quite able to define for him an individual style.

Most of his extant paintings are pictures of bamboo, old trees, or flowers-and-birds. His few landscapes, more ambitious productions, are mostly copies or close imitations of Chao Meng-fu, Wu Chen (whose famous "Fishermen" handscroll of 1342, now in the Freer Gallery of Art, he owned) or Wang Meng. His copy, dated 1476, of Chao's "Fishermen on an Autumn River," which he also owned, is the best evidence we have for Chao's having used, and perhaps originated, this river landscape type that is the stock-in-trade of his followers.[5]

One of Yao's more interesting pictures forms part of a long handscroll presented in 1479 to Wen Kung-ta, grandfather of Wen Cheng-ming, on the occasion of his retirement (Pl. 25). The scroll begins with an essay by Li Tung-yang (1447–1516), famous as a calligrapher and as Grand Secretary; this is followed by Yao's painting and a series of poetic colophons by seventeen scholars of the time, including Wu K'uan (1435–1504), a good friend of Shen Chou. Yao Shou's painting, which bears his seal, probably represents the riverside cottage in which Wen Kung-ta planned to spend his post-retirement years. But it represents it only in a limited sense; it does not inform us about specifics of the actual locale. Probably the general situation of buildings, trees, and hills is true enough to the real scene for the picture to be recognizable, but all particularized references have been absorbed into an ideal image. Much as a European portrait painter would flatter his sitter by dressing him not in his everyday garb but in ceremonial or symbolic robes suggesting that he reincarnated some illustrious figure of the past, so would a Ming artist portraying some friend's retreat (which was a kind of portraiture—Chinese scholars regularly

use their studio names to designate themselves and are called by those names) invest the image with an air of historical sanction by recalling images and styles from the past.

Yao's composition is based closely on Yüan models, chiefly those of Chao Meng-fu and his followers; the texture strokes and dotting on the hills are in the manner of Wang Meng; the fishermen in their boats are lifted directly from Wu Chen's "Fishermen" scroll. That Yao Shou could accomplish this eclectic performance with such ease, avoiding any effect of pastiche, keeping the spatial scheme clear and the proportioning of parts harmonious, is what makes the picture admirable. He builds his composition out of discrete, repeated units but foregoes all opportunities to set up dynamic interactions between them. Like Wang Fu and Tu Ch'iung, he is content with what he has inherited, uninterested in experimentation.

LIU CHÜEH   None of the early Ming scholar-painters treated thus far would require revision of the standard accounts in which Shen Chou finally ends the long lull and rescues literati painting from the doldrums where it had been drifting. The account is essentially correct; but it is incomplete if it does not give due consideration and credit to another of Shen's elders, Liu Chüeh (1410–72), both as a more original and capable painter in his own right than those we have been treating and as an important influence on Shen Chou.

Liu was born in 1410 in Soochow. While still young he was offered a position as a minor clerk in the local administration by the prefect of Soochow, K'uang Chung; Liu wisely refused, asking instead to be admitted as a student at the National University. The request was granted, and Liu, after thus acquiring a good education, took his *chü-jen* degree by examination in 1438. Later he held positions as a secretary in the Ministry of Justice and as deputy-assistant surveillance commissioner for Shansi Province. When he reached the age of fifty, he asked and was granted permission to retire; he returned to Soochow and built a house and garden, where he lived the rest of his life. His friends included many of the leading scholars and poets of the city. Shen Chou, his junior by seventeen years, regarded him affectionately as an uncle, and took him as a model in both painting and calligraphy. He died in 1472.

Liu Chüeh's "Ch'ing-pai Hsüan" ("Pure and Plain Pavilion," Pl. 26) is another depiction of a scholar's retreat, in this case Liu's own. It was painted in 1458, when Liu was about fifty, and one of the poems written on it (by Shen Heng, 1409–77, Shen Chou's father) speaks of his "returning" after "ten years' travel in official service to the rim of the world"; so the gathering represented may well have been held to celebrate Liu's retirement from the bureaucracy. In the summer of 1458, Liu relates in his own inscription, a man called Hsi-t'ien Shang-jen brought wine to Liu's house, and other friends gathered there. Hsi-t'ien asked Liu for a painting as a parting gift; Liu obliged, and five of those present, including Shen Chou's father and grandfather (the latter then aged eighty-three), wrote inscriptions on it. Shen Chou, only twenty-two at the time, was evidently not there; but in 1474, after Liu's death, he added a final poem, using the rhyme words of Liu's, beginning: "The old pleasures of poems and wine now lack my master Liu; / The man himself has passed into silence, the pavilion is deserted."

The "Pure and Plain Pavilion" is in fact a group of low, open buildings, raised on posts above the water, set on a river shore at the foot of steep hills. As in Tu Ch'iung's picture (Pl. 24) the buildings are set far back, separated from the viewer by a succession of barriers—water, banks, and trees. One is not encouraged to move smoothly, in imagination, back to the house and participate in the gathering; it is a private party. Two men sit facing each other inside the house, while another leans on a railing and gazes across the water, or perhaps at a scroll painting of bamboo that hangs in the entrance hall.

The fabric of the painting, the brushwork, differs little from that of Wang Fu and others:

thick, dry strokes, heavy dotting, washes sparingly applied, some finer drawing for details. But now we are once again in the presence of an artist with a serious concern for formal structure and complex formal relationships. The basic repertory of abstract materials owes most, probably, to Huang Kung-wang: clusters of round rocks, uniform in size and edged with dark moss or grasses, in the foreground and the middle ground, and on the mountaintop; upward-pointing masses, barrel-shaped boulders, sheer cliffs topped by slanting plateaus, rhythmically articulating the background. (Compare, for this somewhat schematized version of Huang's style, the landscape by Ma Wan dated 1366, *Hills*, Pl. 62.) The composition is arranged in relation to a central, vertical axis, with one heavy element balanced by another, one thrust countered by another, on either side, so that the whole is remarkably stable. Most satisfying is the clarity with which the picture is put together out of strong, easily legible forms.

In the early spring of 1471 Liu Chüeh, Shen Chou, and a man named Shih Chien set off to visit West Lake near Hangchow. When they reached the region of Chia-hsing, they were stopped by a snowfall and (as Shen Chou relates in the inscription on a painting of his own, which he did on this same trip) were forced to stop over for several days at the home of a friend. Liu Chüeh painted a small picture (Pl. 27), perhaps to pass the time, as a present for Shen Chou's younger brother Chi-nan. Liu, Shen, and Shih all wrote poems on it; Shen Chou added a prose note recounting the event; and three other people added poems later. (One might wish that these latecomers had restrained their hands and not so crowded the sky.) Shen Chou's poem reads:

> As clouds pass over, lights merge on the stream;
> The moon comes out, and bamboo shadows scatter.
> Why do we have to reach West Lake?
> Already we and the hills have seen each other.

Liu Chüeh's painting itself contains no indication of either snow or moonlight; it seems full of wind, with sunlight perhaps breaking through clouds. Like some works of Wu Chen, who is clearly the principal model here, it offers nothing but the plainest scenery: grassy hills between which a stream winds, a pair of ungainly trees, some stalks of bamboo. What makes it one of the most satisfying small pictures of the period is the sense of excitement, perhaps an expression of the exhilaration of travel with good companions, that is caught in the play of brushstrokes and the movements implicit in the forms. The foreground banks slope toward a central base from which arching movements rise, the trees curving leftward, the bamboo stalks rightward, the central hill beyond completing and enclosing this rhythmic swelling. Once more, groups of darker boulders or hillocks weight down a few points in the composition, and clusters of black dots serve to slow the flowing surfaces. The easy but dynamic rendering of mass and space, giving an extraordinary vitality to a stable, earthy structure, must have impressed and affected the young Shen Chou, who creates similar effects in some of his works.

THE RELATIONSHIP OF LIU CHÜEH AND SHEN CHOU   Two powerful landscapes in the Ni Tsan manner by Liu Chüeh (Pl. 28) and Shen Chou (Pl. 29) may help us understand the artistic relationship between the older and the younger master before we go on to consider the individual development of Shen Chou. Neither is dated; Liu's painting bears poetic inscriptions by himself and Shen, the latter once again deferentially using the rhyme words of Liu's poem. Thus Shen Chou, while he may have painted his picture long after, was certainly familiar with Liu's and seems to have taken from it important ideas to use in his own work, along with all he had learned through his study of Ni Tsan originals.

The paintings thus illustrate also a truth about the practice of "following an old master" in Chinese painting: it is, among other things, a form of reverence, bestowing immortality not

only figuratively upon the man, but also, in more tangible form, upon his style. The man may be long dead, but the mode of painting and the compositional types he created continue to evolve in the works of successive "imitators." Each painter thus inherits the cumulative resources of all that has led up to his own point in the development; while he will usually acknowledge his debt, if at all, only to the progenitor, he is likely in fact to be also in the debt of others who have preceded him in similar obeisances to that progenitor. Each such imitation, then, stands not only on the same warp line as its contemporaries—the "period style" of art historians—but also on a woof strand extending back through a "linked series" (Kubler's term) to the creator of that particular lineage. The difficulty of reconciling these individual "linked series" of works with larger chronological developments—of determining, that is, the precise art-historical coordinates of a given work—is part of what makes the history of later Chinese painting so resistant to conventional art-historical formulation.

No work of Ni Tsan survives that could serve as a basis, in more than the most general way, for Liu Chüeh's composition (Pl. 28); we must conclude that it is, in contrast to Wang Fu's essay in the same manner (Pl. 22), essentially original. Comparison with Ni Tsan's "Mountains Seen from a Riverbank" of 1363 (*Hills*, Pl. 48), perhaps as close a model as we can point to, reveals how radically Liu has altered the formula, turning the Yüan master's placid scene into a more monumental and dynamic structure. The foreground is expanded into a substantial base, on which he sets a more extensive array of bare and leafy trees, rocks, bamboo, along with the usual thatched rest-shelter. The area of river beyond is compressed, the distant mountains pulled forward; they loom more imposingly, filling the upper part of the composition. The emotional effect of the wide disengagement of parts in Ni Tsan's picture does not suit Liu's expressive purpose, and he fits his pieces more tightly together. His upper section is composed, as in the formally similar "Pure and Plain Pavilion" (Pl. 26), of a multiplicity of clearly demarcated forms, carefully ranked in size and varied in shape, fitted together into a spatially intelligible whole, within which they engage in dynamic interaction. Ni Tsan's soft texture strokes are replaced by long, bending lines that both define three-dimensional form and emphasize the implied movements.

All aspects of this new stylistic direction are taken up and developed further in Shen Chou's monumental work titled "Walking with a Staff" (Pl. 29). The massiveness of the foreground bank is asserted with a power that is almost harsh; the eight trees are arranged in a spatial pattern and represent a range of types more in keeping with Liu's picture than with any of Ni's. Instead of the standard shelter on posts as the sole and minor human intrusion into the landscape, a solitary walker, his advanced age conveyed by a staff and a hunched posture, now trudges along the path. The river area is further compressed and so crossed by trees that little open space remains. The far shore is brought even closer, and the top of the tallest tree is fitted unnaturally into an inlet there. The almost oppressive top-heaviness of the composition, the drawing in long, taut lines, the upward arching of the land forms in the upper part and their formal complexity, are all extensions of ideas found in Liu's work.

Shen Chou introduces a new compositional principle, not unknown in the landscapes of Ni Tsan (cf. *Hills*, Pl. 49–50) but perhaps never before carried through so systematically: the upper segment of the composition partially forms a reversed mirror-image of the lower. The near and far shores, each slanting slightly, begin this system of echoed forms in the central zone; one stream divides the near bank downward to the left, another the far one upward to the right; a slanting table of land at the lower left is answered by a slanting plateau at the upper right; a curving ridge in the foreground, enfolding a group of "alum stones," is repeated in reverse in the uppermost ridge. Moreover, the studied avoidance of stable horizontals, carried to the point where the huge masses seem to slip sideward and give a feeling of uneasiness to the whole, is new with Shen Chou and is another feature in which he not only departs from, but also positively rejects, the standard affective associations of the Ni Tsan landscape type.

Our argument about "linked series" could of course be carried further if that were not beyond our present purpose; for instance, the superb "Coming of Autumn" by the seventeenth-century master Hung-jen, now in the Honolulu Academy of Arts,[6] would be seen clearly to take as its point of departure this middle Ming stage in the evolution of the Ni Tsan landscape type (the resemblance to Liu Chüeh's picture is striking), or perhaps some later derivation from it, once again no doubt augmented by the artist's studies of Ni Tsan originals and, in Hung-jen's case, Northern Sung landscape as well. For now, an analysis of these two paintings leads us to an understanding of the position of Liu and Shen in the history of Ming painting, which is borne out when we consider their works as a whole. Liu was a more creative, innovative artist than Wang Fu, Tu Ch'iung, or Yao Shou seem to have been (judging from their preserved works); he was also an important influence on Shen Chou. But Shen Chou stands forth nonetheless as the first great Soochow master in the Ming and thus deserves the accolade that history has given him as the founder of the Wu school.

## 3. SHEN CHOU

LIFE AND CAREER    Shen Chou's life was so comfortable and uneventful that he should not, according to some romantic theories concerning the wellsprings of artistic creation, have become a great painter at all.[7] His great-great-grandfather had established the family fortune in the late Yüan, acquiring a large estate about ten miles north of Soochow. The family income derived from this and from the designation of the head of the family, since the beginning of Ming, as a collector of local taxes. It was thus unnecessary for the sons, well educated though they were, to pursue official careers in order to enrich themselves and the family. Shen Chou's grandfather, father, and uncle had all lived as retired scholars, dedicating themselves to the pleasant duties of entertaining literary and artistic friends, to the continual rounds of visits, to poetry and calligraphy, collecting and painting.

Shen Chou naturally followed that pattern; he read widely and learned literary composition, but he is said by his biographers to have given up all intention of attempting the examinations on the death of his father, claiming afterwards that he had to take care of his widowed mother. One suspects this to have been an excuse for a course he had decided upon long before; Shen was already fifty when his father died in 1477. He continued to plead this excuse whenever those in authority attempted to persuade or press him into service, and since his mother obligingly lived to nearly a hundred, he was able to continue the life of a "recluse" to the end, winning besides a reputation for filial piety.

In 1471 he built a home of his own on the family estate, calling it the Bamboo Dwelling. For his *tzu*, or style name (which one assumed on reaching twenty), he took Shih-t'ien, "Field of Stones," a name that signifies uselessness (after a line in the *Tso-chuan*: "To get what you want in Ch'i is like capturing a field of stones: it is of no use"). But we can be sure that he was not expressing in it any real feeling of guilt over spending his time in a socially unproductive way; Shen Chou was perfectly satisfied with the life of a country gentleman. Three successive prefects of Soochow tried to enlist him on their staffs, all without success. On the first occasion, Shen consulted the *Book of Changes*, which informed him that the auguries were inauspicious (again, one suspects some special shuffling of the yarrow stalks).

The third of these prefects, so the story goes, misunderstanding the basis of Shen's fame as a painter or maliciously misinformed (the incident is reminiscent of Chao Yüan's troubles with the Hung-wu emperor), summoned Shen to take part in a project to decorate the walls of his yamen with paintings. Shen Chou, rejecting a friend's advice that he go over the prefect's head to some higher official and have the order rescinded, reported meekly and executed the paintings. The prefect later, on a visit to the capital, was made aware of the true stature and reputation of the man he had treated in this way, and on his return he paid Shen an apologetic visit;

he was received politely. To have acted otherwise, Shen Chou felt, would have been shameful.

The story may be apocryphal, but it reveals Shen's ambiguous position: in spite of his family's hereditary wealth and social standing and his own attainments, he still, because he did not hold official rank, was classed as a commoner and no doubt at times treated as one—or perhaps, because of his success as a painter, treated as though he belonged to the artisan class. He may in fact have painted on a semiprofessional basis, probably following the "exchange of gifts" convention to avoid the stigma of accepting cash payment for his works.

Shen Chou learned painting first from a certain Ch'en Meng-hsien, now completely forgotten except as his teacher. His uncle Shen Chen and father Shen Heng were both painters; the latter studied under Tu Ch'iung; both are represented today by works of small merit but apparently were well thought of in their time. Shen Chou himself knew Tu Ch'iung well and may have studied with him. One of his earliest dated works, an album painted in 1466, with leaves imitating various Sung and Yüan masters, bears an inscription by Tu written in 1471. (The practice of doing albums made up of leaves in a variety of established "styles" or modes begins around this time, very likely with Shen Chou—no reliable earlier examples are known.) The artist who most importantly influenced Shen Chou, however, was probably Liu Chüeh. The closeness of their association during Liu's last years is apparent from the number of inscriptions they wrote on each other's paintings.

Shen Chou's pupil Wen Cheng-ming, in a colophon composed for one of Shen's early works, provides a brief account of his master's development that is a good starting point for our consideration of that development (translation by Sirén): "Shih-t'ien [Shen Chou] was a man by nature deep and bright. His taste and knowledge were unusual. While still a youth he freed himself from the traditional manner of the family. The old masters were his teachers and he copied many of them so successfully that his pictures could not be distinguished from theirs. Most of the pictures he did then (in his early years) were only a foot square. When he was over forty [i.e., after 1466] he began to paint large scrolls, rugged trees with large leaves, in a freer manner. He no longer followed rules and measures, nor did he use colors with the same refinement as in earlier years. Yet his pictures were true to nature and most expressive."

A later critic, Li Jih-hua (1565–1635), states that Shen began by imitating various masters, settled upon Huang Kung-wang as his principal model in his middle age, and in his late years became "intoxicated" with the style of Wu Chen, imitating it so closely that his late works could be confused with Wu's.

EARLY WORKS    The earliest of Shen Chou's surviving works, a hanging scroll dated 1464 (Pl. 30), fits the pattern suggested by Wen Cheng-ming; it is small in size and delicate in execution. Inscriptions on it, besides Shen's own, are by his uncle, his brother, and three others, one of them a teacher in the Shen household. The artist's inscription is a poem, to which he added this note: "Shu-shan has for a long time been asking me for one of my ill-made and deplorable creations; so at last, unhurriedly, I have done this one, and written a poem on it, to give him."

The scene is, as usual, a gentleman's secluded dwelling by a river. The house is set back in middle ground among trees and bamboo; the owner, presumably the Sun Shu-shan for whom the painting was done, appears in the lower right, returning home from a trip to the market in an ox-drawn cart. Strange-shaped cliffs rise above the misty valley, tamer offspring of the mysteriously animated mountains of Fang Ts'ung-i (Hills, Pl. 59, 61). Otherwise the picture is characterized by stylistic cautiousness. The drawing in constrained dry-brush and the fine dotting recall the work of Tu Ch'iung (cf. Pl. 24). The composition, while simple, shows more independence; as in "Walking with a Staff" (Pl. 29), the upper half reflects the lower, with the angle of the riverbank below repeated exactly in the rising skyline above, and a horizontal zone

of tree foliage answering a band of mist, each veering outward at the left. All of this converges on the house at the far left and a group of dark trees that act as a kind of backstop to the compositional forces. Something of the poetic intimacy that Shen Chou brings to Ming painting can already be felt in this rather contrived picture.

Another small work, painted for Liu Chüeh, is undated but was probably done around the same time (Pl. 31); the script style and language of Shen's inscription, with the style of the painting, relate it closely to the 1466 work, even though the two may seem very dissimilar at first. The picture for Liu Chüeh, however, is a spontaneous, even casual production where the other is a careful one. It was done while the painter was drunk, according to the testimony of his own inscription, which is itself written with a calligraphic abandon and an oddness of language that have led to its being misunderstood and mistranslated (several characters are completely illegible).

In the first line, Shen refers to Mi Fu and Huang Kung-wang, suggesting cryptically that his picture both is and is not in the style of either or both:[8]

"[It looks like] Mi but doesn't [look like] Mi; [looks like] Huang but doesn't [look like] Huang—
Dripping-wet ink washes, it overflows with pure luxuriance.
Flinging away the brush with a loud laugh, I am on the point of madness—
I am ashamed of [being] Mo-mu [a virtuous but ugly lady of antiquity] and emulate Mao-ch'iang [a famous beauty].
Yes! I am ashamed of [being] Mo-mu and emulate Mao-ch'iang.

"T'ing-mei [Liu Chueh] doesn't consider my awkward and deplorable pictures to be altogether despicable; whenever we meet he keeps after me, trying to get one by any means he can. It doesn't matter whether I'm sober or drunk, busy or idle, whether it's windy or rainy, cold or hot; even if the painting has to be done by lamplight, he still presses for it. This picture is one I did last night, after drinking; it is all mixed up and wrong, but T'ing-mei *still* won't throw it away. You can see how badly he wants one.
"Inscribed by [Shen] Shih-t'ien."

The painting, in spite of a decided touch of the bizarre in its composition, is in a much milder mood than Shen's inscription might lead us to expect. Again the drawing is sensitive and restrained. The composition divides into three areas that echo but do not encroach upon each other. Treetops and mountaintops mark a simple diagonal progress upward and back; the bisected angle of the middle-ground mountain is repeated upside down, not only in the nearer bank, but also, rather facetiously, in the pair of fishing boats. The plan of the picture is in fact so simple as to be almost simplistic; it might seem overcontrived were the painter's aim more serious, but his capriciousness disarms criticism. Also, the three inscriptions add needed weight to the picture. Shen's first is at the upper left; a friend named Ch'en Meng wrote the one at the upper right, filling the sky and even infringing on the mountaintop (he committed the same transgression in his inscription on Liu Chüeh's picture, Pl. 27); Shen wrote another inscription in response to Ch'en's, filling the remaining sky area. A slight scribbliness in some parts of the painting tightens the visual bonds between painting and calligraphy; the filling of the sky makes the quiet areas of misty space all the more satisfying as relief. Like Liu Chüeh's small picture, this is an unassuming but absorbing work, created extemporaneously under somehow auspicious circumstances. Part of its strength lies in its freshness. Even in such modest works as this, Shen Chou is genuinely concerned with exploring new ways to compose a landscape painting, instead of following established designs that required no compositional inventiveness at all, as most of his contemporaries were doing (Liu Chüeh being again an exception).

Shen Chou's originality is even more evident in his large pictures. His "Walking with a Staff" in the manner of Ni Tsan, a brilliantly original creation, we have already seen (Pl. 29). The first large dated work from his hand is an elaborate landscape in the manner of Wang Meng, "Lofty Mount Lu," done for the birthday of his teacher and dated 1467.[9] By this time, there is nothing tentative or playful about Shen Chou's style; it is an imposing, totally serious picture, filled with convoluted mountain forms, firmly and skillfully composed even though it may appear at first to be a single teeming mass of texture and detail.

Even more revealing of Shen Chou's experimental attitude in this early period is a less well known work titled "Towering Mountains Above a Retreat" (Pl. 32), painted in 1470 as a gift for Liu Chüeh's brother Liu Hung when he went to Peking to take the examinations in the spring of that year. Liu Chüeh inscribed the painting then; in the autumn of 1472, shortly after Liu's death, Liu Hung asked two of Shen Chou's friends who were then in the capital, Wu K'uan and Wen Lin, the father of Wen Cheng-ming, to inscribe it, and still another friend named Li-chai added a poem, undated. Shen Chou himself, while his seal is on the painting, wrote no inscription on it; when he saw it again in 1501 and was moved to add an inscription, no space was left, and he wrote on a separate sheet of paper that is now mounted above the picture. Shen notes sadly that all but two of the writers, and Liu Hung as well, were by then dead. All this now seems dusty history; it is impossible for us to appreciate fully the associations such paintings carried among the people for whom they were intended. Even when the scenery seems generalized to us, it doubtless portrayed recognizably some features of the natural setting of the recipient's house. It might well contain also stylistic references to some famous work owned by one of the group and well known to all. With its poetic inscriptions and written accounts of parties and gatherings, it thus became, in addition to whatever merit it had as a picture, a record of friendships, emotional attachments, meetings and partings.

"Towering Mountains Above a Retreat," in such a context, seems powerful but austere; more of intimacy might have seemed in order. It is tall and narrow in shape. A tendency toward such compositional attenuation, with a dominant verticality, was apparent already in some late Yüan landscapes and some paintings by Wang Fu but was never before carried to such a point. Such vertically-stretched-out compositions were to be a specialty of Wu-school artists until the end of Ming. Beyond a foreground screen of trees, a bridge crosses a river, and a path continues left-ward, beyond the limits of the picture, to re-enter above and lead to a house among bamboo, within which a man, presumably Liu Hung, sits reading. Other buildings are seen farther up the valley. The effect is less of comfortable seclusion than of an almost oppressive constriction. At the right is a tall waterfall; between this and the valley a columnar mass, topped by plateaus, serves as foundation for a ridge that climbs steeply to the summit, where more plateaus end the progression. This whole passage follows closely the schematic mode of construction used by Huang Kung-wang in his "Stone Cliff at the Pond of Heaven" (*Hills*, Pl. 40); but in some places, especially near the top, Shen Chou slips into the manner of Wang Meng (cf. *Hills*, Pl. 53). Shen Chou's performance here is at once eclectic and virtuoso, demonstrating a mastery both of old styles and of the manipulation of complex assemblages of abstract form that none of his contemporaries could equal.

Seeing this painting as a complex and experimental formal construction, and observing the same character in several others by Shen Chou and Liu Chüeh that we have already considered, as well as in still others to be treated in our chapter on the later Wu school, can serve to introduce another aspect of the Che vs. Wu, Sung vs. Yüan set of artistic issues. Such compositions were not painted by the Che-school masters, whose landscapes tended to follow well-established and simpler compositional types. The orderly, architectonic principles underlying many Wu-school landscape pictures had been developed in the Yüan dynasty by Huang Kung-wang and to a lesser extent by Wang Meng and others. Behind these developments, in turn, lay the monumental

landscapes of the Northern Sung, which, although sometimes simpler in plan, were similarly the products of elaborate workings out of formal programs and problems. They conveyed a sense of vastness and universality through offering a richly prolonged visual experience to the viewer, who could move in imagination through them, finding his way among believable masses and spaces, discovering details carefully placed by the artist for rhythmically timed encounters. The paintings seemed, that is, to contain extended stretches of time as well as expanses of space.

In some of the best Yüan landscapes—works by Huang Kung-wang, Wang Meng, and a few others—richness of naturalistic detail gave way to richness of formal interplay, of line and mass, textures and patterns, composite wholes and component parts. The paintings are visually absorbing in a new way, then, but to similar effect in prolonging and enriching the experience of viewing them, and thus conveying a sense of extended time. The same can be said of many of the finest Wu-school landscapes of the Ming.

Che-school paintings, by contrast, tended to follow Southern Sung models in this feature as in others. In the Southern Sung, compositions were simplified and focused so that the matter and message of the picture could be taken in instantly, or nearly so; they were not to be read in parts, or studied, and the experience they offered was immediate and intense. Looking at them longer could deepen the impression but not effectively alter or expand it. Ming works in this tradition are, as we have seen already, more elaborate and less unified in effect, but are still experienced typically as a series of instantaneous sensations; their bold brushwork and forms register suddenly and decisively on the consciousness. Exceptions can of course be found—some Che-school works are more Yüan-like in this respect and many of the Wu school are simple and immediate—but the distinction remains valid for the majority of the output of both schools.

Returning to Shen Chou, his "Fishermen on a River in Autumn" (Pl. 33) was painted in 1471, the year after "Towering Mountains Above a Retreat"; six years later Shen Chou, seeing the painting again at the owner's home, "idly added the distant mountains in blue," as he tells in his inscription dated 1477. "Then, putting aside my brush, I went out the door by quiet lamplight; the garden was filled with frosty moonlight, and my guest's robes were cold." The owner at that time must have taken the opportunity of a visit from the artist to show him the picture, which bore only Shen's seal, and ask for an inscription. Once again, Shen Chou responded by building a bridge across time, recalling and supplementing the original creative act.

The model here was clearly Wang Meng, not only in the twisting, richly textured mountain but also in the way the viewer's gaze is drawn through a constricted opening between rocks and trees to perceive the human focus of the scene, the pair of fishermen in their boats. The establishment of a high vantage point is carried through with unusual consistency. Although the scale is more intimate and the brushwork softer, the picture agrees in its strongly vertical orientation and spatial complexity with "Towering Mountains"; to penetrate the recesses of either picture involves one in the devious traversal of tortuous terrain. The 1471 picture, however, is based not so much on clear formal developments as on the gathering of compositional energies at a few vortical points (the center of the tree branches, a cluster of rocks on the slope above) and the dispersal of those energies elsewhere.

THE DEVELOPMENT OF AN INDIVIDUAL STYLE    These works of Shen Chou's forties (among which "Walking with a Staff," Pl. 29, can probably be included) are all mature, creative explorations and expansions of old styles, and apart from their individual excellence, they had the salutary effect historically of demonstrating that those styles were viable, not merely repeatable; that a reverence for the Yüan masters, expressed in one's own painting, was compatible with stylistic inventiveness; that an art-historical art need not be art-historically static, but could de-

velop in its own right. However, one would be hard put to define the individual style of Shen Chou on the basis of these, although they have of course important features in common; they do not exhibit any more overall stylistic consistency than the works of Tu Ch'iung, Yao Shou, or Liu Chüeh. It was probably not until the middle or late 1470s that Shen Chou developed a distinct personal style, the one that identifies immediately what we think of as his "typical" works.[10]

A major example of the new style is the long handscroll that Shen Chou painted for one of his best friends, Wu K'uan (Pl. 35). Wu and Shen were from the same county and knew each other from boyhood. Wu was born into an artisan family but rose spectacularly, taking first place in the metropolitan and palace examinations of 1472 and eventually becoming president of the Board of Rites and tutor to the Hung-chih emperor, besides being a famous writer. He composed the memorial inscription for the tomb of Shen Chou's father, who died in 1477; and when, in 1479, Wu was to return to Peking after a stay in Soochow to mourn the death of his own father, Shen Chou made him a farewell present and at the same time discharged his debt by painting this scroll.

It is about thirty-six feet long, and required three years to finish. Chinese connoisseurs have considered it to be one of Shen's masterworks; the great literary critic Wang Shih-chen (1526–90) owned it and held it to be Shen's finest painting. It is now in the collection of a publisher in Japan, where it has slipped into unwarranted obscurity through the reluctance of some Japanese scholars to recognize its authenticity.

The scroll takes the viewer on a long journey through the countryside around Soochow, following a path that crosses bridges and disappears at times behind hills but always reappears, so that one never loses his way for long. The view is close-up; except at a few points where the horizon or open sky is visible, the scenery fills the entire scroll, with cliffs, trees, rivers, even walls, cut off by its upper boundary. Shen Chou has again opened a rich quarry of compositional possibilities by exploiting this manner of perspective (which was not unknown before, as an occasional feature of spatial development in handscrolls and album leaves) and making it the basic principle of an entire, large-scale composition.

The passage we reproduce portrays a path-side rest-shelter in which four gentlemen are eating and drinking, while one of them performs on the *ch'in*. Shen continues to compose his scene on a system of strong diagonals, as we have observed him doing in several earlier works. But there is no sense of contrivance to the composition now, no mirroring of shapes. The masses are still powerfully rendered, with tactile surfaces, but are no longer instilled with tension or any feeling of instability by twisting or tilting or attenuation. They are in themselves stable and make up a structure distinguished by a nice dynamic balance. The brushwork is firm, exhibiting an allover consistency—an important feature of Shen Chou's new style—even while it varies in order to produce a rich range of textures.

Chinese writers virtually never discuss directly the question of patronage as a factor in the creation of paintings, except in conventional references to the professional-amateur distinction, and we must deduce what we can from inscriptions. In a long one on this painting, the artist tells how his father's tomb biography was composed by Wu K'uan and ends: "Hurrying to carry out the mourning rites for his father, [Wu K'uan] returned to Soochow. When this period was over and he was to go back, his friend Shen Chou made this [painting], a parting present which, compared with my forebear's tomb inscription, is nothing."[11] The implication is that the painting was done to discharge the obligation assumed when Wu composed the tomb biography.

This exchange probably exemplifies a type commonly carried out between the literati painters and those they considered their social equals (who did not have to be of landed-gentry origins— Wu K'uan was not), men among whom the use of money to repay such debts was considered low-

class, even insulting. A professional "artisan" painter, on the other hand, could be paid in a more straightforward way, either in cash or in goods easily convertible to cash. Something like this system persists today in Taiwan and Japan, where the person of rank pays tradesmen and other social inferiors with money but engages his friends and peers in an elaborate interchange of favors and gifts through which he incurs and discharges obligations. The actual practice behind the theoretical distinction of amateur and professional artists is probably best explained by this difference in modes of exchange, although such an explanation still does not, to be sure, make the distinction perfectly clear-cut.

At the same time that Shen Chou was painting the scroll for Wu K'uan, he was also at work on another major production, an album of twenty-two landscapes (perhaps originally twenty-three) from which we reproduce two (Color Pl. 4–5). The album was painted over a five-year period for a certain Mr. Chou Wei-te and finished in 1482, when Shen wrote the following inscription on the last leaf:

"I have a natural liking for painting landscapes but have never attained the *samādhi* [a state of perfect concentration of mind similar to yoga] of the truly skilled artist—I do them, that is, but am not satisfied with them. When the right mood of exhilaration comes, then 'trusting my hand' I wield the brush and spread on the ink. It is only a way of employing my leisure and a sense of well-fed well-being. I certainly have no intention of making them look attractive to people.

"Mr. Chou Wei-te had this album mounted [i.e., a blank album] and has been asking me for a long time [to do paintings in it]. Sometimes I did only one leaf a year, at other times several in a month—in five years, twenty-three leaves have heaped up. But Wei-te is still eager; with the paintings finished, now he wants an inscription. He won't let me off lightly—it is enough to make the avaricious seeker give up after seeing him! Wei-te's intention, however, is futile. Since the paintings don't satisfy me, how can they satisfy others? If they don't satisfy others, what is his reason for insisting on having them? It is as ridiculous as a hungry hawk going after a rotten rat! But Wei-te wishes to take full responsibility for it. What a laugh! *Jen-yin* year of the Ch'eng-hua [era, 1482], fifth day of the intercalary eighth month, inscribed by Shen Chou."

This is another piece of conventional self-deprecation: Shen Chou has in fact devoted a great deal of time and his best efforts to these leaves, some of which are among his most imaginatively conceived works. His debt to Chou Wei-te, whatever its nature, must have been a large one. Also, we may guess that some real exasperation may underlie the ostensibly joking complaints about Mr. Chou's impatience and importuning, and that Shen Chou may have felt genuinely relieved when the work was completed and could be delivered. The burden of fulfilling such promises, which could pile up to become oppressive, led some artists, such as Tung Ch'i-ch'ang in the late Ming and (according to an anecdote to be quoted in a later chapter) Shen Chou's pupil Wen Cheng-ming, to employ "ghost painters" to do pictures in their styles for them to sign and present to less favored recipients. There is no indication, however, that Shen Chou ever followed such a practice.

The paintings in the 1482 album are landscapes in a variety of manners, in which small figures are seen in houses and boats or walking on paths and bridges. In one (Color Pl. 4) a man is sitting on the edge of a sharp-cut bank under a thatched four-posted shelter, looking across a stream at a cascade on the opposite shore. A series of flat-topped banks begins at the lower right and continues, rhythmically repeated, to the upper right. Three groups of leafy trees provide a countermovement leftward, and both these diagonals are crossed by a horizontally disposed series of three dark clusters of blocky boulders. Beyond, the farther bank is composed of two large similarly shaped earth masses, partly obscured in mist. The clear formal scheme made up of these ordered and interlocked units, which makes the composition stable and easily readable,

extends to the coloring, which is also used more formally than descriptively: the tops of the banks are a uniform pale blue-green, their sides pale yellow, and very light cool washes are applied over the ink elsewhere. The brushwork is in the broad, relaxed manner of Shen Chou's mature style.

Another leaf (Color Pl. 5), which follows loosely the manner of Kao K'o-kung (a manner infrequently used by amateur artists in the Ming, as we noted before), is traversed by a river of windblown fog. The fog flows down from the left, nearly enveloping two houses, and on into a valley between a grove of trees and a steep hill, to hang at last over the base of a waterfall at the far right. Below, a stocky figure stands with a staff, pausing in his journey to observe this swirling interaction of air, water, and earth, in which these different states of matter seem transmuted into a unified flux. A heavily drawn dark tree, its branches bare and blunt, leans down over the figure, focusing upon it the disquieting feeling of the whole scene. Paintings so dark in mood are rare among Shen Chou's works and make us expand our ideas of his expressive range.

In the late winter of 1487 Shen Chou sat through a rainy night talking with Shih Yung-ling, who was the husband of the youngest of Shen's three daughters. Some time during the night he painted a landscape (Pl. 34) representing the house and its setting as it might have been viewed by someone outside, and later he wrote on it this poem and note in remembrance of the occasion:

> "Doing a painting in the rain, I borrow its rich wetness.
> Writing poems by candlelight, we pass the long night.
> Next morning, in sun, we open the gate; the spring freshet has spread.
> At the lakeshore you leave me among the singing willows.

"On the third day of the last month of winter, in the *ting-wei* year [1487], I sat up at night with Te-hui [Shih Yung-ling]. In a chance moment of exhilaration I painted this as a present for him. Shen Chou."

The painting has been given the title "Rainy Thoughts." It is perhaps the most pictorially conceived of Shen Chou's works, seemingly devoid of conventions, type forms, references to the past (although a Chinese connoisseur might still detect echoes of the school of Kao K'o-kung); one is nowhere conscious of brushwork or technique (although the technique of controlled suffusion of strokes in wet areas to convey the murky atmosphere is masterly); the suggestive, undefined rendering of tree foliage and the glimpses of wooded hills through the mists seem extemporaneous, unlearned, invented for the occasion. As in the similarly inspired "Night Vigil" of five years later (Pl. 37–38), Shen Chou creates a feeling of seclusion by setting his house and figures back in the middle ground, flanking them closely with rocks and trees, and providing the viewer with no easy access to this area of the picture. Shen and Shih sit talking at the open window of a thatched house built over a stream, their room a pocket of light in a dark and drizzly landscape. We are made to feel not only the wetness and cool of the scene but also the sound of rain on leaves, a steady, quiet dripping. Comparison with the more romantic depictions of rainy landscapes by the Che-school masters (such as Lü Wen-ying's, Pl. 51) or the Southern Sung works they followed (an ideal example is the "Landscape with Rainstorm" ascribed to Ma Yüan, in the Seikadō, Tokyo), in which the fall of rain is rendered in dramatic diagonal strokes of wash across the sky, reveals Shen Chou's as a more intimate and immediate conveying of a private experience, deeply felt and sensitively set forth, not reworked as a public performance. Once more, the purposes of the paintings must be kept in mind: one cannot imagine Shen Chou's painting hung as a decorative piece, or Lü Wen-ying's as the object of prolonged, thoughtful contemplation.

"Night Vigil"   Shen Chou's "Night Vigil" (Pl. 37–38), painted in 1492, is another picture of the same kind, an extraordinary record, in picture and prose, of an experience he had one autumn night in that year. The importance of this record in understanding Shen Chou and his painting warrants our quoting the inscription at length (although still somewhat abridged, particularly in the paraphrased portions, which are enclosed in parentheses, along with some brief interpretive notes):[12]

"On a cold night, sleep is very sweet. I woke in the middle of the night, my mind clear and untroubled, and as I was unable to go to sleep again, I put on my clothes and sat facing my flickering lamp. On the table were a few folders of books. I chose a volume at random and began to read but, tiring, I put down the book and sat calmly doing nothing. A long rain had newly cleared, and a pale moon was shining through the window. All around was silence. Then after a long time absorbing the fresh brightness, I gradually became aware of sounds."

(He listens to sounds farther and farther off—the wind in the bamboo, the growling of dogs, the drumbeats that mark the hours, and finally, near dawn, the sound of a distant bell. His meditations turn to the difficulty of breaking through the constant operation of his own intellect, which seeks for knowledge more in books than in direct experience.)

"My nature is to enjoy sitting in the night. So I often spread a book under the lamp, going back and forth over it, usually stopping at the second watch. Man's clamor is not at rest, and the mind is yet bent on bookish learning. Until now, I have never attained a state of outer tranquillity and inner stability [rest].

"Now tonight all sounds and colors come to me through this state of tranquillity and rest; they serve thus to cleanse the mind, spirit, and feelings [instead of, as ordinarily, muddying them] and to arouse the will." (But this will, this central point of consciousness, cannot easily dissociate itself from attachment to sensory data.) "It is not that these sounds and colors do not exist at other times, or that they do not strike one's ears and eyes. My outward form [body] is [usually] slave to external things, and my mind takes its direction from them. [True perception through] hearing is obscured by the sounds of bell and drum; [true perception through] seeing is obscured by patterns and beauty. This is why material things benefit people seldom, harm them often." (Once, however, he has arrived at a state of inner tranquillity, the effect of sensory stimuli is very different.) "Sometimes it happens, though, as with tonight's sounds and colors, that while they do not differ from those of other times, yet they strike the ear and eye all at once, lucidly, wonderfully becoming a part of me [absorbed into my very being]. That they are bell and drum sounds, patterns and beauty, now cannot help but be an aid to the advancement of my self-cultivation. In this way, things cannot serve to enslave man."

(Physical sensations are ephemeral, while the will remains more constant.) "Sounds are cut off, colors obliterated; but my will, absorbing these, alone endures. What is the so-called will? Is it inside me, after all, or outside? Does it exist in external things or does it come into being because of those things? In this [i.e., the realization I am now experiencing] there is a means of deciding these questions. Ah! I have, through this, decided them.

"How great is the power of sitting up at night! One should purify his heart and sit alone, by the light of a newly trimmed, bright candle. Through this practice one can pursue the principles that underlie events and things, and the subtlest workings of one's own mind, as the basis of self-cultivation and [a proper mode of] response to external things; through this, we will surely attain understanding.

"I have composed this record of my night vigil in the Hung-chih era, *jen-tzu* year [1492], fifteenth day of the seventh month. Shen Chou of Ch'ang-chou."

While Shen Chou does not specifically relate these meditations to the process of artistic creation, it is probably not unwarranted to use them to illuminate his beliefs, and those of Ming

literati artists in general, on the relationship between external phenomena and one's experience of them—or, by extension, perceived images in nature and the transformation of them in art. Sensory stimuli are in themselves too bewilderingly diverse, press upon the consciousness too constantly and demandingly, to be absorbed fully by the mind or represented in their raw state in art. The literati artists' continual insistence that verisimilitude, "form likeness," is not their aim is based on a conviction that attempts to represent the world as it appears miss the point; realism in art does not truly reflect human experience of the world, or understanding of it; and it is that experience and understanding they mean to convey—insofar as they choose to engage themselves, as artists, with nature at all. At moments of extraordinary clarity, when the mind is receptive but at rest, uncluttered by distracting considerations—moments such as Shen Chou records so movingly here—one's perceptions become a part of one's self, in an undifferentiated "passage of felt life." The cumulative absorption and ordering of such perceptions is the "self-cultivation" of the Confucian system, and this in turn is the proper stuff of art.[13]

In the painting below this inscription Shen Chou has portrayed himself sitting at the open door of his house, with a candle and books on the table beside him. The figure is drawn small and simply but, placed in the precise center of a composition that in every way directs attention toward it, is undeniably the focus. From it the composition spirals outward, beginning with the closest elements, the buildings, through the trees, the stream and a band of mist, finally to the farthest, the banks, slopes, and hills. This simple scheme is effective in conveying visually the mood and sense of Shen Chou's essay, in which the artist's interior experience absorbs and encompasses the world around him as it is perceptible to his senses, first his immediate surroundings and then, through sounds, things farther and farther away. Night and moonlight are suggested in the painting only by paleness of color in some parts and a slight darkening in others. The painting is in harmony with the essay also in its drawing, which, like that of the "Rainy Thoughts," is broad and loose throughout, with no effect of forcefulness, offering thus a visual equivalent for the essay's unassertive, meditative tone. Such drawing, rather than analyzing and defining the objects of the picture intellectually, from outside, seems to become the brush-equivalent of those objects, identical with them; here is still another way in which the painting is analogous to the essay in its approach to the experience of reality.

LANDSCAPES OF THE LATE PERIOD   A number of Shen Chou's finest works, in his most characteristic style, are undated but can be placed in his late period, roughly the last two decades of his life, by comparison with dated pictures that are stylistically similar. The poetic and lovely "Gazing at the Midautumn Moon" in the Boston Museum of Fine Arts should date from around the beginning of this period, i.e., the late 1480s, since Shen Chou speaks of himself in his inscription as being around sixty.[14] Others include the "Scenery of Ch'ang-chou" handscroll in the Palace Museum, Peking,[15] and an album and handscroll representing well-known sights in the environs of Soochow.

The album is in the Cleveland Museum of Art and consists of twelve leaves, some painted in ink only and some with light color, on paper. They represent the renowned Tiger Hill, a pilgrimage place and landmark a few miles northwest of Soochow, identifiable always in paintings by its shape, by the Buddhist temples on its slopes and summit, and by its famous pagoda, visible from afar. It was a favorite picnicking place, since one could view the surrounding countryside from the top of the hill.

We reproduce two leaves from the Cleveland album, one depicting the Thousand Buddha Hall and the pagoda (Pl. 39), and the other the Drought Demon Spring (Pl. 40). Each leaf portrays a single scene as viewed from a particular vantage point. One sees the Thousand Buddha Hall from above, perhaps from higher on the hill, and looks beyond over a river and rice fields. The Drought Demon Spring, a roadside well under great oak trees, is seen from a closer and lower

viewpoint; this allows Shen to fill his composition as he was fond of doing, cutting the trees off at the top. The stocky figures of strolling scholars appear throughout the album, making their way (and so directing the observer's attention) along paths and up stairways, or pointing out the places of interest to each other—two of them stand beside the Drought Demon Spring, probably discussing the suitability of its water for brewing tea.

We would recognize easily Shen Chou's main stylistic model in these leaves even if we did not recall Li Jih-hua's statement that Shen was "intoxicated," in his old age, with the painting of Wu Chen. Wu's fascination with the parallel-line, gridlike patterns of freehand architectural drawing and the interplay of angles that could be set up within clusters of buildings drawn in this way has been brilliantly caught by Shen Chou in the Thousand Buddha Hall leaf, which also sets this busy pattern against patches of wetly dotted foliage and a misty distance rendered in soft ink washes, as Wu Chen might have done. Similarly, the swelling slope behind the Drought Demon Spring, given a tactile bulk by thick modeling strokes in pale ink and bunches of fat *tien* in deep black, is in the Wu Chen mode, as are the strongly rooted trees and the figures.

Nevertheless, it would be a serious mistake if we were to see Shen Chou's artistic career, by misunderstanding Li Jih-hua's account of it or the practice of "following old masters" more generally, as a succession of derivative phases in which he imitated this artist, then that artist, then another artist. For one thing, surviving works do not allow any such neat division; he could work in one mode today, another tomorrow. For another, such a formulation misstates the motivation: rather than a shifting of favor from one old model to another, with a resultant shift in style, Shen Chou's development (like that of any good artist) represents a series of shifts in interest from one set of formal problems to another, and from one set of technical and expressive materials to another. His choice of favored models changed, that is, as different modes from the past came to suit his concerns and his needs at different times. If restated on these terms, Li Jih-hua's three stages noted earlier in this chapter—first imitating various masters, then following Huang Kung-wang, and finally adopting Wu Chen's style—would probably be truer to Shen's development, although still oversimplifying it.

In his early period, one would then say, he is occupied with possibilities of active, sometimes rather fanciful, compositions featuring dynamic forms such as twisting mountains and sensitive dry-brush drawing in which the brushstroke itself, sharp-ended, seems sometimes to twist. Wang Meng is accordingly a favorite model, and there are echoes of Fang Ts'ung-i. Later, Shen comes to prefer more tightly constructed, architectonic structures and is less concerned with rich textures; the styles of Ni Tsan and Huang Kung-wang become more attractive to him. In his late years his line broadens, takes on a thick substance that partly supplants, instead of augmenting, any sense of three-dimensionality in the forms it delineates; it tends rather, by lying so flat on the page, to flatten those forms, reducing them to strong patterns that can then be composed into a picture that is conceived in terms of bold, flat design. At the same time, the artist's whole outlook seems to become warmer, more poetic, and the world he depicts more congenial to the people who increasingly inhabit it. For this mood and these qualities, no painter could better serve as model than Wu Chen.

Under this new set of conditions or "rules of the game," Shen can create brilliantly innovative compositions with a greater sense of ease, dividing his picture space in new and striking ways, adopting unusual viewpoints, chopping off his scenes with daringly unconventional placing of boundaries. The Cleveland album offers a series of surprises and delights of this kind, which can only be suggested by the two leaves we have chosen.

That these innovations occur here in an album is not accidental. The album made up of a succession of leaves by a single artist (as distinct from the earlier type formed by collecting small pictures by different masters), within which the artist normally establishes some unifying theme or program, becomes popular in the Ming; the album of scenes of Hua-shan by Wang Li (Pl. 1–2) is an isolated fourteenth-century example, and it may be questioned whether this type of

landscape album was painted before the Ming at all. (Extant albums of this type ascribed to late Sung or Yüan masters—Wu Chen, Ni Tsan, Ts'ao Chih-po—all appear to be spurious.) The new format had its effect on style, encouraging compositional experimentation in the individual leaves to avoid monotony and setting new compositional problems by not permitting the vertical or lateral extensions of the scroll forms. Moreover, the leaves were intended to be seen close up and for short intervals (before one turned to the next); intimacy and immediacy were qualities to be expected and pursued.

Such a chopped-off view as Shen Chou gives us in the Drought Demon Spring leaf, for instance, had seldom if ever been attempted in a hanging scroll; one might see it as a segment of a handscroll, such as the one Shen Chou had painted in 1479 for Wu K'uan, but to see it that way does not make it, as a complete composition, any the less unconventional. The path enters through the lower margin and disappears out the right, continuous, unarticulated; the bank of earth and the wall behind similarly seem segments of a lateral continuum, as do the trees of an upward one. Liu Chüeh's travel scene (Pl. 27) had provided the germ for such a conception, giving, although less radically, the effect of a momentary pause in a continuing progress. Shen Chou seems, as it were, to be opening the window of a sedan chair in which he is escorting the viewer around the Tiger Hill and allowing him to see what the window happens to frame. To note this impression of chance cutting is not, of course, to deny that the picture is in fact strongly and successfully composed; the central focus of the well, the diverging of the two large trees directly over it, the placing of figures at both sides, most of all the symmetry of the swelling bank, hold it powerfully and stably within its space.

The Thousand Buddha Hall leaf combines in a like way, as do other leaves in the album, implications of quasi-arbitrary cutting of borders with a tight composition within them. Its basic plan may recall earlier works by Shen Chou in which the upper area was made to mirror the lower; but here the effect is less of unification than of sharp contrast, with the highly active and linear foreground answered by a blurred, quieting passage in the distance. A row of strictly horizontal walls and buildings across the bottom provides a stable base from which pictorial tension builds upward, through structures set at dynamic diagonals, to the pagoda, from which the accumulated energy is dispersed outward into the distance.

Less exciting but belonging to the same late style is the long handscroll titled "The White Cloud Spring" (Pl. 41), which takes the viewer on a long tour of notable sites in the vicinity of Soochow, beginning with the same Tiger Hill. The last half of the scroll has been cut off (two other versions of the composition, less convincing as being from the hand of Shen Chou himself but complete, preserve the whole composition) and a spurious inscription has been added at the end of this surviving portion, which bears Shen's seal at the beginning. It is one of the few Shen Chou paintings on silk and therefore contains little dry-brush drawing, for which silk is unsuited. The use of silk was more common among professional artists, since it was better adapted to firm, controlled styles of painting than to the more spontaneous and was the ideal material to use when one wanted to display sureness of hand and technical mastery. Moreover, paintings on silk usually (other things being equal) had a higher market value than those on paper.

These considerations, and the nature and subject of Shen's "White Cloud Spring" scroll, suggest that it may be an example of a kind of painting he produced on a semicommercial basis, once he had become famous enough for his works to fetch good prices. His early paintings, done for friends on particular occasions, were modest in size and specific in their references to times and places (even when the references are not clear to us); their value was in considerable part associational. In contrast to them, this carefully put together and firmly painted scroll offers a generalized, matter-of-fact presentation of famous sights around Soochow, such as any visitor to the area might like to take home as a remembrance of his stay and as a treasure, to be shown with pride, from the hand of the famous Mr. Shen. Throughout the scroll, labels in small characters

identify the places depicted; we cannot be sure that these were written in by the artist himself, but they indicate that the scroll was intended, or at least adapted, for someone not familiar enough with the region for such labeling to be unnecessary. In short, this seems clearly to be a painting less intimate in approach, more public in purpose, than most of the works of Shen Chou we have seen.

The section of the scroll that we reproduce begins (at the right) with a pass in the hills, a place that the label identifies as Mud Flat Ridge. A bent figure with a staff descends the path below, a wood-gatherer is seen coming over the pass, and a crane flies overhead, all arranged in a vertical row and tied into a visual unit by the outline of a distant peak. Farther on, a rocky mountain fills the whole height of the scroll; this is T'ien-p'ing Shan, or Heavenly Peace Mountain. A small waterfall on its slope, with a rest-shelter at its base, is labeled the White Cloud Spring, after which the scroll takes its name. Below is a Buddhist temple, within which the largest, two-story structure, seen through pine trees, is the Ancestral Hall of Fan Chung-yen. Two visitors to the shrine stand in the foreground. At the end of this section, in another gap in the hills, the path proceeds, and another traveler continues the forward progress of the scroll toward the next section.

The mode of composition is a familiar one, of which a simpler version was seen, for instance, in Liu Chüeh's 1471 painting (Pl. 27): two inward-sloping banks in the foreground, through which one moves into middle ground; above, framed by these, a central mass, the upper contour of which repeats, mirror-fashion, the wide-angled gap below. The hills are powerfully rendered, composite forms, still echoing faintly the Huang Kung-wang formula with their even-sized units and jutting ledges. The broad, relatively pale line drawing and the freely placed *ts'un* which model the masses simply but effectively belong to Shen's late style. Nothing of spatial clarity is lost in the screening of the temple behind trees; the construction of walls and buildings is easily but firmly rendered. Even such a detail as the insetting of flat stones, large ones alternating with small, at the base of the wall as facing for the foundation and to reinforce the part that is most subject to erosion and wear, is observed and accurately reported.

In these late works Shen Chou sacrifices stylistic variety and finesse in execution to effect a greater strength of surface design, a greater firmness and massiveness in his forms, and a new clarity. His purpose was probably, and his achievement certainly, to correct some of the weaknesses that literati painting had fallen into—overemphasis on sensitive brushwork, too slavish imitation of past styles. Some features of his late style were taken up by later Wu-school artists —Wen Cheng-ming, Lu Chih, Ch'en Shun—whom we will consider in a later chapter. His influence was not limited to the Wu school, however; it is to be seen clearly in certain of the late Che-school masters—certainly in Li Chu, who studied with him, and perhaps in Wu Wei— and in artists who took an intermediate position between the literati and academic trends, such as Hsieh Shih-ch'en and later Sung Hsü. These artists adopt elements of Shen's late style, notably the drawing in thick, blunt line, that the Wu-school painters of the generations after him seem, on the whole, to reject.

In any case, we know that already by the time of his old age Shen Chou's paintings were extremely popular and widely imitated. There is even a story, of unascertainable credibility, that toward the end of his life he decided to buy back some of his earlier pictures and that the forgeries were by then so numerous and so convincing that he unwittingly bought some of them himself.[16] True or not, the story should warn us against overconfidence when we try to separate the "real Shen Chous" from among the hundreds of spurious works that pass under his name.

PLANT AND ANIMAL SUBJECTS   Besides landscapes, Shen Chou occasionally painted bird-and-flower subjects and animals, including crabs and shrimp. His best surviving pictures of this kind

are contained in an album of nineteen leaves, painted in 1494 and titled "Drawings from Life." The double leaf representing a crab and a shrimp (Pl. 36) is especially fine in its portrayal of the living creatures with wet, sure strokes of ink wash that describe closely, even in their apparent freedom, the stiffness of the shells and flexibility of the jointed legs. Earlier fifteenth-century artists had been experimenting with a manner of painting in wetly applied strokes either of color (the so-called "boneless style," which we will see exemplified in a painting by Sun Lung, Pl. 64) or of ink, and Shen Chou probably knew their work. The style suited the subject, in the Chinese view; neither was quite respectable in scholar-artist circles—the great Ch'an Buddhist master Mu-ch'i of the late Sung period, for example, had been dismissed by later critics as a "vulgar" painter for doing paintings that offered just this combination of commonplace subjects, including shrimps, and brushwork that was too fluid and free, too responsive to representational needs, to meet the established standards for acceptable brushstroke types.

Shen Chou is careful, in his inscription that accompanies the album, to inform the viewer that his purpose was not serious:

> "In themes of things that wriggle and things that grow,
> By playing with my brush, I can still work transformations.
> On a bright day, by a small window, sitting alone,
> The spring wind in my face, this mind with subtle thoughts . . .

"I did this album capriciously, following the shapes of things, laying them out on paper only to suit my mood of leisurely, well-fed living. If you search for me through my paintings, you will find that I am somewhere outside them."

In contrast to these "trivial" themes, paintings of plant subjects that carried symbolic allusions to Confucian virtues were considered thoroughly respectable, requiring no apology from the artist. Such were bamboo, orchids, chrysanthemums (associated with T'ao Yüan-ming), branches of pine and blossoming plum. Shen Chou did these too, on occasion, as did most other scholar-artists. Other kinds of trees were less common in painting, and Shen Chou's famous handscroll portraying three old junipers (Pl. 42–43), which is among his most powerful works, is probably without precedent. The three trees were the oldest of the Seven Stars, seven venerable junipers planted by a Taoist priest in A.D. 500 in the grounds of a temple at Yü-shan, north of Soochow. Shen Chou painted them in 1484 when he paid a visit to the place in the company of Wu K'uan.[17]

Shen Chou includes only the upper parts of the trees and cuts two of them off at the top as well; it is the same device that he employs in his landscape handscrolls, setting the upper and lower boundaries so that the forms are not wholly contained in the picture space, and has the same effect of drawing the viewer close to the subject, even into it, confronting him (in this case) with the massive trunks and thrusting branches. The overlappings and interweavings, intricate or even tortuous as they are, never depart from organic and spatial logic to the point of becoming visually unintelligible, as was to happen in paintings of similar subjects by later and lesser masters.

Shen Chou similarly foregoes the grotesqueries that others achieve by exaggerating suggestively animal-like configurations; poets write of the trees as writhing like dragons, reaching out like the arms of apes, or threatening with sharp claws like giant birds attacking their prey, descriptions that must have tempted the painter to depict them that way, and some painters yielded to the temptation for an easy impressiveness. Metamorphic and metaphorical effects are present in Shen Chou's painting, but they depend on real aspects of the trees and are not mere products of the artist's imagination. The grandeur of Shen Chou's presentation admits nothing of the fanciful; with brush drawing of a rugged integrity that is worthy of its subject, he describes movingly the outcome of a millennium of slow growth, of survival through a thousand winters.

The brushwork is of the constantly modulating kind of his middle period, creating in-and-out movements within the shallow space, rendering rough bark or suggesting light and shadow. In its adaptiveness it is comparable to the brushwork of the "Rainy Thoughts" of three years later (Pl. 34), which similarly conveys a subjective experience through sensitive description of an objective reality. The broader, flattening line of his late landscape style, and the emphasis it gives to surface pattern, would in any case have been unsuited to the subject.

# CHAPTER THREE

# The Later Che School

## 1. Nanking as a Painting Center

The city of Nanking, which had grown to greatness so suddenly at the beginning of the Ming dynasty, lost about half its population and much of its splendor when the capital was moved to Peking in 1421, leaving only the hollow shell of a secondary court behind in Nanking. However, even after the main locus of political and military power had shifted to the northern city, Nanking retained the great advantage of its location at the center of the richest and most productive area of China; it was, as the late Ming writer Ku Ch'i-yüan put it, "the hub of all the wealth and resources of the southeast." While not a major center of production—its textile industry did not compare with Soochow's—Nanking was an important center of trade; and this commercial activity, together with the continued presence of large numbers of administrators and bureaucrats connected with the smaller, largely ceremonial government maintained in the city, enabled Nanking in time to regain a status approaching its early Ming eminence. Here, as in Soochow, there was a lively interaction of officials and merchants, even though they belonged in theory to widely separated social strata: officials and members of the nobility were forbidden to engage in trade but did so through family members and servants; tradesmen and small businessmen could make fortunes and enter some official rank, often through bribery but also because wealth provided the material basis for a good education, the key to penetrating officialdom.

Money was a source of power and also of personal and family prestige, which could be enhanced by patronage of writers and artists. By the late fifteenth century, Nanking was rivaling Soochow in intellectual and literary activity. Leading Nanking writers did not concentrate so much on the literary forms intended for quiet, contemplative enjoyment or edification, the poem or the learned essay (although they wrote those too), as on "performance pieces"—dramatic lyrics (san-ch'ü) and operas. Some of the composers of these were also painters, such as Hsü Lin and Shih Chung, who will appear in this and the following chapter. The directions taken by painting and literature were in some respects parallel. If Soochow painting can be broadly characterized as scholarly and poetic, Nanking painting can be seen as sharing some of the qualities of the genres of literature popular there: a fondness for narrative themes, for the portrayal of human figures and human situations, for effects that can properly be called dramatic. With some of the artists we will encounter, painting itself seems to have been, in a sense, a performance art—Wu Wei, like Wu Tao-tzu and other flamboyant painters of the past, produced pictures with dazzling virtuosity before the eyes of astonished viewers. We may note by contrast that nowhere is there any record of anyone's having watched Shen Chou paint.

For a time in the late fifteenth and early sixteenth centuries Nanking was probably ahead of Soochow in the number of important artists active there. Some of them were natives of the city, but most came from outside, attracted by an atmosphere receptive to the arts, by comforts and pleasures (the Nanking entertainment district was famous), and by the abundance and variety of patronage, from the small merchant through officials at all levels up to the imperial court. The diverse nature of the painting produced in Nanking at this time doubtless reflects a diversity of patrons, but we have little evidence for connecting styles with the tastes of particular kinds of consumers and can only speculate, with the usual risk of falsification, even unfairness—if, for instance, we are tempted to attribute a taste for the showy and vulgar to the merchant class.

In the foregoing volume and chapters we have written sometimes as though certain preferences and tastes were common to the educated elite, the literati; and so they seem to have been, within the particular circles of literati we have treated—those of Wu-hsing, Chia-hsing, and Soochow in the Yüan, and, in the early Ming, of Soochow once more. But there is no reason to suppose that these preferences were uniform throughout China—that scholar-gentry and officials in Hangchow, or lesser centers such as Fukien and Canton, did not support their local artists and favor the local styles, including those that the verdict of history, as pronounced by the most authoritative critics of later times, declared to be low class. Tai Chin enjoyed the patronage and enthusiastic admiration of some of the leading scholar-officials of his day, as did Wu Wei, the next major Che-school master, although both painted predominantly in styles that are generally considered somewhat outside the "literati taste." It is clear that the Che-school styles were popular in Nanking and Peking during the period we are now considering, not only at the courts but also outside them in the cities; the innovations in style that Tai, Wu, and others accomplished were in part responses to an expansion of patronage, the need to satisfy a variety of demands.

The artists who will be treated in this chapter represent in general a continuation of the "academic" trend that was the subject of our first chapter, although most of them, as we will see, engaged in attempts to break free of academicism. Some worked in Peking, in the Academy, others in Nanking, as professional artists outside the court. (The question of whether painters were active in the Nanking court at this time is unanswerable on the basis of presently known evidence; presumably they were, probably in some cases moving or being transferred from service in one capital to the other.) The case of Wu Wei, the central figure in this group, who was both Peking academician and Nanking professional, demonstrates the fluidity of movement possible to painters at this time, a kind of social mobility in the art world.

## 2. WU WEI

LIFE AND CAREER    Wu Wei was born in 1459 in Wu-ch'ang in present-day Hupei Province.[1] His family had produced distinguished scholar-officials in the past, but his father, who received a good education and took the *chü-jen* degree, was reportedly a devotee of alchemy and given to dissipation, besides collecting calligraphy and painting. He died after bringing the family to ruin, leaving Wu Wei an orphan with little prospect of continuing toward an official career himself, although his education had been directed toward that end. Wu Wei had learned to paint, we are told, without a teacher, probably through association with artists and study of his father's collection. He was raised by a provincial official and at the age of seventeen came to Nanking to seek his fortune as a painter.

Among his patrons was a nobleman named Chu, a tutor to the heir-apparent and a descendant of Chu Neng (1370–1406), who had held the same position and title, Duke of Ch'eng-kuo. It was from this man that Wu Wei received the nickname by which he is best known: Hsiao-hsien, or "Small Immortal." This sobriquet, likening him (however unseriously) to a Taoist Immortal

or Transcendant, indicates how he was already regarded by his contemporaries and suggests the kind of renown he would achieve as an unworldly and unorthodox personality. He appears to have been that by nature, but he probably also exploited the popularity of the romantic, "bohemian" image of the artist.

His career fits a strikingly consistent pattern for the painter who is a scholar-official manqué, an educated man who somehow fails to pass the examinations and reach office and turns to painting as a means of earning his living. His position in society is anomalous, since his education has not been put to the normal use: he is learned and talented without possessing either wealth or rank. Typically, in China, such an artist cultivates in his life and his art an attitude of eccentricity, or at least evinces a degree of emancipation from the rules and conventions to which others, whose roles are better defined, are bound. We will encounter other examples in later chapters, and still others could be cited for the Ch'ing period, notably the "Strange Masters of Yangchow" in the eighteenth century.

Wu Wei's success in the south led to an invitation to Peking; he was welcomed there by officials who had heard of his talents and eventually recommended to court, where he became a painter-in-attendance in the Jen-chih Tien and a low-ranking officer in the Embroidered Uniform Guard. Emperor Hsien-tsung seems to have found his paintings admirable and the painter himself entertaining; Wu was allowed entrée to the inner chambers of the palace and could take liberties with the emperor that would have cost others their heads, or at least their jobs. The late-Ming book *Wu-sheng-shih shih* tells a famous story: "On one occasion when summoned by the emperor, Wu was very drunk and came into the imperial presence with disheveled hair and dirty face, his shoes dragging and torn; he arrived staggering, supported under the arms by two court servants. The emperor laughed and ordered him to paint on the spot a picture of 'Pines in Wind.' Wu knelt down and spilled the ink [onto a silk or paper screen laid on the floor], then began to rub and smear it freely, 'trusting his hand,' making wind and clouds arise on the screen so appallingly strong that the two servants grew pale. The emperor drew a deep breath and said: 'This is truly the brush of an Immortal!'"

However, Wu's habits of brooking no criticism, expressing open contempt for high-ranking statesmen and noblemen, and refusing most requests for paintings aroused so much indignation that he was expelled from the palace and returned to Nanking. What happened there can again be read in a vivid account in *Wu-sheng-shih shih*: "Wei was devoted to the theater and to drinking; he sometimes went ten days without eating. The libertines of Nanking [who were after his paintings] invited him every day to drinking parties. When they saw that he was also fond of singing girls [prostitutes] and couldn't really enjoy his drinking without them, they began to compete with each other in gathering singing girls for him too, as bait." Small wonder that high-minded literati critics of later times, holding that the quality of a work of art was linked to the artist's motivation for creating it, often had low opinions of Wu's paintings.

Hsien-tsung died in 1488, and early in the reign of his successor, Hsiao-tsung, whose reign (1488–1506) was titled Hung-chih, Wu Wei was again called to court, advanced in rank to company commander in the Guards, and, most prestigious of all, awarded a seal by the emperor that read: "Foremost Among Painters." Imperial favors were heaped on him. When he asked leave to return to his home in Wu-ch'ang to "sweep the ancestral tombs," it was granted; but a few months later a messenger appeared calling him back to the capital, where the emperor presented him with a house in a fashionable section of the city. Two years later he escaped again from service at court, this time pretending illness, and returned to Nanking, where he lived on the bank of the Ch'in-huai River. He had four wives and at least four children; whether any of them followed him on these back-and-forth moves we are not told. In 1506, Emperor Wu-tsung ascended the throne, and in the third year of his Cheng-te reign Wu Wei once more received an imperial summons. But while he was preparing to accompany the envoy to Peking, he died from the effects of overdrinking. This was in 1508, when he was only fifty years old (by Chinese count).

All in all, it is a career that illustrates a new relationship between artist and patron and a new conception of the artist's position in society. Eccentricity in painters and the tolerance of it were, of course, in themselves nothing new. The Taoist philosopher Chuang-tzu, writing around 300 B.C., told the story of the painter who, summoned by his lord with a crowd of others to perform a job, arrived late and was discovered afterwards sitting idly on a mat outside with his clothes off. This, the lord declared, was a true artist. Ku K'ai-chih, in the fifth century A.D., provided a model for the artist as erratic personality; and Wu Tao-tzu in the eighth (to whom Wu Wei was sometimes likened—the common surname is coincidental but not insignificant if one believes in mysterious affinities) was the great precedent for the "divinely inspired" painter who transcended rules and worked with dazzling sureness and ease. The literati painters from the eleventh century onward supplied countless cases of lofty refusal to produce on demand, and the "untrammeled" ink-splashers of the late T'ang and after, of aberrant techniques for painting. (Besides Wu Wei's "Pines in Wind" performance before Emperor Hsien-tsung, an anecdote relates an occasion when at a drinking party he seized a lotus seed-case, inked it and stamped it a number of times on the paper, and then—while the astonished guests were still wondering what he was up to—turned each of these stamped designs into a crab, creating a picture of "Catching Crabs.")

What was new was the way Wu managed to reconcile all these nonconformist ways with service in the imperial court, and with dependence on multilevel patronage outside it. What we read about him suggests that he was successful not so much in spite of his unservile attitude and eccentricities as (in part) because of them. The necessity for many educated men in the Yüan period to earn livings outside the civil service had required the opening of new modes of turning literary and artistic ability into sources of income without dropping to the status of the artisan on hire. Patterns of patronage developed that continued into the Ming and spread into areas of professional painting where they would once have been thought out of place. The support Tai Chin received from powerful statesmen demonstrates, but also must have enhanced, the prestige of the kind of painting he practiced. The reasons for its popularity (apart from the sheer quality of the paintings) are obvious: his works offered to their recipients an attractive combination of the romantic and bucolic images they enjoyed with a style freed from the stigma of conservatism or academicism by semi-improvisatory sketchiness. Here, again, was a model; Wu Wei's success was surely built on Tai's, and the attractions of his paintings were much the same, but he offered besides a colorful personality and entertaining "artistic" behavior. This, too, must account for some part of Wu's great renown, which is otherwise not entirely understandable, since nothing in his preserved works quite comes up to his reputation as "divinely inspired." Even allowing for the destruction of his larger works, wall paintings and screens, which were said to be his best, we would expect a masterpiece or two to have survived.

LANDSCAPES WITH FIGURES   Some of Wu Wei's paintings are clearly based on Tai Chin's, and these are the ones that most justify his classification as a Che-school artist. They probably date mostly from the earlier part of his career, although since none of his surviving works are dated (with a single exception), we cannot establish this with any certainty.

A good example is "Winter Landscape with Travelers" (Pl. 45). The composition, piled vertically at one side and horizontally on the other, belongs to the standardized plan that we have noted as probably originating with Tai, or at least popularized by him; it was to be employed by most later painters of the school for countless routine productions. (We should note at once that our plates were chosen for variety and quality and hence fail to convey the routine and stereotyped character of the bulk of the Che-school output, especially in its later phases. The reader who wants to look more closely into Ming painting can discover this fact for himself by browsing through some of the hundreds of published Che-school paintings.)[2] Blocky forms,

some of them tilted for instability, are treated with heavy applications of rough brushwork, in which harsh light-dark contrasts can stand either for sunlight and shadow or for snow and exposed earth.

The figures of the plodding traveler and his servant are placed close to the picture plane, emerging from behind a foreground slope; they are drawn in jagged, nervous lines. The same nervous energy permeates the trees and rocks. The artist seems everywhere to aim at effects of animation. Where Chou Wen-ching's landscape of 1463 (Pl. 18) represented a late assertion of the conservative attitude in court painting and homage to the Sung romantic mode, this picture by Wu Wei, probably painted only two or three decades later, represents the ascendancy of the new style introduced by Tai Chin, which was the starting point for Wu's development.

A painting titled "Fishing from a Riverbank" (Pl. 46), one of a pair of hanging scrolls, stands in a close and instructive relationship to the "Winter Landscape with Travelers." It would seem to represent a later period in Wu's career. The composition is basically the same, but the foreground has been brought closer by enlarging the figure and by cutting off the bank and boulders so that they are less completely contained within the frame, seeming rather to extend beyond it into the viewer's space. The spectator is thus involved in the scene more immediately and dramatically, instead of being presented with a separate space beyond the picture plane that is complete in itself. To the same purpose, the overhanging cliff is similarly pulled nearly up to the foreground and continues out the top of the composition. The space of the picture opens diagonally forward from behind the cliff in a manner that was later to be exploited also by Wu's follower Chang Lu.

A more radical change than these, however, is in the brushwork. Rough and scratchy brushstrokes were used in the winter scene but were held within firm contours and served to render rugged surfaces of rock. Such brushwork was still a component, that is, of the old outline-and-texturing mode. In "Fishing from a Riverbank," the rough-brush drawing functions more like the brushwork in some late Yüan landscapes of the literati school, in which it can be said to constitute the masses instead of delineating them or defining clearly their shapes and surfaces, and also becomes in a sense the "subject matter" of the picture, as much as the forms it more or less represents. Some intrusion of the ideals and methods of the scholar-artists into the Che-school style can certainly be noted here, as it can in other aspects of Wu Wei's painting. At the same time, the brushwork is far more loose and unrestrained than any that was tolerated in literati painting, where it would doubtless have been considered insufficiently disciplined. Wu Wei is pursuing an effect of extreme spontaneity and bravura execution, giving free rein to rhythms of movement, allowing the kinesthetic impact of brushwork to overrule its form-defining capacity. The scribbly flourishes are turned at constantly varying angles for maximum agitation of the picture surface. All this confounds the viewer more than it helps him in understanding spatial relationships or comprehending the shapes and structures of the objects depicted; an extraordinary effort is required, for instance, if the tangle of activated brushstrokes that surmounts the foreground slope is to be read as trees. Such dissolution of form is itself an assertion of stylistic independence: earlier painters of an academic bent had felt obliged to provide their audiences with far more detailed and well-organized information about their subjects. In demanding of the viewer this degree of participation Wu Wei implicitly rejects the role of the artist as maker of neat, impersonal images.

That these radical transformations in the fabric of the picture are accomplished within such a standard composition gives us further insight into the situation of Wu Wei and the nature of his achievement. The people for whom he worked, like consumers of art in any time and place, had been conditioned by their past experiences of painting to respond to conventions of theme, of form, of execution; they were comfortable with the familiar but eventually bored by it, demanding novelty. Wu Wei, like any good artist, faced the tension between an impulse to break the

conventions, motivated both by his own urge toward independence and by the demand for new-
ness, and a realization that if departures were carried too far he must fail. Where the great and
original painter could carry out daring leaps into new worlds of form and create new conventions
that worked at least as well as the old, the lesser master had to proceed more cautiously, even
when seeming most incautious, recognizing the limits beyond which he could not venture with-
out running the risk of violating expectations to the point of failing to communicate (or "not
being understood"). Wu Wei is not a notable inventor of new forms or images; he is usually
satisfied to present the old ones in dashing new ways, preserving always enough of the familiar to
ensure intelligibility.

Wu Wei's debt to Tai Chin is demonstrated not only in such river compositions as the fore-
going but also in "Pleasures of Fishermen" (Color Pl. 6), a handscroll similar in subject and style
to Tai's "Fishermen on the River" (Color Pl. 3). Comparison of the two reveals that Tai Chin,
whose drawing seemed so unconventional in a mid-fifteenth-century context, seems rather, when
viewed retrospectively from the early sixteenth century, to have merely exchanged old brush
disciplines for new ones. Wu Wei paints in a looser way, violating old taboos in order to adapt
his brush techniques to the descriptive or suggestive needs of the moment. Here he turns away
both from the rough vigor of Tai Chin's drawing and from the sharp, slashing strokes of his
own "Fishing from a Riverbank," working instead in a broader and wetter manner for most
of the landscape passages. He mixes cool and warm pigments with his ink washes to achieve richly
coloristic effects and blends them or allows them to run together freely in mottled, evocative
areas that will recall, to Western viewers, passages in Impressionist landscapes. The figures,
buildings, and boats appear to have been delineated with a stubby brush of which the tip was
worn or trimmed so as to produce a correspondingly stubby and inelegant line; more refined
drawing would have been ill suited, in the Chinese hierarchy of styles, to the low-life subject.

The range of acceptable subjects in the Academy and Che-school repertory seems to narrow
after the time of Tai Chin. *Ku-shih*, the historical or legendary anecdotes so often depicted by the
earlier Academy masters, are less often seen. Most of the pictures are devoted to time-honored
symbolic themes, and little of the artist's creative effort, one feels, was expended on inventing
new ones, or even on giving fresh interpretations to the old. It is possible to see this phenomenon
—the loss of interest in historical and other particularized subjects—as paralleling a related
development in early Sung painting, where it reflected the artist's wish to deal with more univer-
sal themes, especially those of nature. It can also be seen as paralleling the de-emphasis of subject
matter in Yüan and later literati painting (or in some European painting of the nineteenth
century) where a growing concern with purely formal problems leads to a lessening concern
with specific subject.

Neither of these, however, quite accounts for the nature and function of subject matter in
Che-school works. It can properly be described, for most of the paintings, as conventionalized
and derivative; the same motifs are tirelessly repeated, and a great many of them are taken from
Southern Sung painting, or at least belong to a type popular in Southern Sung. This is the type
that presents images not only of nature but also of particular experiences in nature, or responses
to nature, through the relationship of figures to their surroundings. Examples include the theme
of harsh struggle with an inhospitable world, in pictures of travelers wending their tortuous ways
through rocky ravines; the theme of purifying the mind and emotions through deliberately
sought-out contacts with nature, in pictures of gentlemen gazing at waterfalls or listening to the
wind in the pines; the theme of enjoying both seclusion from the contamination of human
society and the pleasure of congenial company, in pictures representing a scholar-recluse's house
in the mountains, with a friend arriving for a visit; the theme of the simple life spent in un-
conscious immersion in nature, in pictures of wood-gatherers and fishermen. All these except
the first are idealized themes, and the ideals they embodied were (as in Southern Sung painting)

the ideals of noblemen and functionaries at court, and officials, tradesmen, men of practical affairs in the cities, who could seldom expect to realize them in actuality, being too closely bound, by circumstances but also by choice, to the "dusty world" that they professed to scorn.

The paintings offer imaginative escapes to bucolic ways of life and other modes of disengagement from the trammels of society. The emotions and experiences they communicate are not those felt deeply either by the painter (as, for instance, in Shen Chou's "Night Vigil") or by his patrons, nor do their subjects have any special emotional associations (as did Yüan and later depictions of villas and retreats, painted for their owners), nor do they express (as do Shen Chou's "Tiger Hill" pictures) a satisfaction with the immediate surroundings, the here-and-now, of either artist or audience. We learn virtually nothing, except by implication, about life in Nanking or Peking in the middle Ming period from the paintings done in those cities at that time. We are dealing, that is, with an essentially escapist art.

Wu Wei's portrayal of fishermen and their lives, like Tai Chin's, belongs to the category of idealization, not that of personal involvement. The latter approach is best exemplified by a famous tenth-century work, Chao Kan's "Early Snow on the River,"[3] which is based on detailed observation and sympathetic understanding of the lives of fishermen, depicting movingly the arduousness of their labors and their struggle for survival. The fishermen in the Tai and Wu scrolls, and in other Che-school depictions of the theme, inhabit instead a world which, like that of shepherds and shepherdesses in the pastoral myths of Europe, exists only in the collective imagination of sophisticated, urban people who cherish romantic longings for a naive state of being and who are unconcerned with the realities of sheep-herding or fishing. Wu Wei gives an entertaining picture of the bustling life of the village, where the fishermen and their families engage in the tasks and pleasures of the moment, poling their boats, throwing out and drawing in nets, drinking wine, talking, untroubled by any of the sober concerns of the great world beyond their river.

A colophon on the scroll by a writer named Ch'en Pang-yen, dated 1721, goes so far as to suggest that the painter has a deeper and truer understanding of the "mists and waves" of the fishermen's environment than do the fishermen themselves. His poem, which is otherwise a nice literary equivalent of Wu's painting in its descriptive, lightly philosophical tone, ends with these lines:

The fishing boat is a single leaf, poised between heaven and earth.
But one comes to realize that this boat is vast and the floating [ephemeral] world narrow.
Transmitting the spirit of fishermen needs a great artist's hand;
He fills our eyes with rivers and lakes, all on a foot of paper.
The true essence of mists and waves is unknown to fishermen—
If made to look at this painting, they would come to love them more.

FIGURE PAINTING   Wu Wei's prowess as a figure painter can be admired in a number of signed pictures. They range through such a diversity of manners, however, that it is difficult to recognize in them a distinctive style or to decide with any confidence which are really from his hand. They can be divided, to begin with, into "rough" and "fine" works. The decision whether to employ the rough, impulsive kind of brushwork or the delicate and disciplined depended on a number of factors, among which were considerations of subject, purpose, and doubtless the wishes of patrons. Pictures of Taoist or Ch'an Buddhist adepts, or low-life characters such as fishermen, farmers, and woodcutters, were typically done in the rough manner, which was also favored generally for hanging scrolls meant to be displayed in places where strongly decorative paintings were needed. The finer style was typically used for paintings of Confucian scholars and beautiful women and was best suited to the forms of painting meant to be

seen close up, the handscroll and the album. But it was used sometimes also in hanging scrolls, as was the rough manner in handscrolls. The rough, bolder manner was loosely associated with the tradition of Wu Tao-tzu and the fine-line one with that of Ku K'ai-chih.[4] Wu Wei, altogether one of the most versatile of Ming masters, was highly skilled in both but best known for his rough works. This is doubtless why Wang Shih-chen remarks that his style "is suited to painting on the walls of an ancestral temple or on large standing screens, but as for portable scrolls or single leaves, I fear it is inappropriate."[5]

"Two Taoist Immortals" (Pl. 44) is an excellent example of his rough manner. The personages portrayed are probably two of the Eight Immortals of popular Taoist legend; they are about to cross the billowing sea, as all eight are sometimes shown doing in paintings. The nearer figure appears to be Li T'ieh-kuai, who inhabited the body of a lame beggar after his proper body was burned while he was absent from it on a spirit-journey; he will ride the waves on his iron crutch, which is miraculously made buoyant. Li T'ieh-kuai had been portrayed by an early-Yüan-period specialist in Taoist and Buddhist figures, Yen Hui (Hills, Pl. 66), in a style that was widely imitated by Che-school and Academy masters of the Ming. A Yen Hui follower named Liu Chün, for instance, served with Wu Wei in the Hung-chih Academy, and some of Wu's works, including the "Two Immortals," follow this style in important features. The nervous, heavy-drapery drawing, the active poses, and the portrayal of muscular tension, especially in the faces, with lips drawn back tightly and large, expressive eyes, relate these figures to Yen Hui's. The style was well suited to the artistic temper of the time and place in which the later Che-school masters worked, which called for animation and intensity and valued strong effects over subtle ones.

Wu Wei here, as in his rough-manner landscapes, uses a swift-moving brushline that swells and thins suddenly or changes direction abruptly. In places it exemplifies a quality we can call "scribbly," with rapid back-and-forth movements serving chiefly to convey kinesthetically the energy of the artist's hand, at some sacrifice of descriptiveness. This manner of drawing was developed and popularized by Wu Wei; we will see it used also by his followers such as Chang Lu as well as by other Ming masters of Nanking and Soochow. One important model for it was the figure style of the thirteenth-century master Liang K'ai, as seen in his "Hui-neng Chopping Bamboo."[6]

The framing of the figures by a sketchily rendered pine tree also recalls Liang K'ai's compositions. Liang, a person of eccentric habits who called himself "Liang the Wastrel," was fond of drinking, and left the imperial painting academy by choice to live in a Ch'an monastery, was a model or at least a predecessor for Wu Wei also in his personal and artistic behavior, and this correlation between the styles of the two painters and their personalities and life patterns is no accident—as we will see in further examples, correlations of this kind are present throughout much of Ming painting. This phenomenon will be discussed in the next chapter.

At the other end of the rough-to-fine range of brushwork types was the fine-line mode of drawing without washes, or with only limited washes. Pai-miao, almost from its inception in the late Northern Sung period in the hands of Li Kung-lin, had been used by both professional and amateur artists; paintings by Chang Wu and Ch'en Ju-yen were used to illustrate the "social mobility" of this mode of drawing in our discussion of its use in the Yüan period (Hills, Pl. 70–71). By the Ming, it was practiced almost exclusively by the professionals, perhaps because it was by then apparent to everyone that they could do it better than the amateurs. Wu Wei uses it with great finesse, when the subject or the occasion calls for it. The handscroll titled "The Iron Flute" (Pl. 48) is his finest performance in this manner and also seems to be his only extant dated work. The inscription (not included in our plate) reads: "Chia-ch'en year of the Ch'eng-hua era [1484], twenty-eighth day of the fourth [lunar] month, painted by the 'Small Immortal'

from Hunan Wu Wei.'' (His birthplace Wu-ch'ang is actually in present-day Hupei Province, as stated earlier.)

A scholar is seated in a garden, books and brushes on a stone table at his side. A girl servant holds the iron flute; he is presumably about to perform on it for two charming ladies who sit before him on low stools, one hiding her face behind a translucent fan, the other putting chrysanthemum blossoms in her hair. The man is probably the Yüan-period littérateur Yang Wei-chen (1296–1370), whom we encountered before as writer, calligrapher, and painter (*Hills*, Pl. 36, 85; pp. 82, 165, 175). He called himself the Iron-Flute Taoist after an instrument he owned and played, and his dalliances with courtesans were well known; the scroll may well illustrate some colorful story in which he figures.

The line drawing used for the figures preserves some of the smoothly curvilinear quality associated with the *pai-miao* tradition from the time of Li Kung-lin onward, the quality sometimes described as being like ''drifting clouds and flowing water.'' At the same time, as executed by a master of sound technical training, it serves better to render the mass and articulation of the figures than it typically had in the hands of amateur painters, who were more concerned with evoking the antique than with descriptive naturalism. Wu Wei's figures sit firmly on their seats and turn convincingly in space, caught in moments of arrested movement. The brush drawing of the trees and rocks is similarly descriptive, varying for textural contrasts instead of being bound to any established manner to which the artist must conform in the interest of stylistic purity.

The style of Wu Wei's ''Lady Carrying a P'i-p'a'' (Pl. 47) is not true *pai-miao*, since there are limited washes and slight fluctuations in breadth of line, but it carries the same sense of refinement and restraint. The lady is seen in profile, walking forward with a melancholy air, her head drooping, carrying her *p'i-p'a*, or lute, in a brocade bag over her shoulder. The painter writes only his signature, and none of the three poems inscribed on the picture by his contemporaries provide any clue to the identity of the subject; a later writer adds to his poems a prose note saying that he has ''no idea what the meaning of the picture can have been in its time.'' Perhaps this is a courtesan whom Wu Wei knew in Nanking; perhaps he is thinking of Chao Wu-niang, the heroine of the mid-fourteenth-century play *The Lute Song* (P'i-p'a chi), who traveled to the capital to seek her lover, carrying her lute. Whoever she may be, Wu Wei portrays her with a poignancy that excites our curiosity about her story. The absence of any setting, the isolation of the figure in the center of a blank expanse of paper, adds to the feeling of loneliness.

This is another of the excellent figure paintings that are among Wu Wei's finest surviving works; they allow us to understand why he was especially admired and was so influential as a painter of figures. In ''Lady Carrying a P'i-p'a'' we encounter also another example of the manner of drawing that was probably original with Wu Wei and was to be developed during the next half-century by artists in both Nanking and Soochow. At its best the style balances the descriptive or characterizing function of linear drawing with the calligraphic. The line is distinguished by a high degree of fluency and tends to continue unbroken for long stretches, often moving smoothly and supplely, sometimes changing direction sharply or doubling back on itself without the brush being lifted, as in the cursive forms of calligraphy. The character of the line drawing contributes to the characterization of the figure, with smooth or jerky patterns of movement creating a quiet or an excited mood. Wu Wei is a master of both; here it is the quieter mode that suits his expressive needs, and he works with the nuances of touch that best convey the fragile sentiments he is evoking. The more vigorous, ''scribbly'' drawing is only hinted at in a few passages. His line thins at times to hairlike fineness, or becomes so dry as to all but disappear, or dims to the palest of tones without ever relaxing its taut sureness or slipping into aimlessness. The nature of the drawing suggests that the painting was probably done swiftly

and with the ease that superb technical discipline permits; most later imitators would make it look harder but do it far less well.

### 3. Hsü Lin

Nearly the equal of Wu Wei as a colorful personality and example of the new urban-eccentric type of artist was Hsü Lin (1462–1538). Unfortunately, his surviving works do not show him as nearly Wu's equal as a painter and leave us wondering about the basis of his immense success during his lifetime. His biography has recently been skillfully put together and entertainingly presented by Chaoying Fang.[7] We will give only a summary here of his extraordinary career. It parallels Wu Wei's in many respects and must, along with Wu's, have been seen as an attractive and encouraging model by other educated men faced with the necessity of applying their artistic talents to earning their livelihoods without slipping into the low position of the painter-for-hire.

Born in Nanking, Hsü Lin was a precocious child, composing poetry at six and writing calligraphy at eight. At the age of thirteen he passed the examination for admission to the district school and began the studies that should have led to success in the higher examinations and an official post. But instead of concentrating on those studies he yielded to the distractions of poetry and painting, the enjoyments of music, women, and the winehouses, and came to be regarded more as a playboy than as a serious scholar. He failed the provincial examination several times and eventually, in the 1490s, was expelled from the school.

Seemingly undaunted by this failure, which dashed all hope of an official career, Hsü announced that one need not wear an official's robe to be a respected scholar, and he applied himself even more to calligraphy, poetry, and painting. He had, understandably, acquired a reputation for unconventional behavior, which in Nanking at this time seems to have been as much an asset for an artist as it was an obstacle for an office-seeker. Shortly before his expulsion, in 1490, he had met Shen Chou in the company of seven other young scholars. He probably also knew Wu Wei, who was just three years older and of a like artistic disposition. Just as Wu was popularly known as Hsiao-hsien (Small Immortal), Hsü took the name Jan-hsien (Bearded Immortal). He was an imposing, full-faced man who apparently impressed people as much by his person as by his painting. He opened a studio and attracted patrons from among the rich officials and landed gentry who were residents of the city or visitors to it, making enough money to buy a house with several acres of land in the entertainment district.

Guests of high station came to the parties on his estate, which he called the K'uai-yüan, or Satisfaction Garden. There famous actors and actresses performed popular song-dramas, for some of which Hsü himself composed the lyrics. But all his earlier triumphs as a host were outdone in 1520 when he was twice visited in his garden by the Cheng-te emperor, who was staying for some months in Nanking. The emperor was delighted by Hsü's songs and by a New Year's poem he had composed, and he took the painter with him when he returned to Peking. The emperor died soon after their arrival, however, and Hsü was forced to return to Nanking without receiving the expected favors. We can imagine that he was, like Wu Wei, reluctant in any case to remain long away from Nanking and its pleasures. At his seventieth-birthday party over a hundred famous singsong girls came to congratulate him.

All this would lead us to expect paintings of great virtuosity and originality, but they are not to be seen. All we have from him, besides one blossoming plum and one hares-and-chrysanthemums picture, neither of great interest, is a set of four landscapes of the seasons, undated.[8] The painter's intention in these is clearly to offer the same combination of familiar, conservative styles and brilliantly vivacious brushwork that Wu Wei excels in, and the paintings do indeed fall within the stylistic range associated with painters of this type, tempering the hard academicism of much late Che-school landscape with some degree of loosening in brushwork. But this

formula in Hsü Lin's hands fails to produce the same happy blend. The spring, summer, and autumn scenes are surprisingly conventional Che-school performances in the Tai Chin mode.

The winter scene (Pl. 49) is an equally old-fashioned composition executed in a hard variety of the energetic, linear brushwork developed by Tai Chin and Wu Wei (cf. Pl. 17, 46) A traveler and his servants have arrived in the snow at the gate of a house, within which a man is seen awakening from sleep. The picture is believed to represent an incident from the *Romance of the Three Kingdoms* in which the pretender Liu Pei sends an emissary to invite the warrior-diplomat Chu-ko Liang to be his chief counselor. The tight, jerky drawing succeeds in enlivening the scene but falls far short of the sensitivity and calligraphic fluidity of Wu Wei and some of his followers at their best. To say that the painter is conveying the harshness of winter does not make the picture more pleasing, or less retardataire.

Perhaps other, unpublished works of the artist in Chinese collections, when they become known, will allow a fairer and more favorable assessment. But for now, Hsü Lin must be seen as representing the Che school in its decadent phase, when its practitioners lapse too frequently into heavy-handedness and fussiness.

## 4. Painters of the Hung-chih and Cheng-te Academies

The painters to be treated in the remainder of this chapter fall into two groups: Wu Wei's contemporaries in the Imperial Academy at Peking and his followers in Nanking. The former are generally the more conservative painters, continuing with some variations the tradition of the early Ming Academy; the latter are inclined to adopt and exaggerate the less subtle aspects of Wu Wei's style and end by being condemned as a group for wildness and heterodoxy.

Lü Chi    The leading master of bird-and-flower subjects in the Academy in the Hung-chih era (1488–1506), and the best-known Ming painter of those subjects, was Lü Chi. He was born in Ning-p'o, a coastal port-city east of Hangchow that seems to have been the major port on Hangchow Bay, servicing the whole region. It had a centuries-old history as another center for the commercial production of paintings, and the works of artists in nearby centers such as P'i-ling and Hangchow were sold through Ning-p'o. Hundreds of Buddhist pictures had been exported from Ning-p'o in the Sung and Yüan periods to Japan, where they are still preserved in temples; they are by minor masters or anonymous and adhere closely to the styles current in Hangchow in the same periods. The same was probably true of the output of Ning-p'o specialists in other subjects, whose works have not survived in such numbers. Lü Chi, we may suppose, began by following such a conservative local tradition. Later accounts of his career say that he studied the works of T'ang and Sung bird-and-flower masters and resolved to combine the merits of all of them; they say also that he imitated Pien Wen-chin. Both would be normal for an academic, somewhat eclectic bird-and-flower painter of this period.

Lü Chi was recommended to court and entered the Academy early in the Hung-chih era, probably around 1490. He served in the Jen-chih Tien, and became a Commander in the Embroidered Uniform Guard. He was reportedly stiff and ceremonious in manner; the impression of earnestness that his paintings convey (they are characterized by one Ming critic as "methodical") was evidently a quality of the man himself. When called on to paint in the imperial presence, we are told, he proceeded with such clear purpose, "offering rules to the emperor" (presumably on the creation and evaluation of paintings), that the emperor exclaimed: "Lü Chi really has an aptitude for using artistic ability as an admonishment!"

It is possible that Lin Liang, who must have been older by several decades, was still alive and at court when Lü Chi arrived there (although the two cannot have been, as standard late

Ming accounts have it, summoned there at the same time). In any case, some of Lü's works are close imitations of the Cantonese master's style. Most of them, however, are in a much more careful and traditional manner, executed with colors and in firmly controlled brushwork.

The new fluidity of brushstroke popularized by Tai Chin and others earlier in the century was developed by later academic painters in two distinguishable directions. One exploited it for effects of impetuosity or roughness, even wildness; of this, Wu Wei is the prime exemplar. The other aimed at an elegant sleekness of form, accomplished with flowing line and smooth washes; and it is Lü Chi who most successfully turned this latter manner to bird-and-flower painting, to which it is particularly well suited, with results that immediately established him as the outstanding master of that genre in his period. His fame declined only when, perhaps already in his lifetime, other painters began to imitate him so closely as to dilute the attraction that his works had for their viewers.

Among the hundreds of extant paintings that bear his signature, most of them by followers and imitators, a set of four large hanging scrolls now in the Tokyo National Museum, representing birds and flowers of the four seasons, has come to be accepted as the standard by which others are judged.[9] A more recent discovery that stands up well on comparison with those masterworks is "Cranes by a Rushing Stream" (Pl. 50). In addition to a convincing signature, it bears a seal reading *Jih-chin ch'ing-kuang*, or "Daily Approaching the Pure and Radiant." Seals with the same legend are found on works of a few other artists who were active as court painters in the Hung-chih era; as interpreted by Wai-kam Ho, they indicate that the painters had the privilege of working in the imperial presence.

The painting is unusually spacious and elaborate in plan; most of Lü's pictures are simpler and confined to the foreground. That it is a scene of early spring is indicated both by a plum tree just beginning to bloom and by the torrent of water, which emanates from melting snow higher in the mountains. The succession of arching shapes created by the stream as it gushes down from the recesses of the ravine is nicely answered by a flock of small birds above, each an arc in flight, winging into the foreground from a farther distance, to roost in the plum tree. Similarly, the double curves of the cranes' necks and bodies set up a series of echoes in their vicinity, in the rounded hollows eroded by the water in the underside of the cliff and in the billows. The exquisite balance of movement and rest, of curving and angular forms (the rock and tree providing the latter), of filled and empty areas (separated, as in Southern Sung compositions, by a diagonal division across the picture surface, with the tree laid counterdiagonally across them), seems very calculated. But it is in just such overt artifice, and not in spontaneity, that the excellences of Lü Chi lie.

LÜ WEN-YING   Another painter with the surname Lü served at the same time in the Academy, and their contemporaries, with that special Chinese penchant for symmetry that seems at times to prefer it to objective truth, dubbed them Big Lü and Little Lü. Big Lü was Lü Chi; Little Lü was a lesser master, also from Chekiang, named Lü Wen-ying. Biographical sources tell us virtually nothing about him beyond the inconsequential fact that he was only a Vice-Commander of the Guard. By 1507 he had given up his career as a painter, as a palace record of that year reveals, to devote himself to serving as an official at court.[10] Until a few years ago he was known only for two painstaking, unoriginal pictures of toy sellers in Japanese collections. His "River Village in a Rainstorm" (Pl. 51), a recent acquisition of the Cleveland Museum of Art, wins him a place of respect in the history of Ming painting. Under his signature is impressed a *Jih-chin ch'ing-kuang* seal, revealing that he too enjoyed the honor of receiving the emperor's personal supervision.

The painting is grander in scale and sweep than Lü Chi's but similar in its Sung-like technical

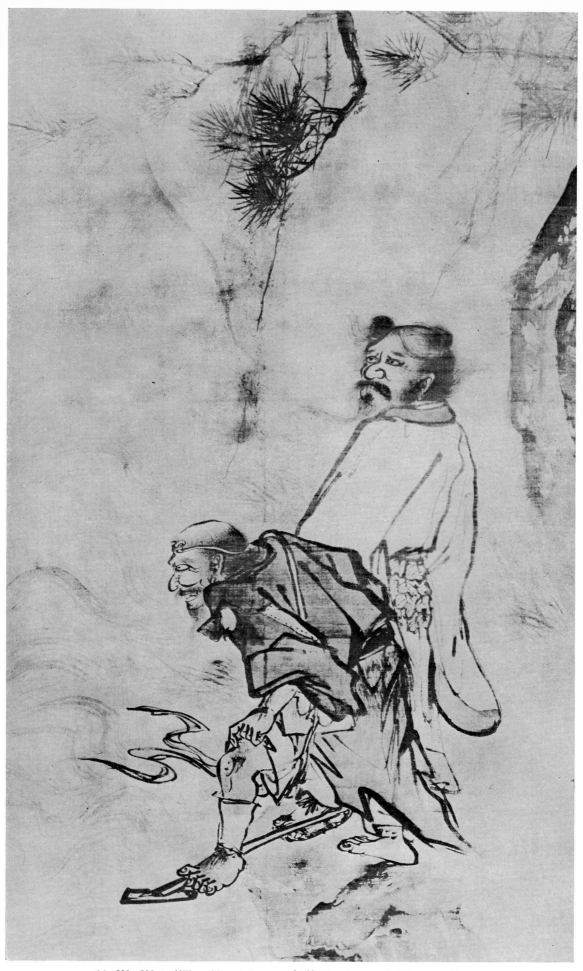

44. Wu Wei: "Two Taoist Immortals." *Hanging scroll. Shanghai Museum.*

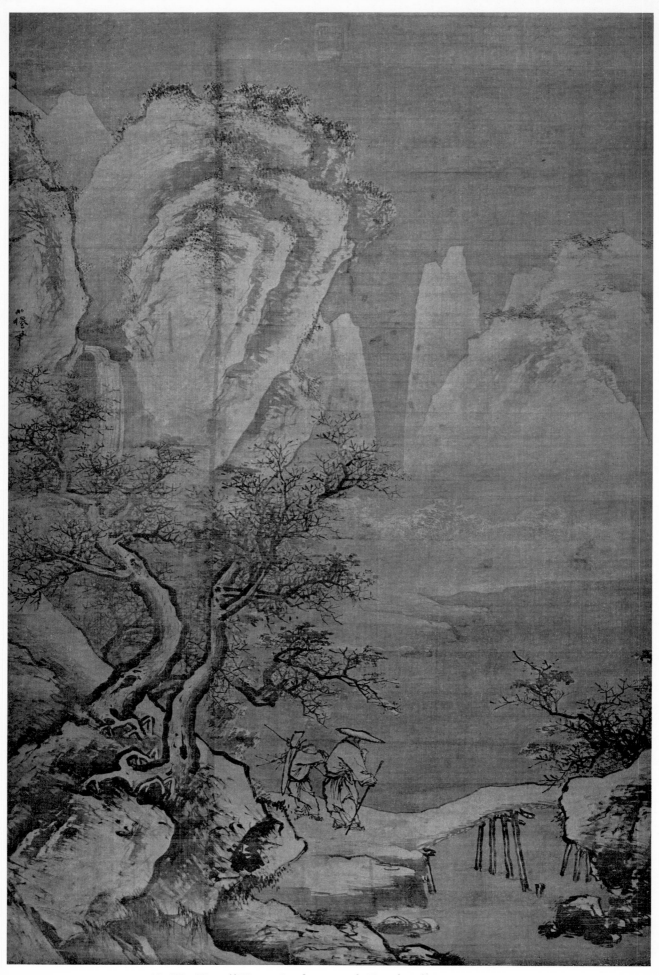

45. Wu Wei: "Winter Landscape with Travelers." *Hanging scroll,
ink on silk, 242.6 × 156.4 cm. National Palace Museum, Taipei.*

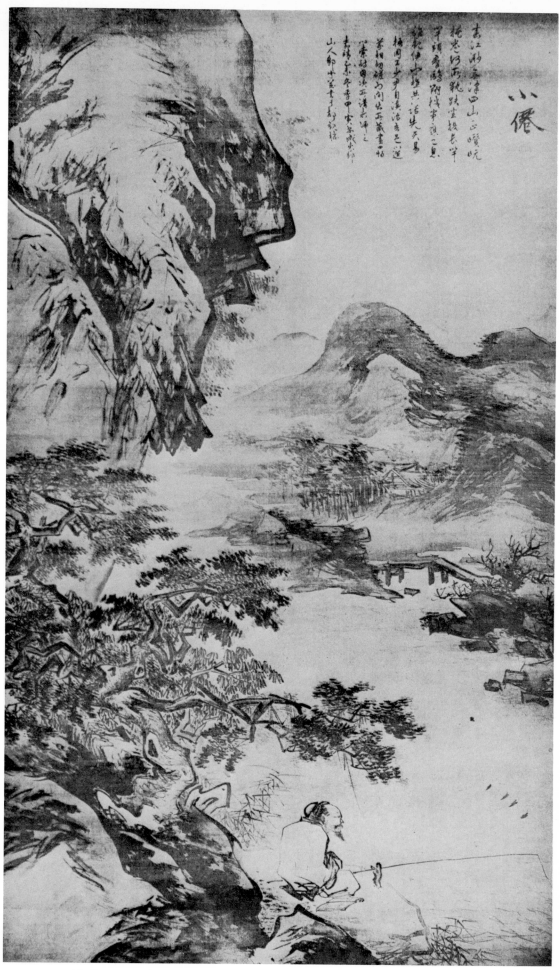

46. Wu Wei: ''Fishing from a Riverbank.'' *Hanging scroll. Collection unknown.*

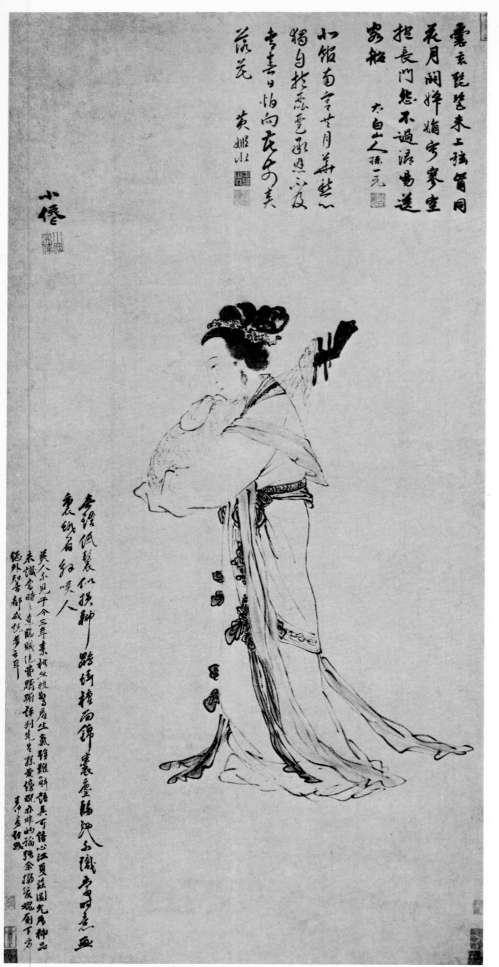

47. Wu Wei: "Lady Carrying a P'i-p'a." *Hanging scroll, ink on paper, 125.1 × 61.3 cm. Indianapolis Museum of Art, gift of Mr. and Mrs. Eli Lilly.*

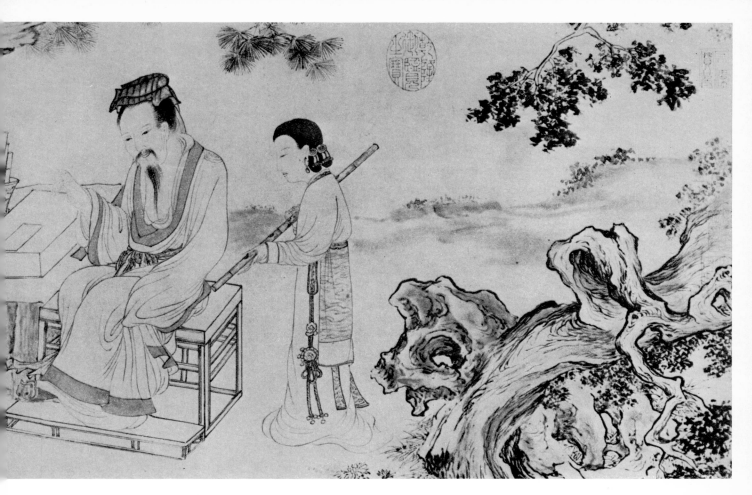

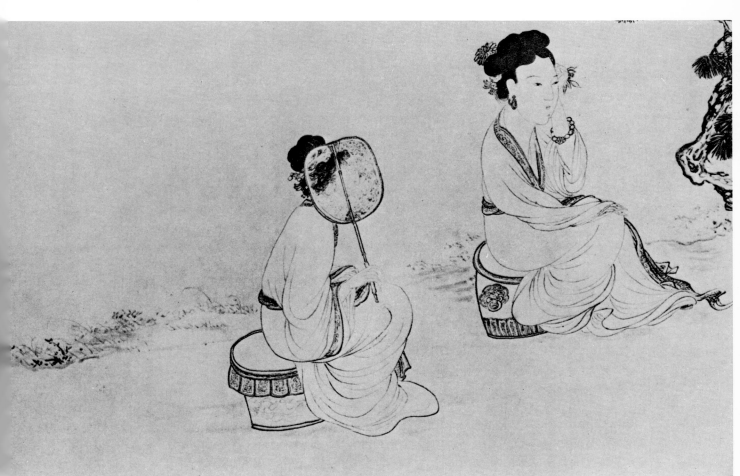

48. Wu Wei: "The Iron Flute." *Dated 1484. Handscroll, ink on paper. Shanghai Museum.*

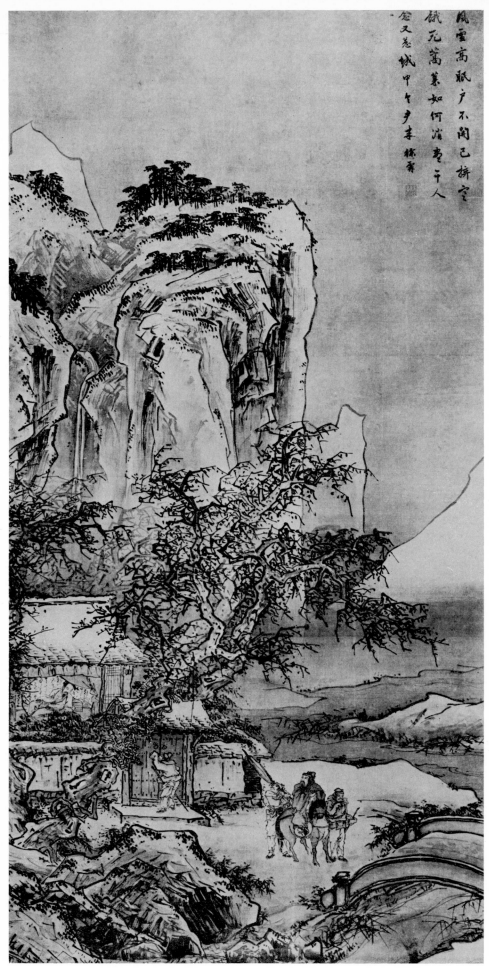

風雪高眠戶不開已排空
餓死萬蕉如何濟魯千人
食又慈城中午少李維雲

49. Hsü Lin: "Winter Landscape with a Man Arriving at a House."
*Hanging scroll, ink on silk. Formerly Hōzō Hara collection.*

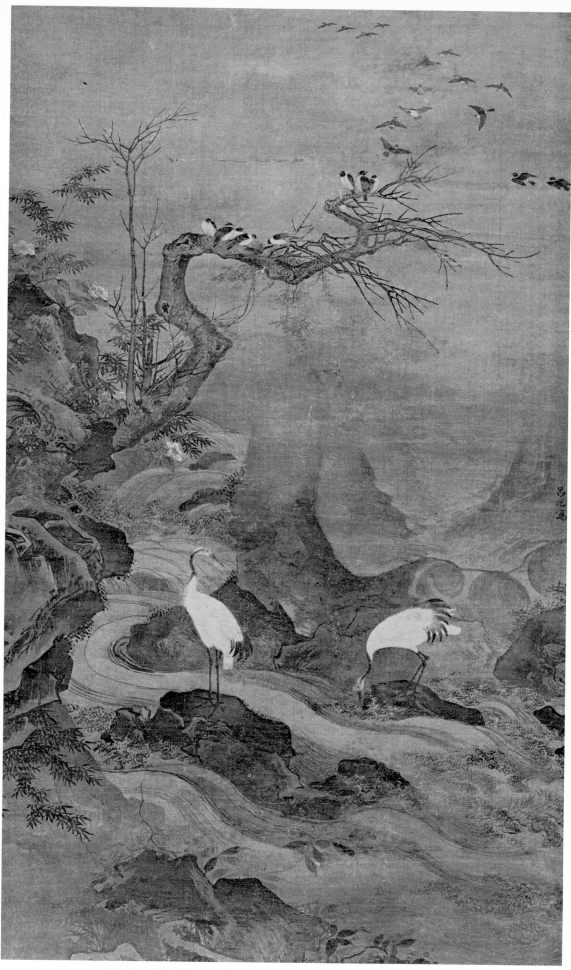

50. Lü Chi: ''Cranes by a Rushing Stream.'' *Hanging scroll, ink and colors on silk, 148 × 84 cm. Ching Yüan Chai collection.*

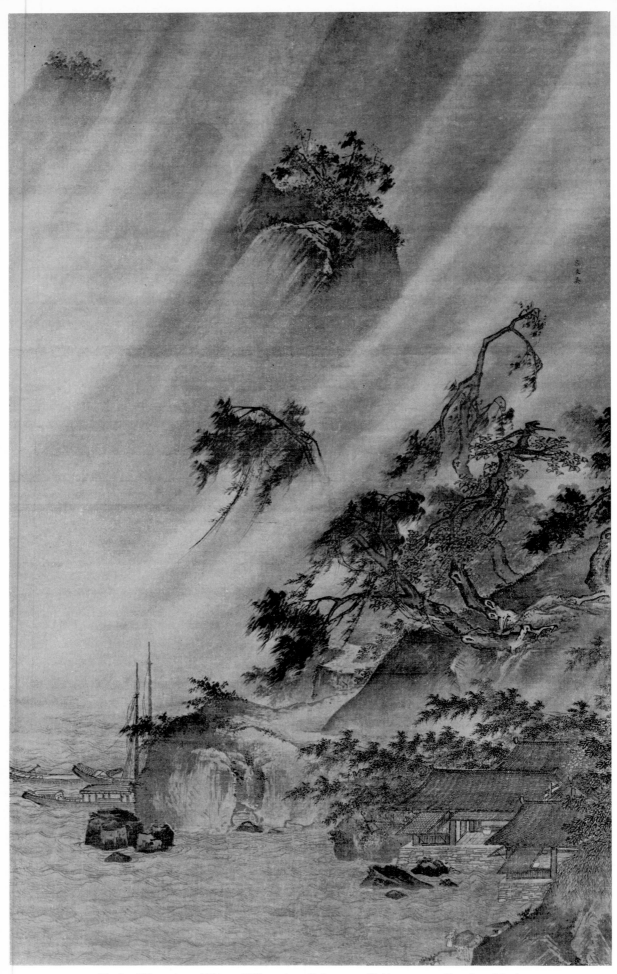

51. Lü Wen-ying: "River Village in a Rainstorm." *Hanging scroll, ink and light colors on silk, 168 × 102.2 cm. Cleveland Museum of Art, John L. Severance Fund.*

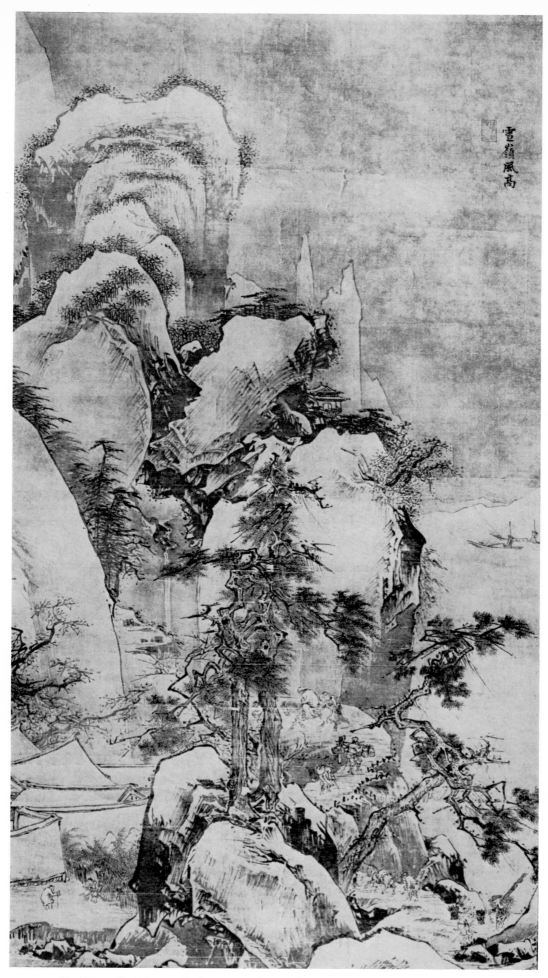

52. Wang E: "Snowy Peaks in a High Wind." *Hanging scroll. Collection unknown.*

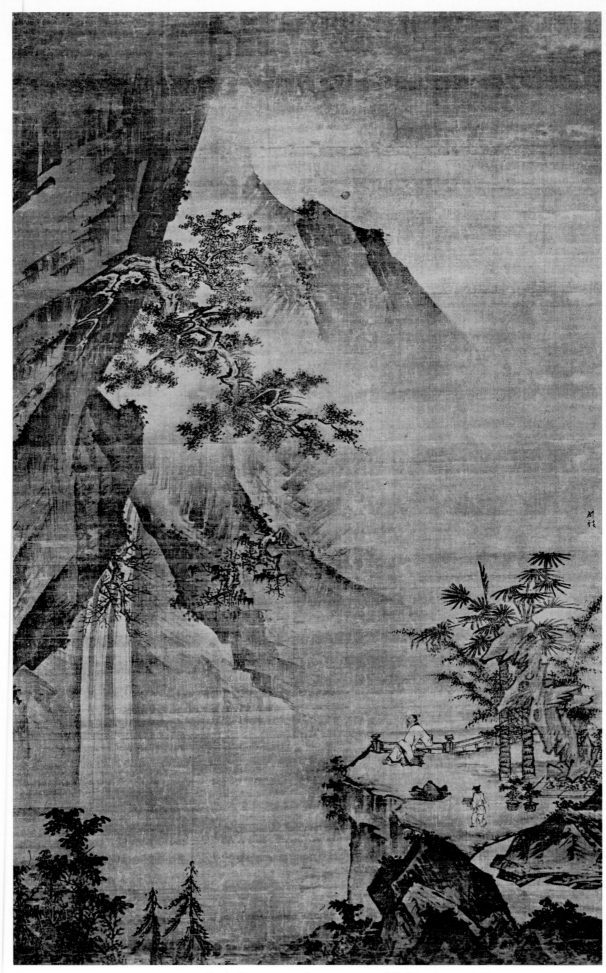

53. Chung Li: "Scholar Contemplating a Waterfall." *Hanging scroll,
ink and light colors on silk, 178 × 104 cm. Private collection.*

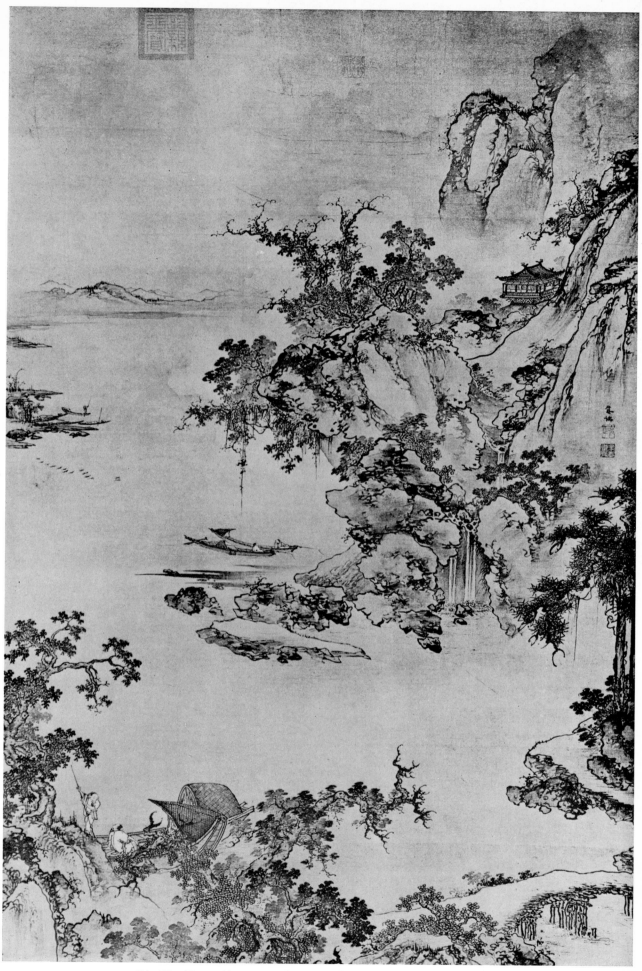

54. Chu Tuan: "River Landscape with Fishermen." *Hanging scroll,
ink and colors on silk, 167 × 107 cm. National Museum, Stockholm.*

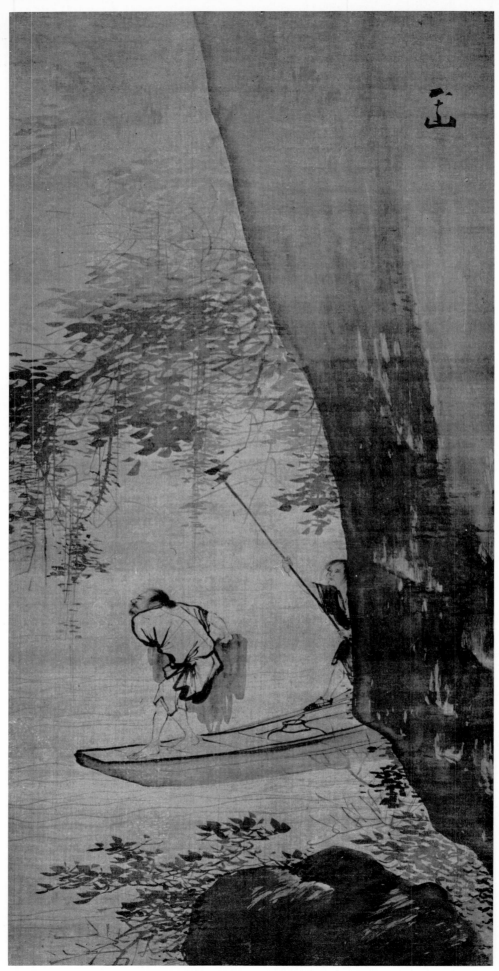

55. Chang Lu: "Fisherman Under a Cliff." *Hanging scroll,
ink and light colors on silk, 138 × 69.2 cm. Gokoku-ji, Tokyo.*

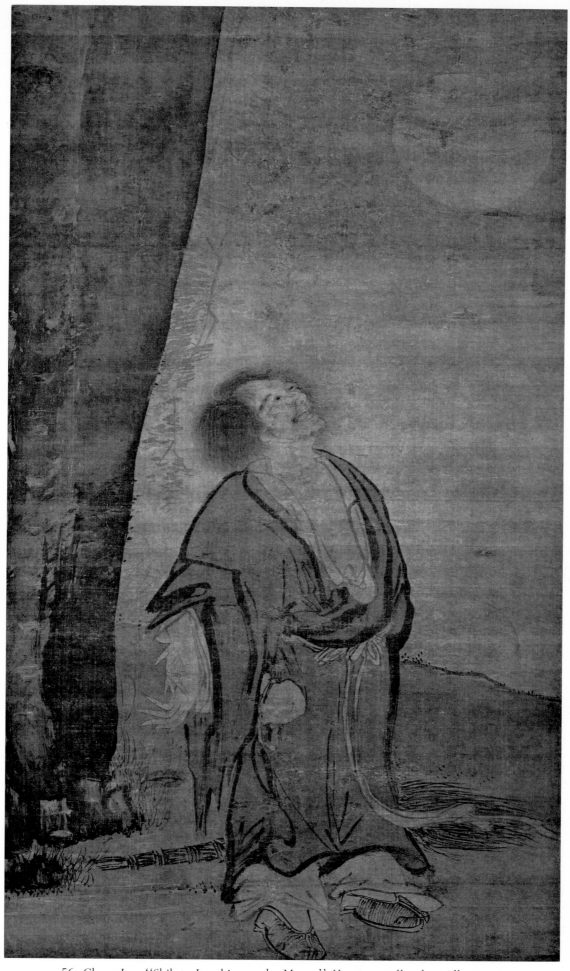

56. Chang Lu: "Shih-te Laughing at the Moon." *Hanging scroll, ink on silk, 158.6 × 89.3 cm. Courtesy of Smithsonian Institution, Freer Gallery of Art, Washington, D.C.*

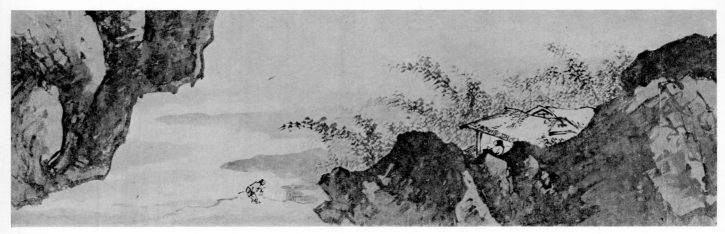

57. Chiang Sung: "Spring Landscape," from "Landscapes of the Four Seasons." *Section of a hand-scroll, ink and light colors on paper, 23 × 118 cm. Museum für Ostasiatische Kunst, Berlin-West.*

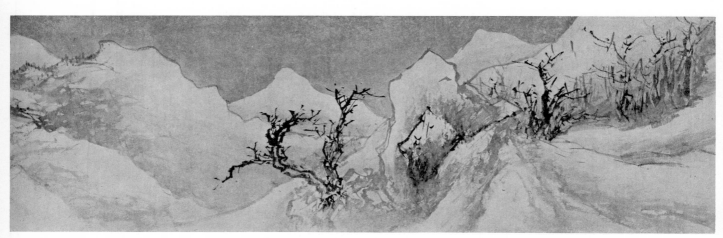

58. Chiang Sung: "Winter Landscape," from "Landscapes of the Four Seasons." *Section of a hand-scroll, ink and light colors on paper, 23 × 118 cm. Museum für Ostasiatische Kunst, Berlin-West.*

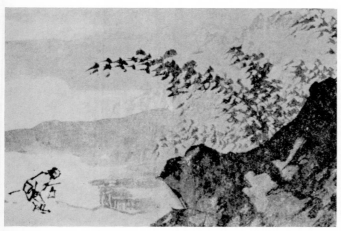

59. *Detail from Plate 57.*

60. *Detail from Plate 58.*

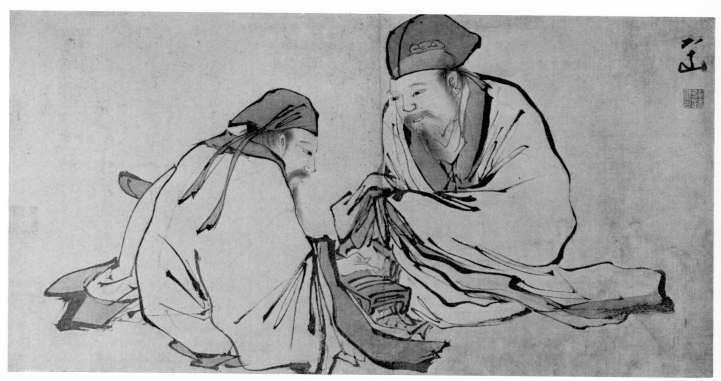

61. Chang Lu: "Playing the Ch'in for a Friend." *Hanging scroll, ink and light colors on silk, 31.4 × 61 cm. Ching Yüan Chai collection.*

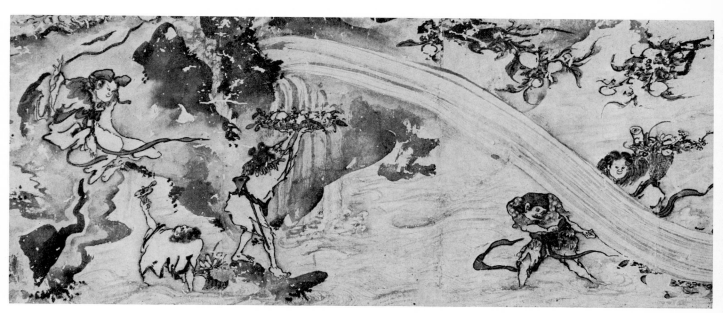

62. Cheng Wen-lin: "The World of the Magic Pot." *Section of a handscroll, ink on paper, 29.7 × 298 cm. Princeton Art Museum.*

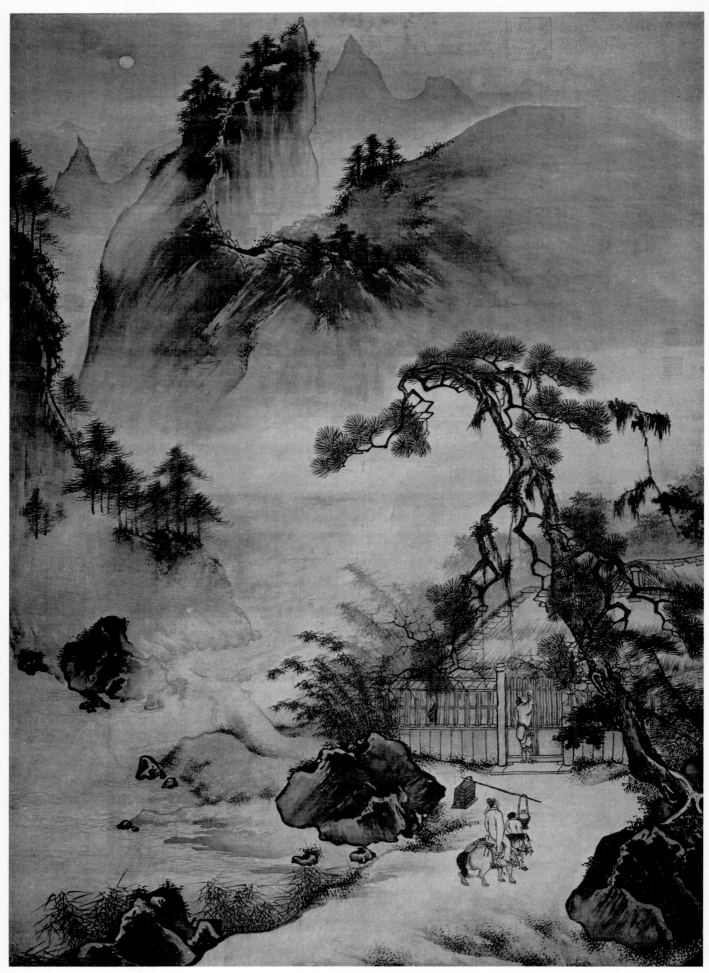

63. Anonymous, Ming dynasty: "Arriving Home by Moonlight." *Hanging scroll, ink and light colors on silk, 155.1 × 107 cm. Courtesy of Smithsonian Institution, Freer Gallery of Art, Washington, D.C.*

finish and sleek elegance. The Sung artist to whom Lü is principally indebted is Hsia Kuei: the rotundity of the slopes is rendered with smoothly graded ink wash, the tree foliage in massed strokes of ink; the composition, which compacts the solid elements into a fairly small lower area of the picture (a notable departure from ordinary Ming practice) and sets in the upper part only the crest of a bluff with wind-tossed trees, can be paralleled in paintings by or after Hsia. Even though Lü Wen-ying inserts slightly more anecdotal detail than the Sung master is likely to have used (the owner of the riverside villa is seen arriving home with his luggage-bearer in the lower corner, a boy servant watches their approach from a window, three boats moored at left suggest other outings by water), it is kept inconspicuous and does not, as in many other works of the school, clutter the scene. Landscapes with rainstorms were favorites among the Che-school artists, and in this too they follow the Southern Sung Academy masters, who have given us the finest storms we have in Chinese painting. (Notable examples include a landscape ascribed to Ma Yüan in the Seikadō, Tokyo, a fan painting by Hsia Kuei in the Boston Museum of Fine Arts, and an anonymous "Summer Rainstorm" in the Kuon-ji, Japan.) They seem restrained and suggestive, however, beside the Ming examples, which are usually more dramatic, as this one is.

WANG E   Wang E, another landscapist active in the Hung-chih Academy, was, like Lü Chi, a native of Ning-p'o in Chekiang Province and learned painting first from a minor master there. At court he served in the Jen-chih Tien and was much favored by the Hung-chih emperor, who was especially fond of the works of Ma Yüan and hailed Wang E as "the Ma Yüan of our time." The Cheng-te emperor, who ascended the throne in 1506, honored him even more highly, raising him to the rank of battalion commander in the Guard and presenting him in 1510 with a seal, which Wang impressed on his paintings after that date.[11] Lang Ying (b. 1487), whose writings on Tai Chin we quoted earlier, tells us that Wang was very famous in the southeast, his homeland. He praises Wang for giving "a misty appearance" to his rocks and trees, "as in the p'o-mo [splashed ink] technique," but adds that they lacked three-dimensionality (literally "four-sidedness") and that the trees were "deficient in the sense of profuse growth, denseness, and sparseness." This is a perceptive comment; Wang is indeed, as his surviving works reveal, interested in large effects of shadowiness and mistiness but even more in bold, distinctive brushwork, and his forms are indeed flat. However, these qualities are not particular to Wang but are characteristic of most painting of the time, from which Lü Chi and Lü Wen-ying are rather the exceptions in their preservation of essential features of Sung style.

A winter landscape in a Japanese collection titled (by the artist himself) "Snowy Peaks in a High Wind" (Pl. 52) bears the seal that Wang E received from the emperor in 1510; so it must have been painted after that date and is thus a late work. The same late date could be inferred from the style, in which the distinguishing traits of Wang's hand are conspicuous. Other, presumably earlier pictures represent him better as "the Ma Yüan of his time"; this one shows him as unabashedly a Ming painter. The scene is typically busy. A procession of travelers climbs the steep road (the motif of ascending a mountain belongs to the larger theme of harsh struggle with the elements; no one ever comes down the road in such pictures). At their head is a gentleman mounted on a stocky horse, accompanied by a servant, and behind them, spaced along the road, are a porter, a weary wanderer, a peasant with a donkey, and two wood-gatherers. A Buddhist temple can be seen above them, but is shown as inaccessible; they are not seeking spiritual grace, but only warmth and comfort. In a thematically irrelevant passage in the lower left corner, a visitor arrives at a villa and is met by a boy at the gate.

The Sung master whose manner is here invoked is neither Ma Yüan nor Hsia Kuei, but Li T'ang, who similarly constructed mountains by using huge masses of rock as building blocks. His, however, interpenetrate as organic components of a geological whole, weathered into strange but never unnatural shapes. Wang invents his own geology (as do most Ming land-

scapists), jumbling his slanting masses together freely, joining them in the upper center in such a way as to force the conclusion that the waterfall flows out of, and the travelers disappear into, a cavern. But the picture is not to be read that way; its spatial implausibilities are beside the point. Like Tai Chin, Wang creates an effect of monumentality without being quite capable of creating truly monumental forms or structures; a kind of massiveness and ponderousness accrue to his forms from the harsh force of their outline drawing and the heavy contrasts of their lighting. In keeping with an allover rejection of naturalism and nuance, the axe-cut texture strokes of Li T'ang's manner are turned into rows of stiff, nail-like strokes, made with a slanted brush pressed to the silk and then drawn downward or sideward as it is raised; these mark the lines of intersection between areas of highlight (or snow) and shadow.

Looking back at Sun Chün-tse's landscape (*Hills*, Color Pl. 4) in which the texture strokes already began to take on a schematic character but still described rocky surfaces, we can see Wang's work as a direct, although extreme, outgrowth of the Li T'ang and Ma-Hsia tradition; and, as the painting itself might cause one to suspect, it marks the virtual end of that tradition. Soochow followers of Li T'ang who will be considered in our fifth chapter take an entirely different stylistic direction, in which the Ma-Hsia stage is largely bypassed and such dramatic, striking effects as Wang E creates play little part.

CHUNG LI    Perhaps the last more or less serious and respectable artist in the Ma Yüan tradition was a contemporary of Wang E in the Academy named Chung Li, who occupies this position at the end of the line partly because he himself helped to bring the line to an end. As we will see below, he is assigned by Ming writers to the "Heterodox school," and so is included in the charges of stylistic perversity and wildness that they level against artists of that group.

Born near Shao-hsing in Chekiang Province, he was orphaned early in life but somehow acquired a good enough education to become a skilled calligrapher and poet. He made his way in the world, however, as a painter of landscapes, imitating Tai Chin. In 1490 he was inducted into military service as punishment for some offense but was released on imperial invitation to enter the Hung-chih Academy as a court painter. His service at court probably continued until around 1510 or somewhat later, when he was permitted to return to his home.[12] His specialties were large-scale compositions of scholars on mountain ledges, gazing at the moon or at waterfalls, and misty landscapes in the Kao K'o-kung manner. No paintings of the latter category are known today, but four or five of the former survive and are so similar as to suggest a narrowness of theme and style. As a group, they can be faulted more for hardness and grandiosity than for anything that could be called wildness; only one, a signed work in a Japanese temple collection, has a slapdash quality that suggests the reason for his inclusion among the "Heterodox" painters.[13] Others make him appear the most orthodox of Ma Yüan imitators in the Ming.

His "Scholar Contemplating a Waterfall" (Pl. 53) is the best of his surviving works. While not entirely free of the heaviness and rigidity that are his vices (and those of much other Hung-chih Academy output) it turns these to use in a powerful composition which does not, like his others, follow unimaginatively the Ma-Yüan-school stereotype for treatments of this popular theme but works an interesting variation on it. The concentration of detail at the lower right is balanced at the upper left by an overhanging cliff and dependent trees, with a huge diagonally set rock mass bridging the space between the two corners. The areas of misty space are similarly placed in diagonally opposite segments: one at the upper right merges upward into the sky, which is ink-washed for dusk, with a full moon suspended in it; the other, at the lower left, is the cavernous depth into which the waterfall drops, with treetops along the lower edge implying farther extension downward. Set in this symmetrical scheme, the scholar looks across the ravine at the waterfall. He may represent, or may simply recall, the T'ang poet Li Po, who was often

depicted gazing at waterfalls to cleanse his mind. This time-honored theme, embodied in a large painting that features the heavy and angular forms, strong light-dark contrasts, and striking design qualities of good Che-school painting, suited it for its purpose of hanging, perhaps, in the large reception hall of an official's residence.

There is not enough datable material to serve as basis for tracing a clear chronological development within the Academy, and, since artists from different locales with different stylistic background came and went, perhaps we should not expect to find any. Nevertheless, a survey of the styles practiced by artists active in successive periods makes it plain that by the early sixteenth century a different taste from the one reflected in most fifteenth-century painting had come to prevail. Suppleness and sensitivity gave way either to hardness or to calligraphic nervousness, romantic warmth to a calculated striving for stronger and more impressive technical effects. Restraints were relaxed, and the artists tended to move into positions of stylistic extremism. A decadence had indeed set in, and no artists of note were to serve as court painters between the eras of Cheng-te (1506–21) and Wan-li (1573–1620).

CHU TUAN   The best of the landscapists who were still active in the Cheng-te Academy was Chu Tuan, another native of Chekiang. He came from a poor family and in his youth worked as a woodcutter and a fisherman. How he learned painting is not recorded, but his reputation grew until it reached the capital, and he was called to court in 1501.[14] He became a commander in the Guard, and the Cheng-te emperor awarded him a seal reading "Imperially Presented to the Single [or Solitary] Woodcutter," signifying presumably that he stood alone among painters but also alluding, perhaps, to his earlier occupation.

The *Ming-hua lu* says that he painted landscapes in the manner of Sheng Mou, an observation that is borne out by at least one of them, a picture dated 1518 in the Boston Museum of Fine Arts. Another, a winter landscape in the Palace Museum, Taipei, is in the same hard-edged, blocky manner as the work by Wang E that we have just considered. Chu Tuan's most distinctive and attractive style, however, is neither of these but a pleasantly playful rococo recension of the Kuo Hsi manner. The anonymous "Spring Mountains" of the late Yüan period, inscribed and perhaps painted by Yang Wei-chen (*Hills*, Pl. 36), revealed how this manner, originally dedicated to the objectifications of comprehensive systems for understanding the natural world, could be reduced to a fanciful play lacking serious implications outside the borders of the picture. Chu Tuan's landscapes after Kuo Hsi are of this same kind; they are even more linear in execution, and the line is even more subject to abstract rhythms of movement.

"River Landscape with Fishermen" (Pl. 54) is an excellent representative of Chu Tuan's works of this type. It is signed and bears three of his seals, including the one presented to him by the Cheng-te emperor. The composition is grandly spacious in spite of the linear rendering of the forms, pulling the viewer's eye across the water to the horizon and marking stages on the way with fishing boats that diminish markedly in size. The broad expanses of empty space serve to absorb the nervous activity of the earth forms and trees, which are drawn with obsessively repeated series of tight curling strokes, occasioned in the trees by the "crab-claw" convention of the twigs, and in the earth contours by the image of "rocks like clouds" distantly inherited from Kuo Hsi's heavily eroded masses. Chu Tuan's geology is no more plausible than Wang E's, and the effect of forced activation of a fundamentally stable structure is no less present; it is the main affliction of much of the late Academy output, suggesting always that the artist is attempting purposefully to escape, through such means, from some irreversible onset of rigidity.

Chu Tuan's touch, however, has none of the heaviness of Wang's; his line resists one's attempts to focus and rest on it, taking the eye instead on excited dances across the surface. In

Sung works of this school, the artist's intent seemed to be to efface himself in a universal vision; now the emphasis has shifted to the other pole, and manifestations of the artist's nervous energy dominate the expression of the painting. The Kuo Hsi manner might seem to have reached here a point of total exhaustion, but it was still to have a brief revival in the works of Yüan Chiang and a few other painters of the early Ch'ing period.

## 5. THE "HETERODOX" MASTERS

We turn finally to the artists termed by later critics the *hsieh-hsüeh p'ai*, or "Heterodox school." The word rendered as "heterodox" also has implications of "depraved" or "vicious" and is used in philosophical writings for wrong teachings that upset the moral order. The application of it to artists carries the same moral disapproval: they destroyed a tradition, the word implies, by willfully perverting it.

The late-sixteenth-century writer Kao Lien, himself a native of Chekiang who was generally sympathetic to the Che school in its earlier phases (and a defender of Sung against the advocates of Yüan in that controversy), assigns Chiang Sung, Chang Lu, Cheng Wen-lin, Chung Li, Wang Chao (another follower of Tai Chin and Wu Wei), and a painter named Chang Fu-yang to this "Heterodox school." The same judgment is pronounced on the same artists by the greatest collector of that age, Hsiang Yüan-pien (1525–96); it must have been widely accepted in critical circles by that time.[15] Ho Liang-chün (1506–73) remarks scornfully that the paintings of Chang Lu and Chiang Sung are good only to mop the floor with. Tung Ch'i-ch'ang (1555–1636) evidently believed—and it is a theory, like most of Tung's, that deserves to be taken seriously—that the decline of the school was due to its geographical dispersal, as painting in this style became popular all over China and artists practicing it arose in various provinces; cut off from its nourishing roots in the Chekiang local tradition, it withered. "The cause of the Che school's gradual decline," he writes, "does not lie so much in 'sweetness, heterodoxy, vulgarity, and dependence' [Huang Kung-wang's 'four faults,' cf. *Hills*, p. 88] as in its having become associated with other centers [than its native province]." If we were to look for a rationale for Tung's thesis, free of mystique, we might find it by observing that the separation of these later Che-school artists from the original locus of the tradition probably robbed them of the rigorous technical training that the young artist could still receive within a strong local tradition, even after the tradition had lost much of its creative impetus. Instead of starting from such a solid base, they departed from others' departures, and their flights, accordingly, were often erratic and inconsequential.

After we have read these judgments, the paintings (or at least the ones we have chosen for reproduction) may come as a pleasant surprise, since they display little of obvious depravity and are, in fact, attractive, interesting pictures. The judgments are historical, that is, affected somewhat by the historical circumstance that these painters stand at the end of a tradition. Chinese appraisals of the last rulers of dynasties tend similarly to be strongly negative, reflecting a conviction that someone must be held responsible for the downfall. The judgments are also colored by regional and social prejudices. When we have granted all this, however, we are forced to admit that the judgments are in large part valid: these painters do indeed represent a phase of decadence. They fail to produce more than a few works that can by any criteria be considered really first class, and produce a great many that are routine and shallow. It would be difficult, with many of the paintings, to imagine that they came into being as the outcome of any authentic creative impulses. The artists repeat standard compositions in set styles without much of interesting variation, in such a way as to suggest that they are supplying demands for pictorial types that had proved popular and saleable. (We do not by any means intend to belittle the professionals

as a whole; the best of them were always able to approach each picture as a fresh creative challenge, as these painters did not.)

Chung Li, judging from the few of his works that are preserved, repeated over and over a simple compositional type derived from the tradition of Ma Yüan, with scholars on mountain terraces gazing at waterfalls or into space; Chiang Sung and Chang Lu similarly replicated compositions by assembling more or less ready-made type forms. An indication of what motivated much of this routine output is provided by a note in the *Chin-ling so-shih* concerning another follower of Wu Wei named Li Chu (whose major surviving work is a handscroll very similar in style to Wu's "Pleasures of Fishermen" (Color Pl. 6):[16] "Li Chu . . . as a boy studied painting under Shen Chou. When his studies were completed, he returned to his home [in Nanking] and there imitated only the style of Wu Wei, in order to sell his works. The reason was that at that time Wu's paintings were very highly valued in the capital."

CHANG LU   The most famous and successful of Wu Wei's followers in the early sixteenth century was Chang Lu. His birth and death dates are unknown.[17] Unlike the other artists treated in this chapter, he was a northerner, coming from K'ai-feng in Honan Province. He showed great intelligence as a child, studied for an official career, and went to the National University (T'ai-hsüeh) in Nanking as a first-degree graduate but somehow failed and was forced to turn to another means of supporting himself. He had reportedly begun painting already while he was in K'ai-feng, inspired first by a viewing of a figure painting by Wu Tao-tzu and later studying the landscapes and figures of Tai Chin by making copies of them. In Nanking he began to imitate Wu Wei, whom he may have known, and became a popular artist: "all the officials and gentlemen enjoyed going around with him."

As an educated man who was also a capable painter, sometimes facile but also sometimes brilliant, he exemplifies (like Wu Wei and Hsü Lin) the type of artist who seems to have been particularly successful in Nanking and later in Soochow, where scholar-officials and merchants could enjoy, through their patronage, both the association with colorful and congenial personalities and the possession of works of art in the currently popular styles. This ambiguous status gave the artist a certain fluid position in society which the intelligent and versatile man could exploit to his advantage, both artistic (in asserting a degree of independence) and economic. At the same time, as noted in the previous chapter in relation to Shen Chou, holding no official rank left him in the status of commoner, however talented and educated he might be, and meant that he could be victimized by any official who chose to do so.

While Chang Lu was still in the north, Wang Shih-chen relates, an official named Sun, who was angry that Chang had not come to pay his respects, enticed the painter to his house and had his left hand put in a clamp, tightening it to torture him. With his right hand, meanwhile, Chang was forced to paint a picture of Chung K'uei the Demon Queller. (The subject itself suggests that Sun thought of the painting more as a functional than an aesthetic object, since pictures of Chung K'uei were hung in houses to rid them of demons.) Chang was only freed when a higher official, a minister from court, happened by and begged Sun to release the artist. Chang Lu was then obliged by gratitude and indebtedness to paint for his rescuer a set of four pictures, on which he "expended the greatest effort of his whole life."[18]

The response to Chang Lu's works during his lifetime seems to have been favorable; people who got one of his paintings treated it "as though they had acquired a precious disc of jade." The adverse criticism, as with others of this school, came later, when the style had dropped out of fashion and the artist was no longer around to lend interest to his works by association. Wang Shih-chen wrote of him: "Among those who carried on Wu Wei's manner, Chang Lu is best known. However, he missed the refinement and freedom of Wu's style, catching only its firm-

ness and muscular strength. Northerners value his works as great treasures." To which the *Wu-sheng-shih shih*, some decades later at the end of Ming, adds: "But connoisseurs feel that [his paintings] aren't really in the best of taste, with the result that both his reputation and his prices have declined gradually in recent times."

Chang Lu was a prolific painter, and his works survive in considerable numbers. Many of them, particularly the stereotyped figures-in-landscape scenes that he did as a specialty, make the harsh judgments of the later critics seem merited. We reproduce instead, to show him at his best, four pictures that display the more admirable side of his art.

His finest surviving work is probably "Fisherman Under a Cliff" (Pl. 55), in a Buddhist temple in Tokyo. The painting is signed, like most of his works, with his *hao*, or sobriquet, P'ing-shan. The composition is based on the river-landscape type of which we have seen examples by Tai Chin and Wu Wei (cf. Pl. 16, 46), with an overhanging cliff on one side and figures and a boat or boats below or beyond it. Chang Lu simplifies the scene and brings it closer; the cliff, painted in broad strokes of ink with patches left in reserve for highlights, seems to loom out at the top into the spectator's space. The bushes that grow from the cliff and also fill out the base of the picture are drawn as silhouettes, dimmed effectively for an impression of mistiness. The broad treatment of these surrounding elements, contrasted with the linear drawing and darker ink tone concentrated in the figure, provides a pictorial approximation of the optical phenomenon of focus; it also conveys a feeling of dim light and damp atmosphere.

Such a visual approach to landscape, evoking an immediate sense of time and place, had seldom been seen since the Southern Sung period. The figures are portrayed with the same immediacy: the boy poles the boat from behind the cliff into the open space; the fisherman, turned partly away from the viewer, crouches to throw his net, the tension of incipient action caught in his stance but even more in the tightly compressed cluster of lines that radiate from his waist to charge the figure with force. Chang Lu's typical line drawing features sudden thickenings and thinnings, sharp changes of direction, and a springy tensile strength. In an age of elegant but generally flaccid figures, one such as this represents a particular achievement.

"Shih-te Laughing at the Moon" (Pl. 56) carries an old attribution to a Sung master but can be confidently credited to Chang Lu on the basis of style—the sheer wall of rock and the dimly silhouetted foliage are clearly by the same hand that painted "Fisherman Under a Cliff," and the composition is similarly made up of large geometric units, with the space opening forward from behind the cliff. (Precedents for this type are to be found in thirteenth-century paintings, notably Liang K'ai's "Sakyamuni Descending from the Mountains.")[19] The plan of the picture is even simpler: a vertical surface (the cliff), a horizontal one, and empty space beyond, the three areas distinguished by clear contrasts in ink-wash values. The figure is set in the center and drawn large.

This was probably one of a pair of hanging scrolls representing Han-shan and Shih-te, perhaps painted for some Ch'an Buddhist temple. Shih-te, who (the legend has it) was a scullion in a T'ang-dynasty temple kitchen, is identified by his broom, which lies on the ground behind him; his gourd-bottle of wine hangs from his girdle; he clasps his hands behind his back and tilts his face upward toward the moon. The figure is intensely expressive but not especially of the ideal that Shih-te represented, which was a carefree unworldliness that found nothing more worth doing in life than watching leaves fall or laughing crazily at the full moon. That ideal is better expressed in the relaxed, capricious, "untrammeled" brushwork of ink-monochrome paintings done in amateurish styles by Ch'an Buddhist monks of the late Sung and Yüan. Chang Lu's figure belongs firmly in another, somewhat opposed tradition, the professional one of Yen Hui (cf. *Hills*, Pl. 66), whose manner of portraying popular Buddhist and Taoist figures was carried on by Che-school artists in the Ming—notably, as we have seen, by Wu Wei. The nervous, heavy dra-

pery drawing and the portrayal of muscular tension, especially in the face, with lips drawn back tightly and eyes narrowed, relate this figure to Yen Hui's and to Wu's.

Chang Lu's figure style is displayed at its best in some smaller works, such as a handscroll in the Tientsin Museum or "Playing the Ch'in for a Friend" (Pl. 61), a large double album leaf (i.e., a composition that originally occupied two facing pages in an album) now mounted as a hanging scroll. Since paintings in these smaller forms were made to be seen at arm's length and had no decorative function, the artist's touch could be softer and his designs less bold. Chang uses this intimate form to demonstrate the extraordinary range of tone, breadth, wetness, and momentum through which his brush can modulate in a small space. The line moves in swift rushes, doubling back and redoubling in tight flourishes for the folds of a bent sleeve or a rumpled hem. Sometimes it is so light and dry that it might have been drawn with a fine charcoal stick or soft pencil; suddenly it will thicken to a heavy black band.

The picture is more, however, than a display of calligraphic versatility. The scribbly back-and-forth strokes describe the bunched cloth, while the swift-running, wavering line used for outer contours conveys the heaviness of the robes. The theme is an old, symbolic one: playing the *ch'in* (a plucked string instrument usually rendered as "lute," although it is more like a zither) for a friend whose sensibility is tuned to one's own represents perfect communication, an ideal communion of minds. When the Chou-dynasty musician Po Ya played for Chung Tzu-ch'i, Chung understood Po's subtlest thoughts through the music; when Chung died, Po broke his *ch'in*, feeling that there was no one left in the world with whom he could reach that kind of understanding. Chang Lu creates a simple but effective pictorial symbol for this rapport by unifying his two figures into a single oval shape.

The distinctive manner of figure drawing seen here and in others of Chang's signed works allows us to ascribe to him an unsigned handscroll depicting "Su Tung-p'o Returning to the Han-lin Academy" (Color Pl. 7). The eminent Sung-period poet-statesman Su Shih, or Su Tung-p'o (1036–1101), was banished for a time from the capital for opposing the radical reforms of the prime minister Wang An-shih but was later reinstated in imperial favor and appointed to the Han-lin Academy. The old empress dowager summoned him to an audience one night and told him that her son the late emperor had in fact greatly admired him and had banished him only under pressure from Wang An-shih's supporters. Su Shih wept with emotion, and the empress dowager wept with him. She sent her attendants to escort him back to the Academy, lighting his way with two lanterns, in the form of golden lotuses, that hung before her throne. This is the moment represented by Chang Lu, who draws Su Shih large (as indeed he was), walking with stately tread, the attendants around him carrying hanging lanterns and playing music on a *p'i-p'a* and a flute.

This processional grouping of figures in a semicircle around the principal personage, with shorter figures in front facing inward, follows a spatial plan that can be seen as early as the Northern Wei reliefs representing the processions of the emperor and empress on the walls of the Pin-yang Cave at Lung-men, carved in the first quarter of the sixth century.[20] The drawing agrees closely in many features with figures in Chang Lu's other works; we will leave it for the reader to discern them.

The touch here is much lighter, however, resembling in this regard the drawing in Wu Wei's "Lady Carrying a P'i-p'a" (Pl. 47). Such a brilliant reconciliation of sureness and spontaneity, modulating smoothly from the sketchy or "scribbly" manner (in rumpled sleeves, the lanterns, the balustrade of the bridge) into disciplined drawing that conveys vividly the volume and postures of the figures, can be matched only in other works by certain Nanking and Soochow masters of the late fifteenth and early sixteenth centuries and was never to be equaled in later times. This and a few other works by Chang Lu should lead us to reappraise the low position to

which critical opinion has assigned him on the basis of the many coarse and routine pictures that bear his signature.

CHIANG SUNG   Chiang Sung is the next most important of the Nanking professionals of this period who were disciples of Wu Wei, and another whose output is made up largely of stereotyped compositions, which in his case fall into two types: river scenes with fishing boats (distantly based on Wu Chen's) and landscapes with scholars strolling or sitting under leafy trees. He was a native of Nanking and must have learned painting from some local master, perhaps from Wu Wei himself. Critical judgments of his paintings range from outright condemnation to praise. His adverse critics relegate him to the "Heterodox" and decadent group along with Chang Lu and Cheng Wen-lin, and the *Ming-hua lu* speaks of the "empty presumption and undisciplined attitude" of his works. The *Wu-sheng-shih shih*, on the other hand, writes of his deeply sympathetic portrayals of the scenery around Nanking, the "rivers and mountains encircling and folding, among which Chiang Sung lived, cherishing their beauty, imbibing the splendor of hills and valleys; but when he began a painting he transformed them, so that it wasn't Chiang Sung who [in his paintings] resembled the landscape, but the landscape that resembled Chiang Sung."

Like Chang Lu, Chiang is best known for large hanging scrolls, painted in ink on silk in a broad, often slapdash manner, but he really excels in small forms, such as fan paintings and handscrolls, mostly done on paper. The form and the medium allow more sensitivity of touch and more compositional variety. A set of four handscrolls called "Landscapes of the Four Seasons" is one of the finest productions of his vivacious brush. From the Spring and Winter scrolls we reproduce sections (Pl. 57–60) that are focal areas of longer compositions. Compositional sparseness is a characteristic of handscrolls by artists of this school—Wu Wei, Chang Lu, Li Chu, Chiang Sung; the painter spreads his more scanty materials over long stretches of paper or silk, offering to his viewers fewer tactile and imaginative adventures per running foot than masters of other times and schools normally did. The positive aspect of this practice is an amiable ease of manner; the artist does not appear to be working hard at his task, and yet, when he succeeds, "everything is complete" (as Chinese writers put it); within the limits of the style, one wants no more.

This quality is of course another manifestation of the attitude suggested in our discussion of Wu Wei: the painter provides his audience with less information, less definition of palpable form, aiming rather at suggestion. This aim is similar to that of some Southern Sung artists, but the results, one must immediately add, are far less evocative of hidden depths and spatial complexities. Chiang Sung sets masses against space in a broad, easy way, relying on the suggestiveness of contrasting ink values and rough brushstrokes for effects of light and shade, convexity and concavity. The dark, scratchy strokes, seen especially in the winter scene, probably exemplify the application of *chiao-mo*, "roasted ink," with a worn-out brush which, as the *Ming-hua lu* tells us, particularly pleased the eyes of his contemporaries.

CHENG WEN-LIN   Very little that we have considered so far in the paintings of this school could be called "wild," much less "depraved"; an example that merits those adjectives had best be introduced, from among numerous possible choices, before we leave the late-Che-school masters, so that we can understand more clearly the nature of the decline. A painting that is probably by another of these "Heterodox" artists, the Fukienese master Cheng Wen-lin (also known as Cheng Tien-hsien, "Mad Immortal"), will serve the purpose (Pl. 62). It is a long, episodic handscroll known as "The World of the Magic Pot," representing Taoist Transcendants engaged in a variety of hyperactive pursuits in an equally activated landscape. The painting is now divided between the Princeton Art Museum and the Metropolitan Museum, New York; the pas-

sage we reproduce is from the Princeton scroll. The signature has been cut off so that the scroll could be falsely attributed to Kung K'ai of the Yüan period, whose works exceed Cheng's many times in value. But its close stylistic similarity to the few known works by Cheng with signature or seals supports a reattribution to him.[21]

The figures in the section we reproduce are gathering fungi and peaches, both believed to be foods for Immortals in the popular Taoist cult of longevity. Cheng Wen-lin paints the river bank in splashes of ink wash, working so fast that wet patches can run together for interesting random formations. This method of applying ink, similar to a technique called *tarashikomi* that was superbly exploited by Japanese painters of the Rimpa school, was consistently disapproved of and generally avoided in Chinese painting, since it was considered too facile and incompatible with canons of good brushwork. Little sense of either rotundity or play of light results from Cheng's use of the technique.

He seems to improvise his composition as he moves across the scroll, giving at least the impression, whatever the truth may have been, of following the centuries-old Taoist tradition of painting while drunk. (The practice was not, of course, confined to Taoists.) The postures of the figures are twisted and contorted, their faces drawn into grins or grimaces, their eyes turned sideward or crossed. The forced, feverish animation of the scene arises most of all from the brushwork, in which the painter permits his own muscular impulses to dictate the character of his forms. The curling and undulating movements are so obsessive as to make an unrolling of the scroll a dizzying experience. Kinesthetic excitement and simple entertainment are what it offers, and these were not enough for the Chinese, who have given Cheng a lowly place in the history of their painting.

This is a good example of what we wrote of earlier as "stylistic extremism," the artist exaggerating some aspect of style beyond the point where it can still be reconciled with pictorial readability. For painters in the late phase of the Che school, the motivation for such ill-advised excursions was surely the desire to escape from the kind of hard academicism represented by Wang E and Chung Li and to assert some artistic individuality and temperament. One popular course for artists so motivated was the use of highly activated brushline, which served to dematerialize the forms by turning them into movement. Chu Tuan (Pl. 54) is another who chose this way out of academicism in the middle Ming, and artists such as Yüan Chiang can still be found attempting it in the early Ch'ing period.[22] The attempts are always short-lived, leading to nothing but dead ends.

"ARRIVING HOME BY MOONLIGHT" AND CHU PANG   A great many of the best surviving paintings by Che-school masters are anonymous, the original signatures and seals having been removed by dealers who wanted to hoodwink their customers into buying them as works of earlier and more prestigious artists, at prices higher than Che-school productions could command. Some of them, such as the Cheng Wen-lin scroll, can now be ascribed to particular hands; others remain mysterious in authorship, and these include many of the finest.

In this latter category is "Arriving Home by Moonlight," in the Freer Gallery (Pl. 63), attributed (absurdly) to Lu Hung of the T'ang dynasty but obviously by some Che-school artist working around 1500. Another work by the same artist, whoever he may be, is in the Osaka Municipal Museum, similarly unsigned. Perhaps the best clue to the authorship of the Freer painting is the resemblance of a number of motifs—rocks, river banks, reeds, and others—to the rendering of those motifs in a large signed work by a little-known master named Chu Pang.[23] An even more significant affinity between the two pictures is the distinctive use of graded ink washes in both and a trick of arbitrarily dimming some passages—one side of a rock, one end of a boat—through abrupt shifts into pale ink. The signed work of Chu Pang is far lower in quality, less well organized, and made up of harder and more angular forms. But, as Chang Lu and others

demonstrate, Che-school artists were capable of transcending sometimes the hack-work level of their everyday productions to create paintings of great beauty and originality.

Chu Pang was from She-hsien in Anhui Province (which was not to become an important center of painting until the seventeenth century). The *Ming-hua lu* gives him a brief note, saying that he painted figures in a very sketchy manner, splashing the ink freely, and that they resembled the works of Cheng Wen-lin and Chang Lu. It adds he also did landscapes in the same style.

The Freer painting depicts a thatched house in a valley by a stream, the owner of which is returning from a day's outing (the luggage consists only of a picnic box and a wine pot). The stream and its banks are partly hidden in mist, which is beautifully evoked by the use of dilute ink. Delicate gradations of wash suggest the pale light of the moon which picks out the edges of boulders and the crests of ridges. The effect of shifting light and atmosphere has seldom been so well conveyed in Ming painting. The stiffness of Wang E and others is avoided through the supplest of brushwork and an extraordinary spatial fluidity: the winding movement into distance which begins with the foreground path continues with the stream, carrying the eye on an S-curved course into the farthest depth, and is echoed in the mountain ridge above. This is a carefully planned composition, executed with versatility and perfect control but with no sense of academic tightness or overreliance on convention.

If the Che-school artists had been able to maintain this level of excellence more consistently, we would not have to talk of decadence. But they did not, and the decline was rapid. Later works in the style were mostly negligible, deficient in both quality and originality. Once Soochow had supplanted Nanking as the leading center of painting, the styles of the Soochow professionals such as Chou Ch'en, T'ang Yin, and Ch'iu Ying became more attractive models than the Che-school styles for later Ming professional masters. Some traces of the Che-school manner persist in works by artists from Chekiang Province, such as Hsü Wei in the later sixteenth century and Lan Ying in the seventeenth. But they are too scattered and weak to constitute a continuation of the school, and it can be considered to have been all but defunct by the middle of the sixteenth century.

CHAPTER FOUR

# Some Nonconformist Painters of
# Nanking and Elsewhere

## 1. Beyond the Che and Wu Schools

Most of the important Chinese painters of the first half of the Ming belonged to one or the other of the two principal currents or schools—the Che and the Wu—that have occupied us in the preceding three chapters. As we have seen, these two schools differ markedly in fundamental stylistic directions, in their choices of old models to imitate, and in the subjects they paint; the artists tended to differ as well in social status and economic basis of activity. This Che-Wu division, in various guises, came to serve as a basic issue in art-historical and theoretical discussions and arguments later in the Ming and was eventually reflected in a grand formulation of the history of painting, the theory of the Northern and Southern schools. It is not entirely without validity, since the correlations between regional and stylistic criteria, or between style and the artist's social and economic position, are observable and real, even after all exceptions and deviations have been noted.

But the Che and Wu schools do not by any means account for all the significant painting being created in China during this lively and productive period. Orthodox Chinese histories pay small attention to the later Che-school artists treated in the preceding chapter, and even less to the masters who will occupy us in this one, excepting the last of them, Hsü Wei; their prejudice is consistently in favor of the Wu-school artists of Soochow. Modern Western studies have similarly slighted developments outside Soochow, and one recent book goes so far as to state that "there was in any event no art of historical consequence being created outside Soochow's sphere of influence in the late fifteenth and sixteenth centuries."[1] On the contrary, Nanking as a painting center in the late fifteenth century was far ahead of Soochow, which had little to boast of besides Shen Chou, and was still a strong rival in the early decades of the sixteenth century. We must, in other words, expand our angle of view and our framework of classification if we are to take in all or even most of the interesting masters of this period.

The first part of this chapter will be devoted to a group of painters who were active in the decades before and after 1500 and who held no clear allegiance to either of the two main currents of the time, although they are most closely related to the Che school. They do not properly form a school themselves, and there is no firm evidence that they even knew one another. But this group, like the others, is definable by regional and stylistic criteria and by similarities in the artists' life situations and artistic attitudes. The painters we are grouping here were all born and were active in or near Nanking, rather than in any of the older centers of painting; most of them (in fact, all of those for whom we have enough information to allow a judgment on the matter)

were educated men, of some literary attainment; all appear to have cultivated around themselves an aura of eccentricity, which they expressed not only in their paintings but also in their inscriptions and in the nicknames they chose or acquired—"Old Fool" or "Pure and Crazy."

These same criteria apply neatly, of course, to Wu Wei, who no doubt was a model for these painters, as he was for his own proper followers. The artists of our present group might, instead of being treated separately, have been put together with the "Heterodox" painters Chang Lu, Chiang Sung, and Cheng Wen-lin, with whom they share some features of style. They similarly tend to adopt traditional themes and compositions associated with Sung painting as points of departure, confining their unorthodoxy mainly to the manner in which the pictures are executed. (Eccentricity expressed through grotesque or fantastic images belongs generally to a later phase of Chinese painting.) They perform these standard themes in unusual brush manners, applying ink and colors to paper and silk in ways that seemed, within the Chinese context, undisciplined or even wild. Their varieties of wildness, however, differ somewhat from those of the late Che-school masters who tried for effects of spontaneity and unconventionality. Those masters, as we saw in the preceding chapter, tended toward an exaggerated boldness or nervousness of brushwork, which often degenerated into the heavy-handed insensitivity of style that afflicted the late phase of the school. The artists we are about to treat worked generally either in less forceful brushstrokes that carry little feeling of tension, or in fast-running line drawing, or sometimes in a combination of the two manners.

## 2. THE NANKING GROUP

SUN LUNG, "BONELESS" PAINTING, AND DETROIT'S "EARLY AUTUMN"   One of the earliest departures from the orthodox outline-and-color technique of painting was the mo-ku (literally, "boneless") manner, so called because the painting was done in brushstrokes and washes of pure color, without the structural "bones" of ink-outline drawing. The beginnings of mo-ku painting were in the T'ang dynasty or earlier; in the tenth century, the flower painter Hsü Hsi worked in broad strokes of ink, without outlines, and added light washes of color; his son (or grandson) Hsü Ch'ung-ssu used the "boneless" technique for flower painting in the early Sung period, as did also, apparently, the greatest flower painter of the time, Chao Ch'ang.

Like other unorthodox techniques, it was considered somewhat erratic and exposed the user to the danger of condemnation by scholarly critics. Chao Ch'ang's paintings, for instance, were judged by Mi Fu (1051–1107) to be "worth keeping if you want something to decorate your reception hall with when you marry off a daughter." Part of the reason for Mi Fu's disdainful opinion was his general contempt for decorative, "pretty" flower pictures, but disapproval of the brush technique was doubtless involved in it also. Pejoratively viewed, "boneless" meant deficient in the structure given by disciplined brush movements; when paintings were assessed on criteria equally applicable to (and partly derived from) calligraphy, any variety of painting that had virtually nothing in common with calligraphy lay outside the range of consideration. Nevertheless, some painters, and especially those who favored bird-and-flower subjects, continued to do paintings in color only or in ink washes overlaid with color, or subdued their outline drawing to a point of near invisibility. During several centuries, from the late Sung into the early Ming, a minor local school of painters in P'i-ling, located about fifty miles southeast of Nanking, specialized in producing decorative pictures of flowers and insects in a heavily colored style, sometimes with outlines but often in the "boneless" manner. Many of their works are in Japanese collections.[2]

The painter Sun Lung, a specialist in just such subjects, came from P'i-ling and used the mo-ku technique. He must have been heir to this local tradition, although nothing is recorded about

his stylistic ancestry, and his works differ from those of his P'i-ling predecessors in being execut-ed in transparent washes of ink and color instead of heavy, opaque pigments.

His dates of birth and death are unknown, but he is spoken of as being contemporary with Lin Liang, and one of his albums is accompanied by inscriptions written by Yao Shou, circumstances that point to a period of activity in the third quarter of the fifteenth century. Accounts describe him as quick-witted and unconventional in his behavior as a child, "like a Taoist Immortal." He was the grandson of a famous early Ming loyalist, Sun Hsing-tsu, who had taken part in the siege of Peking by the forces of Chu Yüan-chang and was later killed in action; Sun Lung, as his descendant, had claims to special favor from the court. According to the *Hua-shih hui-yao*, he sometimes signed his works as "Painter in the Imperial Presence," which would mean that he served at some time as a court painter. Seals on his two surviving albums suggest that they were used as presents from the emperor to some nobleman or high official. One of the nicknames Sun adopted was Tu-ch'ih ("Perfect, or Complete, Fool").

In addition to his pictures of flowers and insects, frogs and shrimp, which were praised as "possessing a vivid air of life," he sometimes painted landscapes that are described as being in the manner of Mi Fu and Mi Yu-jen. The single surviving example of landscape from his hand, a leaf in one of the two albums which, along with one hanging scroll, appear to make up his en-tire extant oeuvre, is a picture of hills and trees done entirely in mottled washes of ink and color, with no individual brushstrokes visible. The critical reaction to such a practice might have been foreseen: the sixteenth-century scholar Wang Shih-chen, after dismissing Lin Liang's paintings as "devoid of spiritual depth," adds: "This is all the more true of his contemporary Sun Lung." Sun is scarcely mentioned, otherwise, in the later literature of painting.

A particularly striking leaf in the album now in the Shanghai Museum portrays a cicada cling-ing to the stalk of a waterweed in a pond (Pl. 64). Other weedy shapes mark the surface of the pond. The dampness and softening effect of a steamy atmosphere are rendered by dimming the ink tone and blurring the brushstrokes, which in some places have been applied to dampened areas of silk so as to suffuse freely. Elsewhere, the brushwork is ragged, the ink or color having been brushed loosely onto the silk in broken strokes that are the Chinese equivalent of scum-bling. The effect is to merge forms with surrounding space, and to create a pictorial approxima-tion of visual perception in a way that had seldom been attempted since the thirteenth century. It was an effect contrary to the whole direction of Ming painting.

Other leaves in the two Sun Lung albums, rendered in strokes and patches of transparent color or lightly tinted ink wash, offer the best clue we have to the correct attribution, in time and place, of one of the loveliest of Chinese paintings. This is the famous handscroll in the Detroit Institute of Fine Arts known as "Early Autumn" (Color Pl. 8), which bears a misleading, inter-polated signature and seals of the early Yüan master Ch'ien Hsüan. Whoever the artist may have been, he was apparently a better painter than Sun Lung, although the possibility should be al-lowed that Sun himself, working in a more careful and conservative manner and perhaps ear-lier in his career, painted this delightful work. The scene is microcosmic in conception: where a landscape handscroll transports the viewer through miles of countryside, offering him a suc-cession of expansive vistas, this one draws him down to the surface of a pond in autumn, into a busy scene inhabited by a teeming population of frogs and insects, and allows him to observe at close range and in sharp detail the creatures themselves, their habitat, and their ephemeral lives. In the latter portion of the composition (not shown here), a diversity of beetles, grass-hoppers, and other insects are arrayed, evenly spaced, against a decoratively flat ground, much as were the birds in, for instance, Pien Wen-chin's "Three Friends and Hundred Birds" composi-tion,[3] with which it might well be roughly contemporary.

The opening section, from which our plate is taken, is more actively composed: three dragon-flies are catching midges in the air, and three frogs on a decaying lotus leaf watch and wait their

chance. The theme is motion and change—fast movement and slow—and the still slower proc-
esses of growth and decomposition. For this theme, symbolized in Taoist thought by the image
and properties of water, an aquatic world is the proper setting; the style, in both its luminous
color and its disinterest in establishing any firm structure of brushstrokes, carries the same im-
plications of impermanence and immediacy. Once more we may pause for a moment to lament
the inhibiting effect of a narrowing of critical taste on both the production and the preservation
of such pictures as this; the Detroit scroll stands as sole survivor, at least on its qualitative level,
of what was probably a flourishing production of paintings of this genre.

LIN KUANG AND YANG HSÜN   The paintings of Sun Lung and the Detroit master, whatever
critics may have thought of them later, display no willful unorthodoxy but only techniques that
did not fit into the generally acceptable range of ways in which ink and color could be applied to
silk and paper. Before continuing with some artists who, by contrast, were rule breakers by
intent, we will look briefly at two fine and little-known works by minor masters that exemplify
more moderate and cautious excursions outside the standard styles of the period.

One is by Lin Kuang, who came from Yangchow, less than fifty miles northeast of Nanking, and
who is said to have followed Li Tsai as a landscapist. The short entries accorded him in the
seventeenth-century dictionaries of painters say that he worked "with a light and unconventional
touch but a great deal of vitality."

Lin's sole surviving work, titled "Spring Mountains" (Pl. 65), fits this characterization well.
The artist's signature and the date are accompanied by a curious poetic couplet which reads:

> Orioles sing in the skies of March, of February;
> Flowers spring up on a myriad mountains, a thousand mountains.

The loose, broad brushline may imitate Li Tsai but seems closer to the drawing of Shen Chou
in its paleness, evenness of breadth, and flattening effect; by 1500, Shen's works could easily
have been known to an artist working in Yangchow. Lin, like Shen Chou, depends on linear
patterning and plump *tien* to enrich and substantiate his forms, using little wash and nearly
eliminating textures. The composition, however, is more agitated than Shen Chou's and more
reminiscent of Sung traditions; it may seem solidly put together until one begins to examine it
in detail, whereupon it proves to be full of inconsistencies, as if Lin had improvised it lightly,
allowing solids to turn into spaces and trees to grow into the masses instead of out from them.
Such passages do not harm the effect of the whole, which is in any case more suggestive than
descriptive, its grassy sketchiness conveying the feeling of a windy day in spring. The exuberance
of the style matches that of the scene, with its gushing waterfall and profusion of flowering trees,
which are drawn pale so as to appear bathed in air and sunshine. Through such formal means the
painter transmits his own experience and that of the figure seen in the pavilion over the water in
the foreground. Such a telling use of calligraphic and abstract qualities for expressive purpose
anticipates seventeenth-century painting, and one might be tempted to date the picture as late
as that if it were unsigned. As the work of a little-known painter of 1500, it is surprisingly fresh
and original and makes us wish that more of the artist's production had survived.

The same can be said of the landscape by Yang Hsün (Pl. 66), who is even less known as a
painter, our only information on him coming from an inscription written by a Japanese scholar
in 1874 on the box for one of his paintings. The data is unconfirmed and hence not entirely trust-
worthy.[4] According to it, Yang Hsün was from Hsien-ning in Hupei Province, about fifty miles
south of Wu Wei's birthplace. He took his *chin-shih* degree in 1454; was a scholar in the National
University, probably at Nanking, in 1489 and was given an honorary rank by the emperor Hsiao-

tsung that same year; and died in 1508. If this is indeed the correct identification of the artist, the cyclical date on the painting would correspond to 1483, and the painting would take its place as a very interesting work by a scholar-artist working in a style not ordinarily associated with the literati school.

Yang Hsün is represented today by only three landscapes, one of them small and on paper, the other two large and on silk. Both of the large works bear the same cyclical date: the one reproduced here is signed "The Drunken Profligate of West Lake, Yang Hsün," suggesting that Yang must have spent some time in Hangchow, which would help to account for the Che-school flavor of the work. If we wonder, in fact, what kind of picture a scholar-amateur working within the Che-school styles might do in the late fifteenth century, Yang Hsün's landscape may furnish one of the very few pieces of evidence toward answering the question. The tradition on which he draws is not that of Ma Yüan, but of Li T'ang, whose craggy mountain peaks lie far behind those in Yang's picture. The separation of sunlight and shadow which, in Li T'ang's style, was systematically employed to distinguish the faces of a rock and thus to reveal its form, had already by the Yüan dynasty (cf. *Hills*, Pl. 29) been simplified into a free, wet application of patches of ink wash that suggested highlights and shadows without assigning them to clearly demarcated surfaces. Yang Hsün's is a further extension of the same technique; it is more schematic, less descriptive of visual phenomena of light, but can still create an impression of strong sun and shade, enhancing the powerful presence of his rocky masses. In a few passages it does more, providing a positively illusionistic rendering of three-dimensional forms by portraying the play of light and dark on their surfaces.

The plan of the picture is similarly old-fashioned but effective in giving spaciousness and monumentality to the scene; the composition is in fact so imposing as to seem more like a professional performance than a scholar-amateur's. Beyond a rocky foreground shore topped with leafy trees, the river carries the eye back to the middle ground, where a traveler crosses a bridge on a donkey; behind is a misty ravine, out of which rise tall spires of rock. The parts of the composition are arranged in three planes of depth, offset on a receding diagonal, with the rocky masses increasing in size from the foreground boulders to the peaks that tower over the scene and block any further penetration.

SHIH CHUNG, "THE FOOL FROM NANKING"   Neither Lin Kuang nor Yang Hsün is likely to have adopted any outward, public stance of eccentricity; the one was a professional painter and follower of an Academy master, the other probably a respected scholar-official. Originality in their paintings is manifested in relatively restrained, unobtrusive ways. The situation that seems typically to have led to overt unorthodoxy in painting is the one exemplified by Wu Wei: an educated man of low economic status decides for some reason not to pursue a career as a government official, or attempts one and fails, and so is forced (presumably—we are seldom told as much in biographical accounts) to practice for his livelihood what he may have begun as an avocation. This option became more attractive to men in this special position as the rewards, both in patronage and in respect, became greater, and the role of the artist as a talented and cultivated man with some measure of artistic independence came to be recognized and socially accepted. Again, the successful careers of Tai Chin and Wu Wei may have been crucial in opening the way to such recognition; and innovative, even heterodox styles were, among other things, assertions of the artists' newly won independence.

Heterodox modes of brushwork in Chinese painting usually took one or the other of two directions, which we can term *scribbliness* and *splashiness*. Good examples of the former we have seen in works by Wu Wei and Chang Lu: it is the manner of drawing in which the brush is not lifted between strokes, so that the line runs on as it deviates or reverses direction abruptly. Splashiness, by contrast, records little if any trace of brush movement, the ink being applied so

broadly and wetly that its suffusion absorbs and obscures the brushstroke. An extreme form of this latter was practiced already in the eighth and ninth centuries by eccentric "ink splashers" who, in some combination of creative frenzy and alcoholic intoxication, spattered ink and sometimes colors onto a painting surface and then, usually after regaining their sobriety, turned the largely random outcome of this activity into a representation of landscape or some other subject through the addition of proper brushwork.[5] By the fifteenth century, only literary accounts of these painters remained, their works having long since disappeared; but they could still serve, along with latter-day Heterodox painters such as Fang Ts'ung-i, as models for any painter who wanted to venture into aberrant techniques.

The anecdotal biographies of brilliant, erratic painters tend to have another feature in common: the painters begin their lives as unusual children. Shih Chung, who was born in Nanking in 1438, follows that pattern, but not in the standard precocious way; on the contrary, he reportedly could not even speak until he was seventeen. Outwardly a simpleton during these youthful years, he was inwardly very intelligent—or so people decided later, after he had learned in a short space of time not only to speak but also to read, write, and compose poetry and prose, and to paint. His talents also included the composition of popular songs, which he would sing when drunk, beating time; he taught them to his concubine Ho Yü-hsien ("Jade Immortal"), whom he had taught to play the p'i-p'a. He avoided the ordinary even in his name: his original name was Hsü Tuan-pen; why he changed to Shih Chung and why he continued to use the earlier name along with the later in his seals are questions still unsolved. The name Ch'ih ("Fool" or "Idiot"), which he had presumably acquired during his dullard days, pursued him into his later years, when he was a fool only insofar as he chose to be. He used the name proudly, calling his house Wo-ch'ih ("Fool's Rest"), taking in his old age the name Ch'ih-weng ("Old Fool" or "Foolish Graybeard"), and so forth.

One anecdote relates the circumstances of his first meeting with Shen Chou. Coming to visit Shen but finding him absent, Shih walked into Shen's studio and painted a landscape on a piece of unused silk that was stretched on the wall. Then he departed without leaving his name. When Shen returned and saw the painting, he knew immediately that it must be by "the Fool from Nanking" since no one in Soochow used the brush in such a way. He sent his servants to find Shih and bring him back, and the two became fast friends, sometimes staying at each other's houses. Shen Chou once inscribed a portrait of Shih Chung that had been painted by Wu Wei, a remarkable conjunction of three leading artistic personalities of the age; the painting has not survived. Shih lived to be about eighty and so must have died around 1517. Like Wu Chen and others, he is said to have foreseen, or even determined, the time of his death, and then died without any sign of illness at the self-appointed time, after participating in his own funeral procession.

Shih Chung's training as a painter is nowhere described, but his stylistic affiliations seem to be principally with the late, "wild" academic masters, especially Chiang Sung (who was also a native of Nanking), and we may suppose that he started from a similar academic base. No early work remains to answer the question of what his early style may have been; all that we have appears to be late and agrees with his descriptions of his work as "unrestrained by adherence to any school manner" and "like clouds scudding and water churning." Occasionally encountered in his work are passages that recall Shen Chou, but he lacks the control and formal power of the far greater Soochow master.

His style is especially suited to snowscapes, and two of his best known works are of that genre: a handscroll dated 1504 (Pl. 68) and a hanging scroll dated 1506 in the Museum of Far Eastern Art, Cologne.[6] One might at first take the hanging scroll that he painted in the spring of 1504 (Pl. 67) to be a snowscape also, but it probably was not intended as one. The patches of untouched paper left in reserve between the amorphous strokes of wet ink laid on so freely by the artist might be read either as pockets of snow or as highlights standing out from shadows; the latter reading seems more likely, since the leafy trees and open-fronted house, within which two men

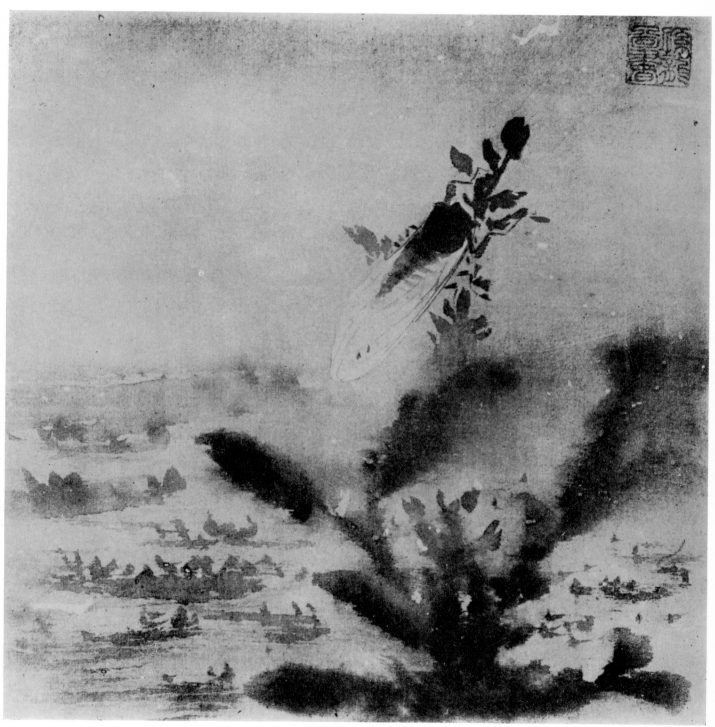

64. Sun Lung: "Cicada and Waterweeds." *Album leaf, ink and colors on silk, 21.8 × 22.9 cm. Shanghai Museum.*

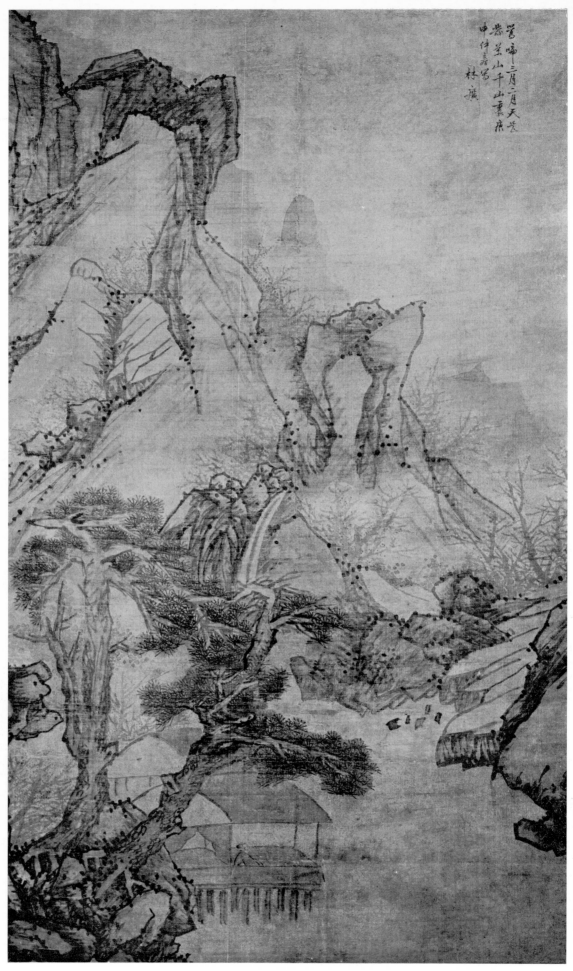

65. Lin Kuang: "Spring Mountains." *Dated 1500. Hanging scroll, ink and light colors on silk, 182.8 × 103.8 cm. National Palace Museum, Taipei.*

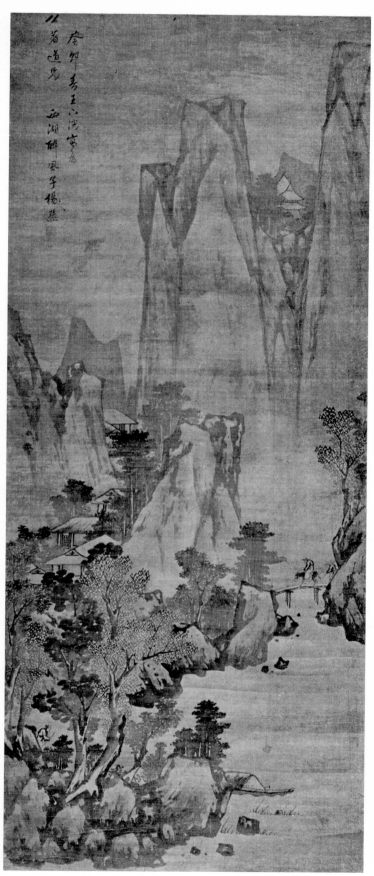

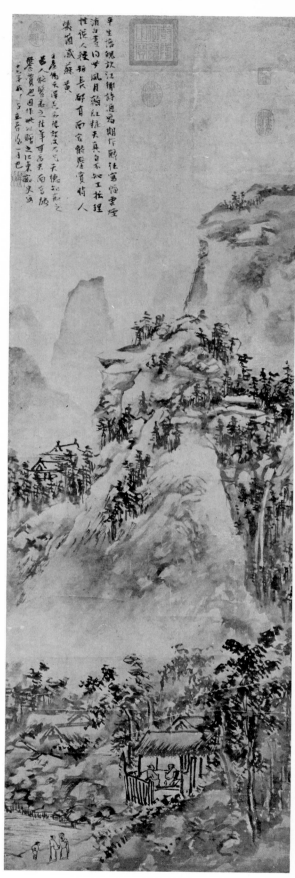

66. Yang Hsün: "Landscape with Travelers." *Dated 1483. Hanging scroll, ink on silk, 183.6 × 77 cm. Collection of George J. Schlenker, Piedmont, California.*

67. Shih Chung: "Landscape." *Dated 1504. Hanging scroll, ink on paper, 142.7 × 46.1 cm. National Palace Museum, Taipei.*

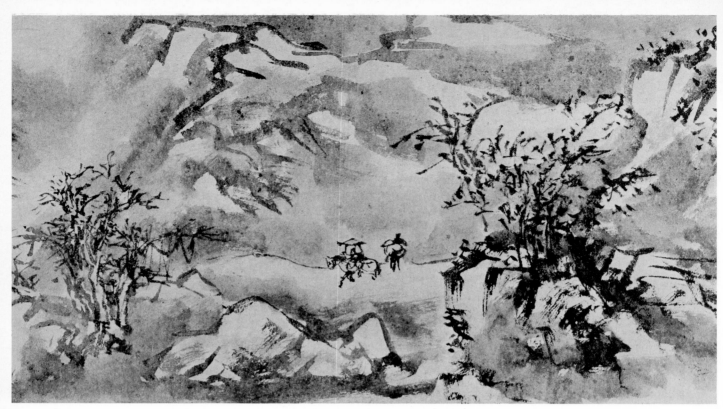

68. Shih Chung: "Clearing After Snowfall." *Dated 1504. Section of a hand-scroll, ink on paper, 25 × 319 cm. Courtesy of Museum of Fine Arts, Boston.*

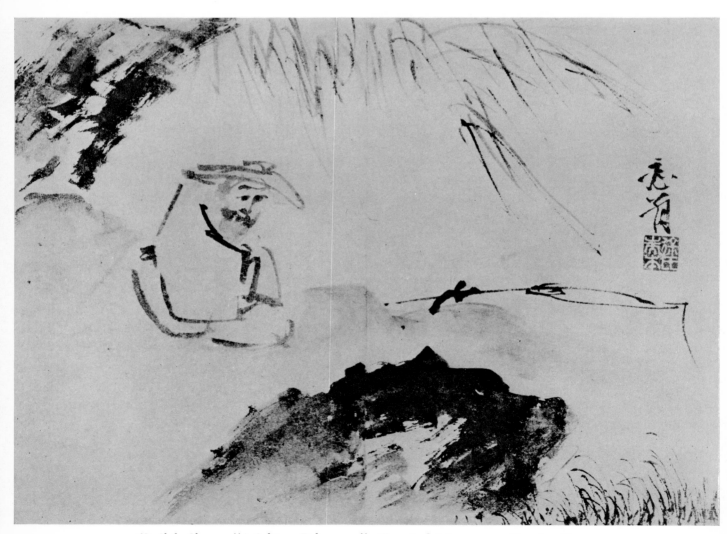

69. Shih Chung: "A Solitary Fisherman." *Album leaf, ink on paper. Shanghai Museum.*

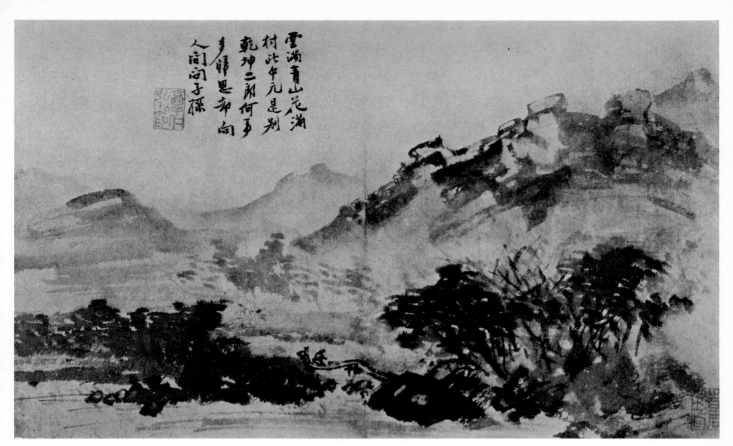

雲
滿
青
山
花
滿
村
此
中
元
是
別
乾
坤
二
月
何
事
多
歸
思
卻
向
人
間
問
子
孫

70. Kuo Hsü: "Landscape." *Album leaf, ink on paper. Shanghai Museum.*

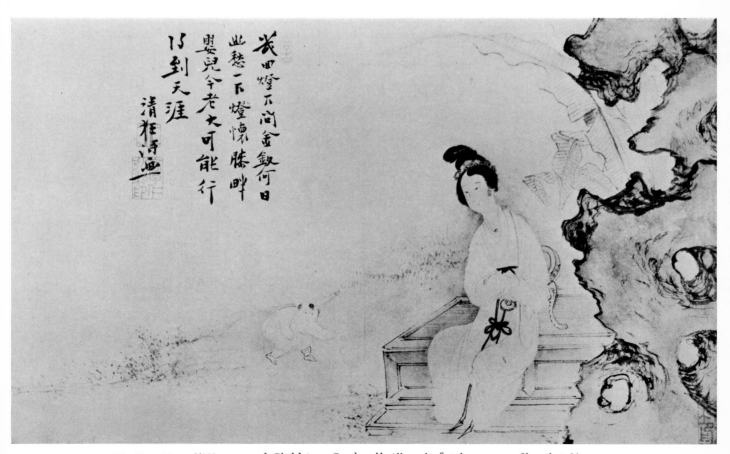

裁
四
燈
下
尚
金
釵
何
日
此
愁
一
下
燈
懷
膝
畔
嬰
兒
今
老
大
可
能
行
怕
到
天
涯
清
狂
詩
畫

71. Kuo Hsü: "Woman and Child in a Garden." *Album leaf, ink on paper, Shanghai Museum.*

72. Tu Chin: "T'ao Yüan-ming Viewing a Painting of the Peach Blossom Spring.

73. Tu Chin: "Enjoying Antiques." *Hanging scroll, ink and colors on silk, 126.1 × 187 cm. National Palace Museum, Taipei·*

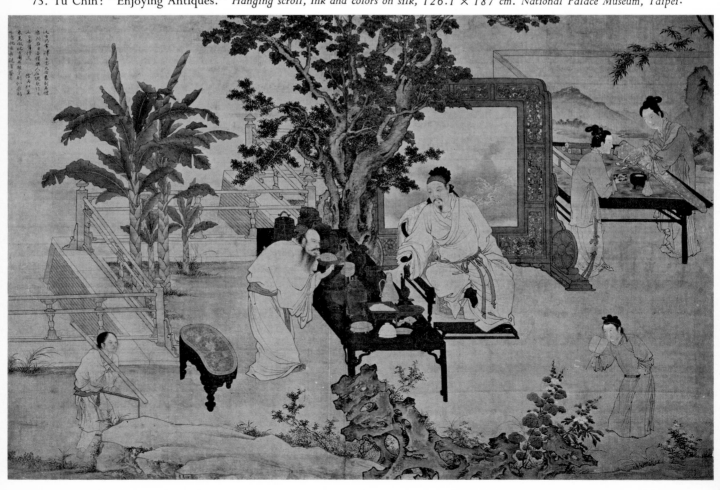

*Section of a handscroll, ink on paper, 28 × 108.2 cm. Palace Museum, Peking.*

74. Wang Wen: "Landscape with Pavilion." *Album leaf, ink on silk. Collection unknown.*

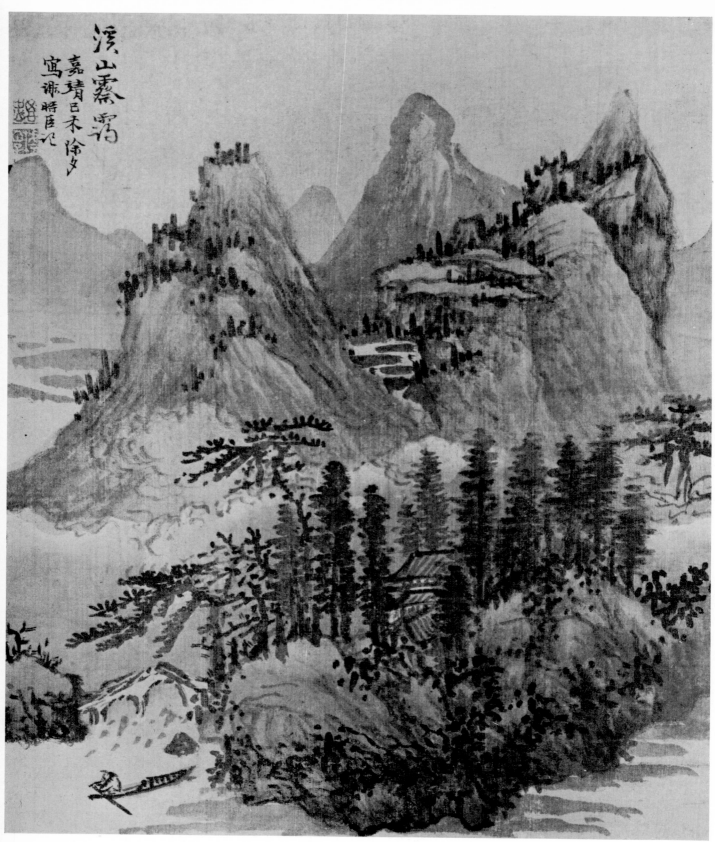

溪山霽霜

嘉靖己未除夕
寫謝時臣記

75. Hsieh Shih-ch'en: ''Landscape After Rain.'' *Dated 1559. Album leaf mounted as a hanging scroll, ink on silk, 26.6 × 22 cm. Ching Yüan Chai collection.*

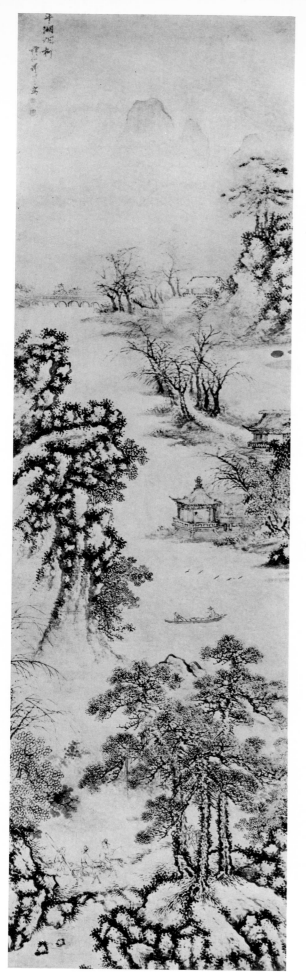 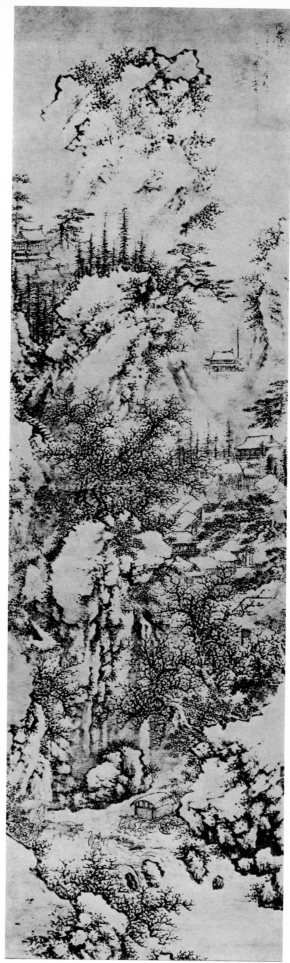

76–77. Hsieh Shih-ch'en: from "Landscapes of the Four Seasons." *Left*, "Misty Trees by a Level Lake";
*right*, "Clearing After Snow in a Mountain Pass." *Hanging scrolls. Collection of J. T. Tai, New York.*

78–80. Hsü Wei: "Flowers and Other Plants." *Sections g*

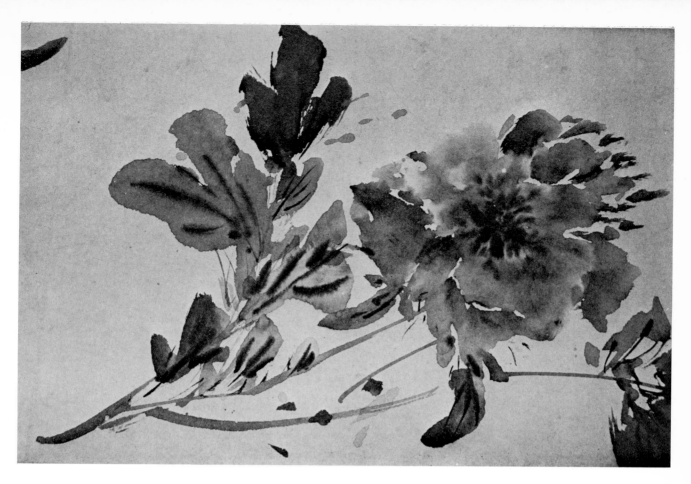

handscroll, ink on paper, 30 × 1053.5 cm. Nanking Museum.

81–82. Hsü Wei: "Landscape with Figures." *Sections of a hand-scroll, ink on paper, 30.2 × 134.6 cm. Private collection, Tokyo.*

sit conversing, indicate a warmer day. But the ambiguity is itself revealing. Shih Chung's style does not so much describe the landscape as convey quick, imprecise impressions of it. The mode of achieving a strong rendering of light and shadow (supposing it is that) by applying broad strokes of ink wash and leaving areas of light between them is one of a number of features the painting has in common with Yang Hsün's; but where Yang separates one form from another with utmost clarity, Shih blurs boundaries and distinctions by using the same uncouth brush movements whether he is drawing rocks, snow, or trees and avoids firm and continuous outlines throughout.

The painting appears in catalogues as "Landscape in the Manner of Huang Kung-wang" but bears no easily recognizable resemblance to that Yüan master's work except perhaps in the way the mountainside is built up. Shih Chung's inscription reads: "Yang T'ien-ts'e from Chin-t'ai came by my Fool's Tower, and we got to talking about natural virtue. He knows what kind of person the Fool is [i.e., I am] and can appreciate the Fool's awkwardness. Truly, he is another Mi Fu in his capacity for aesthetic discrimination. Accordingly, I have done this as a gift for him. Drawn by the Fool Shih of Chiang-tung, in [1504]."

The "Clearing After Snowfall" handscroll (Pl. 68) was painted in the same spring of 1504 but probably earlier in the year, "when the snow was deep," according to Shih's inscription. The handscroll is about ten feet long and is a brilliant performance, executed with an air of complete spontaneity, as though the artist had set down rapidly a succession of visual impressions absorbed on a walk through snowy hills by a river, at the same time composing his picture skillfully and satisfyingly. The brushwork is allowed to turn dry and scratchy in a few places, producing occasional outbreaks of rougher texture, and the drawing tightens just enough to fulfill its descriptive function in figures, houses, trees; otherwise, the whole painting is done in seemingly lax contour strokes and uneven patches of wash, the one merging unclearly into the other. The style seems here so ideally adapted to the theme as to make the issue of unorthodoxy beside the point.

Shih Chung's more striking ventures into the borderlands of eccentricity are to be seen in his album paintings. The new popularity of the album in the late fifteenth century, already noted in connection with Shen Chou, had a liberating effect on style; faced with the necessity of creating variety throughout the whole album, an artist might risk in a single leaf some uncautious experiment that he would hesitate to attempt in an integral work on a larger scale. In a twelve-leaf album in the Shanghai Museum, undated but doubtless from his late period, Shih Chung displays his undisciplined brushwork in pictures more "splashy" or "scribbly" than either of the 1504 works. The subjects and compositions, however, continue to be familiar and old-fashioned: scholars walking in the mountains with their servants, or sitting in a boat admiring the scenery, or standing on a ledge gazing over a river, or playing at being hermit-fishermen as in "A Solitary Fisherman" (Pl. 69). The romantic appeal of these images was largely in the way they flattered the viewer by suggesting that his true longings were for the untrammeled life. Executed in brushwork that had the right nonconformist associations, such pictures were obviously aimed at people of conventional tastes but with aspirations toward the unconventional—those people to whom some artists in all ages have catered in the pursuit of benefits usually more material than artistic. The real level of Shih Chung's eccentricity is hinted at by his having made several of the figures in the album (including the fisherman of our plate) cross-eyed.

Kuo Hsü   Our suggestion that stylistic eccentricity in this period is a self-conscious offshoot of academicism—which is, of course, consistent with the account we have given of the decline of the Che school—is strengthened by a sameness in the manifestations of this eccentricity from

artist to artist; if it were really a natural effusion of idiosyncrasy from truly deviant people, "fools" or "crazy" in more than their chosen names, the stylistic affinities between artists should not be so close—the idea of a school of eccentrics carries an inherent contradiction. That contradiction is well embodied in the works of Kuo Hsü (1456 to after 1526).

He was born in T'ai-ho in Kiangsi Province and was well educated; he prepared for an official career, which was for some reason abortive. When in the 1490s he was invited to the capital and offered an official post by a powerful eunuch at court named Hsiao Ching, he rejected the offer firmly, and for this act was praised as equal in high principle to the loyalists (i-min) of earlier ages. He is said to have been recommended at court as a painter by the great philosopher-statesman Wang Shou-Jen (or Wang Yang-ming, 1472–1528), who inscribed one of his paintings and presented it to the emperor. Kuo may have served in some official capacity for a short time but then gave up his post or lost it. After this, we are told, he traveled to view the famous mountains in China and declared that they, and not other people's paintings, would serve as his copybooks. The same story is told of many other painters, but there are few whose works make it sound so unconvincing. Equally unlikely, in the light of his extant oeuvre, is the story that he was considered in his time the superior of Wu Wei, Tu Chin, and Shen Chou.

The comment that he was able to handle any landscape style skillfully fits better with what we know of him but could also be stated negatively: he seems to have no clearly recognizable style of his own. Two extant landscapes dated in the first decade of the sixteenth century are orthodox performances in the manner of Kao K'o-kung, which was, as we have noted, a manner used chiefly in this period by academic artists. Two figure paintings, one in the Palace Museum, Taipei, dated 1526, are reminiscent of the work of Wu Wei and Chang Lu. An undated album of eight leaves in the Shanghai Museum contains one picture of a frog and lotus in the Sun Lung manner, several landscapes similar to those of Shih Chung (Pl. 70), and a figure painting close in style to works of Wu Wei and Tu Chin (Pl. 71). This last portrays a lady seated in a garden, while a boy at her side tries to catch a butterfly. The faces of both have the winsomely cross-eyed look of Shih's fisherman. Kuo signs this and his other pictures with his favorite sobriquet, Ch'ing-k'uang ("Pure and Crazy").

TU CHIN A much more serious, original, and influential artist of this group was Tu Chin, whose birth and death dates are unknown but who was active in the later fifteenth and early sixteenth centuries. A native of Chen-chiang, located to the east of Nanking on the south bank of the Yangtze River in Kiangsu Province, he was the son of an official and studied the classics in his youth, reading widely in literature of all kinds, including novels. He himself wrote poetry that was "strange and old-fashioned." His ability as a poet and as an accomplished if somewhat idiosyncratic calligrapher can be seen in an inscription he wrote to accompany a bamboo painting by Ni Tsan.[7] Some time in the Ch'eng-hua era (1465–88) he passed the examination for the chin-shih degree, but because he did not place high enough to be offered an attractive post, he gave up all ambition toward a bureaucratic career and turned, like the others, to painting. His earliest dated work is from 1465. There is no record of who his teacher was, but he was surely influenced by Wu Wei, who was probably some years older.

Tu settled permanently in Nanking, no doubt because this was the best place for an artist of his stylistic persuasion to make his living. He called himself Ku-k'uang ("Antiquated and Crazy"). His most admired works, however, were those in such highly disciplined techniques as pai-miao, the fine-line manner of drawing used for figures, and chieh-hua ("boundary painting"), used for architecture; these works of his were praised as "strict and restrained." Critics note that he painted rocks, trees, and other landscape elements in the broad, broken brushwork called fei-pai ("flying white"), but his works in this manner, according to Wang Shih-chen, were not so highly regarded. It would appear, then, that in spite of his self-designation as "crazy," he

was more appreciated for his fine technique than for the mild touches of unorthodoxy in his works. The *Hua-shih hui-yao* notes that he was widely copied and imitated by later artists, a statement that is confirmed by what we can observe of his influence, especially on the professional masters of Soochow. When T'ang Yin visited him in the first month of 1499, he was old and poor, as we know from a poem that T'ang wrote to him. He probably died shortly after 1509, the year of his last dated work.

The subjects of Tu Chin's pictures are mostly popular and anecdotal; he painted few pure landscapes, specializing rather in scenes of figures in landscape or garden settings. Pictures of poets gazing at the moon or walking by moonlight (a fine example portraying the Sung poet Lin Pu is in the Cleveland Museum of Art) evoke a Southern Sung mood of lyricism, echoing in their style the Academy painting of that earlier age, especially the work of Ma Yüan. A handscroll in the Peking Palace Museum contains nine illustrations that Tu painted to accompany old poems inscribed by a contemporary named Chin Tsung (1448–1501), whose note at the end of the scroll identifies Tu as the artist and is dated 1500. The pictures portray scenes from the lives of poets and literary men of the past.

In one of them (Pl. 72), the poet T'ao Ch'ien, or T'ao Yüan-ming (365–427), stands with the ubiquitous boy servant in a garden before a screen on which hangs a painting depicting the subject of one of T'ao's own most famous literary compositions, the story of the Peach Blossom Spring. This is a tale of a fisherman who finds his way through a narrow opening at the remote source of a stream in the mountains and comes out beyond into an Elysium where people live in perfect happiness and peace, isolated from the rest of the world. The fisherman in the picture is seen walking, his oar over his shoulder, toward the entrance to the hidden valley, here represented as a cave.

This painting-within-a-painting is rendered in the bold, spontaneous manner of Shih Chung and Kuo Hsü; it is matched, in the larger picture that contains it, only by the garden rocks at the left; otherwise the execution is linear and controlled. The rocks are shorthand performances of the angular and faceted type created by Li T'ang and imitated by countless artists afterwards. From the original model remain the "axe-cut" texture strokes, now nervously applied, and the dependence on suggestions of strong highlights and deep shadows to assert solidity. The figure of T'ao Yüan-ming belongs also to an old type but is here portrayed with a tense sharpness—the eyes narrowed and alert, the torso bent back—that is new. The composition resembles some late pictures by Shen Chou in dividing the space geometrically with strong diagonals and verticals and in cutting off the screen at midsection.

The fact that no signature or seal of Tu Chin appears on any of the paintings is indicative of their "social status"; they were done on commission, as adjuncts to the calligraphy. Chin Tsung relates in his inscription that a certain man (whose name has been expunged, as was frequently done when scrolls dedicated to a particular patron or friend were later sold, to avoid embarrassment to the man or his family) "asked me to write twelve old poems; then he went to get Tu Sheng-chü [Tu Chin] to do pictures illustrating them." The paintings were thus intended to be functional, not to be appreciated primarily as creations of an individual artist, and his identity was accordingly of less interest to the viewer or owner of the scroll. It was common for paintings done as illustrations to go unsigned, even when they were by respected artists; another example is the scroll illustrating the "Nine Songs" of Ch'ü Yüan, by Chang Wu of the Yüan period (*Hills*, Pl. 70), in which the artist is similarly identified only in a note by the calligrapher who wrote the text.

A functional picture of another kind is "Enjoying Antiques," in the Palace Museum, Taipei (Pl. 73). It is mounted now as a hanging scroll, but its unusual shape and size (it is over six feet long) indicate that it was probably painted to be mounted on a flat screen like the one seen in the upper right of the picture itself. Such screens have not survived in their original form, and

since the paintings on them were of an awkward size for remounting as scrolls, they have with very few exceptions been lost, or at best cut up so that they survive only in fragments.[8]

Another version of the left-hand third of the present composition was in fact recently discovered in a Japanese temple, the Kongōbu-ji on Mount Kōya; the other two parts (center and right) may also be in the collection of the same temple, the original painting having been cut to make scrolls suitable for hanging in the Japanese *tokonoma* alcove. The Kongōbu-ji version agrees better in the calligraphy of its inscription and in its drawing with the other extant paintings by Tu than does the Palace Museum version, which may in fact be a copy by some Soochow artist close to Ch'iu Ying, or perhaps by Ch'iu himself.

Leaving aside this question of authenticity for future investigation and treating the Palace Museum painting as a Tu Chin composition (which it is in any case), we may note that the assumption that it was a screen composition might explain some of its characteristics: it is stable and expressively unassertive (as is also the case, for instance, with Kano-school figure-in-landscape screen compositions in Japan—which are, to be sure, different in many other respects); it is full of anecdotal detail, and so would continue to entertain through repeated viewings; it is executed with a superlative technical finish, in a conservative style, and so could be admired and enjoyed by anyone who might encounter it. The form has affected the style, as in the case of album paintings, but in just the opposite direction: this was not an intimate kind of painting, meant to occasion a momentary and intense experience, nor did it encourage experimentation of any kind.

The subject is itself generalized and conventionalized (again, like the "Four Accomplishments" theme so common in Japanese screens). On a garden terrace, a rich collector of antiques is showing off his acquisitions to a friend, who examines archaic bronzes set out on a table. A boy enters the scene at the left, carrying a scroll painting; two maids at the upper right arrange other treasures—a *ch'in*, handscrolls, a vase, incense burner and tortoise-shell box, albums—on another table. A child at the lower right, pursuing two butterflies with a fan, seems irrelevant and has a purely compositional role: he fills a space and adds another passage of frozen activity to the tableau.

A little-known painting titled "The Scholar Fu Sheng in a Garden" (Color Pl. 10–11) can be added to the oeuvre of Tu Chin on the basis of its close similarity, in many features, to "Enjoying Antiques." A painting of this same subject is recorded in a Chinese catalogue;[9] the picture we reproduce may be the same, with the artist's inscription removed, or perhaps it is another version by Tu Chin.

Our plate is a detail of the main figure group. The old man in the center is Fu Sheng, a Confucian scholar who, after the fall of the Ch'in dynasty in the third century B.C. and the founding of the Han, brought forth a copy of the *Shu-ching* (Book of Documents) that he had hidden in the wall of his house to rescue it from Ch'in Shih-huang-ti's attempted destruction of all Confucian books; Fu Sheng devoted his remaining days and energies to giving lectures on the text to a scholar especially sent by the Han emperor to receive and preserve the old man's wisdom. His pupil appears to the right (outside the area of our plates) seated before a desk, assiduously recording Fu Sheng's words. He and the servants flanking Fu Sheng belong to conventional figure types, by Fu Sheng does not; his grizzled face is individualized, and the withered and sagging flesh of his shoulders and arms is depicted with a sympathetic understanding that must be the outcome of careful study of the anatomy of the aged. A famous early portrait of Fu Sheng, ascribed (probably arbitrarily) to the T'ang-dynasty master Wang Wei,[10] is even finer in this respect, but Tu's is an uncommon achievement for its late period, rivaling Chou Ch'en's "Beggars" (Pl. 88–89) in its touching portrayal of infirmity and emaciation. The line drawing, especially in the figure of the old man, is masterly, modulating with great versatility from the most subtly responsive delineation of the body to a springy calligraphy for the robe.

## 3. Two Painters of Soochow and One Other

For reasons that have not yet been determined but will probably prove to be in part economic, the commercial production of paintings declined in Nanking after the early sixteenth century and shifted to Soochow, which continued to be the principal locus of the amateur current at the same time as it now became a professional painting center as well. Nanking was not to regain its importance as an artistic city until the late Ming period. The important following of the new style of Tu Chin and the others was not to be in Nanking but among the professional artists of Soochow. Before turning to them, however, we shall devote the remainder of this somewhat catch-all chapter to three painters of the sixteenth century who are not easily definable by school affiliations and thus have a place here if for no other reason. In fact, however, they have some real affinities with the foregoing group of painters both in their lives and in their styles.

WANG WEN  The first, and least distinguished, of the three is Wang Wen (1497–1576), a native of Wu-hsi, a city located a short distance to the northwest of Soochow in Kiangsu Province. He took the *chin-shih* degree in 1538 and served in a number of capacities in the government, including a position as secretary in the Ministry of War in Nanking from 1544. This post he requested so that he could be near his father in Wu-hsi. Later, appointed to a job in Canton, he resigned rather than leave his aged parent unattended. After the death of his father he retired to the shore of T'ai-hu, or Great Lake, built a villa and garden, and lived out the remainder of his life there, devoting himself to poetry, calligraphy, and painting and associating with local scholars and Taoist priests.[11]

The crucial stage in the formation of his artistic style must have taken place, judging from his surviving works, during his service in Nanking. A single painting dated 1539, before he went there, is in a soft, undistinguished style that belongs loosely in the Soochow stylistic sphere, whereas all the others, dated 1552 and after, betray strongly the influence of Wu Wei and his followers, whose works Wang must have seen at the southern capital. Some are done in deep, wet ink and impetuous brushwork that anticipates strikingly the painting of Hsü Wei, to whose far greater achievements Wang Wen's modest ones can be seen as an important link. Wang also works, as Wu Wei and Tu Chin did, in a manner that is at the opposite extreme from this, the fine-line, highly disciplined *pai-miao*. Between these, within his oeuvre, lies a pleasant manner that represents Wang's attempt to combine, as so many others had tried to do, the still-popular themes and compositions of the Che school and its derivatives with the softer, broader kinds of brushwork popularized by Shen Chou and his imitators. One who had made the attempt, for instance, was a minor artist named Li Chu, mentioned in the previous chapter as having begun as a follower of Shen Chou and having later switched to the style of Wu Wei after moving to Nanking and finding that pictures in that style were most in demand.

A leaf from an album of five landscapes and figure paintings by Wang Wen (Pl. 74) exemplifies the same stylistic direction in its drawing of angular forms in blunt strokes and its decorative (rather than atmospherically descriptive) use of ink values, with the deepest clustered at the center right to give the composition a loose sense of focus. The strongly vertical-horizontal emphasis of Che-school landscape persists, as does the Che-school satisfaction with massive, simple forms and avoidance of complexities of all kinds, formal and expressive. An inscription on another leaf of the album was written by Wang Wen in Nanking in 1554, during the several months he stayed there with his father after the two escaped from Wu-hsi when that city was menaced by Japanese pirates. A collector named Erh-ku brought him the album, which Wang had painted some years before (probably during his earlier stay in Nanking), to ask for inscriptions, and Wang obliged him.

HSIEH SHIH-CH'EN   Hsieh Shih-ch'en (1487 to after 1567) is another sixteenth-century master who turned Shen Chou's brush manner to artistic purposes that are usually quite different from Shen's own. He came from a well-to-do family in Soochow and spent his whole life in that region, except for short trips to other places, living most of the time in a villa on a mountainside overlooking Great Lake. It is generally assumed from the nature of his output that he was a professional artist, although there is no clear documentary evidence of this. The *Ming-hua lu* accords him heavily qualified praise as a painter who was "very competent in executing screens and large hanging scrolls which were bold and energetic in manner but didn't escape the affliction of fussiness." Accounts of his stylistic development state that he first mastered Shen Chou's style and then altered it by adding features from the tradition of Tai Chin and Wu Wei. The charge of being "deficient in harmony and sensitivity" commonly brought against his painting, for example by the author of the *Wu-sheng-shih shih*, seems justified on the whole with respect to his large-scale works, which too often are banal in their themes and heavy-handed in their execution, featuring lumpy land and mountain configurations drawn with nervously shaky outlines. Many of them have narrative subjects taken from old stories. His smaller hanging scrolls, on the other hand, and his paintings in handscroll and album form, are quieter and generally more attractive; hills and cliffs in them are as engagingly earthy as those in late works of Shen Chou, figures and buildings have the same thick-line robustness. In the context of mid-sixteenth-century Wu-school painting, in which (as we will see in a later chapter) sharper modes of brushwork and deliberately induced formal tensions were prevalent, Hsieh's more relaxed pictures must have appealed to many people for the same qualities that made them seem unexciting and old-fashioned to others.

A good example is a small painting dated 1559, "Landscape After Rain" (Pl. 75), which shows Hsieh in his most amiable mood. Behind the stable, compact composition, the fat *tien*, the broad, pale texturing, the simple trees, stands Shen Chou, and behind him Wu Chen (compare, for the truncated-cone shape of the hill at the left, Wu's "Central Mountain"— *Hills*, Pl. 27); but Hsieh's painting is not a simple imitation of either. The composition is pleasingly symmetrical: a steep riverbank in the foreground is composed of two rotund masses, with houses seen through the gap between them; a band of fog separates this from the middle ground, which is similarly bifurcated; two winding rivers provide the simplest indication of recession into the background, which is marked with high mountains. A fisherman in his boat and a bridge at the lower left relieve slightly the simplicity of this scheme.

A set of four huge hanging scrolls on paper representing the four seasons, of which we reproduce the spring and winter scenes (Pl. 76–77), are among Hsieh's most impressive pictures. They must have been intended for the high-ceilinged reception hall of some grand official or rich merchant, to be hung in rotation according to the season. Like most other large paintings that were exposed in this way for prolonged periods, they have suffered considerable damage and undergone some retouching. (For the same reason, Che-school and academic paintings of the Ming as we see them today are usually darker in tone and in poorer condition than other paintings of the same age that were hung less frequently and for shorter periods.) The size and function required significant adjustments in the style; Hsieh's softer manner of brushwork as used in his small works could not sustain compositions on this scale. The forms necessarily became bolder and heavier, tonal contrasts more dramatic, and the compositions took on, more or less unavoidably, a loose-hung and episodic character. Only a few masters in the later history of Chinese painting could organize effectively and unify such large expanses of painting surface, and Hsieh Shih-ch'en was not one of them. The viewer's attention moves from bottom to top as he absorbs the incidents of each picture sequentially, helped by bridge passages that are not, and do not pretend to be, true formal transitions.

In the spring picture, which is titled "Misty Trees by a Level Lake", one encounters, successively, travelers on horseback with their servants, a man being sculled across the lake in a ferry, another reading in a waterside pavilion, some houses, and, at the top, another mounted traveler crossing a bridge. The pair of horsemen in the foreground has been taken fairly literally from a winter landscape by the late Sung master Liang K'ai, or else from one by Tai Chin in which the motif also occurs, or from some other secondary source.

The title of the winter scene is partly illegible because of damage but appears to be the same as that of a painting done earlier in the century by T'ang Yin, "Clearing After Snow in a Mountain Pass" (Pl. 93). The composition is also based loosely on T'ang's, or on some derivative of it, presenting ox carts trundling up a valley between steep mountains, a village with a hostel farther up in the pass, and a Buddhist temple located still higher. T'ang Yin's sensitive evocation of cold, clear wintry air and stillness is quite lost in this greatly enlarged rendering, and the forms adhere too strongly to the surface to allow the viewer to be drawn into this picture as he is into T'ang's. The patterns of vigorously depicted bare trees and the heavy dotting applied throughout serve to enliven and enhance the decorative effect of the picture. As with Kano-school painting in Japan, one must take into account the purpose for which the paintings were intended in order to appreciate their success in fulfilling that purpose.

Hsü Wei   One of Hsieh Shih-ch'en's admirers was Hsü Wei (1521–93), a painter who was also given to heavy applications of ink for striking effects; he wrote of Hsieh:

"In contrast to the other painters of Soochow, who were mostly quite sparing of ink, old Hsieh used ink copiously, to the great astonishment of his fellow citizens. But those who are like dwarfs at the theater [i.e., too short to see for themselves] simply follow the crowd [applauding when the others do]. Such people do not know that when a picture is defective, it isn't the result of heavy or light ink but depends on whether there is sufficient life-movement.

"Chao Fei-yen [a courtesan of the Han period] was slender, and Yang Kuei-fei was stout; the two ladies were thus quite different, and if their masters had changed places, they would not have pleased the men. But if a great connoisseur had looked at them from without [objectively], he would have had no difficulty in finding them both very lovely. That is the way the ancients judged calligraphy and, still more, painting.

"Once old Hsieh came to Yüeh [Chekiang] and finally reached Hangchow. He gave me four or five paintings, all very vigorous. Then he went back home, and his work was ended. When I now look again at this picture, I cannot help feeling sad."[12]

By the time of Hsü Wei's activity as a painter—his dated works are from 1570 and after, and most of the others probably also date from the last decades of his life—neither the heavy landscape style of Hsieh Shih-ch'en nor the conscious craziness of Shih Chung and the other Nanking artists of that group was still in fashion. Nevertheless, Hsü Wei, who (as can be seen already in the above quotation) cared little for fashion, worked in the "Nanking unorthodox" mode on occasion, doing splashy renditions of the once romantic, now conventionalized, themes. As a genuinely deranged painter who was a native of Chekiang Province, he had a legitimate claim to this aberrant offshoot of the Che-school style on at least two scores. We will illustrate his continuation of it, before treating his life and his complex and tragic personality, with two pictures from an undated handscroll (Pl. 81–82) that are among the few surviving landscape-and-figure compositions from his hand.

Hsü Wei is not an artist who is customarily discussed in terms of traditions at all, since his paintings seem, as spontaneous and inspired creations, to claim complete independence from models and conventions. But neither the image of a man seated pensively on a hillock by a broken willow tree nor the scene of a traveler on a donkey and a luggage-bearing servant on foot is in itself especially unconventional in either subject or composition; they gain their effect of

idiosyncratic abandon through the manner in which they are painted. One can imagine Hsü inebriated (as he apparently was much of the time, in his late years) producing these pictures at some drinking party, in the manner of the *i-p'in*, or "untrammeled class," artists of the ninth and tenth centuries whose distant descendant he is, seeming to splash and spatter the ink freely, flourishing the brush as if at random, and astonishing his audience by creating in this improvisatory way rough approximations of more standard representations.

It is in fact the viewer's familiarity with more careful and conventional rendering of similar subjects that makes Hsü's pictures readable at all. The overhanging cliff that the travelers approach and the leafy tree bending down over them are in themselves amorphous, but are registered as familiar images because they had performed the same compositional role, more descriptively portrayed, in innumerable pictures by Chang Lu and others. Similarly, the cluster of dabs and scratchy strokes of ink at the left of the seated man is legible as a clump of bushes only as a result of the artist's having calculated closely the viewer's expectations and given him the right clues. If one sees this as the work of a madman (as Hsü's works are often seen), one must add that there is a distinct and analyzable method in his madness and that it has obvious precedents in the work of such painters as Shih Chung. Hsü Wei's aberrations must thus be distinguished from, for instance, those of Chu Ta of the early Ch'ing period, another "mad" painter, whose images are in themselves disturbing and intensely private.

The life of Hsü Wei is unusually well documented and has been the subject of several detailed studies.[13] We can give only the barest outline of it here. He was born at Shao-hsing in Chekiang Province, the third son of a retired official who died the year he was born. His mother was a concubine and was dismissed from the family when the boy was only nine. He was given a pampered upbringing by his stepmother, Madame Miao, an educated woman whose excessively affectionate treatment of him expressed her own loneliness and frustration. She died when he was fourteen, leaving him in the care of his eldest brother. The effect of such a childhood on a highly sensitive and precocious boy was to implant the emotional disorders that would make a normal life impossible for him. He mastered quickly whatever he turned to: poetry and essays, which he was writing by the age of seven; the *ch'in*, for which he was soon composing works of his own; operatic singing, swordsmanship, calligraphy, and painting—the last two studied seriously from the decade of the 1540s. He passed his first-degree examination in 1540 but failed the provincial examination seven times after that and lived in semipoverty, occasionally making money as a tutor or a professional writer. During this middle period he composed four strange and highly original *tsa-chü*, plays with songs, to which he gave the name *Four Cries of the Gibbon*, and also wrote two important studies of the Southern-style drama.[14]

In 1557 he became secretary to the provincial governor, Hu Tsung-hsien, who was conducting a campaign against Japanese pirates. Hsü, versatile as always, not only composed official documents and memorials to the emperor for the governor to sign but also gave him valuable advice on strategy. Hu Tsung-hsien was imprisoned in 1562, on suspicion of involvement with the powerful and unscrupulous prime minister Yen Sung, who was finally overthrown in that year. Hsü Wei was afraid that he himself would be implicated, and he pretended madness. How much was pretense and how much a real, unfeigned psychosis is impossible now to say. In any case, three years later his mental disorders, aggravated by these strains and setbacks, were severe enough to drive him to attempt suicide by terrible self-mutilation: he drove a nail into his ear, cracked his head with an axe, and smashed his testicles. Shortly before that he had composed his own obituary, expecting to die in that year; it ends with this poem, intended to be engraved on his tombstone:

He survived child disease brightly, and does not deserve to die;—death hurts faith.
Tied in dread, persistently locked in, no need for him to live;—lived for nothing.
Afraid of drowning he jumped in first.

Laugh at Wei, who had a bald head, it is too late to turn him into a monk.
Have pity on his misfortune, once he was an intelligent lad.
He wore the ancient sage's outfit and simulated madness.
Fought time and again to be a normal being.
He was guilty of that,
Now, all is intelligible.[15]

Friends nursed him back to health, but the following year his attacks returned, and in a moment of derangement he stabbed to death his third wife. For this he was sentenced to be executed, but he was spared on the intercession of friends and finally released from prison after seven years of confinement. During the last two decades of his life he was ill and mentally disturbed, and drunk much of the time; although admiration for his writing, calligraphy, and painting was growing among some of his more perceptive contemporaries, Hsü was seldom able to turn this admiration to material advantage and continued to lead an impoverished, hand-to-mouth existence. He often repaid gifts of food or clothing with a painting or a piece of calligraphy, but he alienated well-meaning friends by turning on those who tried to help him. To the man who had procured his release from prison he said: "I was fine in the cage. Now I am all scattered. You misunderstand me!" He lived during his last years with his two sons, until the older could stand him no longer and moved out; he died at seventy-three, penniless, in the household of his younger son's wife.

Tracing the development of Hsü Wei's painting style is hampered by the absence of one crucial link: a painter named Ch'en Hao, one of a group of Shao-hsing literati with whom he associated in the 1540s, may have been the most important single influence on him during his formative period, but no works by Ch'en are known today. Some features of Ch'en's life and artistic activity parallel Hsü Wei's strikingly. He was another child prodigy and an eccentric who renounced a hereditary sinecure to lead an independent life; he composed dramatic lyrics and was probably Hsü's teacher in this form also. He painted, often while drunk, very sketchy landscapes and flowers in ink, in which he "somehow managed to preserve the disciplines in the midst of [apparent] sloppiness and abandon." When we add the earlier example of Shih Chung, we can begin to note a pattern: this manner of painting and the composition of popular songs and drama were both, in the sixteenth century, manifestations of a chosen life style that was outside the Chinese norm for educated men.

Another important influence on Hsü Wei's painting was Ch'en Shun (1483–1544), a Soochow artist who will be treated in a later chapter. Painters whom Hsü mentions with approval in his writing, besides Hsieh Shih-ch'en in the comment quoted above, include Shen Chou and Tu Chin.

Among Hsü Wei's surviving works, the unrivaled masterpiece is a long handscroll in the Nanking Museum; it is signed but bears no date. The painting (Pl. 78–80) is dazzling even in reproduction and overpowering in the original. It presents, in ink monochrome, renderings of a succession of flowers and fruits, banana palms, and trees, some of them drawn close-up and filling the whole scroll. The picture of the peony with which the scroll opens (Pl. 79) is in a style obviously derived from the more reserved manner seen in Ch'en Shun's rendering of the same subject (Pl. 127). It is not, however, made up of brushstrokes of predetermined shape, as Ch'en's can still be said to be, but of irregular patches of ink wash, laid on as if without conscious planning. Where Ch'en Shun's flower, for instance, is a concentric formation of shaded strokes that are allowed to run together slightly but are still distinguishable, Hsü Wei's is a single ragged-edged puddle of ink, through which darker ink suffuses to suggest the same manifold petal structure that Ch'en Shun portrays more fully.

The peony is followed by some others of Hsü Wei's favorite subjects—a pomegranate, lotus,

a broad-leafed tree, chrysanthemums, and a melon with its vine and leaves (Pl. 78). In this last, the brush has quickened and does not pause to describe the joinings of parts of the plant; it is the continuity of movement itself that binds the image together. Nevertheless, within this method, Hsü Wei manages to convey some sense of the weight of the melon and the springiness of the vine. Moreover, his brilliant scaling of ink values is as effective in giving a spatial existence to the cluster of vines and leaves as some illusionistic technique from the West might be, and preserves more of the appearance of growing life.

This scroll is one of the small group of Chinese paintings that seem, through some effortless and near-miraculous transmutation of visual form into brushstrokes, to reconcile ideally the excitement of ink-and-paper calligraphy with a deep commitment to the object, its underlying nature and its visual properties. T'ang Yin's painting of a bird on a branch (Pl. 99), in which the depiction of the branch anticipates Hsü Wei's style, is another. Such paintings seem to have escaped the process of conventionalization that normally intervenes between a natural image and its re-creation on paper. Hsü Wei does not by any means abandon the conventions altogether, as we could easily demonstrate with other comparisons like the one with Ch'en Shun's peony, but he violates and expands them selectively, and those he retains are skillfully altered so that they do not read as conventions but as fresh means of description. He runs together lines and shapes, avoids the well-established brushwork types, and exploits techniques which, if not wholly new, were at least uncommon, such as the shaded stroke produced by uneven inking of the brush, the mottling of a wash area by touching darker ink into it while it is wet, or the drawing of split-brush lines vigorously over the inked leaves, to trace veining but even more to charge them with an electric force.

The climax of the scroll is reached in a long passage portraying grapevines (Pl. 80)—or, another opinion has it, wisteria; the forms are ambiguous enough to allow such an alternate reading. Two vines, drawn as long, ragged strokes with a semidry brush in the *fei-pai* ("flying white") technique of calligraphy, snake across the surface between heavy groups of leaves, which are painted in powerful overlays of massed ink. The pendant bunches of grapes (or flowers) are seen between the leaves and vines, depicted with loosely clustered dabs of dilute ink. Over all this is drawn a network of twisting tendrils.

But to describe the painting in such a way is to suggest a stricter assignment of representational functions to the brushstrokes than the artist gave them; in fact, the furious momentum of Hsü Wei's brush and the free splashing of ink go far toward erasing distinctions, and some passages, such as our Pl. 80, could hardly be recognized in isolation as representing anything at all. As in Hsü Wei's landscapes and figures (Pl. 81–82), the brushstrokes and splashes of ink work suggestively in the context of the whole image, and their suggestiveness depends in part on the viewer's unconscious memory of similar but more conventionally rendered pictures. The relationship of Hsü Wei's grapes to a traditional painting of the same subject is like that of a highly cursive *ts'ao-shu*, or draft script, writing of a poem to a transcription of the same text in the standard script: the viewer remembers the poem and reads the cursive characters, which are often in themselves nearly or entirely illegible, by referring their kinetic structures to the more controlled movements that would produce the standard characters. In both painting and calligraphy, it is the tension between the understood norm and the work as executed that creates the effect of unconventionality or, in extreme cases as here, of wildness.

Such semicontrolled applications of ink had a long tradition in China, beginning with the *i-p'in* ink-splashers of the T'ang dynasty and continuing through the Ch'an Buddhist artists and others of the late Sung. A painting of grapevines dated 1291 by the eccentric Ch'an monk-artist Jih-kuan, for instance, could be seen as a precedent for Hsü Wei's grapes;[16] in the thirteenth-century context it seems itself splashy and unconstrained but conveys nothing like the fervor of Hsü Wei's performance. The conventions from which it departed were tighter, and even a

radical departure from them carried the style to a point of dissolution that was still far short of what was possible in the late sixteenth century. Hsü Wei's style probably represents the extreme point reached in that direction by Chinese painting, at least up to the present century. As such, it continued to inspire later artists who were inclined by taste or temperament to bold and extravagant manners of painting. That it can be seen today as a striking precursor of Abstract Expressionism is therefore no accident, since this modern movement was inspired in turn by the practice of Far Eastern calligraphers and painters.

It is natural, then, even inevitable, to see Hsü Wei's painting style as an unmediated out-pouring of the painter's deranged mind. In passages such as the grapevines of the Nanking scroll, the fury of his attack of brush on paper, and what appears to be a kind of automatism in his barely controlled movements, seem to betray a psychic state bordering on delirium. But an important qualification must be made when we see Hsü Wei's paintings in the light of twentieth-century Expressionism: nothing in them quite corresponds, in expressive intent or effect, to the dissonant colors, cruel distortions, or nightmare-like images by which European Expressionists sought to exteriorize their internal anguish. The tortured inner life of Hsü Wei, which is the very content of much of his writing, has not been projected with anything like the same self-revelatory pathos into his paintings. We may account for this to some degree as a difference in media, or in the expressive potential to which those media had been developed; the truth remains that while Hsü's paintings convey a high intensity of feeling, impetuosity, sometimes violence, nothing in them would in itself necessarily suggest the tragic character of the man to a viewer who encountered them in ignorance of Hsü's life. Such a viewer could easily, in fact, if he chose to adopt a psychological approach at all, see the paintings as revelations of a brilliant, high-strung, but essentially well-adjusted personality. They express a sense of release rather than of repression, and this may be a key to their effect: as a channel for drawing off some of the psychic energy that fed his turbulence, painting was probably for Hsü Wei more therapeutic than symptomatic. One's emotional response on retracing empathically the movements recorded by one of his paintings is thus a feeling more of liberation than of discomfort.

The quality of the visually and emotionally uncomfortable in Chinese painting is to be experienced more frequently in the works of artists who had, so far as we know, reasonably stable personalities: Wang Meng, Wen Cheng-ming, Wu Pin, Tung Ch'i-ch'ang—painters who worked more calculatedly than did Hsü Wei and who chose to include deliberate dissonances and tensions as part of their calculations.

## 4. LIFE PATTERNS AND STYLISTIC DIRECTIONS

We have touched a number of times in this chapter and the preceding ones on the correlations that can be observed between the artist's position in society and the styles in which he works. Correlations of this kind have always been assumed by Chinese theorists and historians of paintings, and the assumption underlies much of what they write about particular artists and schools. Some Occidental writers in recent years, by contrast, have been inclined to deny that social and economic factors affected art as decisively as the Chinese have maintained. They have questioned, that is, whether the artist's amateur or professional status is really a significant determinant of style, or whether the distinction between the Che and Wu schools is a clear and useful one. We have here another instance of the classical confrontation of the "splitters" and the "lumpers," as some perceptive person has termed them. Splitters move toward understanding by recognizing distinctions, by classifying and categorizing; lumpers tend to blur over the distinctions and to doubt their validity. The reader who has come this far will not need to be told that the present writer is a confirmed splitter, and so will not be surprised at the discussion

that follows, which will argue that the distinctions are clear and useful—that the correlations between life patterns and stylistic directions, that is, are real and demonstrable—and will suggest why this is so.

The lumpers' arguments have often been advanced in defense of Che-school and other professional artists as attempts to rescue these artists from what the writers believe to be prejudice and social snobbery on the part of Chinese critics. Those arguments, as far as they go, have much merit; Chinese critics have indeed often been prejudiced and snobbish, and their bias has colored their judgments of artists and paintings. The remedy, however, is to try to eradicate the bias, not to argue that the distinctions are invalid. Otherwise, one makes the mistake of Wang Shih-chen, quoted in our first chapter, who thought he was praising Tai Chin by saying that a certain series of paintings by him could hardly be distinguished from the works of Shen Chou. That kind of praise Tai does not need, and would doubtless disavow.

The distinctions commonly held to affect style in Chinese painting are the ones usually adduced in other areas of art: distinctions of period, of locale, of the artist's social and economic status, of his individual character and personality. The first two and the fourth give little trouble; they are accepted by most people as playing significant parts in setting the coordinates by which styles are defined. The third is the difficult one. People who would admit the others as determinants stick at this; they seem to be disturbed, for good, liberal, somewhat confused reasons, by the idea that style has any clear correlation with the social position of the artist or the economic basis of his activity, and resist assigning any significance to such distinctions as professional vs. amateur, or gentry vs. plebeian. This is apparently because such distinctions, as the Chinese have made them, carry unpleasant associations of class prejudice. Those who object point out that artists of different classes and types associated with each other, or made occasional intrusions into each other's stylistic territory. But after granting these quite unobjectionable points, one has only to return to the paintings and the accounts of the artists' lives to find correlations between them that are clear and demonstrable. The question is not whether these are genuine correlations—of course they are—but rather, how they are to be explained or accounted for.

In asking this question we come to the crux of the problem. Objections to associating style with social status, or with amateurism or professionalism, are really directed at the idea that such a status is like a quality inhering in the artist which has its natural expression in a certain kind of style. Taking that view seems to argue for the artist's style being predetermined by the circumstances of his birth and upbringing, and to allow little freedom of choice. But the effect of these factors on style need not be understood in that way at all. Another kind of explanation could be offered, one that has considerable currency today in analogous situations, such as, for instance, the differences in speech, behavior, and other forms of expression between the sexes. If we were to assemble an exhibition of paintings by Chinese women artists, we could no doubt find common characteristics in most of the works which are not common to Chinese painting as a whole, and which we might then proceed to designate as features of "feminine" styles. But if we were to explain this by saying or implying that the artists painted that way because they were women—as though, that is, these styles were the natural and more or less inevitable expressions of the "feminine temperament"—strong objections would be voiced, and properly, since the idea is indeed objectionable. Instead, one deals with such a phenomenon now, typically, by pointing out that a person grows up and develops in an atmosphere in which certain expectations are always present; girls are expected to act like girls and boys like boys, from the earliest age. The same situation continues into their creative periods as artists, and they tend to conform, without necessarily thinking about the matter or even being aware of it. Women artists in China seem to have done this, painting generally in restrained, sensitive manners rather than the bold and "virile" ones, specializing in orchids or flowers-and-birds or other "suitable" subjects.

In an analogous way, artists occupying certain positions in Chinese society, and functioning on

certain economic bases, were subject to corresponding expectations from all around them, and from inside themselves as well; their choices of styles were affected, within broad limits even determined, by the sets of expectations that applied to their particular situations. Shen Chou and Wu Wei, that is to say, could not have changed places, each painting the other's pictures. Shen worked within a spectrum of styles allowable for someone in his social position, and Wu Wei within another spectrum allowable for his. Within each there was room for great diversity and manifestations of individual genius, but each had boundaries outside which the artist seldom if ever ventured.

The amateur-professional classification and the styles associated with each category are in considerable part to be accounted for in the same way. The amateur, however proficient he might be in reality, could not venture too far into the realm of the accomplished technicians and their Sung-derived styles without risking adverse criticism. Nor could the professional, even when he was affecting a degree of "amateurish" ineptitude, fail to display behind this his real technical virtuosity—true amateurishness was for him unacceptable.

It is more interesting, however, to go beyond that broad division, as well as the standard Che-Wu distinction, to recognize recurrent types among Ming artists—to observe, that is, the degree of stylistic conformity that exists in the works of artists whose lives follow a common pattern, such as the one (the "cultured professional" type) of which we have seen a number of examples in the last two chapters. We will consider that type again as a general phenomenon before going on to its great Soochow exemplar, T'ang Yin, and two other painters associated with him.

In speaking of established expectations we raise the question of how they are established, how the pattern is set. For the Ming dynasty and for the type we are considering, it was Wu Wei who provided the paradigm. Tai Chin was, of course, Wu's predecessor in important features of style and in some features of his career as well, but Tai seems not to have been properly an artist of this type. In a search for more distant forerunners we could go all the way back to the eighth-century Wu Tao-tzu, to whom Wu Wei was likened, and who established basic characteristics for the type: childhood evidence of a "divine" talent; nonconformity in personal behavior, including a fondness for drinking; service as a court painter greatly admired by the emperor (i.e., dependence on high-level patronage—all painters of the type were of course not court painters); and a virtuoso manner of working which dazzled his viewers (although we have no direct evidence for Wu's style in the form of extant works or even reliable copies, he is reported to have worked swiftly and is assumed to have adapted into his painting style something of what he learned from the "wild" calligraphy of his teacher Chang Hsü). This suggests a mode of drawing somehow akin to the cursive mode of calligraphy, within the stylistic context of his time, some variety of the "running" manner.

In the Sung period, Liang K'ai might be cited as another model. Heavy drinking and eccentric behavior are reported of him as well; he served as a court painter but left the Academy voluntarily; and he moved, in style, between a relatively conservative, even academic manner and one brilliantly cursive and abbreviated.

The characteristics of this type of artist in the Ming include the following (not all applicable, of course, to all): lower- or middle-class origins, or family impoverishment; early signs of intellectual brilliance; education directed toward civil-service careers, which are somehow aborted; eccentricity, sometimes to the point of feigned or even real madness; the adoption of nicknames or studio names containing such words as *hsien* ("transcendant"), *k'uang* ("crazy"), or *ch'ih* ("fool"); participation in popular culture, the drama, songs, etc.; a penchant for elegant urban dissipation in wineshops and brothels; a willingness to fraternize with, but not to be subservient to, the rich and powerful. Artists of this type are active in the great cities, Nanking and Soochow, although they may come from the provinces. In their socio-artistic positions they might be termed "cultured professionals," since they belong neither with the scholar-amateurs nor with the more or less uneducated "artisan painters." In style, they tend to move smoothly

from conservative Sung-based styles into virtuoso, cursive renderings of the same, in brush drawing of the kinds we have termed scribbly and splashy. Or they may, judged at least by extant works, practice only the latter varieties of style. They paint figure or figure-in-landscape compositions, often with historical or literary *ku-shih* themes, as well as bird-and-flower pictures. Pure landscapes are less common, and they are not ordinarily invited to portray scholar-officials' retirement villas or farewell gatherings, as the amateur artists are. (This restriction relaxes, as we shall see, with T'ang Yin.)

Painters who belong to this type and exhibit most if not all of these characteristics include Wu Wei himself, Hsü Lin, Chang Lu, Sun Lung, Shih Chung, Kuo Hsü, Tu Chin, and Hsü Wei; others whom we have not treated could be added.[17] The works of any one of these might, if considered in isolation, be taken as direct revelations of the artist's individual personality and situation in life; it is only when the painters and their paintings are observed as a group that the recurrences become apparent, bringing us to the inescapable conclusion that even these unconventional masters, whether they were aware of it or not, followed models for their unconventionality.

When we read the life of T'ang Yin, in the next chapter, we shall find that it fits neatly the pattern for this type and shall expect to find corresponding affinities in style. We shall not be disappointed; T'ang is a more complex figure than the others, both in his person and in his styles, and only part of his output relates closely to Wu Wei, Tu Chin, and others, but it is a large and important part. Nor will we be surprised to learn that he visited Nanking shortly before turning to painting as a career. Conversely, when we read in the last chapter about T'ang's exact contemporary and friend Wen Cheng-ming, whose life differs from this pattern at virtually every point, we will expect his paintings to differ accordingly, as indeed they do. We have, in other words, seen and learned enough of Ming painting already to recognize the types and have our own expectations.

# CHAPTER FIVE

# The Soochow Professional Masters

In considering the Academy and Che-school masters, we noted in passing the existence of local schools in the early Ming period—those in Hangchow and Ning-p'o in Chekiang Province, as well as others in Fukien and Kuangtung provinces—within which artists continued to base their styles on Sung traditions. These schools and artists are largely unnoticed today, although they may well be responsible for the bulk of the early Ming painting that survives (most of it now ascribed to earlier and more illustrious masters) and may also have produced, in sheer quantity, most of the painting of their period, although not the most original or interesting. The Sung, as the culmination of the early development of Chinese painting and the apogee of the main conservative tradition, remained through all the later centuries the principal inspiration and stylistic source for artists of a conservative bent, still devoted to technically finished and representationally directed styles, or professional artists induced by the demands of their public to adhere to these still-popular styles, whatever their private inclinations may have been. Such painters, working in many places and using many derivatives of the Sung models, made up a common, broad base out of which arose the new movements and individual or local innovations. They were often regarded with disdain by the literati artists and critics, and often deserved to be. The most efficacious remedy for the stagnation from which they suffered seems to have been the kind of lively interaction of artists of different backgrounds that a city like Nanking could offer, and the chance to see old paintings in a diversity of styles in private collections or in the imperial collection.

From the beginning of the sixteenth century, Nanking was gradually replaced by Soochow as the city in which the most fruitful intercourse of artists, patrons, and collectors took place. The greatest collections were by this time located in the Soochow region. Moreover, Soochow's long-established tradition of literati painting interacted with the professional tradition in mutually beneficial ways, as had never happened at Nanking, where no comparable school of scholar-amateur artists had grown up. Throughout the sixteenth century, it is the Soochow masters, both professional and amateur, who accomplish the most bounteous production of excellent painting. This chapter will be devoted to the greatest of the Soochow professionals, three artists active in the early decades of the century.

There is little information available on the earlier phases of the Soochow professional tradition, and very few works to represent it. Nevertheless, we can suppose that a local school of conservative masters working in Sung styles preceded the painters we are about to consider. A follower of Sheng Mou named Ch'en Kung-fu worked in Soochow in the early part of the century;

he was the teacher of Ch'en Hsien (1405–96), who "could do imitations of old paintings so good they could almost be confused with the originals." Ch'en Hsien was a close friend of Tu Ch'iung, and in 1488 he was invited to the court in Nanking and "presented with a cap and girdle," symbolic apparel that was usually the insignia of the literati. Ch'en is today represented only by three unpublished paintings preserved in the Tōfuku-ji, a Buddhist temple in Kyoto.[1] They are landscapes with buildings and figures—travelers, scholars, courtiers, fishermen—and are are clumsily organized hack performances that surely cannot show at his best an artist with whom Tu Ch'iung associated by choice, or whom the emperor chose to honor. Quality aside, however, they reveal Ch'en to have been a very conservative practitioner of a fine-line manner of painting who fills his pictures with anecdotal detail. For his rocks he uses a heavy-handed version of the "axe-cut" manner of Li T'ang, with deep shadows. If these pictures represent fairly the Soochow professional tradition in the fifteenth century, it would appear to have been largely independent of contemporary developments in the Che school and to have offered less of creative reworking of the Sung materials.

## 1. Chou Ch'en

Ch'en Hsien's pupil was Chou Ch'en, who was born around the middle of the century and must have died shortly after 1535, the year of his last dated work. It was Chou Ch'en who raised the professional side of Soochow painting to a level commensurate with that of the scholar-amateur side and who was the teacher of its two most renowned figures, T'ang Yin and Ch'iu Ying. Chou Ch'en himself has generally been underrated, cast in the shadow of his more illustrious pupils; but in the light of his works, when these are assembled and surveyed, he stands forth as a painter of more breadth and power than he has been credited with by either Chinese or Western critics. Wang Chih-teng, writing his brief account of Soochow painters only about thirty years after Chou's death, comments slightingly on him: "He was praised by everybody in his time as an artisan-painter [i.e., for his technique]; the feelings of loneliness and solitude, the flavor of remoteness and reserve, were not within his reach." Late Ming sources say that he was "outstanding among the academic painters," that his brushwork was "full-bodied and mature," and that he "excelled especially in the so-called 'running' manner"—this is the manner that we have in the preceding chapters termed "scribbly."

Chou Ch'en seldom writes more than a simple signature on his paintings; although the *Huashih hui-yao* reports that he could compose poetry, no surviving work bears a poetic inscription by him. With a single exception ("Beggars" of 1516) he tells us nothing of his thoughts or circumstances at the time he did the pictures, nor, except in a few cases, does he even date them. All this is quite in keeping with professionalism, but it means that, as with most Chinese professional painters, we have no solid basis on which to trace the development of his style. If we suppose (insecurely) that his early works should be in his most traditional and meticulous manner, the "North Sea" handscroll (Pl. 84) is an ideal one with which to begin.

This painting is composed and executed as faultlessly as any that Ming painting can offer; there is nothing in it that seems arbitrary, or calligraphically assertive, or the outcome of momentary whim. Spontaneity is irrelevant to its character, as is, almost, to all but art historians, the fact that it is a work of the late fifteenth or early sixteenth century rather than of the twelfth. It is a near-perfect replication of the Li T'ang mode as practiced in the Southern Sung period by Academy artists, in whose works parallels can be found for the rising diagonal movement of its composition, its old-fashioned but effective portrayal of raging waters and wind-whipped trees, its program of building to a climax that centers on the figure of a man sitting at the open window of his house, looking out into the storm. The ending is made up of massive cliffs and boulders,

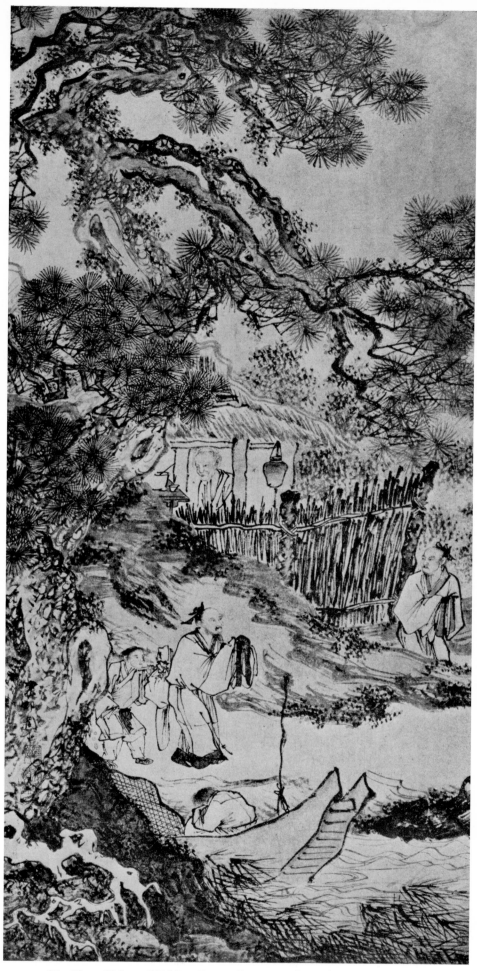

83. Chou Ch'en: "Bidding Farewell at a Brushwood Fence." *Hanging scroll, ink and colors on paper, 120.5 × 56.8 cm. Nanking Museum.*

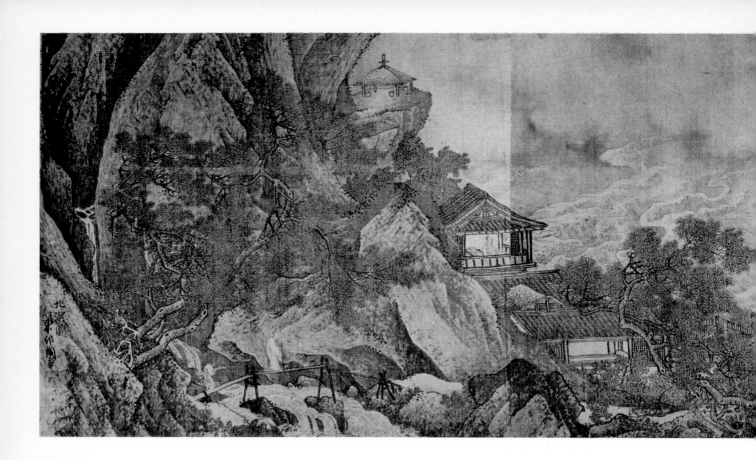

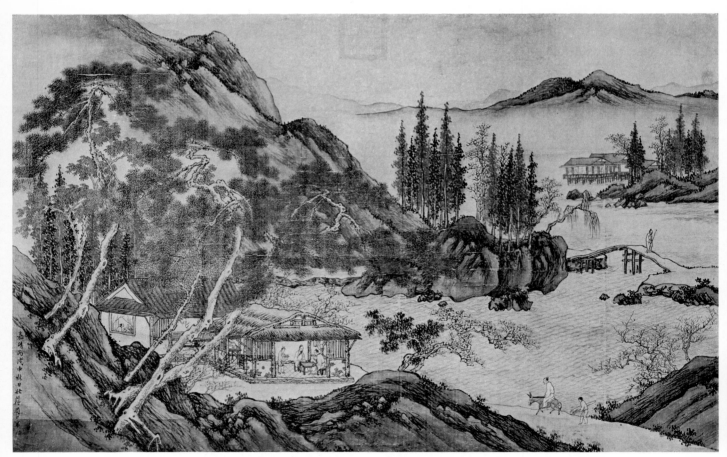

85. Chou Ch'en: ''Playing Wei-ch'i Beneath Pines.'' *Dated 1526. Hanging scroll, ink and light colors on silk, 84.2 × 132.2 cm. National Palace Museum, Taipei.*

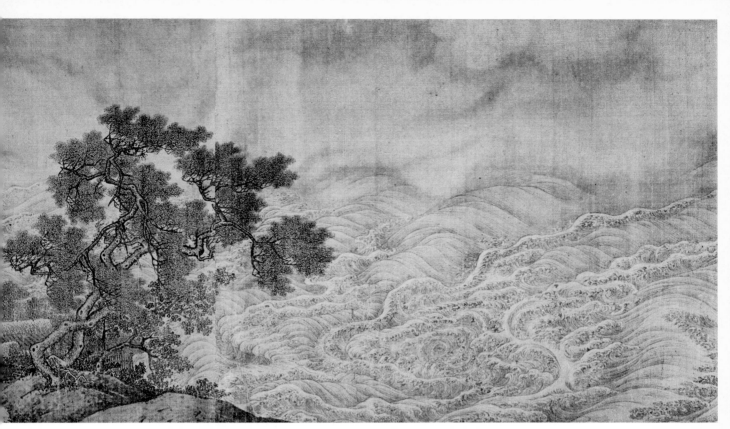

84. Chou Ch'en: "North Sea." *Section of a handscroll, ink and light colors on silk, 28.6 × 135.3 cm. Nelson-Atkins Gallery, Kansas City.*

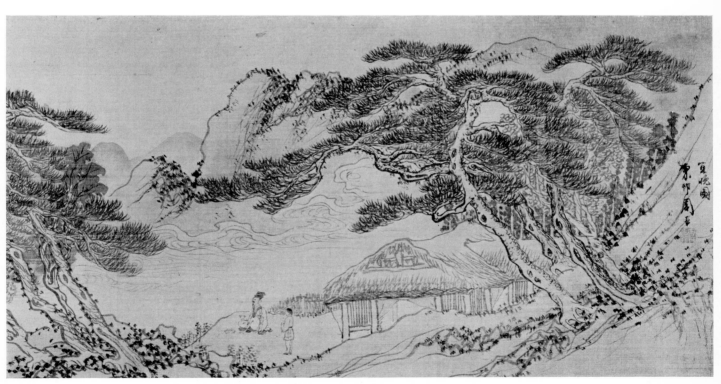

86. Chou Ch'en: "Enjoying the Dusk." *Section of a handscroll, ink on silk, 28.2 × 105 cm. National Palace Museum, Taipei.*

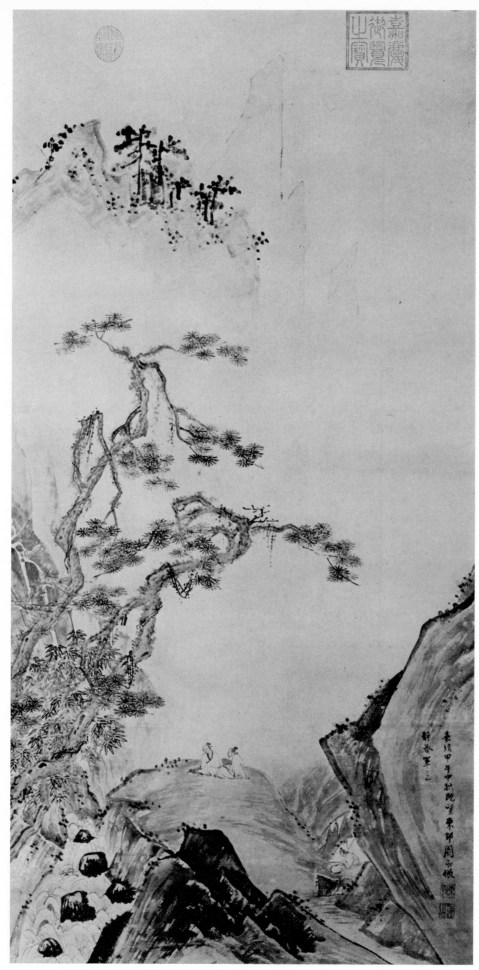

87. Chou Ch'en: "Poetic Feelings Beneath Pines by a Stream." *Dated 1534. Hanging scroll, ink and light colors on paper, 114.6 × 53.1 cm. National Palace Museum, Taipei.*

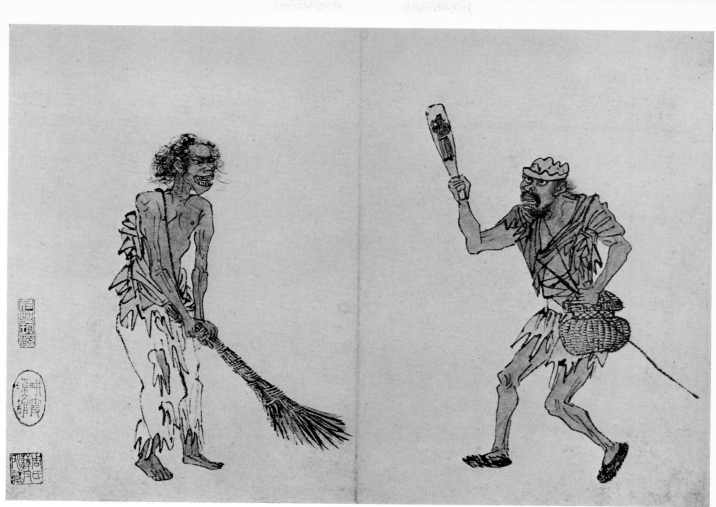

88–89. Chou Ch'en: from "Beggars and Street Characters." *Dated 1516. Album leaves mounted in a hand-scroll, ink and colors on paper, 32.9 × 843.9 cm. Honolulu Academy of Art, gift of Mrs. Carter Galt, 1956.*

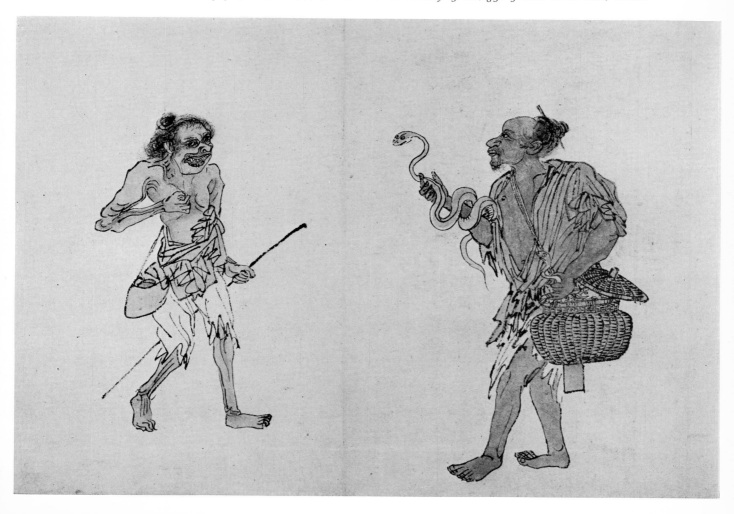

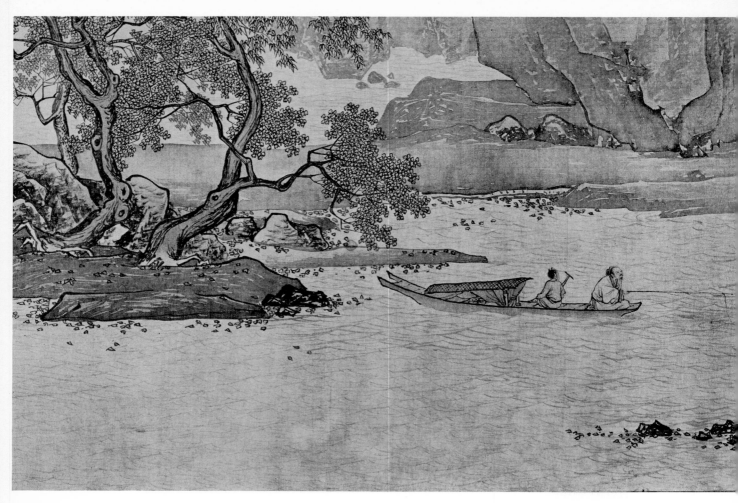

▲ 90. T'ang Yin: ''Secluded Fishermen on an Autumn River.'' *Section of a hand-scroll, ink and colors on silk, 29.4 × 351 cm. National Palace Museum, Taipei.*

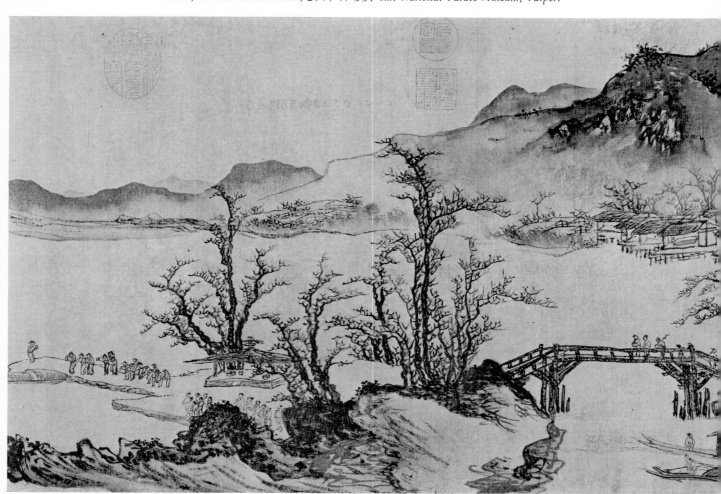

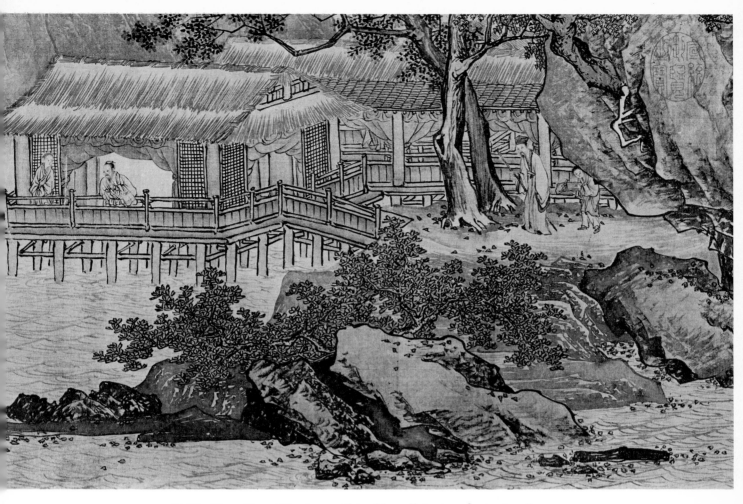

▼ 91. T'ang Yin: "Parting at Chin-ch'ang." *Section of a handscroll, ink on silk, 28.5 × 126.1 cm. National Palace Museum, Taipei.*

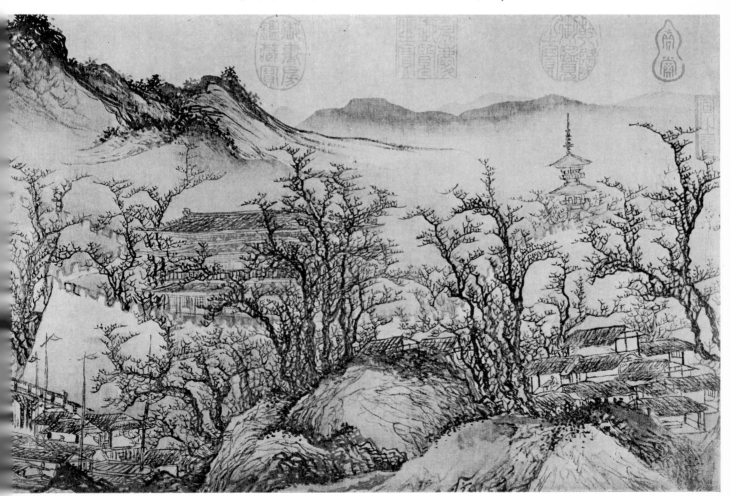

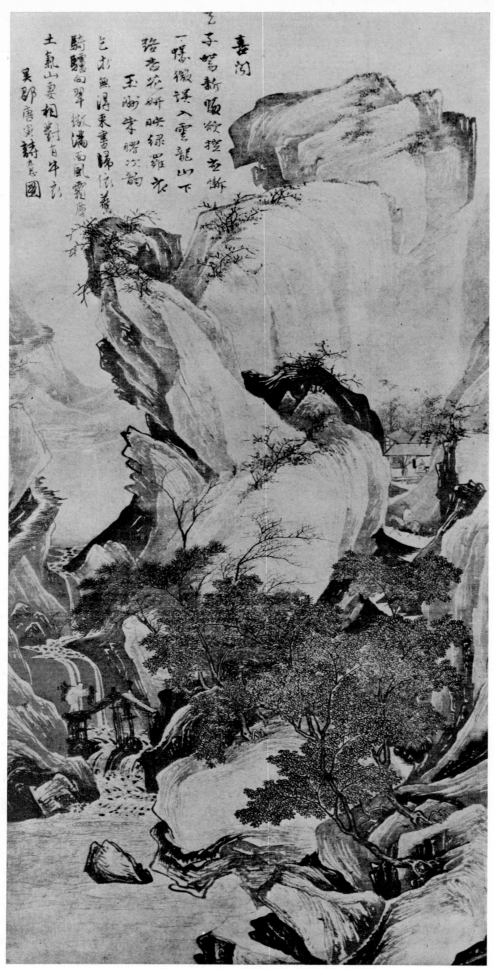

喜洵
王孫駕新暖欲控忘懶
一鶏徽誤入雲龍山下
路杏花妍映綠羅衣
玉顔李暫沉韵
乞求無得來書歸你養
騎驢向翠徽滿面風霜廛
土氣山妻相對百年飛
吴郡唐寅詩意圖

92. T'ang Yin: "Poetic Thoughts: Traveling by Donkey." *Hanging scroll, ink on paper. Former Wu Hu-fan collection, Shanghai.*

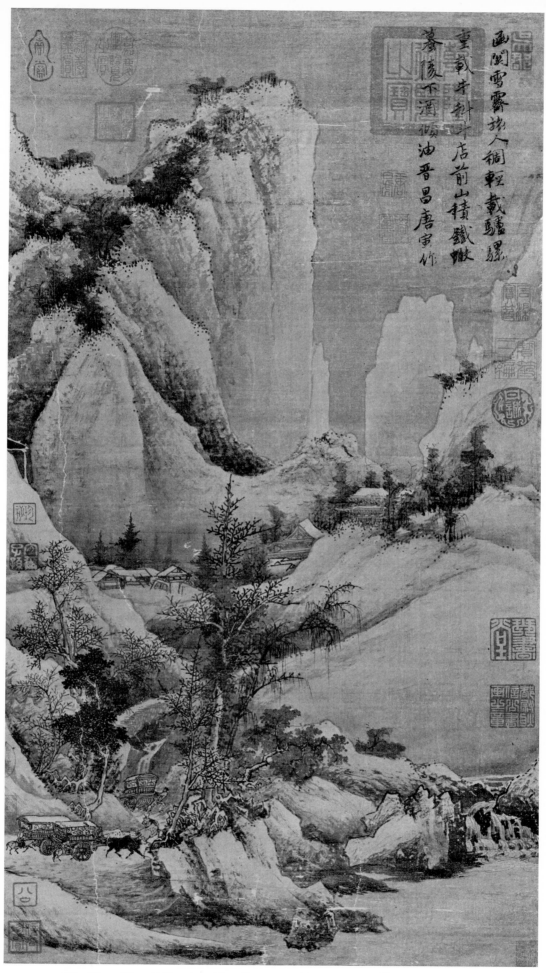

函關雪霽旅人稠 輕載驢騾
重載牛 科斗店前山積鐵
蓁蓁後下酒壚油 晉昌唐寅作

93. T'ang Yin: "Clearing After Snow in a Mountain Pass." *Hanging scroll,*
*ink and light colors on silk, 69.6 × 37.3 cm. National Palace Museum, Taipei.*

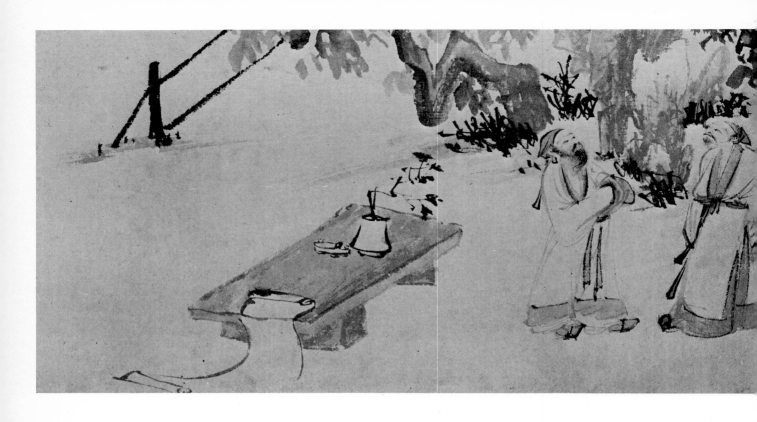

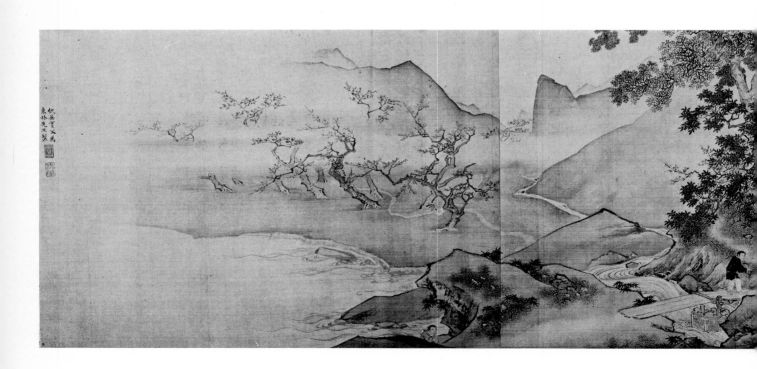

94. T'ang Yin: "The Noble Scholars" *(Kao-shih t'u). Handscroll,*
*ink on paper, 23.7 × 195.8 cm. National Palace Museum, Taipei.*

95. Ch'iu Ying: "Master Tung-lin's Villa" *(Tung-lin t'u). Section of a hand-*
*scroll, ink and colors on silk, 29.5 × 136.4 cm. National Palace Museum, Taipei.*

一宿囷稜進旅中短詞聊以
識泥泥當時我作陶穀者
何必尊前面發紅 唐寅

96. T'ang Yin: "T'ao Ku Presenting a Poem." *Hanging scroll, ink and colors on silk, 168.8 × 102.1 cm. National Palace Museum, Taipei.*

憶昔吳江楓落
時長天秋水
動漣漪招々
舟子橫塘畔
攬物風人弓
所思
乾隆御筆

97. Ch'iu Ying: "Waiting for the Ferry in Autumn." *Hanging scroll, ink and colors on silk, 155.4 × 133.4 cm. National Palace Museum, Taipei.*

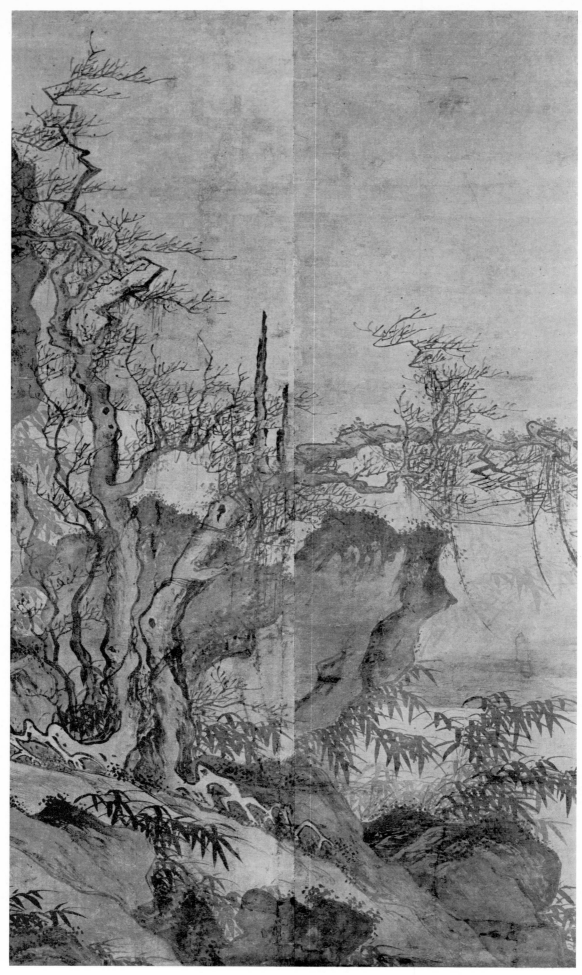

98. T'ang Yin: "Trees, Bamboo, and Rocks by a River." *Pair of hanging scrolls,
ink on silk, 107.5 × 30.5 cm. Courtesy of Museum of Fine Arts, Boston.*

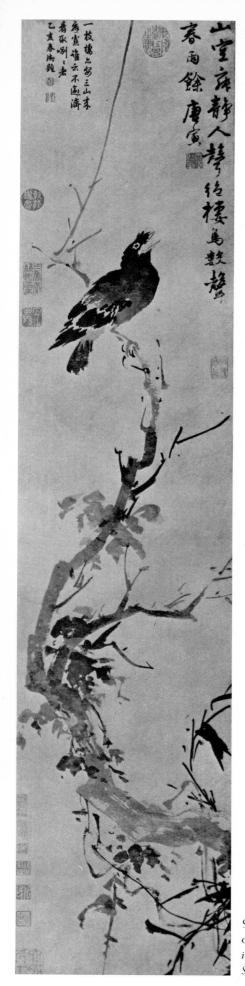

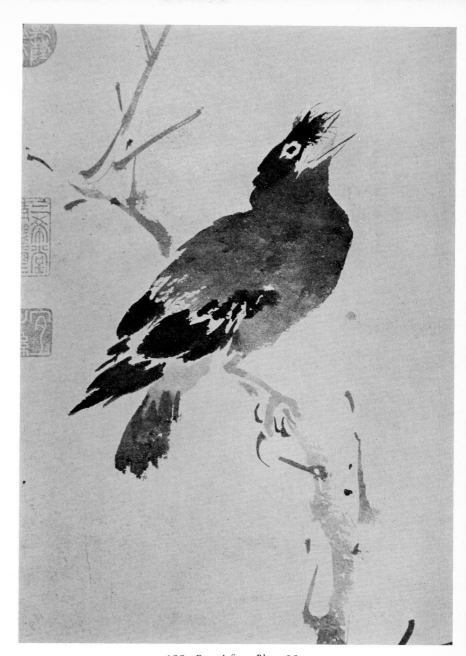

100. *Detail from Plate 99.*

99. T'ang Yin: "Singing Bird on a Branch." *Hanging scroll, ink on paper, 121 × 26.7 cm. Shanghai Museum.*

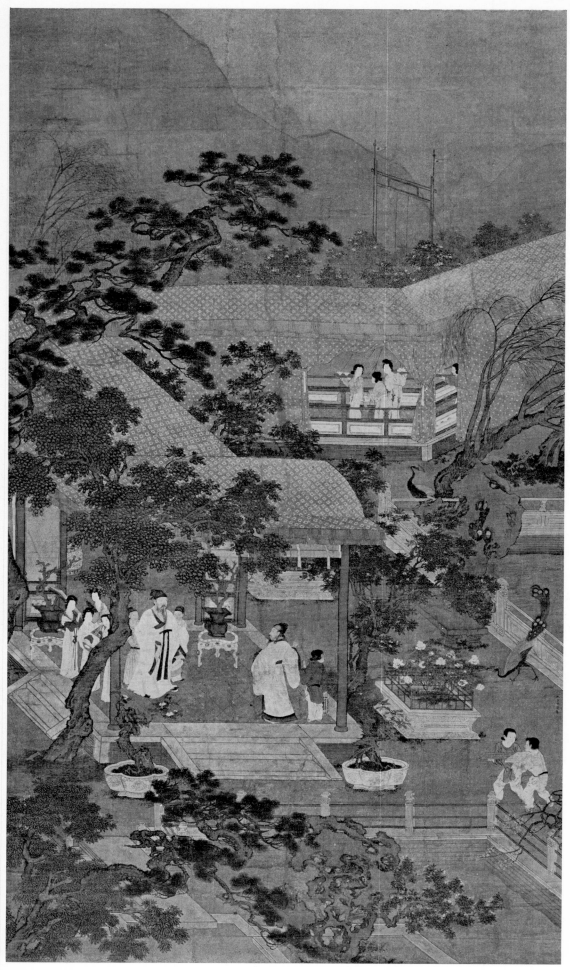

101. Ch'iu Ying: ''The Golden Valley Garden'' (Chin-ku yüan). Hanging scroll, ink and colors on silk, 224 × 130 cm. Chion-in, Kyoto.

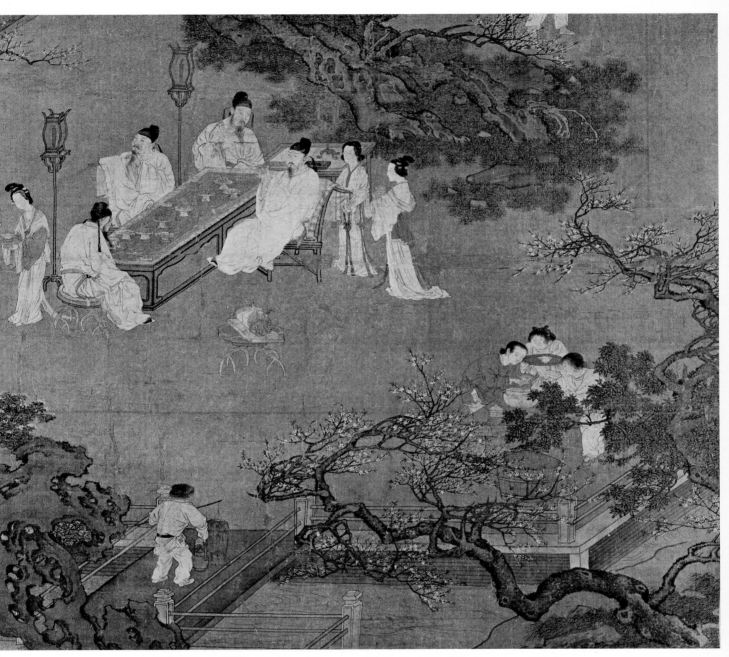

102. Ch'iu Ying: "The Garden of Peach and Pear Trees" *(T'ao-li yüan)*. *Detail from a hanging scroll, ink and colors on silk, 224 × 130 cm. Chion-in, Kyoto.*

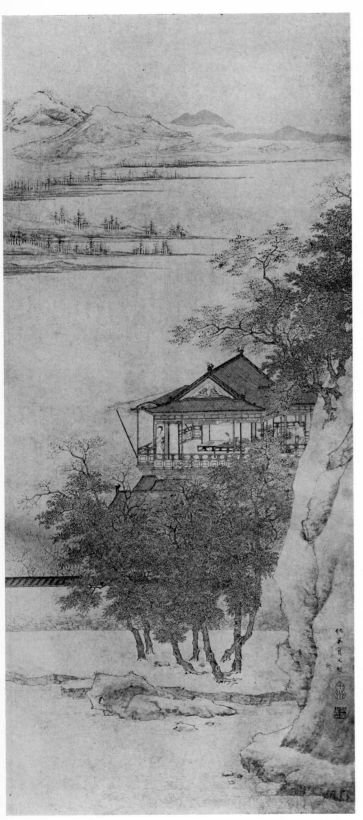

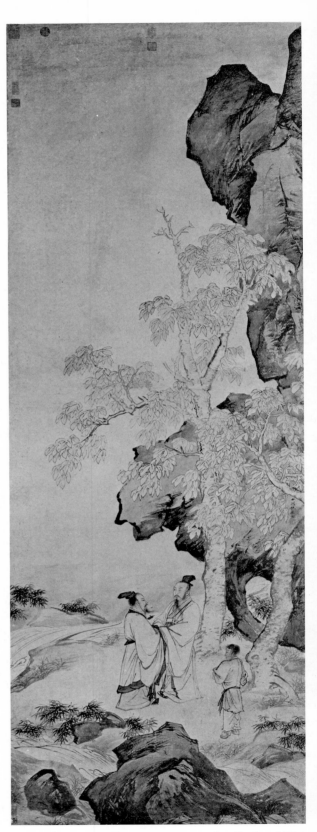

103. Ch'iu Ying: "Lady in a Pavilion Overlooking a Lake." *Hanging scroll, ink and light colors on paper, 89.5 × 37.3 cm. National Palace Museum, Taipei.*

104. Ch'iu Ying: "Conversation in the Shade of Wut'ung Trees." *Hanging scroll, ink and light colors on paper, 279.5 × 100 cm. National Palace Museum, Taipei.*

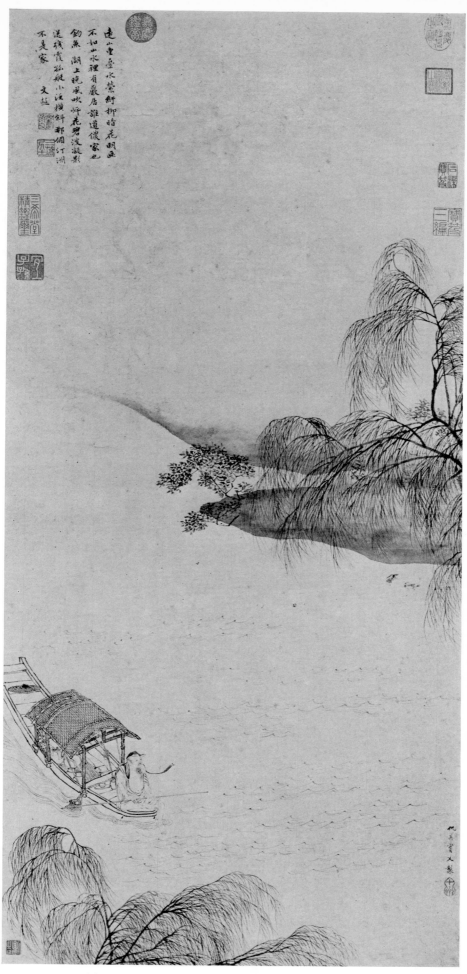

105. Ch'iu Ying: ''Fishing Boat by a Willow Bank.'' *Hanging scroll,
ink on paper, 102.9 × 47.2 cm. National Palace Museum, Taipei.*

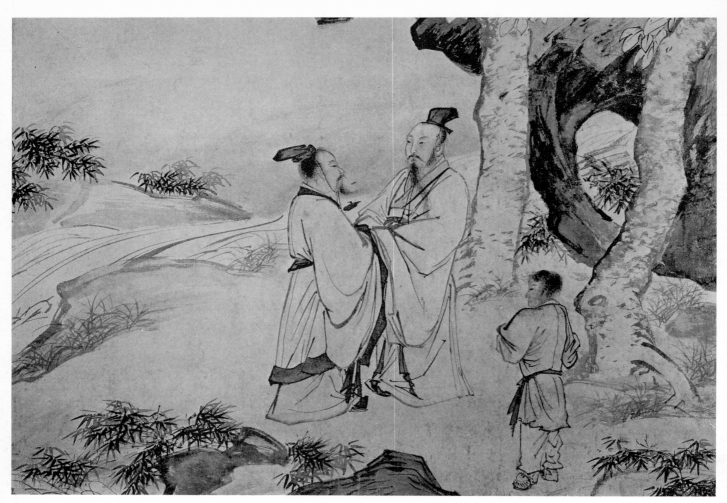

106. *Detail from Plate 104.*

107. *Detail from Plate 105.*

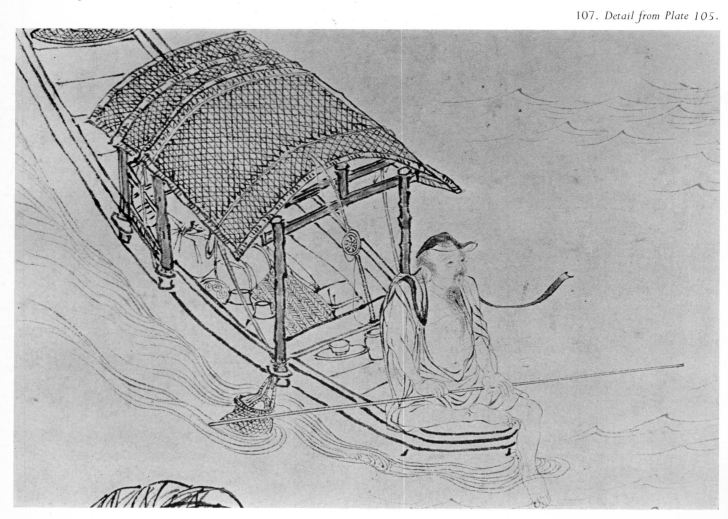

through which a stream rushes. A visitor, followed by his servant carrying a *ch'in*, crosses a rustic bridge to approach the house. The rocky surfaces are rendered with axe-cut texture strokes, and shadowed vertical or slanting fissures set up a forceful cadence within the dynamic structure.

The issue of originality seems also beside the point here; in an age of mild scenery and self-conscious evocations of the past, this must have stood out by its very fidelity to a mode of painting that concerned itself with sensory experience in a palpable world. Since the use of the Li T'ang style is not of a consciously archaistic kind and does not intrude on the pictorial aspect of the painting—which does not depend for its expression, that is, on the antiquity of its style, but is (like works of Ch'iu Ying to be considered later) art-historically unconscious and independent—no screen of style-consciousness intervenes between the viewer and the scene presented by Chou Ch'en, and his wind and rain, his waves and rocks and pines and figures, evoke a more immediate emotional response and appeal more directly to the senses than do the materials of most Ming paintings. Chou is not using the scenery as a vehicle for the presentation of an old style, but using an old style that suits his descriptive intent to present vividly a moving scene.

Whatever the date of this work, it exemplifies Chou Ch'en's fundamental commitment to the landscape manner of Li T'ang, which is evident also in most of his other conservative works. A professional painter in China typically began in this way by mastering some traditional style, from which his individual style departed in some definite direction. If we suppose Chou Ch'en to have followed that pattern, the problem of understanding his stylistic development becomes one of defining the particular direction he took.

His "Playing Wei-ch'i Beneath Pines" (Pl. 85), although it is dated 1526 and thus cannot properly be used to represent any formative stage in his career, suggests, when juxtaposed with the "North Sea" scroll, a move into a swifter, more linear, "scribbly" manner. The artist foregoes the painstaking rendition of textures and detail, nuances of tones and transitions, in pursuit of the greater fluency and visual excitement of the running-line drawing, which carries the eye restlessly over flowing surfaces and along continuous contours. The "axe-cut *ts'un*" of the more traditional manner, applied as separate strokes that stabilize the forms, are replaced by veiny networks (reminiscent of Sheng Mou's) that seem to continue the fish-net pattern of the water onto the land. Pine trees, already attenuated in the "North Sea" scroll, are drawn out to even greater height, as if by the sheer momentum of their contour drawing. In place of the angular structure of rocky cliffs, the composition is based on curving and arching movements, with a few vertical and horizontal elements (houses and farther trees) as points of rest.

The outcome of the running-line manner is the transformation of mass into movement. The gains, consequently, are in a lighter fabric and a livelier picture surface; the losses are in substantiality of form. Loss of substance was always the danger that accompanied the "scribbly" manner: used in excess, it made the picture seem facile, too fluid to engage the viewer's tactile imagination. The undated handscroll titled "Enjoying the Dusk" (Pl. 86) is for this reason a much slighter work than "North Sea"; it is nevertheless an interesting and entertaining performance, in which the same landscape materials are reduced almost to pure linearity. Since the nature of the drawing works against the convincing rendition of space as well as mass, Chou Ch'en introduces an archaically hard-edged passage of fog between near and far grounds to compensate for the lack of depth. In the strong, flat design produced by the heavy delineation and simplification of forms, the painting resembles late works of Shen Chou, and probably reflects his influence; Shen, whether or not he was still alive when this was painted, was no doubt still the most prestigious figure in Soochow painting circles, along with his student Wen Cheng-ming. There is no evidence that Chou Ch'en had any close associations with members of the Soochow gentry-scholars, as T'ang Yin and Ch'iu Ying did, but he must surely have been acquainted with

them and their painting, especially since his pupil T'ang Yin was a friend of Wen Cheng-ming from childhood.

Experiments with a calligraphic manner, however, did not represent any true incursion into the territory of the literati painters, except insofar as an emphasis on brushwork had that implication; this is still essentially a shorthand rendering of an academic style, more akin to the sketchier works of late Che-school and Nanking painters than to the styles of Chou Ch'en's scholar-artist contemporaries in Soochow. The undulating lines that serve as contours of hills, trunks of pines, the curling top of the fog bank, even the thatched roof, all belong to the same "script style." The work lacks the variety in textures and touch that the literati painters pursued and does not hold one's interest for long.

Some of Chou Ch'en's works seem clearly to be imitations of Wu Wei, who, although probably not much older, was by far the more famous and influential master in the late fifteenth century; new directions in painting in Soochow as well as Nanking owe a great deal to him. Chou Ch'en's "Bidding Farewell at a Brushwood Fence" (Pl. 83) shares all the main features of Wu's style (cf. Pl. 45) to the point where it could almost, if unsigned, be ascribed to him: the composition divided into large geometric units; the telescoping of space, with layers of depth compressed against the picture plane, like a scene photographed from far away through a telescopic lens; the rough drawing with a broad brush, its tip sometimes divided for the nervous "split brush" manner of drawing; the activated figures, bending and twisting. The whole effect of unremitting agitation and harsh power places the painting in the sphere of the late Che-school styles. It was an effect that the Soochow painters occasionally sought but in the end rejected, preferring generally a greater fluency and finesse of execution.

The difference in style and taste that separates the Che school from the Soochow masters, whether amateurs or professionals, is well illustrated by a painting that Chou did in 1534, "Poetic Feelings Beneath Pines by a Stream" (Pl. 87); in his brief inscription on it Chou writes that it was done in imitation of Tai Chin. This must be the kind of painting to which the *Wu-sheng-shih shih* refers when, after naming Li T'ang as Chou's principal model in landscape, it adds: "But he also painted in the styles of Ma [Yüan] and Hsia [Kuei], and in such pictures he was the equal of Tai Chin." The scale of figures to setting, and the spaciousness of the whole, with such motifs as the distinctively posturing pine trees (very different from those of Chou's usual style) and the dark boulder in the foreground, are features of the Ma Yüan mode which Chou Ch'en transmits fairly faithfully. By not crowding his picture and by focusing it so effectively on his two seated figures, in fact, Chou makes it more Southern-Sung-like than most of Tai Chin's; he knows when to stay his hand, as Tai and his following in the Che school generally did not; and he escapes banality with a composition that follows the principles of Southern Sung design without adhering to any established type—one that achieves originality, that is, at a time when an original composition in the Ma Yüan manner was all but a contradiction in terms. The central location of his figures and tallest mountain suggests a typical sixteenth-century axial plan (cf. Wen Cheng-ming's painting of the following year, Pl. 115); the tall pine trees at the left, with the hilltop above and stream below, offset this with asymmetry of the Che-school kind, in which the weightiest elements are aligned vertically on one side; but the diagonals set up by the pine trunks and branches and the foreground rocks and cliffs, along with the empty area in upper right, partake enough of the diagonally divided asymmetry of Southern Sung landscapes to produce quiet reverberations of that style. The empty area, however, which in a Southern Sung picture would read as deep space, is here irredeemably blank paper; the clues with which the painter surrounds it are not the right ones to project us imaginatively into depth; this is, in the end, essentially a Ming painting. The drawing is broad, relaxed, free of the tensions of the Che-school

brushwork. Here again we can hypothesize that Chou has been drawn enough into the Soochow scholar-painters' milieu to be affected by their tastes.

The tastes of the literati, however, were by no means always aesthetically salutary; as often as not they were inhibiting, and the artist who wished to keep his freedom of choice might have been well advised to stay clear of them. We have already spoken of artists disparaged by the literati critics for using "coarse" brushwork, i.e., varieties that did not fall within their fairly narrow criteria of "good" brushwork, or for representing "vulgar" subjects—by which was meant, much of the time, unidealized portrayals of subjects on a lower social stratum than their own, which could suggest uncomfortably that the poor were not really so contented and picturesque as they preferred to believe. Patrons of art in China, like those in most other times and places, saw no reason to pay for what offended their eyes. Later collectors responded in the same way, and pictures thus stigmatized as "vulgar" or "low-class" ran poor chances of survival, not being considered suitable for inclusion in respectable collections. This kind of posterior censorship, we may assume, is partly responsible for the relative poverty of subject matter in later Chinese painting as it survives—what has been transmitted, that is, consists largely of what has been judged worthy of transmission. Other kinds of pictures were painted, but few of them are now to be seen.

The uniqueness of Chou Ch'en's now famous "Beggars and Street Characters" (Pl. 88–89; Color Pl. 12) is probably to be so explained. No collector lists it in his catalogue; it bears several laudatory colophons but has come down to us completely unrecorded. Originally painted as an album of twenty-four leaves, arranged in facing pairs with each leaf containing one figure, the work is now mounted in two handscrolls and divided evenly between the Honolulu Academy of Arts and the Cleveland Museum of Art.

Chou Ch'en's inscription accompanying the album reads (translation by Wai-kam Ho): "In the autumn of the *ping-tzu* year of Cheng-te [1516], in the seventh month, I was idling under the window, and suddenly there came to my mind all the appearances and manners of the beggars and other street characters whom I often saw in the streets and markets. With brush and ink ready at hand, I put them into pictures in an impromptu way. It may not be worthy of serious enjoyment, but it certainly can be considered as a warning and admonition to the world."

Although Chou Ch'en writes of his paintings as pictorial records of what he "often saw in the streets and markets"—not, that is, what he saw from his window as he painted—the pictures have the appearance of sketches from life, with an immediacy and particularity that are rare in Chinese painting, as are the subjects themselves. Beggars had appeared before in Buddhist paintings (such as the well known twelfth-century "Arhats Bestowing Alms" by Chou Chi-ch'ang in the Boston Museum of Fine Arts)[2] and occasionally in narrative scenes, but no earlier paintings are known that treat them as an independent theme. (Street vendors, who also appear in Chou's series, are of course to be seen in earlier painting, e.g., the toy-sellers of Li Sung and others.) Chou's final statement that his pictures "can be considered as a warning and admonition to the world" can be interpreted in several ways. One might relate it to Japanese *emaki* (picture scrolls) of the Kamakura period such as the "Diseases" and "Hungry Ghosts" scrolls, which are believed to be based on the Buddhist doctrines of karma and reincarnation, according to which those born into a miserable state in their present life are paying for misdeeds in a previous one. By this interpretation, Chou would be "warning" his viewers against committing the sins that might bring them to such an unhappy rebirth. One of the three colophons by later sixteenth-century writers, however, suggests instead that Chou is making a pictorial protest against the misrule by eunuchs in his time, by showing its effect on the lives of common people. After the Cheng-te emperor, Wu-tsung, ascended the throne in 1505 as a youth of fifteen, his power was usurped by a clique of eunuchs led by Liu Chin, who drained the country through excessive taxation and corruption

—when Liu was finally overthrown in 1510, the treasure he had amassed was found to be more than the total annual budget of the state. The three colophons have not been translated or published previously, and are of enough interest in conjunction with the painting to warrant quoting at length here.

The first, dated 1564, is by Huang Chi-shui, who, after noting that Chou Ch'en was especially famous for figure painting, continues:

"This album depicts the appearances of all the different kinds of beggars whom Chou Ch'en observed in the streets of the city, capturing perfectly the special aspect of each. Looking at the pictures, one can't help sighing deeply. Nowadays people come around on dark nights [covertly], begging and wailing in their desire for riches and high position—if only we could bring back Mr. Chou to portray them!

"The summoned scholar Wo-yün brought out this album to show me, and I wrote this impromptu inscription at the end."

Huang's point is that there are beggars in high places as well as low, in the yamens as well as in the streets. "Summoned scholar" was a term of respect for one who had been given a post at court; Wo-yün (literally "Lying in the Clouds") is a studio name, probably that of an official named Cheng Kuo-pin.

The next colophon is by the more famous Chang Feng-i, who took his *chü-jen* degree in 1564. He writes: "This album presents us with the many aspects of misery—hunger and cold, homeless destitution, infirmity and emaciations, deformity and sickness. Anyone who can look at this and not be wounded to the heart by compassion is not a humane person. The *ping-tzu* year of the Cheng-te era [1516, when the album was painted] was only a few years after the seditious [Liu] Chin spread his poison; this was the height of [Chiang] Pin's and [Wang] Ning's exercising of their brutality. I imagine also that the officials and nobles were seldom able to nurture and succor the common people. Thus this work by Chou Ch'en has the same intent as Cheng Hsia's 'Destitute People': it was meant as an aid to government and is not a shallow thing—one can't dismiss it as a 'play with ink.'"

Cheng Hsia was an eleventh-century scholar-official-artist who, as is told in a lengthy account in the official Sung history, depicted in a painting scenes of starvation that he saw in the city streets during a famine of 1073–74 and showed the painting to the emperor in order to shock him into taking action to relieve the people's suffering. This is a nearly unique case of a politically motivated Chinese painting: Cheng Hsia's real target was the prime minister Wang An-shih (1019–86), whose radical reforms he blamed for the famine. Chou Ch'en, of course, had no official status or access to the emperor; Chang Feng-i does not speculate about who was supposed to see, and be moved to effective action by, Chou's picture.

Finally, Wen Chia, the son of Wen Cheng-ming, contributes a colophon dated 1577:

"This painting by Chou Ch'en depicts the appearances of hungry and chilly beggars, in order to 'warn the world.' Huang Chi-shui takes it to represent those who 'come around on a dark night seeking alms,' while Chang Feng-i compares it to [Cheng Hsia's] picture of the An-shang Gate. These views of the two gentlemen both have their points.

"In the old days T'ang Yin, whenever he saw a painting by Chou, would kowtow deeply before it and cry 'Master Chou!'— so much was he aware of not being able to equal Chou's divine wonders. This album could not, I believe, have been done by anyone else; I am in complete agreement with T'ang Yin's heartfelt obeisance. Such a piece is not to be acquired easily. The qualities that Huang and Chang point to must be considered beyond the [forms of the] painting— they are not to be found in formal likeness, or in brush and ink."

Whatever message the paintings were intended to convey, they seem clearly to reflect a sympathetic involvement with their subjects, even a kind of clear-eyed compassion, that is a profound departure from the usual Chinese practice of portraying low-life figures—happy fishermen, carefree wood-gatherers, and the like—so idealized and sentimentalized as to allow no real feeling

of concern for the realities of their condition. Chou Ch'en has not only observed closely, but seems also to have experienced empathically, the emaciation and brutalization of the people he paints. They include a demonic street-sweeper and a fierce-looking character who may be an exorciser of demons, since he brandishes a paddle that bears an image of Chung-k'uei the Demon Queller (Pl. 88), a beggar with a hideous grin revealing rows of crooked teeth, and a seller of snakes for medicinal use or as a delicacy for eating (Pl. 89). Another (Color Pl. 12), wearing only a loincloth and carrying a broken begging bowl, with a bundle of firewood slung on his back, is so gaunt and ghostlike as to inspire more awe than pity. His neck seems barely able to hold his head up.

Although the individual figures are to be understood as single and separate, the pairings of them on facing pages of the original album are formally and psychologically effective, offering similarities and contrasts in type, posture, costume, and accessories. The drawing seems, in the Chinese context, informal and sketchy, and even after one has noted its adherence to the "scribbly" manner and precedents in great early masters such as Liang K'ai, one must in the end see it as basically descriptive, rendering superbly the tattered cloth and unkempt hair in a way that calls no attention to "brush manner." There is enough deference to established conventions and techniques to make the pictures acceptable to Chou's contemporaries, along with, more importantly, an eye and a brush that penetrate deeper beneath surface appearance than the Chinese painter of figures normally does. The style, that is, while by no means realistic, conveys a reality that the artist perceived and felt.

The anatomical understanding that Chou Ch'en displays and the sensitivity and skill with which he embodies it in his drawing were never to be matched, and scarcely attempted, in later painting, at least as we know it from surviving examples. Once again, as with "Early Autumn" (Color Pl. 8), we are faced with the troublesome question of why post-Sung Chinese artists, when they were capable of such trenchant realism, so seldom chose to practice it. And again the possibility must be allowed that we have been deprived, by the narrowness of taste of later critics and collectors, of whole rich categories of painting that existed once but have not been preserved except in such chance survivals as this.

One can imagine that some, at least, who saw Chou Ch'en's painting in his time responded by thinking: here, at last, is an artist who gives us pictures that are not of the same old things, who presents his unhackneyed subjects movingly, who is more concerned with vivid portrayal than with refined brushwork or stylistic knowingness or Confucian reticence. To recognize this was to acknowledge the considerable strengths of Chou Ch'en. Unhappily, these were not in China the strengths that obtained for one a place in the first rank of artists, and Chou was never accorded that rank, in his own time or later. His pupil T'ang Yin was esteemed so much higher that, the story goes, Chou sometimes served as his "ghost painter"; when T'ang was too busy to keep up with the demand for his pictures, he would ask Chou to paint them for him, and sign them and sell them as his own. The story, which is told by both Ho Liang-chün and Wang Shih-chen,[3] has recently been branded apocryphal by Chiang Chao-shen in his study of T'ang Yin; in fact, we have no evidence either to confirm or disprove it.

## 2. T'ANG YIN

T'ang Yin was born in Soochow in 1470 and died in 1524; he was thus about twenty years the junior of Chou Ch'en, who nevertheless outlived him by at least eleven years. His father was a man of the merchant class, a restaurateur. Such a calling brought no elevated social status but enough material prosperity, evidently, for him to start his son, who showed early signs of brilliance, on a good education. This was continued under the guidance of Wen Lin, the father of Wen Cheng-ming, who introduced his young protégé to the gentry and literati society of Soo-

chow. T'ang was able in this way to meet Shen Chou, Wu K'uan, and the great calligrapher Chu Yün-ming. He was a profligate youth, who spent too much of his time and money on drinking and debauchery; but after a terrible two-year period in 1493–94, during which he lost successively both parents, his wife, and a beloved younger sister (the last by suicide), he grew soberer, shut himself away from temptations, and studied for the examinations.

In 1498 he took first place in the provincial examination in Nanking (Wen Cheng-ming also tried it and failed), and the following year he traveled to Peking with a friend, a rich playboy named Hsü Ching, for the metropolitan examination, the most important of all. In this, T'ang was again favored to take first place, and perhaps he would have; but he and Hsü Ching fell under suspicion of having received advance information on one of the questions from the chief examiner, and Hsü, under torture, confessed to having bribed a servant of the examiner. T'ang Yin, although probably innocent and the victim of envy, returned to Soochow under the cloud of scandal and had to give up hope of a bureaucratic career. At this time he wrote a long, moving letter to Wen Cheng-ming, in which he protests his innocence: "I have been, as it were, adjusting my cap under a plum tree, and I deserve to be suspected of stealing plums and must therefore suffer the consequences!"[4]

Back in Soochow, T'ang returned to his old life of drinking and dissipation; he also took up painting for a living. He had learned painting earlier, and around 1500 he began studying under Chou Ch'en. By 1505 he was so successful that he could build himself a villa on the Peach Blossom Embankment near the city, where he entertained friends such as Chang Ling, also a painter, and Chu Yün-ming. In 1514 a prince of the imperial family named Chu Ch'en-hao, who was plotting a rebellion, enlisted T'ang in his cause; but T'ang, after accepting a position on Chu's staff, became aware of the danger into which he had fallen and pretended madness until the prince finally allowed him to leave. In his late years he was famous, even notorious, in Soochow for his libertine ways, as well as for his painting, which captured the popular fancy of Soochow society in this heyday of the city's cultural life.

He was surely one of those whom Frederick Mote was thinking of when he wrote, in his study on the history and culture of Soochow: "There is no doubt that in traditional cities such as Soochow in Ming and Ch'ing times, freer expression of individual eccentricities was possible, and deviant behavior escaped some of the surveillance and restriction that the village would have imposed. In Soochow, with its great wealth, pleasures became more varied, the idle could congregate, imaginations stirred each other. . . . Many of those who lived on the fringes of Soochow's more flamboyant dissipation were the immortals in scholarship, in thought, in literature and the arts."

We cannot, of course, be sure just how dissolute or eccentric T'ang Yin really was, and how much belongs to a cultivated image or posthumous legend. In any case, he himself helped to feed the legend—while still in his forties he wrote of himself as "old, mad, and stubborn," and his letters and poems contain many passages that tend to confirm the popular image of him. It is also true, however, that he continued at the same time to occupy himself with serious scholarship and literary production. Testifying to this is a letter written to a friend some time late in his life, in which he lists the books he has written—works on painting and calligraphy, on fortune-telling, on the annual festivals of the Wu region, on old and modern history.[5] Unfortunately, none of these seem to have survived.

He continued an off-and-on friendship with Wen Cheng-ming, who, with his more severe temperament, disapproved of T'ang's behavior and probably of a good deal of his painting as well. Late in life, T'ang turned to Buddhism but never seems to have adopted wholeheartedly the austerities it advised. His relatively early death, at the age of fifty-four, was said to have been the result of his overindulgences.

It will be apparent even from this brief account that T'ang Yin fits—in fact, is one of the prime Ming-period examples of—the pattern outlined in the foregoing chapters, that of the artist who

is educated for an official career but fails somehow to pursue or achieve one and who takes to painting instead as a means of winning for himself a respected and economically secure position in society. Typical features for this artistic type are present in his case: intellectual brilliance as a child, a leaning toward profligacy and attachment to the pleasures and entertainments of the popular urban culture, a flirting with madness or pseudo-madness (which was one of the few acceptable ways of placing oneself outside normal social obligations), friendships and associations with people in both high and low positions. The stylistic analogue to this mobility (or ambiguity) of social status, we have suggested, is a repertory of styles that cuts across, or rather attempts with varying success to cut across, the distinctions and semibarriers that separated scholar-artists from professionals. In actual practice, the pattern tended to manifest itself in a relatively wide stylistic range that moved from a base in some careful and conservative manner through more calligraphic and cursive versions of essentially the same manner, into extreme positions that in their time seemed distinctly unorthodox and, in their departures from normal expectations, were suited to the life style of this kind of painter as the styles of the established scholar-gentry artists were to theirs, or the painstaking performances of the "artisan painters" to theirs. T'ang Yin eminently exemplifies this part of the pattern as well; and with him, the crossing of social and artistic boundaries was more than usually successful. He seems often to be demonstrating that he can equal or best the masters of both camps, amateur and professional, on their own terms, in a single picture that combines the strengths of both.

Chiang Chao-shen, author of the most recent and thorough study of T'ang Yin's stylistic development, believes that T'ang began painting in the manner of Shen Chou (this first period is represented, in Chiang's view, by a handscroll in the Palace Museum, Taipei), then adopted the Li-T'ang-derived manner of Chou Ch'en when he turned professional around 1500. To this account of his early development should certainly be added the strong influence of Wu Wei, Tu Chin, and other Nanking masters. He came to know their styles and, at least in Tu's case, the painter himself, during his stay in that city in 1498–99. Of T'ang Yin's works that show clear influence from these Nanking artists, none is safely datable to his early period; but two paintings dated 1501 and 1504 by his intimate friend and drinking companion Chang Ling, obviously in the Wu Wei manner,[6] are evidence that that manner was surely known to T'ang Yin, and presumably practiced by him, in the years immediately following his trip. T'ang may well have been instrumental in introducing these Nanking styles, and the life style associated with them, to Soochow art circles and may also have been inspired by the models he encountered in Nanking in the creation of his own artistic persona. (We should note here in passing that Chang Ling appears to be another example of our type: he passed his *chu-sheng* examination but was "deprived of his degree, because of his mad ways"[7] and became a hard-drinking "bohemian" artist.)

A handscroll titled "Secluded Fishermen on an Autumn River" (Pl. 90) is a particularly fine example of T'ang Yin's most finished and conservative style, as he learned it from Chou Ch'en. The passage we reproduce, near the end of the long scroll, depicts a scene on the river shore, where a retired scholar has built an elegantly rustic retreat; he relaxes on his veranda, engaged only in a silent interchange of gaze with a friend in a boat who fishes, no more purposefully. A third figure, a visitor, arrives at the right, leaning on his staff. All are attended by servants. The images, the attitudes, the occupations, are all ideal and conventional; we are back in the familiar, escapist world of the scholar-recluse whose disengagement from all disturbing realities becomes the very theme of art. As an artist, T'ang Yin, for all the bitterness of his own experience with the harsher world outside the charmed circle of the Soochow gentry-scholars, never ventures to disrupt their complacency, as he might have done by following the lead of Chou Ch'en's "Beggars" scroll—or if he did (we must add, as always) the paintings have not survived.

The landscape setting of his scroll is sleek and tidy; even the fallen leaves produce no clutter

but serve only as scattered symbols of autumnal decay, meant to arouse a feeling of pleasant melancholy. The clarity and order that distinguished Li T'ang's style in the Sung period, and Chou Ch'en's works in that style, persist in the works of T'ang Yin—in which, however, the order is more artistic than natural: firm boundaries set off each object from the rest, and ink washes of varying value add further visual distinctions. *Ts'un*, or texture strokes, serve more to separate light and shadow than to describe surfaces. In some places they are dry, applied with a "squeezed brush" held obliquely to the surface; elsewhere they are laid on more broadly and wetly, with the spaces left between the pale, overlapping strokes reading as highlights—a technique used also by the Che-school artists and sometimes by Chou Ch'en.

One of the most striking features of T'ang Yin's individual style is his way of animating his structures of earth and rock by making their component masses lean and twist; his compositions are thus typically more dynamic than those of Shen Chou or Chou Ch'en. This is true of "Secluded Fishermen"; it is even more marked in a hanging scroll titled "Poetic Thoughts: Traveling by Donkey" (Pl. 92). The quatrain inscribed on it by the artist reads (translated by T. C. Lai):[8]

> A failure, taking my books, I go back home
> Riding a mule again up the blue hills.
> Tired with a world of wind, frost, and dust,
> I greet my wife, poor but not destitute.

Chiang Chao-shen believes that the "failure" must be T'ang's disastrous trip to Peking, and that the last line refers to his second wife, whom he divorced in 1500; he would date the picture, accordingly, to that year. If this interpretation is correct, the figure on the donkey, ascending the mountain path toward a house in a ravine at center right, would be T'ang himself. Going beyond Chiang's reading, one might take the feeling of instability and insecurity in the landscape, sharply in contrast with the amiable world of "Secluded Fishermen," as an expression of T'ang's emotional state. The trouble with such an interpretation is that the qualities of the picture which one is tempted to explain in this way are common to too many others, from different stages in his career, that cannot similarly be taken as autobiographical.

The composition is based on a monumental type but is not made up of massive, stable forms as a typical Northern Sung work of the type would have been; everything in T'ang Yin's picture is calculated, on the contrary, to induce a feeling of perturbation. The separation of light and dark is stronger and more sudden, with patches of deep shadow placed rhythmically throughout the composition. Local texturing is replaced by a system of lines and long strokes of wash that cover all the forms, following and emphasizing their larger movements. These movements are carried from one mass to the next, pushing and curving in a surging motion, first in one direction and then in another, up along the central ridge to the peak, which thrusts leftward and ends. This dynamic mode must be seen as totally free of the influence of Shen Chou, perhaps even as a reaction against his stabilizing, broad-line drawing and more firmly rooted forms. T'ang Yin seems to have opted for excitement.

Many of T'ang's best surviving paintings are, like this one, virtuoso performances, highly active compositions that are executed in swift, sure drawing. As the paintings of Shen Chou or Wen Cheng-ming reflect the temperaments of those artists, so do T'ang Yin's reflect his: brilliant, mercurial, often impatient. If their styles seem ideally suited to quiet contemplation, his often aim rather at impressing, entertaining, even dazzling the viewer. We speak, of course, only of a strong tendency within his works, and in noting it do not mean to deny that he could also paint, when he chose to, as part of his amazing versatility, landscapes of a soberer character, whether simple lyrical scenes or complex, monumental compositions. The latter are well rep-

resented by a superb series of "Landscapes of the Four Seasons" in the Shanghai Museum,[9] the well-known "Whispering Pines on a Mountain Path" in the Palace Museum, Taipei,[10] in which an imposing and basically stable design is made to incorporate outbreaks of the "scribbly" manner with no loss in power, and the smaller "Clearing After Snow in a Mountain Pass" (Pl. 93), which Chiang Chao-shen believes to be a work of the artist's late thirties.

This painting admirably combines grandeur of scale with sensitivity of execution. The season is early winter, when brown leaves are still on the trees but snow lies lightly on the ground. Ox carts heavily laden with bales of rice approach the end of their day's journey, a village in the pass which is overlooked by a Buddhist temple. The mood is quieter; instead of thrusting its masses forcibly upon the viewer by shading them heavily and filling the entire picture space with them, as does "Traveling by Donkey," the painting opens hollows of space in the central area of the composition and encloses them with terrain masses that curve into depth at the sides, carrying the eye in a winding progress from foreground to farthest mountain peak. Similarly hollow-cored compositions had been painted in the Sung and Yüan periods, especially by artists of the Kuo Hsi tradition (cf. *Hills*, Pl. 35–36). Here, it is certainly Sung painting that is evoked, not least in the restraint of the drawing.

Among T'ang Yin's essays in the running-line manner—a manner in which he is rivaled, for sheer technical mastery, only by Chou Ch'en at his best— "Parting at Chin-ch'ang" (Pl. 91) is outstanding. It belongs to a special subject category, the "parting at the shore" scene, of which other Ming examples (by Wang E among others) are known. These were used as farewell presents and follow an established convention, always depicting a riverbank where the subject, the recipient of the picture, is shown bidding farewell to a party of grieving friends and admirers before boarding the boat that will carry him away. In the present painting, it is a man named Cheng Ch'u-chih who is departing, as T'ang Yin writes in his inscription, for an audience with the emperor in Peking. As T'ang arranges his composition, this properly focal scene occurs almost as a postscript to an elaborate landscape with buildings and figures that seems irrelevant to the ostensible theme—except insofar as T'ang is conveying the painfulness of leaving Soochow by contrasting its rich and busy scenery, in the first part of his scroll, with the sparse concluding section, which represents the world beyond its walls. The artist wisely recognized, we may suppose, that Cheng Ch'u-chih would rather own a full-scale T'ang Yin painting than one that concentrated on the farewell group and hence treated the landscape setting, as was normal in such paintings, in a perfunctory way. One aspect of T'ang's superiority to the ordinary artist-for-hire is illustrated here: even when producing an occasional painting, he treats his task as a fresh artistic problem and creates a work that can stand on its own merits, without reference to its original purpose.

As the scroll opens, a section of the Soochow city wall is seen through bare trees, enclosing a pagoda and a large multistoried building, all no doubt immediately recognizable to people of that time and locale. The Chin-ch'ang Gate, from which the farewell party has issued, is not shown; it may be farther to the right, outside the boundary of the picture. In the foreground is a cluster of small houses and boats, busy with figures. A long bridge joins this area of land to an island, or promontory, from which Mr. Cheng is preparing to embark. The well-wishers stand in a crowd with their hands clasped before them; Cheng faces them, in the same respectful posture; the boatman behind him is hauling up the sail, suggesting imminent departure.

All this is drawn with a vivacious freehand virtuosity, in line that is constantly moving, as if impelled by sheer calligraphic buoyancy, but which nevertheless delineates clearly, even though almost casually, all the materials of the picture. That this effect of spontaneity can be sustained evenly in rocks, trees, hills, even buildings and bridges (which nowhere settle into orthodox straight-line patterns) and in the tiny figures, is one aspect of the effortless tour-de-force quality of the painting; another is the total absence of routine and repetitive patternization from those

passages where lesser artists, including T'ang Yin's numerous imitators, fall into just that trap: the texturing of the rocks, the lacy profusion of bare branches and twigs.

These examples do not by any means exhaust T'ang's versatility as a landscapist, but they are all that space allows. A like versatility is to be seen in his figure compositions, for which he was equally famous. In these, the influence of Wu Wei and Tu Chin is present along with that of Chou Ch'en. T'ang probably met Tu Chin in Nanking in 1499; one of his poems is dedicated to Tu, and on at least one occasion he inscribed a painting by him. T'ang Yin painted several garden scenes with figures and furniture that closely resemble Tu's works not only in general type but also in particular motifs and features of style. His "T'ao Ku Presenting a Poem" (Pl. 96) is one of the best of these. The figures of T'ao Ku and the courtesan Ch'in Jo-lan are set back behind a huge garden rock and a row of banana palms, which form the lower two sides of a parallelogram; two screens and the tree branches form the upper, the whole containing the figures within their private environment, allowing the viewer to look down upon them but screening them even from the boy servant at the lower left, who blows the fire in the stove to warm their wine. All this makes them a bit remote, as befits people from the past.

T'ao Ku (903–70) was a scholar-official in the late Five Dynasties period and the early Sung; he was sent by the first Sung emperor as an emissary to the Southern T'ang state, which at that time had not yet capitulated to the Sung (as it would do in 975). There he met the courtesan Ch'in Jo-lan and, mistaking her for the daughter of the posthouse keeper, composed a lyric for her. The next day the ruler of the Southern T'ang gave a banquet for him. T'ao acted unbending and unapproachable until Ch'in Jo-lan, who was in fact a court entertainer, was brought in and began to sing his song, whereupon he became aware of his blunder and was overcome with embarrassment.

The painting depicts the two in a garden, on the night preceding the banquet; a candle burns on an elaborate stand between them. T'ao, beating time to the music with hand and foot, gazes at her with obvious design; the poem is already taking form in his mind. Beside him are his brush and a roll of paper and an inkstone on which the ink is already rubbed. Ch'in Jo-lan sits on a stool facing him, playing the *p'i-p'a*, an instrument associated (like the *samisen* in Japan) with women entertainers and prostitutes, love affairs, popular songs, and drinking parties—just as the *ch'in* was associated, by contrast, with scholars, quiet and meditative solos played on mountain terraces, and high-minded communion between friends.

The picture is surrounded by an aura of delicate associations: refined eroticism, historical allusion, amusing incident. The agreeable looseness of the style, the flowing outlines and surfaces of the rock and tree, the relaxation of the figures, are in keeping with the mood of the scene it describes, a formal equivalent for transient feelings rather than permanent principles. Pictures of "singing girls" or courtesans, and of their romantic liaisons with scholars of the past, are conspicuous among T'ang Yin's works, and the girls may well have been favorite subjects for him as an artist as they were favorite companions for him in his own life. They were also painted by artists of the Nanking group, such as Wu Wei (cf. Pl. 48), and T'ang's paintings of them are close in style to the Nanking examples. (Both T'ang Yin and Ch'iu Ying were also apparently famous, or notorious, in their time and later for erotic scenes or "spring pictures"; unfortunately, none seem to have survived in originals, although copies or imitations and woodblock-print reproductions to which their names are attached are to be seen in some number.)

T'ang Yin's handscroll titled *Kao-shih t'u* ("The Noble Scholars," Pl. 94) is an excellent example of his most cursive, "running" style. According to a colophon by Wang Chih-teng written in 1594, now partially lost but recorded, the scroll originally consisted of four paintings in the manners of four great Sung-dynasty masters of figure painting: Li Kung-lin, Liu Sung-nien,

Ma Ho-chih, and Liang K'ai. It was owned by the same Wu Hung-yü who as he was dying in 1650 tried to burn Huang Kung-wang's "Dwelling in the Fu-ch'un Mountains"; T'ang Yin's scroll was thrown into the fire with Huang's, and only the last picture, the one done in imitation of Liang K'ai, was saved. T'ang's own inscription, now also lost but recorded, contained a dedication to a Mr. Ching-ch'üan.

Our present-day understanding of the early-thirteenth-century master Liang K'ai is based chiefly on a few works preserved in Japan which have for centuries been venerated as Ch'an (Zen) Buddhist paintings and thus as works of a serious, semireligious character. Liang's reputation in China in the later centuries was very different: he was remembered as a somewhat eccentric painter who drank a lot, called himself Liang the Wastrel, left the Imperial Academy abruptly after a period of service in it, and liked to paint sketchy, facetious pictures. Works that go under his name in Chinese collections, most of them spurious, agree with this image better than with that of the revered Ch'an master of the Japanese, and it is the Chinese image that T'ang Yin must have had in mind when he painted "The Noble Scholars."

The title, together with the nature of the picture, makes one suspect satire or irony; the scholars are not so much "noble" as pompous, with their upturned faces and strutting demeanors. The servant boy at the beginning, thrusting his pinched, overeager face farther forward than laws of balance would strictly allow, seems a similarly ironic portrayal of servility. The three scholars have gathered in a garden for a session of composing poetry and writing calligraphy, and all their implements and materials are spread out: a mat on which are lying a brush, inkstone, copybook (probably an album of rubbings from a stone engraving of some masterwork of calligraphy), and roll of paper, other rolls on the ground and on a stone table which also holds an incense burner and a vase with a flowering branch. All the necessities for cultivated creativity are at hand (an earlier portion of the picture, now missing from the original but preserved in a copy, includes the stove that will warm their wine).

On the surface, then, this is another glorification of the scholar-gentlemen in their pursuit of rarefied aesthetic experiences. An artist of another kind (such as Hsieh Huan, cf. Color Pl. 2) would have presented it in a straightforward and straight-faced way. T'ang Yin declines to take the scene quite seriously and, far from concealing himself in his style, asserts a creative freedom of his own to match that of his Noble Scholars: his painting is not an impersonal report of something outside the artist but is itself like a work of calligraphy, a poem, a piece played on the ch'in, similarly conveying momentary mood through modulations and nuances of touch; it is a direct and personal communication that places artist and viewer on an equal plane by proclaiming its independence from objective description and by demanding that the viewer create the scene himself from the visual data that T'ang Yin supplies. The sharp tipping of the ground, accomplished in large part by an audaciously two-dimensional drawing of the mat and implements, helps to hold the picture on the plane of calligraphy; in particular, the mass of rocks, trees, and grass at the top, boldly cut off by the upper edge of the picture, is rendered in nondescriptive, amorphous strokes—one can scarcely distinguish the tree from the rock. T'ang Yin, like Chou Ch'en, has learned much of this from Wu Wei and his Nanking followers but performs with greater ease and less tension, in keeping with the generally more relaxed brush-manners favored by the Soochow artists.

T'ang Yin's versatility extends to the other, lesser branches of painting such as flowers and birds, bamboo and rocks, and blossoming plum branches, all of which he practiced at times. A picture of "Trees, Bamboo, and Rocks by a River" exists in three versions, all incomplete, of which the best is now cut into two hanging scrolls (Pl. 98).[11] Once more the possibility must be raised that we are dealing with pieces of what was originally a screen—the similarity in composition to the screen depicted behind Ch'in Jo-lan in Tang's "T'ao-Ku" picture (Pl. 96) is striking.

Judging from this and other examples of screens that can be seen represented in paintings of different periods, the scenes chosen for portrayal on them were usually spacious, opening into distance with the aim of seeming to expand the space of the rooms or enclosures in which they were placed. This may be part of the reason why T'ang Yin's picture, for all the brilliance of its calligraphic brushwork, is no flat, semiabstract performance like the typical scholar-artist's rendition of similar scenes (cf. *Hills*, Pl. 85) but is painted with what is, in the sixteenth-century context, a naturalistic concern for atmosphere, space, light and shade, and a sense of vigorous growth that is not merely a reflection of vigorous brush movement.

T'ang Yin's visual (rather than schematic or formalistic) approach to his subject, integrating luxuriant vegetation with an earthy and airy environment through highly adept handling of ink gradations and supple brushwork, relates his style to that of his contemporary Chang Lu (cf. Pl. 55). Chang, however, attains this height less often than T'ang, who is, moreover, a far more inventive master, seldom following established conventions or repeating his own. For another aspect of the painting, the constant, restless movement that inspires all the forms, a closer parallel might be seen in the work of Sheng Mou (*Hills*, Pl. 23), whose drawing seems similarly a manifestation of a controlled, artistically channeled nervous energy.

The successful reconciliation of naturalistic values with the abstract ones of brush and ink, in a way that entails no serious sacrifice of either, is a far rarer phenomenon in the later centuries of Chinese painting than it had been in the Sung, and when it occurs (in exhilarating, sometimes breathtaking moments) it is less often in the works of either the proper scholar-amateurs or the truly conservative or academic professionals than in paintings by those in-between artists whom we have been trying to characterize as a group, without meaning to classify, since they elude classification: Wu Wei, T'ang Yin, later Hsü Wei, still later a few of the Individualist masters of the early Ch'ing, with Tao-chi supreme among them.

If one were obliged to choose a single painting from among the surviving works of T'ang Yin that best exemplifies that ideal achievement, it might be his "Singing Bird on a Branch" (Pl. 99). The intense lyricism of the picture is captured also in the couplet that T'ang has inscribed in the upper right:

> The mountain deserted, everything still, no human voices heard.
> With the last drops of a spring shower, the songs of a roosting bird.

The leafy branch, still wet after rain, extends upward from the bottom of the tall composition, tracing an S-curve for most of its length and springing up at the top in a long, taut twig. After one has apprehended the branch and bird as a unified image, it is all the more impressive to note that T'ang Yin, far from relying on ready-made types of brushstrokes to depict them, has scarcely repeated a stroke in the entire picture. His brushwork in this small space runs through virtually the entire possible range of tonal depth, wetness or dryness, momentum, shape, without in the end giving any impression of calculated virtuosity or variety. It seems rather to adapt with the utmost responsiveness to the essential character of what it is describing, conveying the stiffness of the branch or the suppleness of a twig, a sinuous vine or soft cluster of leaves.

This informal, ad hoc quality in the drawing contributes to a feeling of exuberance that builds upward as the brush movement quickens and reaches its climax in the bird, which lifts its head and opens its beak to pour forth song (detail, Pl. 100). The bird, a myna, is painted in slightly shaded but unbroken ink wash, except for the eye, beak, leg, wing tips, and tail feathers; but in the consummately conceived shape of this simple patch of wash is implicit the structure of a vital organism. T'ang Yin's technical mastery is in the service of a poetic mode of apprehending reality; together they raise the picture to the plane of the Sung-dynasty masterworks of ink monochrome painting.

### 3. CH'IU YING

T'ang Yin was an educated and cultured man forced by circumstance to become a professional artist; the third of this group, Ch'iu Ying, was a professional artist who found himself by circumstance associating closely with educated and cultured men, with profound effects on his painting. He was younger than the other two, born probably in the last decade of the fifteenth century; he may have been dead, and in any case was inactive as an artist, by 1552, since a colophon written in that year by the writer and calligrapher P'eng Nien (1505–66) remarks that his paintings "are no longer to be obtained."[12] His active career cannot have covered much more than thirty years. He came from a humble family in T'ai-tsang, near present-day Shanghai, but moved to Soochow while still young. There he worked as a painter's apprentice, no doubt producing decorative pictures as well as, quite likely, copies of old paintings intended for sale as forgeries.

His talents came to the attention of Chou Ch'en, who took him on as a pupil. Chou, and perhaps T'ang Yin, whom Ch'iu must have known, probably introduced the young man to some of the eminent literary men of Soochow, including Wen Cheng-ming and his circle of friends; Wen and others, such as the poet-calligrapher Wang Ch'ung (whom we will encounter as a painter in the next chapter), inscribed many of his paintings. By the 1530s he was established as a successful and admired artist, with a studio and students of his own. He not only could paint near-faultless landscapes in the Li T'ang manner already popularized by Chou and T'ang, but also gratified the art-historical tastes of his patrons by doing superlative copies and imitations of old works that they owned or had seen.

During his later years he lived with several collectors as a "painter in residence," a common arrangement in China by which the painter was lodged, entertained, and supported by a patron, who received paintings in return. Ch'iu lived in this manner for several years at the mountain retreat of a minor official named Ch'en Te-hsiang, several more with a certain Chou Yü-shun in nearby K'un-shan, and, most importantly of all, a period with the greatest collector of the age, Hsiang Yüan-pien (1525–90).

Hsiang, the youngest son in a wealthy family, had tried for an official career but, after failing in the examination, devoted himself to managing the family estate at Chia-hsing and to building up a huge collection of art.[13] Among his business interests was a pawnshop, and he probably made some of his acquisitions by giving loans against objects of art that were forfeited for nonpayment. The famous pieces of painting and calligraphy that he owned must have numbered many hundreds, perhaps thousands; he left no catalogue, so we have no way of determining the number, but a great many of those to be seen today bear his seals. The collection attracted art lovers from far and near, including some of the Soochow connoisseurs.

An album of six landscapes after old masters and a picture of narcissus and apricot flowers,[14] both painted by Ch'iu Ying for Hsiang in 1547, place their association around that time; how long it lasted is unknown, but it was long enough for Ch'iu to produce for him hundreds of paintings. Many of these were copies or imitations of older works that Hsiang owned. Ch'iu's extraordinary facility for re-creating antique styles, and his familiarity with classic modes of composition, doubtless went back to his period as apprentice in some Soochow commercial-painting atelier but was immeasurably refined by all his later opportunities to see, study, and copy the paintings in Hsiang's and other collections. Such opportunities placed him in a funda-mentally different art-historical situation from that of the ordinary professional artist, who had no such extensive access to the past history of his art; where others normally followed a tradi-tion, the one to which circumstances of time and place assigned them, Ch'iu Ying found a diversity of traditions open to him.

Mere skill in copying and imitating never earned a painter much esteem in China (contrary

to a misconception common in Western writings, which should be laid to rest once and for all, along with the notions that an excellent copy was considered as valuable as the genuine work, that originality was not especially valued, etc.). If Ch'iu had been a simple copyist, his reputation would not be what it is today; he was much more than that. The long landscape handscroll now in the Freer Gallery of Art, for example, painted for Hsiang and designated in Ch'iu's own inscription as a copy after a scroll by Li T'ang,[15] is in fact executed in a style distinctively of its time and would never be mistaken for a Sung painting; nor could the superb "Spring Morning in the Han Palace," based at least in part on passages from old paintings of palace ladies, be confused with the works of Chang Hsüan or Chou Fang, the T'ang-dynasty originators of the tradition, or with ordinary copies after their works.

At the same time, it must be granted that one comes away from viewing Ch'iu's works with an impression of a transcendental talent and technique that constantly required inspiration from outside; the imagination that creates individual worlds of form, the forceful personality that stamps itself on everything it conceives, are not present. Chinese critics would explain this lack by pointing to Ch'iu's illiteracy, his exclusion by birth and upbringing from the literary culture that shaped their sensibilities. Their charge is in itself not entirely without foundation—Ch'iu probably was illiterate, or close to it. He has written no poetic or other lengthy inscriptions on any of his works; they bear, at most, a signature and a simple dedication, with perhaps the name of the old master imitated;[16] it was even said (and this probably *was* unfounded) that he could not write at all and that his signatures were inscribed by others, especially by Wen Chengming's eldest son, Wen P'eng (1498–1573), who was a noted calligrapher.

Chinese prejudices can be noted here once more—proficiency in literary composition and calligraphy are obviously not requisites for being able to paint well. But it seems nonetheless justified, and not prejudiced, to mark in Ch'iu Ying's works a quality of art-historical unconsciousness and naiveté, and to account for this by suggesting that Ch'iu had the wrong background for developing the kind of style-consciousness that the scholar-artists possessed—and the wrong professional status, probably, for manifesting it even if he had it. Ch'iu painted what his patrons wanted, and did it wonderfully well. (Looking at his versatile re-creations of a variety of styles, one has the feeling that if Hsiang Yüan-pien had given him a few Italian Renaissance portraits to study and the materials he needed, with a day or two to master the medium, he would have been capable of producing on demand a creditable portrait in Quattrocento style of Hsiang as a Florentine nobleman.) He and his works raise the complex and fascinating question of internal and external motivations in artistic creation, to which we will return after considering a few of the paintings.

A good introduction to Ch'iu's painting, since it displays so many of his particular strengths, is a large, majestic landscape titled "Waiting for the Ferry in Autumn" (Pl. 97), which bears seals of Hsiang Yüan-pien and was probably painted for him. Resemblances to the conservative works of Chou Ch'en and T'ang Yin are obvious. Like them, Ch'iu Ying avoids the overtly expressive devices of Southern Sung painting and its Che-school followers to return to the more objective mode of Li T'ang; or, for some elements, perhaps even further back, to Northern Sung masters. The composition is firmly and stably put together, amply spacious and symmetrical. (Each of the vertical halves separated by the seam down the center could stand as a satisfying picture, and broad compositions such as this were often turned into two pictures in just that way, since the two would have a greater combined market value than the single large picture.) The tree groups, treated as decorative silhouettes and colored with rich red, yellow, and green for an autumnal appearance, diminish systematically in size and grow paler in tone to reinforce the recession into distance, which is flat and visually convincing.

The narrative elements of the picture are as neatly distributed as the rest and are similarly graduated in size and specificity as the eye moves back through successive stages of depth. A

gentleman sits on the bank at the lower left with his servants beneath tall trees, awaiting the return of the ferry. It is to be seen across the water; two other men are about to disembark and make their way to a house almost hidden by trees, where their host is no doubt preparing for them a literary banquet or drinking party. Moving back across the river we see a houseboat near a spit of land in the middle ground and, on the far shore, houses among leafy trees. The farthest hills are encircled by fog; otherwise, everything in the picture is viewed with telescopic clarity. The hills are smooth, with well-defined, continuous surfaces broken by only a minimum of texturing and treated with washes of pale ink and warm color for a surprisingly illusionistic rendering of late-afternoon sunlight and shade.

The painting, like others by Ch'iu, is difficult to discuss, easy to describe. Its meaning and expression lie almost exclusively in pictorial values: the touch of autumnal melancholy inheres in the red-leafed trees, the placid mood in the proportioning and placing of the forms, and one does not associate either with the temperament of the artist. Ch'iu Ying, here as elsewhere, is strangely invisible as an artistic personality. His contemporaries mention him without telling us anything about him, and his paintings tell us little more, apart from testifying to his unsurpassed technical proficiency. His subjects, and the characterizations of them, seem to pertain more to the experience and vision of his patrons than to his own. Another question arises, then, with respect to this remarkable master: how can an artist of such dazzling attainments conceal himself so completely? One looks in vain for some small outbreak of individuality, even a turn of line that betrays the person behind the brush.

Two large, signed, superb pictures of figures in garden settings by Ch'iu Ying are among the treasures of the Chion-in, a Buddhist temple in Kyoto (Pl. 101–102). Both represent historical gardens.

The Chin-ku Yüan, or Golden Valley Garden (Pl. 101), belonged to Shih Ch'ung, who lived in the Western Chin period; he made a fortune in the shipping trade at the end of the third century A.D. and built the garden in Golden Valley in the outskirts of Loyang as a place to hold lavish entertainments. The awnings over the walkways were of rich brocades from Szechwan, and trees of coral and other rare and beautiful objects assembled from far places stood around the house and garden. Guests at his parties were set to composing poems, and those who failed to complete theirs in the allotted time drank three *tou* of wine as penalty.

In Ch'iu Ying's picture the party has not yet begun—here as in his "Waiting for the Ferry" he chooses the moment of arrival, touching perhaps deliberately on the viewer's memories of occasions when the excitement of anticipation surpassed that of the event. Shih Ch'ung stands at the entrance, receiving a guest. Flanking the steps are two dwarf trees and, to the left and right of the door, two trees of coral in antique bronze vases. A quartet of girl musicians waits nearby, and girl servants carrying trays of food and wine can be seen walking along the covered walkway farther back. In the garden are fantastically eroded T'ai-hu stones, brought from the great lake of that name in Kiangsu Province and set up like sculptures. Peacocks and peonies, emblems of wealth, complete the sumptuousness of the scene. Beyond the flowering shrubs in the distance one sees the top of a frame for hanging a swing, put there for the recreation of the ladies of the household (gentlemen in China do not swing). The tone of the sky and of the whole picture is of dusk, within which the white and colored pigments glow.

The figure groups and other elements of the composition may have been taken, like the figures in the companion piece and in other works of this type by Ch'iu, from some old model. Such groups were preserved in sketch copies or tracings called *fen-pen*, which artists made, as the opportunity arose, for later use. Collections of these were passed from master to pupil and were a principal means of transmission of motifs and designs. Few old examples are preserved, but a collection of them in album form by a seventeenth-century follower of Ch'iu Ying named Ku Chien-lung, now in the Nelson Gallery, Kansas City, is probably representative of such

collections, being a small repertory of the favorite school motifs. A painting inscribed as being "after" some old master was probably based in most cases on *fen-pen* taken from a work ascribed to him. (This was true at least for the professional artists; the amateurs were likely to do their "copies" from memory, and accordingly these works are usually looser approximations of the originals.)

Ch'iu Ying made copies of all the T'ang and Sung paintings to which he had access, the *Wu-sheng-shih shih* tells us, and kept them as *kao-pen* ("draft sketches") to use later in his finished paintings. His imitations of old styles were thus so exact, it comments, that they could be confused with the originals. As noted above, this is true only of Ch'iu's most conservative and derivative works, some of which may indeed be mixed in among the masterpieces from the early periods that are most esteemed today. In any case, the comment reveals the nature of Chinese estimations of Ch'iu's works. The *Wu-sheng-shih shih* describes them as "beautiful and elegant, full of delicate and graceful detail. The brushwork was so refined that the pictures looked as if they had been carved in jade."[17] This is a good description of the truly lapidary character of Ch'iu's most polished productions, of which the Golden Valley Garden is certainly one. We might also, however, find the profusion and variety of jadelike detail in it a bit excessive and agree with Wang Chih-teng who (borrowing a phrase from the pre-Han work *Chan-kuo ts'e*) charged that Ch'iu, "when painting a snake, could not refrain from adding feet."

The other painting, of which we reproduce a detail (Pl. 102), represents the T'ao-li Yüan, or Garden of Peach and Pear Trees, in Ch'ang-an. The name suggests an orchard, but the peach and pear, like the prunus or blossoming plum, were grown and enjoyed in gardens more for their flowers than for their fruit. During their brief season of blossoming the master of the garden and his guests would hold parties beneath the trees to contemplate the flowers, drink wine, and compose poems. (The custom is still followed, loosely, in cherry-blossom season in Japan.) At one such memorable gathering in the T'ao-li Yüan, on an early spring evening in the eighth century when T'ang culture was at its glorious peak and Ch'ang-an was its center, the poet Li Po wrote a famous prefatory essay to the series of poems that he and the others had composed, and this is probably the occasion that is the theme of Ch'iu Ying's painting.

Li Po, whose dependence on alcohol to inspire his poetry is well known (his contemporary Tu Fu remarked that "one gallon produces a hundred stanzas") may be the figure holding a cup seated at the right of the table. Servant boys and women are pouring, warming, and carrying more wine to ensure the unimpeded flow of poetic sentiments. The blossoming trees, enough in themselves to intoxicate the senses, frame the scene. But where another artist might have painted them as great masses of bloom, with the figures seen between them, to convey something of the experience that one has in a grove of flowering fruit trees of being enveloped in a fragrant cloud, Ch'iu Ying separates figures from trees with expanses of empty ground and is sparing in his distribution of blossoming branches. The postures of the seated poets similarly suggest their inebriation only delicately.

It is Ch'iu Ying's artistic method, whether or not conscious, to depict the physical elements that make up or contribute to an experience or mood, without attempting to induce that experience or mood directly in the viewer's mind by any of the abstract means of expression that were by this time so highly developed. He presents the materials of his picture meticulously, spacing them on the surface for optimum legibility, drawing them with a technical finish that is unmatched in Ming painting, but remaining always coolly aloof from them, as though they concerned no more of his being than his artist's eye and hand.

The great gardens of Soochow, laid out and built in the Yüan and Ming periods and in many cases still to be seen there, were not only the settings but also the subjects for much of the best

and most typical work of Soochow poets and artists. In themselves private pleasances from which everything harsh and upsetting could be expelled, they translated easily into an art that had the same character and aims. If the paintings seem two-dimensional transcriptions of the gardens, so do the gardens exist as physical embodiments of the paintings and the ideals they express and as midway realms between art and life. Early sixteenth-century Soochow, like Fujiwara-period Japan, represents one of those rare moments in human history when a society, or a privileged segment of it, succeeds in structuring itself so that people within it can live as though they were inhabiting works of art. The garden was situated just on this blurred boundary between real and aesthetic modes of being. It stood equally, and again like the work of art, for the interpenetration of present and past, since it could span the centuries (one might compose a poem or paint an album in the very garden that Ni Tsan and Chao Yüan had once portrayed, the Shih-tzu-lin or Lion Grove Garden) and could be made (or imagined) to reincarnate gardens of the past that were known to all within the circle through literary accounts or paintings.

We have no clue to the identity of the patron for whom the Chion-in pair were executed; he may have been a scholar-official who inherited such a garden with the family estate or a rich merchant who had built his own as a visible proclamation of new wealth and who saw himself as a latter-day Shih Ch'ung. Whoever he was, his ideals are embodied by Ch'iu Ying in paintings as unproblematic and perfectly controlled as the gardens themselves. Prototypes for the compositions can be found in Sung-period paintings depicting garden banquets and parties, and some of those were based on even earlier models. The serving women in both pictures are obviously descended from the court ladies who appear in paintings by or after Chang Hsüan and Chou Fang of the T'ang period, whom Ch'iu is said to have imitated.

But finding sources for motifs in Ch'iu Ying's paintings is an academic exercise that scarcely affects our appreciation of them, since they are, with a few exceptions (one of which we will consider later), quite devoid of deliberate archaism, conscious stylistic allusion, or any variety of primitivism. The absence of any of these qualities that the scholar-artists were inclined to mix into their styles as added flavorings, and the absence as well of conscious individuality of style, sets Ch'iu's works apart from theirs, even when the subjects are similar and the styles superficially so. The difference, then, is not so much in awkwardness and skill as in the greater or lesser degree of self-consciousness, or style-consciousness, in the artist that is manifested in the paintings. The scholar-painter, when he invoked old styles, was likely to exaggerate their archaic features, or introduce subtle distortions, to signal that his use of the past was a knowing one, not simple imitation. He put his quotations, that is, within quotation marks, with the same double implication that they carry as punctuation: that the user is quoting from some earlier source and that he stands off or dissociates himself slightly from what is expressed. Ch'iu Ying does neither; his uses of the past, and his dissociation from his subjects, are of other kinds. He remains always on the plane of total seriousness, from which the archaistic works of the scholar-artists are often removed by touches of irony or wit (cf. Wen Cheng-ming's "Red Cliff," Pl. 117).

In addition to pictures of gardens and villas of antiquity, Ch'iu Ying was sometimes called on to do idealized portrayals of his patrons' "rustic retreats." We have already seen examples of this special Chinese genre in the works of scholar-artists of the Yüan and Ming periods; it was not ordinarily among the categories of subjects that the professional artist was commissioned to undertake—none are to be found, for instance, among the works of the Che-school masters or of Chou Ch'en—and the existence of such pictures by Ch'iu Ying may be another indication of the degree of esteem in which he was held by the cultivated gentry and literati of Soochow. The prestige attached to such a picture, when the owner of the villa later brought it out to show his guests, normally depended less on its artistic excellence or success in describing the place than on the fame and stature of the painter—anyone with money could hire a competent limner

to portray his summer home, but not everyone could have had Wang Meng or Shen Chou as an obligated guest. Presumably it was through association with Wen Cheng-ming and his circle that Ch'iu obtained such commissions.

Outstanding among his works of this type is the handscroll titled "Master Tung-lin's Villa" (Pl. 95). It was painted, according to his dedication, for a certain Master Tung-lin, who may be an imperial censor named Chia Ting (1448–1523). It exists in at least three versions, and the question of which if any of them is Ch'iu Ying's original remains to be investigated thoroughly.[18] The one we reproduce is the better of two in the Palace Museum, Taipei, and could be from Ch'iu's hand, although certain weaknesses in some passages suggest that it too may be an excellent copy by one of his followers. In its present form it is accompanied by only two inscriptions, poems written by T'ang Yin and his friend Chang Ling. The other version in the Palace Museum bears a more informative colophon, consisting of two poems with a prose note, written by Wang Ch'ung in 1532. It is likely, however, that this colophon belonged originally to a different picture, done for another patron. Even so, it is worth quoting for the information it gives on how such a scroll came into existence: "These are two poems that I composed for Mr. Wang Ching-chih's Garden Dwelling. Now he has engaged the painter Ch'iu Shih-fu [Ying] to depict it in a small handscroll. Ching-chih, in a leisure moment, brought out the scroll to show me and asked me to inscribe it; so I wrote out the two poems to follow the picture."

Wang Ching-chih was Wang Hsien-ch'en, a Soochow scholar-official who, like Chia Ting, rose to the position of imperial censor. He "engaged" Ch'iu Ying, who is designated a *hua-shih* (limner, artist-on-hire), to do a picture of his garden dwelling; the word rendered as "engaged" means to hire as a workman. Even in this brief note, then, Ch'iu is implicitly relegated to the status of artisan-painter.

The "Master Tung-lin's Villa" scroll opens with a small waterfall in a rocky ravine and continues with a passage in which leafy trees enframe two servant boys who are engaged in their customary chore, warming the wine. Master Tung-lin sits in the doorway of his house, talking with a guest. Another stream runs past the house at the left, crossed by a plank bridge over which another servant approaches, carrying a package. The ending is pure Southern Sung: a slanting foreground rock announces a change of key; a river appears, revealing that the whole scene has been set on its shore; the bank recedes into mist and, paralleling it and echoing the recession, a grove of peach trees in the distance, through which a band of fog floats. The whole composition is exquisitely calculated, moving from constriction to expansion, from dense textures to smooth, from the sterner symbolism of weathered rock and twisted shade trees to the exuberance of spring freshets and blossoming fruit trees. Once more, the style is virtually beyond discussion; one can neither find serious fault with it nor find much to praise, apart from the same near-perfection of technique within a highly derivative mode that we have seen in Ch'iu's other works.

The looser manners of brushwork, the bold calligraphic gesture, "scribbliness," and other modes of drawing that exploited the spontaneous effects of relaxing kinesthetic control over the movements of the brush—none of these seems to have held much attraction for Ch'iu Ying. No doubt this is in part a matter of his temperament and training, but it has to do also with the lateness of his main period of activity, relative to Chou Ch'en's and T'ang Yin's: by the second quarter of the sixteenth century, the restrained and highly refined taste of Wen Cheng-ming had permeated Soochow painting, and those styles of the preceding decades that had washed over from Nanking and the late Che school were mostly out of fashion. Ch'iu Ying's alternatives to the sleek manner that he shares with Chou and T'ang generally do not take the form of excursions into activated calligraphy, like theirs, or indeed of stylistic adventurism of any kind. He follows, always comfortably, in ways well prepared by others, whether they are his contemporaries or masters working centuries before, taking no chances and making no mistakes. He does excellent

*pai-miao* drawing, landscapes with palaces and figures in the *chieh-hua* ("boundary painting") tradition, blue-and-green landscapes in the archaistic-decorative mode developed by Ch'ien Hsüan, and paintings in the mild and poetic manner used by Wen Cheng-ming and Lu Chih, in which pale washes of cool and warm color are added to brushwork of extreme finesse.

We will see excellent examples of this last style by Wen and Lu themselves in the following chapter. Ch'iu uses it in a number of his works, probably under their guidance and certainly under their influence; one of the finest is his "Lady in a Pavilion Overlooking a Lake" (Pl. 103). The composition clearly depends on the common Che-school type in which the main elements are aligned vertically up one side and spaced horizontally on the other, a type also used occasionally by Chou Ch'en and T'ang Yin. But the resemblance goes no further. The tight interlocking of strongly defined units that is typical of the Che-school productions is inimical to Ch'iu's aim, nor does he use this compositional plan as a stable frame within which to generate dynamic tensions.

His drawing is everywhere unassertive, reticent, in keeping with the poignant but understated theme of his picture. It is a theme that might equally have been expressed in a poem—and had been, innumerable times. A woman stands at the balcony in the open upper story of a house by the river, looking out over the water. As any reader of T'ang poetry (and this meant any educated Chinese) would know immediately, she is thinking of her absent husband or lover and watching for his returning boat. But, just as the composer of a classical quatrain might reserve this image for the third line, using the opening distich to establish setting and mood, Ch'iu removes his house and melancholy lady to the middle ground, beyond a stretch of water, a steep cliff, a flat bank on which grows a screen of fully foliated trees, and a wall.

All this is arranged and portrayed with cool precision, leaving one no doubt about the placement of each part; the sharp cutting of the bank and the uncompromising horizontality of the wall, its top and bottom edges drawn as if with a ruler, seem to reflect the painter's scorn, which he shares with Wen Cheng-ming, for blurred transitions and softening of any sort. From the house to the far distance the river stretches unbroken until a few spits of land with stubby trees enter from the left, and low hills a little farther back close the recession, except for the dim silhouettes of still more distant hills. The evocation of loneliness through physical remove is worthy of Ni Tsan, a master to whom Ch'iu Ying is not ordinarily likened.

The Sung styles that Ch'iu re-created for his patrons usually extended no further down through that dynasty than the mid-twelfth century, as represented by the followers of Li T'ang and by Chao Po-chü. Beyond lay the romantic realm of Ma Yüan and Hsia Kuei, which seemed separated from sixteenth-century Soochow by some fundamental disjuncture of sensibility. On the rare occasion when Ch'iu Ying ventures into that realm, the outcome is more akin (to use a musical analogy) to the post-romantic restraint of French composers of the late nineteenth and early twentieth centuries than to the full-blown richness of the Germans or Russians.

Ch'iu's "Fishing Boat by a Willow Bank" (Pl. 105), one of his few hanging scrolls in the ink-monochrome medium, is also one of his very few in the Ma-Hsia mode. In it we can observe the artist making use of selected aspects of that mode without compromising his basic approach, which remains cool and controlled. His adaptation of the diagonally oriented composition is especially interesting. The placement of the fisherman and his boat establishes the viewer's vantage point with unusual firmness: one looks at the boat downward and to the left, and the drawing of it, besides being far more structurally descriptive than was usual by this time in *pai-miao* drawing, is meticulously consistent with that perspective (see detail, Pl. 107). Consistent with this, in turn, are the flat plane of the water and the outline of the riverbank. Countering the diagonals set by all these, in good Southern Sung fashion, is another that is felt rather than seen, between the fisherman and a pair of small ducks near the opposite shore, above him and to the right. Of the willows, only the tops enter the picture space, where they catch the wind, together with

the wave-ruffled surface of the water and one tassel of the fisherman's cap, for a delicate impression of summer breeziness. That Ch'iu Ying achieves this effect while yielding nothing of his propensity for the explicit over the suggestive is remarkable: the curving strokes of the willow tendrils do not simply form patterns but describe growing forms; the bank is rendered with a calculated semivagueness that in fact implies nothing beyond what is there; the fisherman is drawn with the anatomical accuracy of Chou Ch'en's beggars.

Around this time, the very tall hanging scroll, intended for display in high-ceilinged reception halls, becomes popular and continues so through the seventeenth century. Examples exist by Wen Cheng-ming, Hsieh Shih-ch'en, Tung Ch'i-ch'ang, and others to be treated in the succeeding volume. Two of the most impressive works of Ch'iu Ying are on this scale, over nine feet tall. They are the surviving pieces from a set of four corresponding to the seasons and were no doubt meant to be hung in rotation throughout the year. Collector's seals of Hsiang Yüan-pien on the paintings again indicate that they were probably painted for him.

The one we reproduce (Pl. 104) is the spring scene of the set and is titled "Conversation in the Shade of Wu-t'ung Trees." Two men are standing beneath the broad-leafed trees (*Firmiana simplex*) near tall rocks, beside a rushing stream which is the main indicator of the season. The other scroll extant from the set, the summer scene, is titled "Passing a Summer Day Beneath Banana Palms."[19] The standing figures in the "Conversation" (detail, Pl. 106) are not unlike T'ang Yin's "Noble Scholars" (Pl. 94) in their costumes and staid postures; the difference, and it is fundamental, is that Ch'iu Ying takes them perfectly seriously, as he does all his subjects. They clasp hands with calm dignity, as if meeting or parting, their faces impassive. The swift-flowing water and the rocks echo the human theme, suggesting the passage of time and endurance, two aspects of friendship; the enclosure formed by the rushing stream, the trees, and the shadowy undersides of the rocks suggests the mood of leisurely conversation in the cool shade more than do the figures themselves. Unlike most of his scholar-artist contemporaries, Ch'iu manages the tall composition without resorting to mannerist attenuation or episodic piling of incident; the focus is maintained, the structure clear. Seen in detail, and in relation to Ch'iu's other works, the execution of the picture seems fluid, even dashing, with taut, resilient brush-lines for the figures and split-brush contours for the rocks.

Ch'iu Ying adds to his signature on the accompanying summer scene a phrase meaning "playfully drawn," a conventional disclaimer of seriousness which he must have meant to apply to the whole set. The phrase was often used by the amateur artists on their small, improvisatory "ink plays," to which it seems appropriate. But to apply it to four huge, highly finished works seems, on the contrary, anomalous; one does not dash off such paintings as these. In fact, they show no evidence at all of improvisation, or even of much real spontaneity. The compositions must have been carefully planned, and each stroke in them plays its role faithfully. Within Ch'iu's whole oeuvre, these two scrolls do indeed represent his nearest approach to the impulsive, semi-controlled drawing of artists who were truly able to relax the discipline of their brushes; but it is not very near, and Ch'iu Ying remains always in full control of his means and his forms, always the master painter. What he demonstrates here is not that he too can relax, but that these broader, more brilliant manners of brushwork are not completely incompatible with his totally disciplined way of working.

From the time of Wen Cheng-ming, in keeping with the literary and poetic orientation that he gave to Soochow painting, pictures based on old stories and poems appear with greater frequency among the works of the major and minor Soochow masters. These are not straightforward storytelling pictures like, for instance, the early Ming Academy masters' depictions of *ku-shih*, "events of antiquity" (cf. Shang Hsi's "Lao-tzu Passing the Barrier," Pl. 6). They were independ-

ent landscapes, in which the narrative elements were often inconspicuous; the audiences for whom they were done knew the stories well and needed only minimal clues. Often they accompany transcriptions of the texts, written out by noted calligraphers of the time such as P'eng Nien and Wen P'eng. Themes of a meditative or melancholy flavor were preferred; the favorites were T'ao Yüan-ming's "Peach Blossom Spring" story, Su Tung-p'o's "Red Cliff Ode," and Po Chü-i's "Lute Song" (P'i-p'a Hsing).

The last was written in 816 when Po Chü-i (772–846) was serving in a lowly post in exile at Chiang-chou in Kiangsi Province. He had come to the shore of the river to see off a departing friend. Hearing the sounds of a p'i-p'a being played in a nearby boat and recognizing the style of playing as that of the capital, Ch'ang-an, Po plied the performer with wine and persuaded her to sing for them, later inquiring and learning that she was an old courtesan who, when her period of youth and popularity was over, had married a tea merchant and moved to this hinterland. As he listened to her and remembered his own years in Ch'ang-an, he realized poignantly how much he missed the good music and companionship of which his exile had deprived him.

Of the hundreds of paintings based on this poem that are still to be seen, one by Lu Chih, painted in 1554, best matches the nostalgic tone of the poem with a pictorial style that evokes a similar complex of feelings (Pl. 121). Ch'iu Ying's "Lute Song" handscroll (Color Pl. 9) is less evocative, more explicit, like others of his works. In spite of the literary subject his scroll remains squarely in the realm of painting: where Lu Chih recalls delicate sentiments transmitted by the ninth-century poet, Ch'iu Ying recalls the archaic blue-and-green landscape manner as transformed by Ch'ien Hsüan and others in the Yüan dynasty (cf. Hills, Color Pl. 1). A T'ang-derived style was, of course, proper for a picture to accompany a T'ang poem; but this is more a matter of history than of any real correspondences between pictorial and literary styles.

In Ch'iu's hands, the archaistic manner becomes more abstract and schematic than ever before, the waves more insistently patterned, the mountains more geometrically striped and segmented. Colors are conventionally applied, with blue clearly separated from green, and conventional, hard-edged bands of fog cut across the middle distance. As in the archaic originals, everything is equally weighted and the composition is not made to direct attention to the boat with the p'i-p'a player, which is the proper narrative focus of the scene. But, as noted above, the storytelling aspect of the picture is almost peripheral; what is most impressive, in the end, is its sheer decorative beauty. Once again we may recall descriptions of Ch'iu's painting as "jadelike" and remember that Soochow was famous for handicrafts such as embroidery, lacquer, and carving in a variety of materials, with all of which this painting has qualities in common: rich surface, decorative flatness, great precision of workmanship.

It is, however, a painting, and demands to be judged and understood as a painting, not as a craft production. Such a spaceless and schematic offering from an artist who could, when he chose, create illusionistic effects more skillfully than anyone else in his time raises questions of intent. We have encountered already, in the works of Wang Meng and others, deliberate denials of space for effects of oppressiveness or disjunction from the physical world, or the reduction of natural form to pattern for similar ends. But the expressive neutrality of Ch'iu Ying's picture makes it difficult to regard the painting as the outcome of any expressionist urge. Archaistic pictures we have also seen, by artists such as Chao Meng-fu who explore old styles partly out of devotion to the past and partly in search of new creative possibilities as alternatives to those generally current in their time. But again, neither of these motivations seems quite to fit the character of Ch'iu Ying's work. A good assumption might be that he was provided by one of his collector-patrons with some antique model and commissioned to paint a scroll in a similar or related style, a work that would gratify an antiquarian taste. It is this situation and its consequences that we meant to suggest in writing earlier in this chapter about internal and external motivations: the involvement with the past that underlies the painting, in this case, would be

external, more that of the patron than of Ch'iu Ying, to whose own taste such primitivist awkwardness and stiffness cannot have been entirely congenial. His use of the manner is accordingly detached and coolly objective; the commitment is not thoroughly his own.

The resemblance of this and others of Ch'iu's archaistic pictures to Ming-dynasty forgeries of antique paintings, however, suggests another explanation for some aspects of the style: it may well be that Ch'iu, who was very likely employed as a forger himself in his early years (and also later, for all we know), is not only referring to a truly ancient style, but also—perhaps primarily —giving us a more accomplished and refined rendering of a style that was normally used, in his time, by low-level hack artists in producing fakes for equally low-level and undiscerning buyers. Connoisseurs belonging to the circle in which Ch'iu Ying worked were not likely to be taken in by such forgeries, which to them must have seemed crude and garish. What, then, can have been their response to Ch'iu's work? All we know of them suggests that their sophistication was sufficient, their style-consciousness highly enough developed, for them to savor a bit perversely, by a turn-about phenomenon of aesthetics familiar to anyone who follows even superficially the fashions of art in our own time, a technically superior but otherwise only slightly altered form of a "vulgar" style at which, in other contexts, they would scoff. If this is a valid interpretation of the implications of Ch'iu's painting, we are in the presence of a fascinating phenomenon, the "feedback" of late and low-class or even degenerate derivatives of an old tradition into high-class revivals of that tradition; it is a phenomenon we will encounter in unmistakable form in the late Ming, especially with Ch'en Hung-shou. When we turn from the response of the connoisseurs, however, to try to imagine how Ch'iu Ying may, in turn, have responded as an artist to the demands of that kind of taste—what, that is, his own feelings about the style can have been—we realize how far we have already extended our argument beyond what the evidence will safely sustain, and leave the question unanswered.

T'ang Yin and Ch'iu Ying had no direct followers of any significance; Ch'iu's son-in-law Yu Ch'iu, who paints neat, uninspired figure-in-landscape scenes, is no exception. A whole industry of imitators and forgers grew up in Soochow, however, feeding the demand that T'ang and Ch'iu had been so instrumental in arousing, turning out thousands of routine copies and pastiches, some of which were given the signatures of great early masters while others were ascribed to T'ang and Ch'iu themselves. The spurious "Chiu Yings" that have flooded the painting market ever since have in fact injured his reputation by their association with his name, and it is only when the genuine works have been separated from this marsh of mediocrity that Ch'iu's real stature can be assessed. Already in the late sixteenth century he and T'ang Yin, along with Shen Chou and Wen Cheng-ming, were numbered as the "Four Masters" of Ming painting. T'ang, Ch'iu, and their teacher Chou Ch'en had brought professional painting to a plane of excellence and prestige from which it had slipped badly with the decline and discrediting of the Che school. But no followers were to appear who could keep it on that plane. Soochow continued to be the principal center for the commercial production of paintings into the seventeenth century, and several more excellent artists were to take their places in the tradition before its virtual extinction at the end of Ming. But few painters of any later period even attempt to equal Chou, T'ang, and Ch'iu on their own ground, and none succeed.

# Wen Cheng-ming and His Followers: The Wu School in the Sixteenth Century

## 1. WEN CHENG-MING

Although Shen Chou is properly given credit by historians for "founding the Wu school," i.e., establishing Soochow as the leading center of literati painting in the Ming, it was not Shen's styles but those of his pupil Wen Cheng-ming (1470–1559) that were most influential and most widely imitated among the local group of scholar-painters in the sixteenth century. Wen Cheng-ming, more than anyone else, gives Soochow painting of this period its special color and flavor.[1]

THE EARLY DECADES   Wen's family had been distinguished in scholarship and public service since the Sung dynasty. They had moved to Soochow in the generation of his great-grandfather and were among the leading gentry families of the region. Wen Cheng-ming's grandfather Wen Kung-ta and his father Wen Lin (1445–99) have already appeared on the fringes of our discussions, the former as the recipient of a painting by Yao Shou presented to him on his retirement in 1479 (Pl. 25), the latter as a patron of T'ang Yin. Wen Cheng-ming and T'ang Yin were born in the same year, 1470, a circumstance that led inevitably to rivalry, in which Wen seems to have come off badly: while T'ang was a precocious child and brilliant youth, Wen was reportedly a dullard in his early years. Although he received the best education available in his time—Wu K'uan, for one, was his tutor in classical literature—he tried and failed the examination for an official post no less than ten times, between 1495 and 1522, before he was finally given a position at the capital in 1523 on the basis of a recommendation from the local governor.

This succession of failures left Wen bitter; characteristically, he blamed them on his inability, or disinclination (as one devoted to classical literature), to write in the modern prose style. When T'ang Yin passed the local examination with distinction, Wen's father wrote to his son: "T'ang Yin's talent is such that it is right he should succeed in the examination. But he is undisciplined and I fear in the end he will not accomplish anything. You will go far on some future day. He is not your match." After T'ang returned to Soochow in disgrace, suspected of having cheated in the examination, relations between him and Wen worsened until they saw very little of each other. Two long letters from T'ang suggest that he wanted to keep Wen's friendship and support but recognized that they were opposites in character. A few excerpts from one of these letters will convey their tone:

"You and I have been friends for thirty years. I met your late father at a tender age and he was

*211*

fond of me and thought highly of my qualities and had hoped that I would one day achieve something. . . . In Peking when I was the victim of the slanderous tongue of someone who was envious of my popularity, you were the only person to rise and speak in my defense. . . .

"I was careless in speech and often offended your servants; I was addicted to drinking and often was penalized for it; I often got myself in trouble because of my predilection for beauty, song, flowers and birds. But you were so different . . . you are so calm and imperturbable in spite of all the multitudinous forms of temptation. . . . So let me follow the precedent of Confucius and call you teacher. I do not say this just to please you; I really mean it. As far as poetry and painting are concerned, I can claim to be your peer; as for scholarship and personal conduct, I am ashamed to say that I am a far cry from you. When I say I want you to be my teacher, my sole purpose is to be able to win your friendship so that I might improve my mind and make it more perceptive: it is not for the sake of distinguishing myself. . . ."[2]

Wen Cheng-ming never lost his confidence of excelling in the end. While T'ang Yin and his friends Chu Yün-ming, Chang Ling, and others were taking their pleasure in the elegant and erotic diversions that the city offered, Wen practiced calligraphy at home. He was abstemious, never drinking more than six cups of wine at a party. Invited on one occasion to a dinner on a houseboat by T'ang Yin and suddenly confronted with a selection of Soochow party girls who had been smuggled aboard, Wen "started screaming and threatened to jump into the water until T'ang Yin finally let him escape in a sampan."[3] Stories such as this, like the similar ones told about Ni Tsan, may be apocryphal but indicate that their subject was at least sufficiently strait-laced to inspire them, and they provide a counterbalance to the more frequent expressions of admiration for Wen's moral rectitude.

From the late 1480s Wen was also studying painting under the guidance of Shen Chou. In an inscription written much later on a landscape handscroll that Shen began in 1489 and he himself completed, Wen quotes the older master as having given him this advice: "As far as methods of painting are concerned, the basis is planning the composition; but 'engendering movement through spirit resonance' is essential if one is to attain the level of the marvelous. Planning the composition is easy to master, but spirit resonance is a matter of mental concentration that cannot be conveyed in words."[4]

Wen Cheng-ming continued to learn from Shen Chou until Shen's death in 1509, after which he studied independently, in part by imitating old works in his own and other local collections. A problematic work that may date from the period 1496–97, titled "Leisurely Living at the Stream Pavilion," is a loose, still immature essay in the manner of Huang Kung-wang and, if genuine, can serve to represent his early studies of the Yüan masters, presumably undertaken with the encouragement of Shen Chou.[5]

Of more sure authenticity, and more useful for understanding on the one hand Wen's debt to Shen Chou and on the other his emergence as a distinct and independent master, is "Spring Trees After Rain" (Pl. 111–12). It is useful to compare it with Shen Chou's "Walking with a Staff" (Pl. 29). As we might expect after reading Shen's advice quoted above, the immediately striking similarities between the two pictures are compositional, having to do especially with the way the picture areas are divided. Compositions based on clear divisions of the picture surface into large geometric shapes were characteristic also of the Che-school masters, but in their works the shapes were usually fewer, simpler, and not locked together so tightly or interrelated so dynamically as those in the works of Shen and Wen. Shen Chou avoids the static and stereotyped compositions of most of his contemporaries, working with greater versatility to reveal a whole new set of compositional problems and possibilities. Wen Cheng-ming begins by imitating Shen's compositions but goes on to imitate, more creatively, his experimental approach.

Read upward as formal sequences, the two pictures prove to have a great deal in common.

Each begins with a wedge-shaped area of water and continues with slanting banks joined by a bridge and surmounted by trees. A larger water area occupies the center of each; it is in each case a positive shape that exerts its counterpressure against the earth masses, not merely a neutral ground that sets them off. The farther banks, which in Wen's picture seem to lie on the water like floating cakes of ice, are again slanting and again divided by the river. The "principal mountain," really only a steep ridge or bluff, is centrally located in each, with its peak offset to the left, so that the eye ascends to it on a curving movement into depth. Foreground and background are about equally weighted in each, with some key forms in the upper part that seem almost mirror reflections of those in the lower. The mode of composition that the two paintings share depends on delicately calculated repetitions, proportionings, instabilities, imparting a sense of precise planning and suggesting that the removal or displacement of any part would upset the fine-strung balance of the whole.

Wen Cheng-ming's rendering of the composition, however, reveals an artistic personality very different from Shen's in many respects. His thin dry-brush contour lines move slowly in delineating the forms; the dotting (sparsely applied, with no aim of enriching the surface, since a thinness of texture is crucial to the expression of the work) and the meticulous rendering of tree foliage are done with the same deliberation. There is not an impulsive stroke in the entire painting. Shen Chou's early works (Pl. 30–31) were also executed in more slender brushwork than his typical late ones, but were done with touches of exuberance and impromptu invention that are wholly absent from Wen's picture, in which evidences of afterthoughts and corrections, although fairly numerous (Wen is still far short of complete technical control), are carefully concealed, to the best of the artist's ability. Where Shen Chou's landscape is bold, robust, built up of powerfully assertive masses, Wen's is cautious and reserved, made up of smaller and unassertive forms.

This quality of reserve in Wen's style had its own positive value and seems to have exerted a quiet but strong appeal to the temper of early-sixteenth-century Soochow, underlying a poetic mildness of mood and slight nostalgia that eventually imbue much of the output of the school. If we look for precedents in the past for this quality, or flavor, they are to be found in the works of Ch'ien Hsüan and certain of those by or after Chao Meng-fu, notably "The Mind Landscape of Hsieh Yu-yü" and "Gazing at the Stream" (Hills, Pl. 10, 18). We know from Wen's writings, including inscriptions on paintings, that Chao was the artist he most admired and his principal model for many features of his style, as well as for the air of classical coolness in his works.

Wen's inscription on his picture informs us that it was painted for a certain Lai-shih, who was about to depart for Peking, presumably to take up some official post; Wen suggests that Lai-shih can look at it while traveling by boat, when he wishes to remember the scenery around Soochow. His quatrain reads:

> After rain, the spring trees cast a green shade.
> I love most the western hills as they turn to evening light.
> There should be people's houses at the foot of the hills—
> Across the river, in far distance, rises a white fog.

"Spring Trees After Rain" indicates the principal direction of Wen Cheng-ming's early stylistic explorations and the character of most of his work: methodical, sensitive, reserved. Admirable as it is in its cool clarity, it leaves room for progress, as Wen must have realized, in the convincing rendition of mass and space. His progress beyond this point and his solutions to the fundamental problems of painting landscape are of the kind we might expect from what we know of him—a man for whom nothing came easy, who had to work through each achievement of his life slowly, carefully, after failures and false starts. Wen was not the kind of painter (as T'ang Yin was) who could evoke effects of massiveness and spaciousness as if effortlessly, in brilliantly pictorial creations; he had to master his technical means painstakingly. Several pictures dated

or datable to the following decade reveal him thus working out, with help from a number of old masters, a consistent system for constructing a landscape "from the ground up," with each part firmly related to the others, and the whole readable and (in imagination) traversable.[6]

A good example is a well-recorded painting that has only recently come to light, "The Chih-p'ing Temple" (Pl. 113). It was painted in midwinter, on a day corresponding to January 8, 1516, as we learn from the artist's inscription; after writing out a long poem (which was later included in his literary collection *Fu-t'ien chi*) in the "small standard" (*hsiao-k'ai*) script for which he was renowned, Wen adds: "Li-jen [Wang Ch'ung] has been staying for a long time at Mount Chih-p'ing. As the [lunar] year closes, I thought fondly of him and inscribed this to send to him." Wang Ch'ung (1494–1533) we will re-encounter later as a painter; although scarcely over twenty when the picture was painted, he was already one of Wen's close friends and was staying at the Chih-p'ing monastery on Mount Shang-fang, located a few miles southwest of Soochow, probably to study for the official examinations, away from the distractions and temptations of the city. He may be the man seen in a house at the center of the picture, with shelves of scrolls beside him, and the wall and gate seen in lower right may belong to the temple. But the painting, typically for Wen Cheng-ming, seems in itself neither topographical nor very personal.

Anne Clapp has written that this painting "shows in uniquely pure form the Northern Sung Academy style which Wen derived from Chao Meng-fu, or in this case perhaps directly from a Sung original, and which became the starting point of his garden style. Here at the beginning of the series he is so faithful to his model that we would not know without his inscription and signature that the 'Chih-p'ing Temple' is his own handiwork."[7] Although this greatly exaggerates the derivativeness of the painting (Wen Cheng-ming's hand is, on the contrary, apparent everywhere), Clapp is certainly correct in stressing the studies of Sung painting, whether or not first-hand, that must underlie it.

A work from the same year in the Li Ch'eng manner (cf. note 6, above), designated as such in Wen's own inscription, corroborates the evidence to be seen in the style of the present work: the patient, systematic blocking out and building up of the landscape indeed recalls Northern Sung painting. In the solidly based foreground, flat banks are raised above the water surface, as in "Spring Trees After Rain"; the wall, fences, and groups of trees surround areas of space and take us back gradually into depth. From the centrally placed house, the focus of the composition, space opens back diagonally to each side, while the steep ridge rises between these two recessions, curving off rightward at the top. The aim of the artist is to create a sense of substance and space, the former through volumetric drawing supplemented by earthy texture strokes and dotting on the slopes, the latter through a calculated echoing of nearer forms by farther, which establishes a resonant interval between them: the foreground and middle-ground figures, one arriving and the other waiting (active and passive); the pairs of trees in lower right and middle left; the parallel ascensions of ridges at the right.

Paintings in the restrained, rather remote manner of "Spring Trees After Rain" and in the careful brushwork of "The Chih-p'ing Temple" continue throughout Wen's painting career; those in a bolder style are fewer. A saying current among Chinese collectors is that one should look for "fine Shen and rough Wen"—for the more careful works of Shen Chou, that is, and the bolder ones of Wen Cheng-ming.

A striking example of the "rough Wen" category is a large painting of 1519 titled "Lofty Leisure Beneath a Sheer Cliff" (Pl. 108–10). In a rocky ravine a man sits on the riverbank, attended by a boy holding books; he awaits the arrival of a friend, who approaches across a stone bridge, walking with a staff. The pairing—one arriving, one waiting—follows the formula that Wen used in "The Chih-p'ing Temple" and several others. The space of the picture, here more constrained, funnels back to a waterfall at the upper left. The waterfall does not (as in many other works of the school) perform a simple compositional role as a conventional motif but seems

to fill the scene with sound and mist. The shade of the pines and leafy trees that occupy the upper part of the composition is similarly felt rather than represented and enhances the sense of cool atmosphere, as do the overhanging cliffs. The impassivity of the figures is in keeping with all this; Wen Cheng-ming's world is made up of clear, fast-moving water, rocks, and trees, and humans have a place in it to the extent that they assume the qualities of their surroundings.

Wen's broad-brush drawing, superficially similar to Shen Chou's, has none of the implications of relaxation and amiability with which Shen invests his, especially in his later works; it carries far more tension and, when applied to these more angular forms (distantly derived, in part, from the tradition of Li T'ang), creates a sense of severity, even harshness. Nor does Wen ever seem to be improvising, as Shen sometimes does. One is aware always of a powerful intellect behind the paintings, exercising tight control. It can be seen operating in the composition, which introduces a new mode that we will see brought to culmination in a work of 1542 (Pl. 114). The picture surface is divided into large segments; the dense, busy area at the upper right, filled with tree branches and leafage, is set against an open area at lower left, while the lower-right and upper-left segments are occupied by large pairs of crossed trees, the farther echoing the nearer. Compositions of this type had first appeared among the late works of Shen Chou, for instance in some leaves of the "Tiger Hill" album (Pl. 39–40).

PEKING INTERLUDE   The majority of Wen's works, and the best of them, belong to the last three decades of his life, when he was again living in Soochow, in retirement after his brief period of service at the capital. He traveled to Peking in 1523, already in his fifties but hopeful of an official career that would at last vindicate his confidence in his scholarship and justify his decades of study. He was appointed, without having to go through the usual final examination, to a position as consultant in the Han-lin Academy, where he worked on compiling the official history of the era that had just ended, the Cheng-te (1506–22). However, for a complex of reasons, he was unhappy in his post and petitioned the emperor three times for permission to retire before he was finally, in 1526, allowed to return home.

During his three years at court he was homesick, beset with illnesses, and underpaid (or, some of the time, not paid at all). A series of nine letters written to his wife and two sons, Wen P'eng and Wen Chia, are poignant accounts of his arduous journey to Peking and frustrating life there.[8] He was beset by requests for occasional writings: "I am in a bad state of mind—and without a single vacant day, writing poems and compositions for social occasions." He was probably also well enough known as an artist to be subject to requests or demands for his paintings from higher officials and colleagues. At the same time, as we learn from Ho Liang-chün (1506-73), who seems to have known him and is thus a relatively reliable source of information, Wen was resented by others who felt that a painter had no place in the Han-lin Academy: "In the days when Master Heng-shan [Wen Cheng-ming] was serving in the Han-lin Academy, he was harassed by Yao Ming-shan and Yang Fang-ch'eng. At times they would speak out directly to everyone, saying: 'Our office is not the Painting Academy; what is a workman-painter doing here?' "[9] To call Wen a "workman-painter" and to imply that he did not merit a place in the Han-lin on his scholarly merits alone were serious insults and, if the story is true, must have added to his other afflictions during the Peking period. Ho Liang-chün goes on to suggest that Yao and Yang, two fellow compilers in the Han-lin Academy who had taken first place respectively in the chin-shih examinations of 1523 and 1521, had devoted themselves too narrowly to their studies to be interested in anything else and mentions others who were Wen Cheng-ming's friends, men of broader cultural attainments with whom he chose to associate and exchange verses.

Another reason why, within the Academy, respect for Wen's literary and artistic abilities was mixed with resentment was that scholars of longer standing at court and with far more practical experience were placed under him. The Grand Secretary Chang Ts'ung, an old friend of Wen's

father, gave him support that proved in the end an embarrassment when, in 1526, Chang criticized other court officials to the emperor so vehemently that they were flogged, several of them to death.

In the winter of that year Wen finally resigned, and his resignation was accepted. His son Wen Chia, in his biography of his father, reports that he said at this time: "Ever since I was a young man I have devoted myself to writing, hoping to establish a career in government service. But I have not been able to win even one degree. How can I now have the temerity to remain here any longer, especially when I have nothing to do and am still being paid a salary? I am uneasy in my mind."[10]

THE LATER YEARS   Back in Soochow, Wen devoted his time to poetry, calligraphy, and painting more assiduously than ever. He never again tried to hold office and reportedly even refused requests from politicians for his works, to avoid incurring or imposing obligations of any kind with them. He also refused to paint, we are told, for foreigners or merchants. (Several of Wen's friends were the sons of merchants, but they were educated men with the proper credentials for acceptance into literati circles; it was presumably with the ill-educated mercantile sort that Wen high-mindedly declined to engage in the kind of social intercourse that giving paintings, and being recompensed for them, entailed.) His art, then, was directed more or less exclusively to an audience of literati, most of them of the gentry class, who shared his tastes and admired his achievements; after his bitter experience in the larger world of practical affairs, with which he could not cope, he was determined to limit his involvements to those over which he had a large measure of control. With all ambitions toward publicly recognized scholarship and socially beneficial service put behind him, Wen became reconciled to his role as littérateur and painter; aiming at last at what was within his reach, he was an unqualified success. A circle of poets and artists formed around him, of which he was indisputably the center, as he was of the whole Soochow literary and artistic culture.

Since we have stressed, in the preceding chapter, the professional standing of Chou Ch'en, T'ang Yin, and Ch'iu Ying, we must distinguish the economic basis of Wen Cheng-ming's painting career from theirs. The distinction, while not absolutely clear-cut, is real and important. It is not based so much on whether or not the artist derived some profit or material benefit from his paintings—most artists did, whatever their status—but rather on questions (crucial ones for the Chinese) of whether the artist painted his pictures with the aim of selling them, accepted commissions, worked for any patron who would pay a high enough price or provide him with support of another kind (such as lodging and entertainment), or otherwise allowed the demands of others to affect his choice of subjects and styles.

T'ang and Ch'iu would have had to answer most if not all these questions in the affirmative; Wen would give a vehement (and indignant) no to all of them, even though he must at times have lapsed from pure amateurism. He seldom if ever painted, as Ch'iu and T'ang regularly did, pictures of a decorative or functional character (i.e., those designed to be hung on special occasions, holidays, etc.) or pictures with narrative, genre, or other popular themes (a few paintings based on poems such as the "Red Cliff Ode" being exceptions). He gave his paintings to friends and relatives, we are told, especially those who were poor and could sell them to get living expenses. He also engaged, we may assume, in the kind of informal exchange of gifts and favors that we described earlier in connection with Shen Chou's paintings. If he sometimes accepted gifts from wealthier recipients in exchange for his works, it was at no sacrifice of artistic independence.

Nevertheless, in the eyes of most Soochow citizens, no doubt, a painter was a painter, to whom one went when one wanted a painting. This was the paradox: learning and a high level of

culture theoretically placed one outside the marketplace, where one's creations were not for sale; but in a strictly practical sense, the fruits of learning were objects of value, marketable commodities just as were the productions of the artisan. The noncommercial, "literary" aspect of the scholar-amateur's painting enhanced its value in the eyes of the connoisseurs and thus, surely, for many Soochow collectors of that time, its monetary value as well. It is often said that the emergence of the literati school raised painting to the status of a fine art alongside calligraphy and literary composition, but in fact those arts were beset with the same ambiguities. A leading calligrapher might be regarded as only a loftier counterpart to the village scribe: one went to the scribe for ordinary, functional writing, such as a letter, and to the calligrapher for beautiful, prestigious writing, such as an inscription for the plaque over the door of one's studio.

Painting in Soochow can be viewed as belonging to a similar continuum, from the simplest decorative and functional works up to those intended for the most rarefied aesthetic contemplation. As for literature, Wen himself, in a letter to his friend Wang Ao, dispels any notion that it was produced in a purely disinterested way out of the writer's inner necessity: "Now crowds come seeking my writing and I am often overwhelmed with work. I do not like to turn down people's requests and try to fulfill them all. What they want are always farewell letters, elegies, and, even worse, the minor works the common call miscellaneous. What I term my literary creations are usually this kind of perfunctory and impersonal composition. Alas! Can such things still be considered literature?"[11]

We can be sure that Wen did not expend his time and abilities on such writing purely out of friendship; but here, too, the mode of recompense must have been something other than simple cash payment. Wen, who was not a rich man, must have been well aware of the monetary value of his paintings, many of which found their way onto the market during his lifetime. Also, as in the case of Shen Chou, forgeries were already in circulation. A revealing story is told in a late Ming miscellany about Wen's pupil Chu Lang, who is said to have "ghost-painted" for Wen, doing pictures for the master to sign when Wen was too busy to produce all the paintings he needed to requite favors or discharge obligations. (The practice was apparently common, the pictures presumably being intended for those not perceptive enough to know the difference.) A visitor from Nanking sent a boy servant bearing presents to Chu, to ask him for a "fake Wen Cheng-ming." By mistake the boy delivered the presents and the request to Wen himself, who laughed, accepted the presents, and said: "I'll paint him a genuine Wen Cheng-ming; he can pass it off as a fake Chu Lang."[12]

All the tensions and ambiguities implicit in this complex situation were heightened, in Wen Cheng-ming's case, by the high level of technical proficiency in his paintings, which must have ensured their appeal to people of widely divergent tastes. Ho Liang-chün stresses this aspect of his art: "Heng-shan [Wen Cheng-ming] was basically an amateur; but when we look at his colored paintings done in imitation of Chao Meng-fu, or his small landscapes in the Li T'ang manner, they are all works of the utmost refinement—works of an amateur, that is, but with nothing in them that is really unprofessional. Tai Chin, by contrast, was simply a professional and to the end was unable to be amateurish at the same time. This was because of limitations in his personal quality."[13]

Many of Wen Cheng-ming's paintings are of houses set in gardens and represent the residences or studios of his Soochow friends and acquaintances. Whether or not they bear inscriptions with dedications, we may assume that these were done as presents. A painting of this kind dated 1543, titled Lou-chü t'u or "Living Aloft" (Color Pl. 13), is dedicated to a Mr. Liu Lin (1474–1561), who had just left government service at the age of seventy and returned to Soochow, where he planned to build a two-story house and dwell on the upper floor. Wen Cheng-ming, who suggests (perhaps punningly) that the plan reveals Liu's "lofty-mindedness," portrays the house before it was in fact completed, with Liu and a friend seen in the upper window, and adds a poem describ-

ing how the windows of this room would open "on all eight sides." The poem ends: "While worldly affairs shift and change, the lofty man is centered and at peace."[14]

Like Shen Chou in his "Night Vigil" of 1492 (Pl. 37), Wen places the house and figures in the far middle ground, transmitting in pictorial language the desire for aloof withdrawal, occasioned perhaps by bitter experiences during his official service, that underlay Mr. Liu's aspiration toward second-story living. The upstairs room is the apex of one of the orderly, symmetrical compositions that Wen loved. He begins it at the bottom with two bare willows growing on a slope and continues it across a stream and over a sharp-cut bank and a wall; these are the lower sides of a lozenge-shaped space of which the upper sides are marked by the bases of trees. The trunks and leafage of this grove form a dense screen across the middle of the composition, out of which the house rises. The whole is rendered in fine lines and strokes overlaid by light washes of ink and cool color; it is done with the same air of exactitude as the 1507 "Spring Trees" and the 1516 "Chih-p'ing Temple."

Wen Cheng-ming's decades of devotion to historical and literary scholarship deeply affected his painting. As Anne Clapp writes: "His long academic experience . . . reinforced his native tendency to austerity and restraint of feeling, and brought to his art an intellectual discipline which shows in all styles."[15] Like his favorite exemplar, Chao Meng-fu, Wen approached painting with a historian's dedication to the past, working in a number of manners that were rooted in old painting traditions. So, one might interject, did such a professional master as Ch'iu Ying; but, as we have tried to show in the preceding chapter and in this one, Ch'iu's uses of the past differed in important respects from Wen's. Moreover, Ch'iu's set of preferred models, as well as T'ang Yin's, corresponded only in part with Wen's, although their acquaintance with old paintings and old traditions cannot have been so very different. They made different choices, that is, in drawing upon a more or less commonly held understanding of their past.

It might be said that each major school of Chinese artists, in making its choices of past styles as models, constructed its own history of painting. The sixteenth-century Soochow artists, whether professional or amateur, seem to have held a view of earlier painting and the significant moments in it that differed from the "histories" of both the late Yüan before them and the late Ming after them. We can understand this middle-Ming Soochow version of the history of painting both from the uses of old styles in surviving works of Soochow artists and from critical discussions or accounts of collections seen there. In this version, polite recognition was given to T'ang and pre-T'ang painting, but Soochow artists seldom imitated directly styles of such antiquity. The landscape styles of Tung Yüan and Chü-jan in the tenth century and those of the Northern Sung masters were similarly appreciated and discussed without playing much part in the actual production of the school. (The revival of Northern Sung monumental landscape in the late Ming thus ends a long period of relative neglect, and a painter of that age can write: "It is a long time since anyone has carried on the styles of the Northern Sung masters.")[16] The works by Wen Cheng-ming and a few others "in the Li Ch'eng manner" mostly reveal little real acquaintance with the early phase of that tradition, seeming to be based more on the Li Ch'eng mode as practiced by Yüan masters.

The period most favored by Soochow painters and connoisseurs was from the twelfth century through the fourteenth. Li T'ang looms large at the outset of the period, and his conservative followers later in the Sung, notably Liu Sung-nien, seem more important as stylistic models than Ma Yüan or Hsia Kuei in the same period. Chao Meng-fu is the commanding figure in the early Yüan and Ch'ien Hsüan a much lesser one. The Four Great Masters of the late Yüan are especially revered and are major influences on the Soochow painters.

Out of this repertory of models, the Soochow professionals favored the Li T'ang lineage, the amateurs the Yüan literati masters; but the restriction to "suitable" lineages was not so firm as it was to become in late Ming theory and practice. Wen Cheng-ming sometimes adopts elements

of style from the Li T'ang manner, and other influences from Sung painting can be found in his works. He never imitates Sung painting so closely as do T'ang Yin and Ch'iu Ying, however, and on the whole his works follow the formalist directions established by the Yüan scholar-artists rather than the more naturalistic, truly pictorial modes of Sung.

Another source of inspiration and influence for Wen Cheng-ming and others of his group was in the works of a few sophisticated and style-conscious artists of the late Northern and early Southern Sung, i.e., the late eleventh and twelfth centuries, beginning with Li Kung-lin and Mi Fu, artists who were themselves archaistically inclined. On one occasion, for instance, Wen made a copy of a handscroll by the mid-twelfth-century artist Chao Po-su illustrating the latter of Su Tung-p'o's two "Red Cliff" odes (Pl. 117). A colophon by Wen Chia dated 1572 relates the circumstances under which his father had made the copy in 1548:

"The Later Red Cliff Ode was a favorite subject in the Painting Academy of the Sung period; both Chao Po-su and [his older brother] Po-chü depicted it. I have seen both versions. It is Po-su's which was in a local collection. Later there was an official who wanted to acquire it in order to present it to the prime minister of that time [Yen Sung]. But the owner was reluctant to give it up. My father said to him: 'You can't miss a chance to sell it at that price; I'll draw you another one that will at least preserve its general appearance.' And so he did this scroll."

The original painting by Chao Po-su does not seem to have survived; the most closely related Sung-period representation of the subject is a handscroll by a slightly earlier artist, Ch'iao Chung-ch'ang, now in the Crawford Collection, New York.[17] No surviving paintings can be reliably ascribed to Chao Po-su, but an unpublished handscroll attributed to him in the Palace Museum, Peking, representing a riverside landscape with pine trees and cranes, indicates that he belonged, along with his contemporary Ma Ho-chih and the late-eleventh-century Chao Ling-jang, to a small and very interesting group of artists active in the middle Sung period who might be called "poetic archaists" since they use antique styles for poetic, unrealistic, sometimes dreamlike effects, perhaps in reaction to the strong realistic tendencies in other painting of their time. Even when they are associated with the imperial court and the Painting Academy, these artists stand somewhat apart from the main Academy tradition, having closer ties, in their styles and approach, with Li Kung-lin and others of the early scholar-painters; and it is chiefly the scholar-painters in later centuries who admire and imitate them. Ch'ien Hsüan and Chao Meng-fu are not unaffected by them, although the acknowledged sources of their archaistic styles are further back in time; Wang Meng (especially in his figures and houses), Ch'en Ju-yen, and others later in the Yüan draw on them in various ways; and they are an important part of the background of Wu-school style in the sixteenth century.

In the paintings of Ma Ho-chih, and presumably those of Chao Po-su, archaism takes the form of a concentration on certain conspicuous elements of style, such as insistent linear rhythms and a childlike or *faux-naïf* drawing of figures, animals, buildings, etc.; such concentration on antirealistic aspects of style drops a screen, as it were, between the painting and both its subject and its model. The artist, that is, is neither portraying his subject nor imitating the antique in a simple and direct way, but is regarding both from a certain distance and from a sophisticated, art-historical viewpoint. When these archaistic styles are in turn imitated in later periods, the distancing is compounded. It is this quality of remove that we alluded to in the preceding chapter, using a different metaphor, as putting stylistic quotation marks around the picture. Wen Cheng-ming's scroll is a perfect exemplification of the practice, displaying his stylistic awareness in touches of irony or antiquarian whimsy that prevent the viewer from taking it quite seriously as illustration.

The passage that we reproduce represents the moment when Su Tung-p'o, after climbing at night to a ledge atop the Red Cliff, suddenly becomes frightened: "The grass and trees stirred and shook, cries in the mountains were answered in the valleys, the wind rose and the water

seethed. I felt uneasy and dispirited, frightened by the eeriness of it; I shivered, it was impossible to stay there."[18] Wen Cheng-ming, doubtless following his Sung original, begins to step up the intensity of activity in his composition as he approaches this climactic scene from the right (which is always the direction from which handscrolls are read) by such standard devices as increasing the steepness of diagonals and crowding the space of the scroll with huge, unstable forms. There is a sudden shift from quiet to wind-whipped trees, and the small figure of the poet on the ledge, his sleeves and robe blowing in the wind, is poised precariously between a layer of scudding fog above and the churning waves below. Yet to depict a figure in a situation that would in real life excite feelings of turbulence and insecurity is not the same as conveying those feelings; Su and his surroundings are not believable enough to be deeply moving, nor is it Wen's intention to move the emotions—he is not telling a story but presenting a style.

Admirable and entertaining as such paintings of narrative and otherwise particularized subjects may be, Wen Cheng-ming's most innovative works, and ultimately his most important, are the pure landscapes of his late period. In these, evocations of old styles matter far less than the creation of new ones. The compositional inventiveness that he inherited from Shen Chou and the self-confidence of his own maturity ensured that even when he was ostensibly working "in the manner of" some earlier master, the outcome would be fresh and creative.

To say that his "Verdant Pines and Clear Springs" of 1542 (Pl. 114), for instance, is in the manner of Wang Meng is true enough, by the Chinese definition of what makes up a manner, but scarcely touches on the fundamental qualities of the painting, which is conceived on different premises from any by the Yüan master. This small, delicately executed picture is an essentially two-dimensional creation (or "frieze-like" in Anne Clapp's term), divided vertically by a tall pine, which seems unnaturally to hold in the cliff and foliage to the left of it, and horizontally by the farther limit of the shallow platform on which the two men are seated. An earlier, less extreme example of this mode of composition may be seen in "Lofty Leisure" of 1519 (Pl. 108). Densely textured areas at the upper left and lower right are balanced by open spaces in the other two segments, and each area is further divided into interesting shapes by tree trunks and branches, the edges of the bank, and the odd configurations of the cliffs. This flat patterning of the picture surface is accomplished by deliberately compressing planes of depth, so that, for example, the upper branches of the cypress tree at right seem to tangle with one projecting from the central pine, which is located some distance behind it. Even the figures are treated as shapes, set within and against the larger ones. The convoluted, churning earth masses of the Wang Meng manner here serve to build up pressures within the circumscribed areas, pressures that are exerted against the surrounding spaces but at the same time tightly contained by firm contours and rigid trees, so that there is little dynamic interaction between the parts of the picture. That this effect of suppressed energy is accomplished in a picture representing what would normally be a placid theme—two friends on the bank of a stream under the trees, gazing down into the water—only demonstrates once more the separation of expressive content, in much of Ming painting, from its subject matter.

The landscape composed within a narrow vertical shape was a type that Shen Chou, while he did not invent it, had exploited brilliantly and no doubt popularized in Soochow painting circles. It was also favored by Wen Cheng-ming, perhaps because it permitted, even encouraged, the radical compacting and stretching of form on which the power of his pictures often depends. Two notable examples, dated 1535 and 1550 (Pl. 115–16), almost identical in size, look very similar at first glance but are significantly different in plan, and the difference corresponds to a change in Wen's style, from the more delicately executed works of his middle period (a designation that will sound strange, especially to Occidental ears, when applied to a work of his

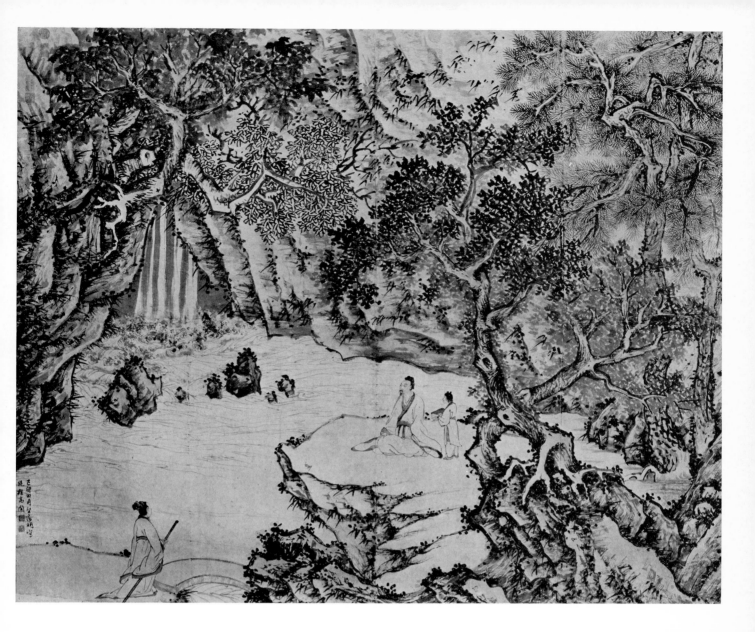

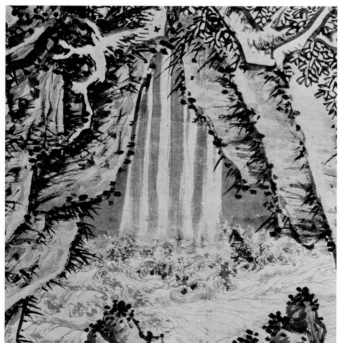
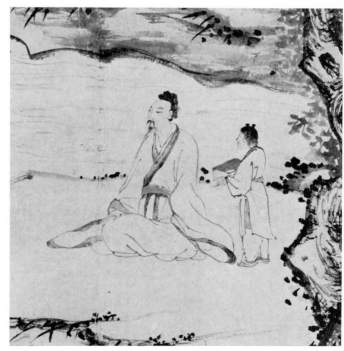

108–10. Wen Cheng-ming: "Lofty Leisure Beneath a Sheer Cliff." *Dated 1519. Hanging scroll (with details), ink and light colors on paper, 148.9 × 177.9 cm. National Palace Museum, Taipei.*

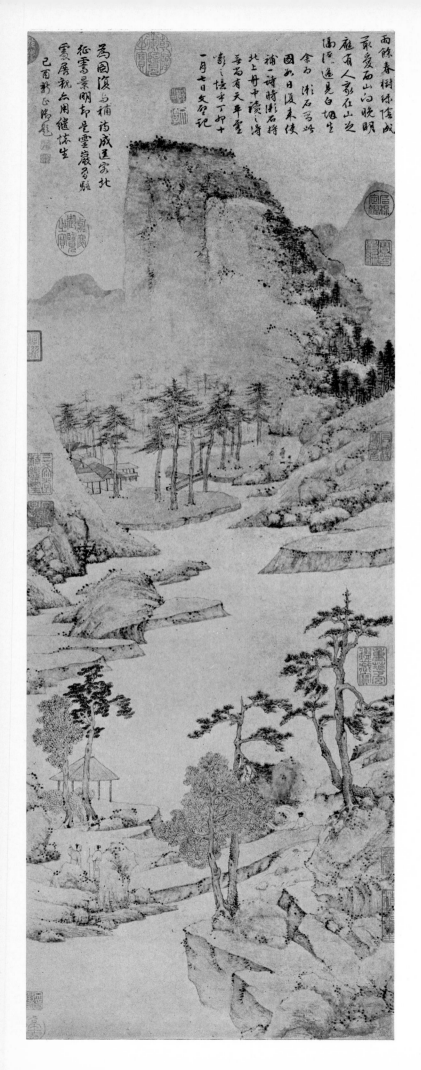

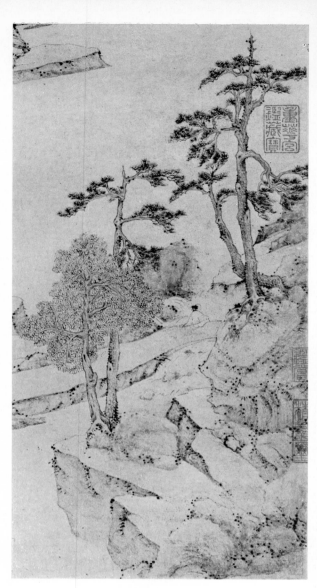

111–12. Wen Cheng-ming: "Spring Trees
After Rain." *Dated 1507. Hanging scroll
(with detail), ink and colors on paper, 94.3
× 33.3 cm. National Palace Museum, Taipei.*

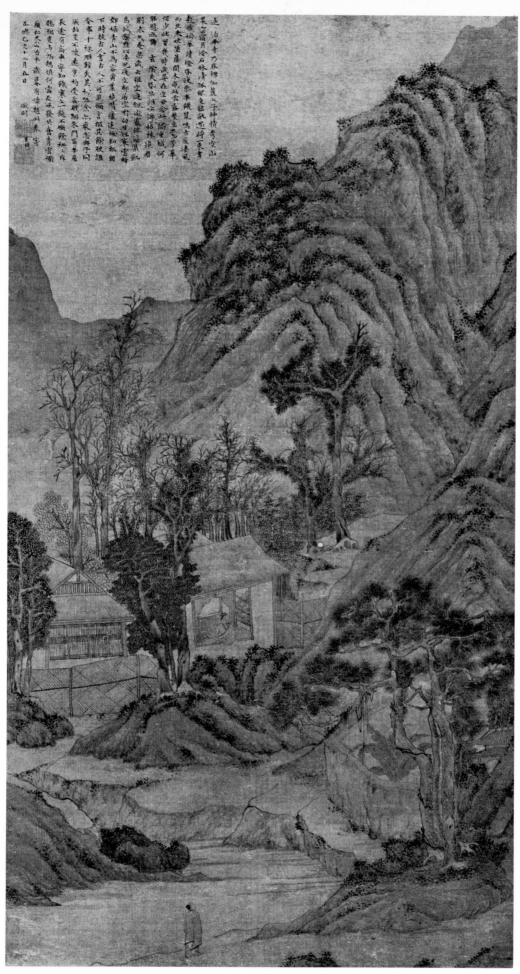

113. Wen Cheng-ming: "The Chih-p'ing Temple." *Dated 1516. Hanging scroll, ink and light colors on silk, 77.4 × 40.6 cm. Ching Yüan Chai collection.*

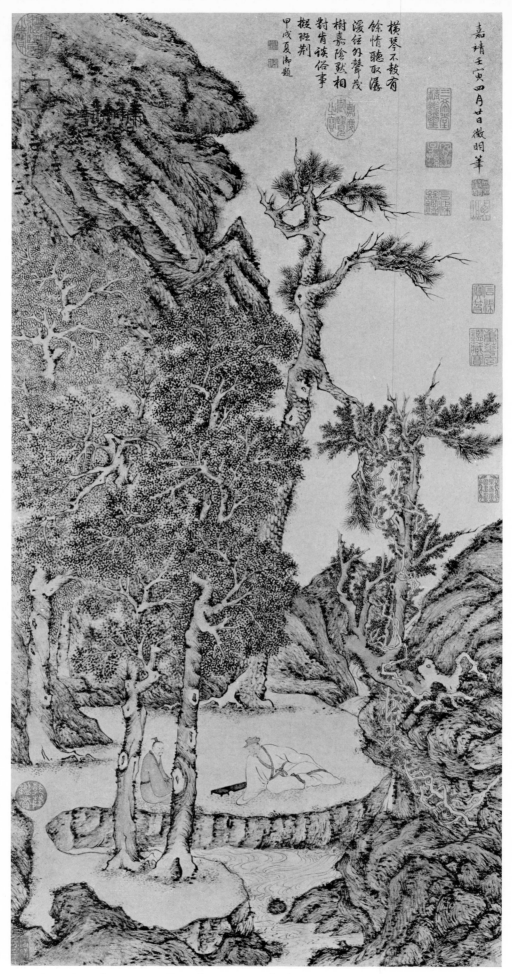

114. Wen Cheng-ming: "Verdant Pines and Clear Springs." *Dated 1542. Hanging scroll, ink and colors on paper, 89.9 × 44.1 cm. National Palace Museum, Taipei.*

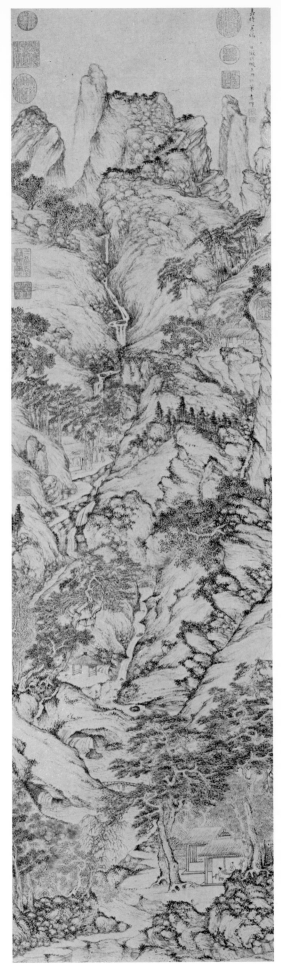

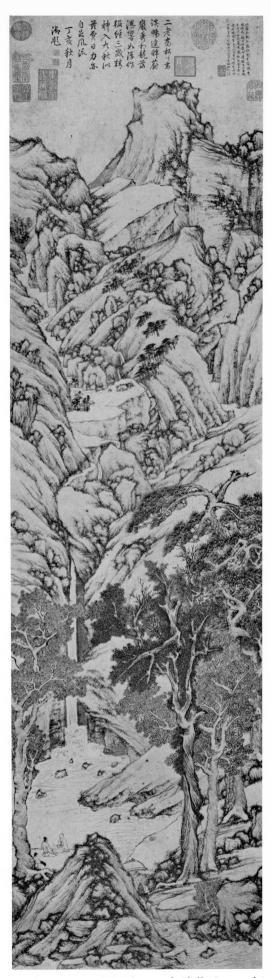

115. Wen Cheng-ming: "Landscape in the Manner of Wang Meng." *Dated 1535. Hanging scroll, ink on paper, 133.9 × 35.7 cm. National Palace Museum, Taipei.*

116. Wen Cheng-ming: "A Thousand Cliffs Contend in Splendor." *Dated 1548–50. Hanging scroll, ink and light colors on paper, 132.6 × 34 cm. National Palace Museum, Taipei.*

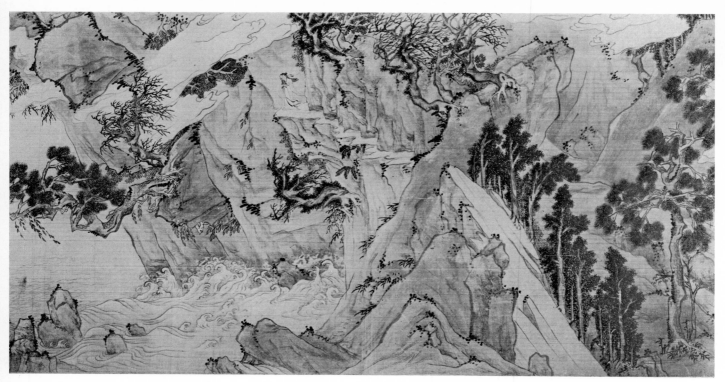

117. Wen Cheng-ming: " 'The Red Cliff' After Chao Po-su." *Dated 1548. Hand-scroll, ink and colors on silk, 31.5 × 541.6 cm. National Palace Museum, Taipei.*

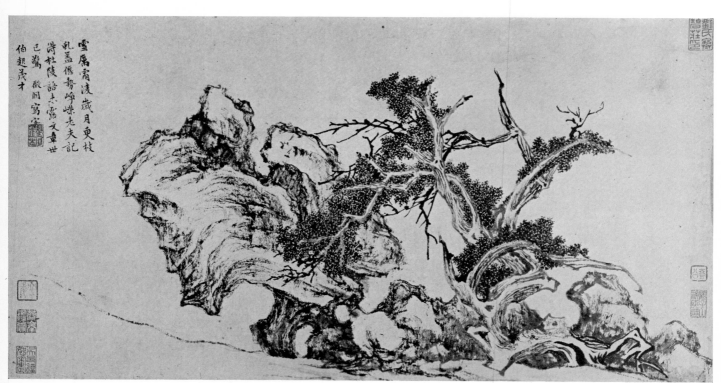

118. Wen Cheng-ming: "Cypress and Rock." *Dated 1550. Handscroll, ink on paper, 26 × 48.9 cm. Nelson-Atkins Gallery, Kansas City.*

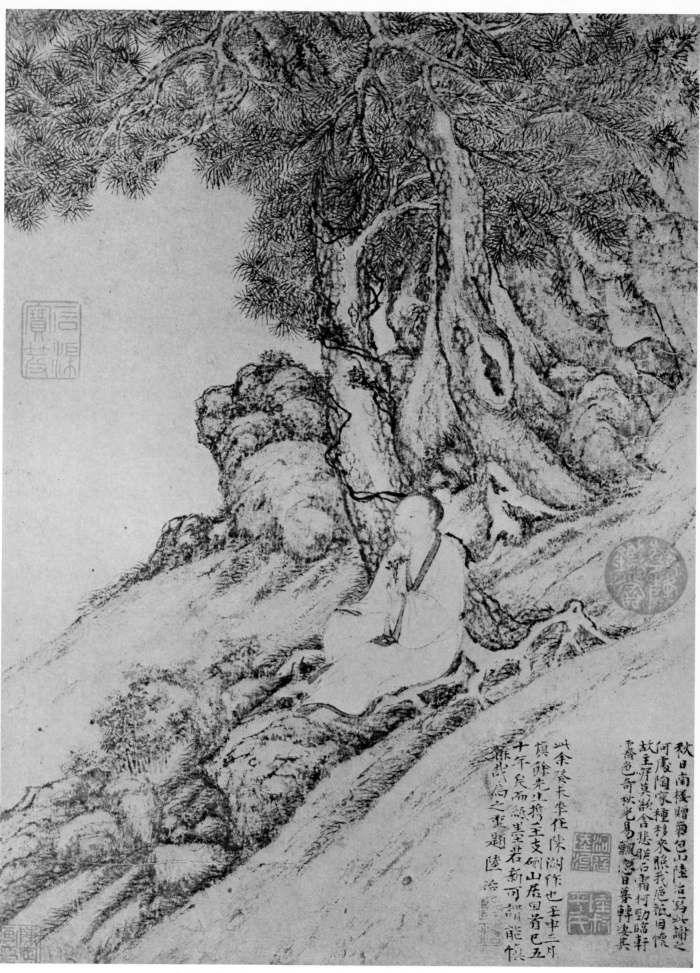

119. Lu Chih: ''Portrait of T'ao Yüan-ming.'' *Dated 1523. Album leaf, ink on paper, 34.2 × 23.8 cm. National Palace Museum, Taipei.*

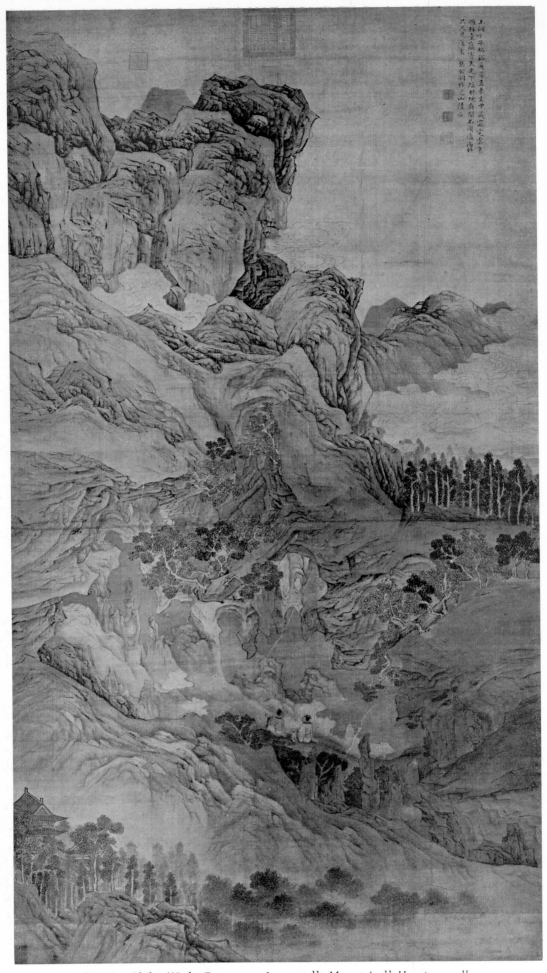

120. Lu Chih: ''Jade Cave on an Immortal's Mountain.'' *Hanging scroll,
ink and colors on silk, 150 × 80 cm. National Palace Museum, Taipei.*

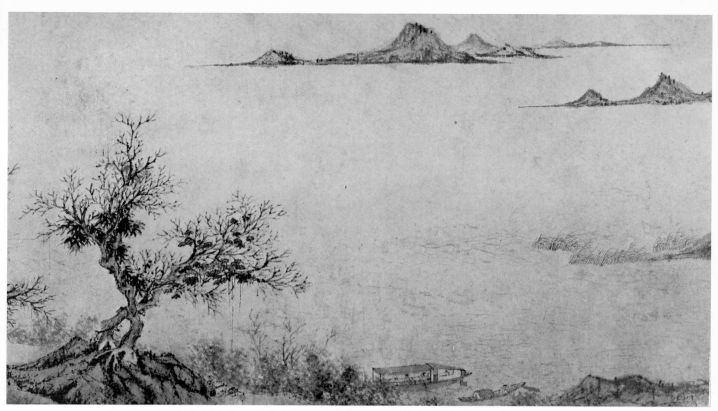

121. Lu Chih: "Autumn Colors at Hsün-yang." *Dated 1554. Handscroll, ink and light colors on paper, 22.3 × 100.1 cm. Courtesy of Smithsonian Institution, Freer Gallery of Art, Washington, D.C.*

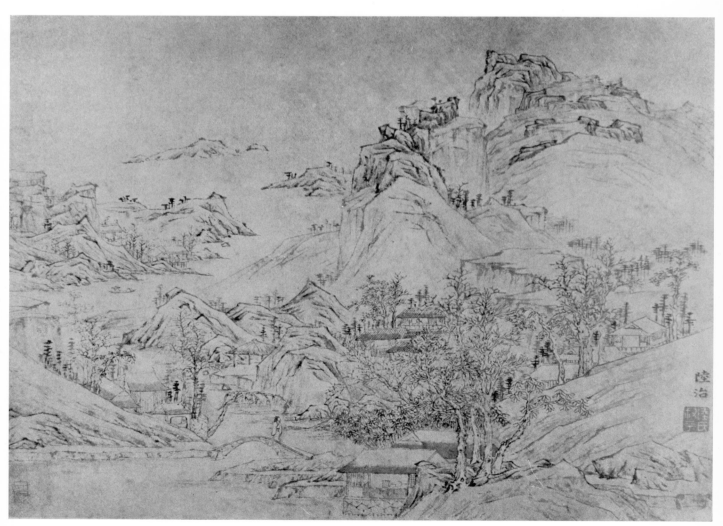

122. Lu Chih: "Landscape." *Hanging scroll, ink on paper. Soochow Museum.*

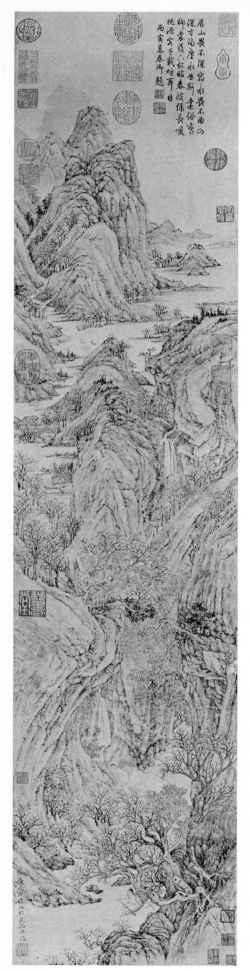

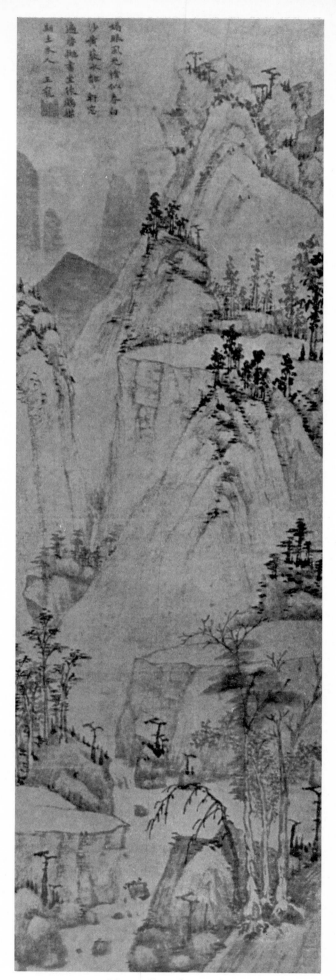

123. Lu Chih: "Fisherman-Recluse at Hua-ch'i." *Dated 1568. Hanging scroll, ink and light colors on paper, 119.2 × 26.8 cm. National Palace Museum, Taipei.*

124. Wang Ch'ung: "Landscape." *Hanging scroll, ink on paper, 100.8 × 30.5 cm. Soochow Museum.*

125. Detail from Plate 124.

126. Ch'en Shun: ''Landscape.'' *Dated 1540. Album leaf, ink on paper, 30.1 × 48.2 cm. National Palace Museum, Taipei.*

127. Ch'en Shun: ''Peonies.'' *Dated 1538. Section of a handscroll, ink on paper, 34.9 × 253.3 cm. National Palace Museum, Taipei.*

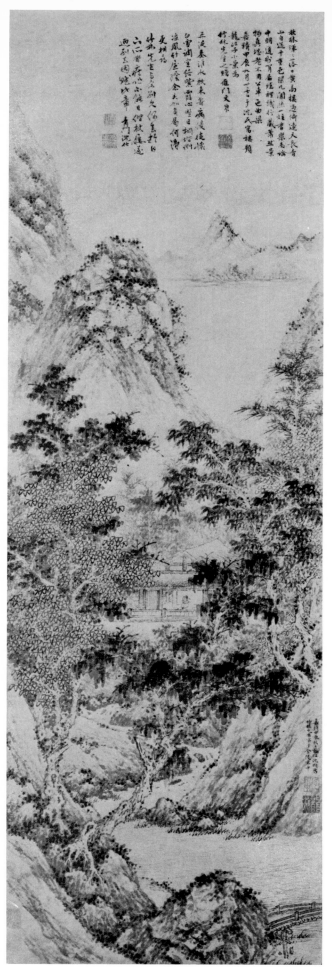

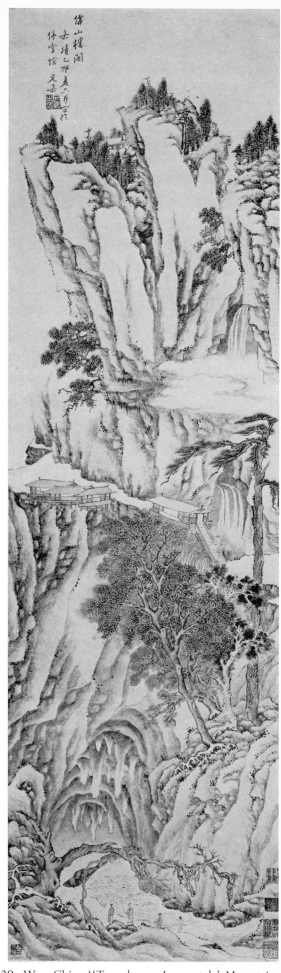

128. Shen Shih: "Sunset in an Autumn Valley."
*Dated 1544. Hanging scroll, ink on paper, 96.8*
*× 30.8 cm. Ching Yüan Chai collection.*

129. Wen Chia: "Temples on Immortals' Mountains."
*Dated 1555. Hanging scroll, ink and light colors on*
*paper, 102 × 28.2 cm. Ching Yüan Chai collection.*

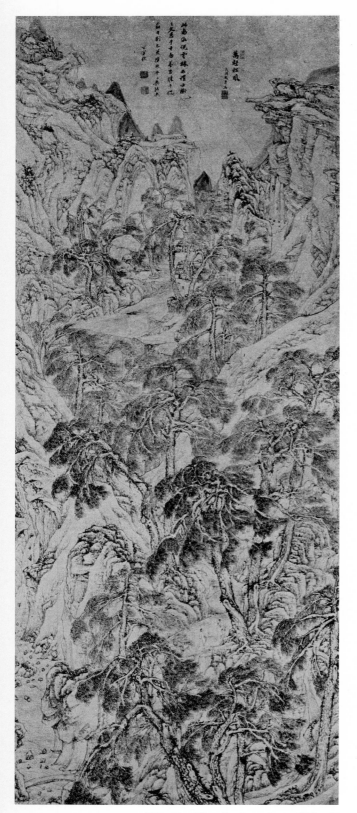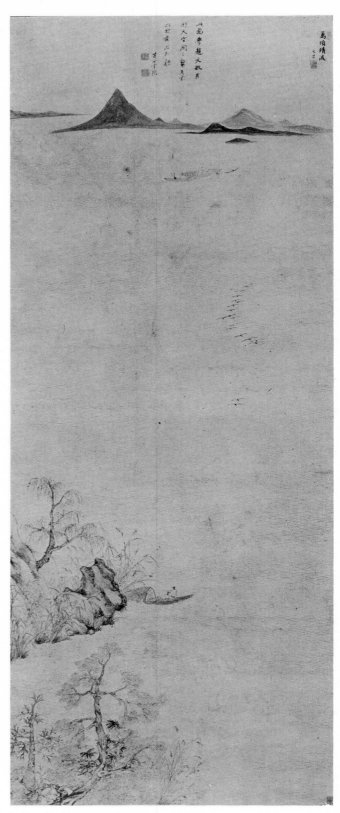

130–31. Wen Po-jen: from "The Four Myriads." *Left*, "A Myriad Ravines with Windblown Pines"; *right*, "A Myriad Hectares of Sunlit Waves." *Dated 1551. Hanging scrolls, ink on paper, each 191.1 × 74.6 cm. Tokyo National Museum.*

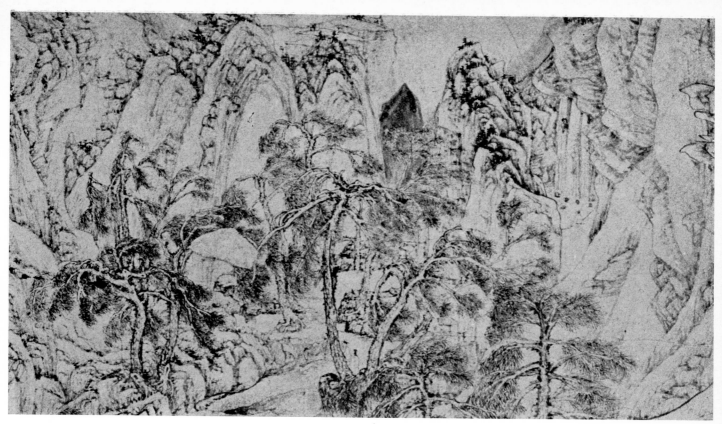

132. *Detail from Plate 130.*

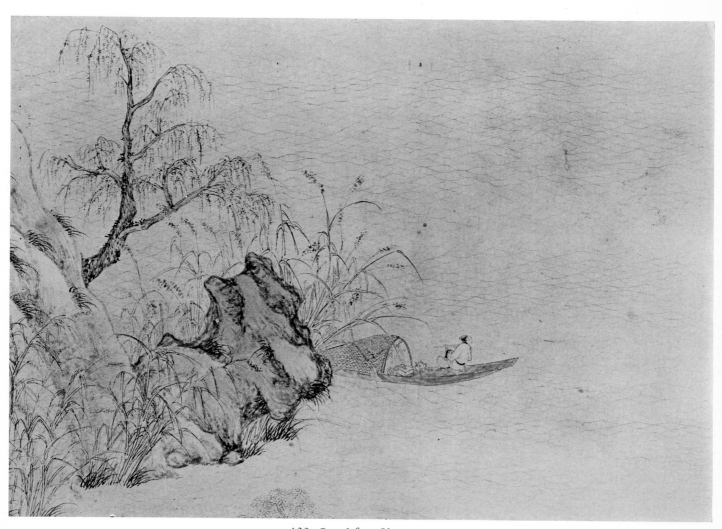

133. *Detail from Plate 131.*

134. Hou Mou-kung: "Landscape." *Hanging scroll, ink and light colors on paper, 112.3 × 34.9 cm. National Palace Museum, Taipei.*

135. Chü Chieh: "Spring in Chiang-nan." *Dated 1531 but probably later. Hanging scroll, ink and light colors on silk, 113.6 × 31 cm. National Palace Museum, Taipei.*

sixty-fifth year, but is justified in the context of his late-starting, long-lasting career) to the more strongly and clearly structured creations of his late period. Interestingly, a precedent for important compositional features of both paintings can be seen in "Gazing at the Stream" (*Hills*, Pl. 18), which is probably a copy after a work by Chao Meng-fu and is dated 1309. Like Wen Cheng-ming's 1535 landscape, it is constructed around a ravine with a succession of waterfalls that divides the picture vertically, and the mountainside fills almost the entire picture space. As in Wen's 1550 "Thousand Cliffs," the lower section is conceived as a concavity, a rocky grotto, while the upper section slopes upward steeply. This small work, "Gazing at the Stream," when its true historical position is determined, may well prove to have been a significant element in the background of sixteenth-century Wu-school painting.

Wen does not, however, mention Chao Meng-fu in the inscription on either of his two pictures. The 1535 landscape is inscribed by the artist as being in the manner of Wang Meng (literally "done in imitation of Wang Meng's brush-idea"); in this case, in addition to the Chao Meng-fu composition, it must have been paintings like Wang's "Dwelling in the Ch'ing-pien Mountains" or his "Forest Grotto at Chü-ch'ü" (*Hills*, Pl. 53, 58) that inspired Wen Cheng-ming to eliminate space from his picture and to fill it from the base almost to the top with a steeply rising mountainside. The painting is in fact more spaceless than any of Wang's, and also more restrained and stable: the dry-brush *ts'un* (texture strokes) that impart a twisting motion to the earth masses are sparingly applied, and the energies they generate are confined within the forms and compartments of the composition (as in the 1542 "Verdant Pines"), the only pervasive movements being the long, slow, winding ones that carry the eye up the ravine. The painting cannot easily be comprehended as a single coherent image and must be read episodically, like a vertical handscroll. But the events that one encounters as he climbs are formal rather than anecdotal: the buildings and figures spaced neatly at the sides of the central axis are too simply and conventionally drawn to arrest one's upward progress for long. One is given, instead, a remarkable complex and varied succession of abstract incidents in clusters of rocks and leaning trees, paths and ledges and cliffs that provide counterpoint to the main path of ascent, which is along the series of waterfalls and cascades. The brushwork, dry and fastidious, belongs to Wen's "fine style"; the unremitting concentration on refinement of execution rules out all possibility of spontaneity or of dramatic development. Disciplined, unimpassioned, the painting radiates an austere beauty.

The other work, titled "A Thousand Cliffs Contend in Splendor," was begun in 1548 and finally finished in 1550, when Wen added this inscription:

"Once on a winter's night when I couldn't sleep I playfully sketched out this 'Thousand Cliffs Contend in Splendor' picture but scarcely finished a single tree. Since then I have worked on it off and on from 1548 until now, 1550, when I have finally finished it; the seasons have gone around three times.

"Long ago Wang An-shih, in selecting T'ang poems, said: 'It's a shame to spend so much time and energy on this.' It is an even worse shame for me to spend my time on this [painting]! "On the tenth day of the third month, inscribed by Wen Cheng-ming at the age of eighty."[19]

This later work is even more austere than the 1535 landscape, the drawing firm where that of the other was sensitive and soft, the ordering of forms more systematic and lucid. The composition is an ambitious one: instead of weighting the elements of his picture more or less equally, as in the 1535 work, and distributing them evenly around the picture surface, strung together on a few long connecting lines, the artist essays the difficult feat of combining systems of larger and smaller forms, and two different compositional formulae, into a single strong design. The lower half repeats the compositional type that Wen had used so successfully forty years

before in his "Lofty Leisure" of 1519 (Pl. 108), with two men on the bank of a stream beneath trees, and behind them a pool extending back to a waterfall that drops between overhanging cliffs. The center of this lower portion of the picture is thus occupied by a hollow of space, which the solids serve to enclose.

In the upper half, the roles are reversed and the mountain masses dominate, defining only their own volumes and scarcely opening any chinks for space to penetrate. This upper portion, while it is not painted in any distinct "manner," belongs in a broad sense to that of Huang Kung-wang in its reordering of the natural materials into an elaborate but comprehensible structure. The masses here are physically locked together, interpenetrating, the smaller boulders firmly embedded in the slopes. The lower part, by contrast, is unified by repetitions of line or shape: the pyramidal mass in the foreground answered by the recessed limits of the pool and the arching branches of the trees, a slanting bank at the lower right by a slope farther back, the verticals of the tree trunks by the waterfall. Considering these differences in plan between the two sections, the integrity of the whole design is all the more remarkable.

It is typical of the development of an artistic school or movement that the polarities which will eventually pull it apart, by drawing the artists ever further in conflicting directions, are contained already in the works of the early, founding masters, who are able to reconcile these directions as later artists cannot. The Che school, for instance, might be seen as pulled apart by the issue of orthodox academicism versus unorthodox individualism; the two are harmonized in many works of Tai Chin, less often in those of Wu Wei, and hardly at all afterwards.

In the Wu school, the central issue could be defined as the particularized versus the abstract, attachment to concrete experience as against aspirations toward the universal. The former, the particularized, itself contains a further distinction, between depictions of literary themes of the past and portrayals of present reality, since what we have termed the poetic mode within the Wu school, the mild evocation of poetic sentiment in delicate depictions of the materials of subjective experiences, was used for both: whether the experiences were those of the artists or those of earlier poets seems almost immaterial, perhaps understandably so in view of the fusion of poetic and mundane reality in the Soochow scholar's world. To the realm of the specific, then, belong paintings of local scenery and records of meetings and partings, along with pictures based on old poems, while explorations into the realm of pure form and semiabstract construction are carried on in landscape compositions devoid, or all but devoid, of specific references to time and place or human activities. The distinction is relatively clear in the works of later artists of the school but less so in the early period, when Liu Chüeh could record the impression of a journey in a generalized depiction of hills and trees (Pl. 27) or a gathering of scholars in a landscape that follows the constructivist manner of Huang Kung-wang (Pl. 26), and Shen Chou could portray a friend's retreat nearly hidden in a landscape composed in that same manner (Pl. 32).

Wen Cheng-ming, while many of his works belong clearly to one or the other category, in others seems to move between them or to combine or harmonize them. His "Thousand Cliffs," seen in this light, brings the two not only into juxtaposition but into concord, opening with a passage that draws the viewer into sharing a particular experience—this is no conventional sign for sitting-by-the-water—and then shifting, above and farther back, to the more abstract and universal mode.

Paintings of old trees, especially the pine and cypress, are conspicuous among Wen Cheng-ming's late works. Like waterfalls and rocks, they belonged to an austere, uncompromising environment, free of blandishments; that was the way Wen sometimes chose to see his world, as one in which survival required tireless effort, and in which life made a place for itself through steadfastness and integrity. This may seem a curious attitude for a member of the affluent Soochow gentry, and at odds with the concurrent view of the world as a garden; but, for Wen

Cheng-ming, commitment to the austere was a matter of moral principle, not of physical circumstance. With similar motivation he painted wintry landscapes, writing on one of them: "The lofty scholars and recluses of the past . . . often did snow scenes; they chose to make use of that subject in order to embody their feelings of noble loneliness, of freedom from vulgarity." As early as the T'ang dynasty, evergreen trees had become symbols, in poetry and art, of the perseverance and immutability of virtuous men's minds. Yüan-period artists often made them the central themes of their paintings but usually placed them in landscape settings, which could be reduced to the most minimal role but were seldom eliminated altogether. Shen Chou's "Three Juniper Trees" (Pl. 42–43) is to that degree innovative in presenting a close-up portrayal of the trees alone, cut off at top and bottom by the edges of the handscroll.

Wen Cheng-ming apparently painted scrolls of that type, although it can be questioned whether any genuine example survives. We have, on the other hand, three masterworks from his late years that follow Yüan precedents in including only enough additional elements to provide the trees with a spatial context and to reinforce their expression with symbolically related motifs—a sheer cliff, a waterfall, a stream, a stone. The "Old Trees by a Cold Waterfall" in the Palace Museum, Taipei, and the "Old Trees by a Wintry Brook" in the collection of Mrs. A. Dean Perry, Cleveland, were painted in the winter of 1549 and the spring of 1551.[20] Between them falls the small, superb "Cypress and Rock" (Pl. 118), which Wen painted (according to a colophon by the calligrapher P'eng Nien) in 1550.

It represents a twisted, stunted cypress tree growing beside an equally twisted-looking rock. That the tree has reached its present condition by slow, steady growth and the rock by much slower erosion—the one by internal, the other by external process—is a distinction that registers as another overtone in the mind of the viewer without being specified in the picture, which scarcely distinguishes texturally between bark and stony surface. The remarkable fusion of the two elements of this double theme is effected even more by compositional means: a line drawn so as to enclose the tree would trace a shape virtually congruous with that of the rock, and the arching and thrusting movements of the one are repeated in the other. A third, lesser element is space, but flat space; the limbs of the tree and outline of the rock define empty shapes between them that work with the forms of the rock and tree themselves into a complex and absorbing pattern. This densely compacted, tightly composed design is executed in brushwork that offers as tactilely satisfying a combination of sensitivity and strength as is to be seen in all of Chinese painting; the concept of integrity as revealed in the artist's hand is nowhere better exemplified. Working through the full range of dry to wet and pale to sooty black, Wen Cheng-ming sustains an intensity which, as Max Loehr wrote of this picture, "is a matter of mental and psychic energy, not of keen observation."[21]

## 2. Wen's Friends, Contemporaries, and Students

Lu Chih   The next best painter in Wen Cheng-ming's circle, after Wen himself, was Lu Chih (1496–1576). He was a native of the region and came from a gentry family; after receiving the standard education for one of his social class, he became a *chu-sheng*, a scholar in the district school, and was recommended by the local education inspector for the *kung-sheng* degree, which was based on recognized merit and bypassed the examination. But Lu disliked officialdom and seems never to have held office. Like Wen Cheng-ming, he gained a local reputation for uprightness of character, which in his case was based on filial piety (solicitude for his aged mother) and a high-minded unconcern for money—he gave what he had to a younger brother and used a piece of land that he owned to build an ancestral temple. The biographical sources supply no information on how he made his living. He was proficient in poetry and other literary composition in old forms. According to Wang Shih-chen, his calligraphy teacher was Chu Yün-ming,

and Wen Cheng-ming taught him painting; these accomplishments probably earned him most of his income, presumably received in return for gifts freely given (at least in principle) through one or another of the roundabout methods of repayment on which the scholar-artists insisted. Lu is said to have rejected indignantly a direct cash payment for one of his paintings, saying: "I paint for my friends, not because I'm poor." Anyone who tried to get a painting from him by applying pressure of any kind stood no chance, we are told, but those who didn't force the matter might succeed. He did not participate much in the rounds of drinking parties given by rich hosts. In his later years his eccentricities became more pronounced. He retired to live in poverty in a house at the foot of Mount Chih-hsing, south of Soochow, which was (again according to Wang Shih-chen, who composed Lu's biography in 1571) "surrounded by clouds and mists on all sides, with a running stream winding around it. There he planted hundreds of kinds of beautiful flowers, and when a guest whom he liked arrived, at any time of the year, he would go to greet him among the flowers and would cut off a piece of honeycomb or a bamboo shoot to give him. But if it was someone he didn't want to see, he would put a stone against the door and, no matter how loudly the person knocked, he wouldn't hear."

Lu Chih as a painter was highly praised by Ming writers for his pictures of flower-and-bird subjects, but his reputation today is based chiefly on his landscapes, for which, the critics say, he took Sung-dynasty masters as his models. Wang Shih-chen writes that "he practiced painting in an effort to exteriorize the strange feelings in his breast and in order to vie with the old masters; people of the time liked to praise him as the equal of Wen Cheng-ming." We may not agree in ranking him so high as that; he sets himself less serious and usually less interesting artistic problems than Wen, and too much of his work is merely charming. But even then it is more charming, inspires more sheer delight, than the paintings of most other artists of his time; the sterner virtues of Wen Cheng-ming, when imitated by others, tended to produce uncomfortable, sometimes tortured mannerisms, which Lu Chih generally escapes.

Lu is perhaps the supreme master of that special mode of landscape cultivated in sixteenth-century Soochow that treats the local scenery as neat, fragile, cleansed of clutter; appeals to tactile sensation are avoided in such paintings, as are overt emotional statements; figures and buildings are depicted with a light ingenuousness that expresses, as the artist intended it should, disengagement from mundane reality. If we find this attitude in the paintings and their artists escapist, we must say the same of most of the rest of Soochow culture and remember that this was a period when attempts at political or social action were unlikely to achieve any beneficial effects but were quite likely to bring about the extinction of the well-intentioned official who made the attempt, sometimes along with his entire family.

The Chia-ching era, 1522–67, i.e., the forty-five-year reign of the emperor Shih-tsung, who came to the throne at the age of fifteen and was the pawn of court cliques throughout his period of rule, was a dark chapter even in the shadowy history of the Ming: intrigues at court, corruption in the levying of taxes (despite attempts at reform in the "Single Whip" system, which simplified the setting of rates and collecting of taxes), and other economic disorders that brought about widespread poverty, continuing war against the Mongols, ill-conceived expeditions into Southeast Asia, revolts at home, raids by Japanese pirates—all weakened the effectiveness and authority of Ming rule.

Lu Chih's earliest dated painting, "Portrait of T'ao Yüan-ming" (Pl. 119), is in fact an imaginary portrait of the outstanding Chinese exemplar for all refugees from political life, T'ao Ch'ien, or T'ao Yüan-ming (365–427), who resigned from a good job as magistrate to return to his country villa and live in seclusion, avoiding (like Lu Chih) all contact with people in high positions. Lu Chih's first inscription begins: "On an autumn day Nan-lou brought a present of chrysanthemums, and Lu Chih drew this to thank him." A second inscription by the artist reads: "This is a work I did in the *kuei-wei* year [1523] at the Ch'en Lake. In the third month of the

*jen-shen* year [1572] Shen-yü [a name meaning 'excessive care' or 'solicitude'] brought it here to my dwelling on Mount Chih-hsing. I turn my head, and already fifty years have passed! But the paper and ink of this are like new. It can be safely said that he has given it 'excessive care'! I have written this second inscription for him." Shen-yü is probably an official named Li Chao-hsiang, who served as secretary of the Board of Works in Nanking.

T'ao Yüan-ming sits in a relaxed posture on a slope, his seat the roots of a pine tree, holding a few chrysanthemums. These are his usual attributes in painting—the pine as a symbol of the moral rectitude he exemplified, the chrysanthemums because he was especially fond of them and cultivated them in his garden. T'ao's virtues and way of life correspond so well to Lu Chih's that we may suppose this to be another double image, an idealized self-portrait as well as an image of the ideal on whom the Ming scholar-recluse modeled himself. The drawing of the figure is expressive of self-sufficiency and inner harmony, the face alert but impassive, the simple oval of the head answered by the larger ovals of the body in its loose-fitting robe.

This image of the scholar-gentleman, drawn in fine lines that trace smooth, harmonious curves, became a hallmark of Wu-school painting; in the late Ming it was subjected to whimsical distortions, but in this early appearance it is still relatively naturalistic and innocent of style-conscious mannerism. Pronounced traits of individual style are absent as well from the depiction of the setting, although Lu Chih's characteristic use of *chiao-mo* ("roasted ink," deep black ink applied dry and sparingly) can already be marked.

In most of Lu Chih's landscapes it is difficult to discern the signs of adherence to Sung painting traditions that the critics refer to, but a few large, imposing hanging scrolls do appear to be based on the Northern Sung monumental-landscape model. The delicate linearity of Lu's usual manner would seem ill adapted to such compositions, incapable of creating the sense of bulk that they normally required, and Lu Chih thus foregoes, in these, his characteristic lightness of touch and tonal paleness. In "Jade Cave on an Immortal's Mountain" (Pl. 120), a large, undated picture painted on silk, he has applied extensive washes of ink and color so that the component masses of his mountainside appear to be illuminated by a subdued, inconstant sunlight, and has drawn his contour lines and rock divisions more heavily than in his typical works. The passage with trees and fog in the foreground is treated as atmospheric space, in contrast to the conventionalized clouds in the distance. The theme and scale are Northern Sung, but the dynamics of the composition relate rather to Yüan-dynasty painting: beginning at the lower-right corner a rising slope establishes a dominant diagonal movement, paralleled above and below; at the left it is caught up, twisted powerfully, and diverted downward through a succession of impulsive, powerfully plastic masses toward the cave, which is the vortex of the main compositional movements. Above and to the right are quieter passages which serve, with the foreground villa and trees, to frame and contain the active center. Two gentlemen sit at the mouth of the cave, one of them pointing out some notable feature of it to the other.

Despite the fanciful title, the picture represents an actual place, Master Chang's Grotto, located at I-hsing across Lake T'ai to the west of Soochow. It was named after the Han-dynasty Taoist magician Chang Tao-ling, who was supposed to have lived in it, and had been the subject of paintings by Shen Chou and others. Caverns and grottoes are in fact common in Wu-school landscape, and one could, without lapsing into the Freudian mode, see in the prevalence of this motif another expression of the urge to withdraw into safe seclusion, especially since the caves are usually not portrayed as awesome or frightening places. What Lu Chih emphasizes—and this is another recurrent theme in Soochow painting, which will be brilliantly exploited in the late Ming by Wu Pin—is the impression of otherworldliness, escape from everyday existence, which strange formations in nature can evoke by themselves and which an artist can intensify. Lu's poem likens Master Chang's Grotto to Mount P'eng-lai, the legendary Isle of Immortals beyond the ocean:

The Jade Cave, a thousand-year-old secret;
From it a stream flows out of endless darkness.
Its farthest depths enclose a cavern dwelling,
Towers and terraces concealed in clouds.
A cavern in the cliff, the sky lighting its floor,
A forest of jasper grown in this underground palace.
What need have we to go beyond the ocean?
Here in a foot of space we view P'eng-lai.

The portrayal of real and identifiable places in landscape paintings had not been a widespread practice in China before this period; even when the literati artists of the Yüan and early Ming depicted the retirement villas of their friends, they placed them in generalized settings, with terrain features perhaps recognizable to intimates but appearing in themselves unspecific, more affected by considerations of style than by any intention to describe how the places really looked. Shen Chou, as we have seen, painted scenes of Tiger Hill and other landmarks of the region, and the practice continues among later Wu-school artists, culminating in the truly topographical works of late-Ming Soochow masters, notably Chang Hung. Lu Chih did a number of pictures of this kind, in both hanging-scroll and handscroll form.

One of the hanging scrolls, undated but probably belonging to his middle period, the 1540s or 1550s, represents Mount Chih-hsing, where Lu was eventually to retire (Color Pl. 14). Perhaps as a reflection of a greater feeling of intimacy toward this less awesome scenery, he chooses a thinner, linear style, with flat washes of light green and yellow-orange color, using the denser patterns of the buildings and the carefully spaced clusters of leafy trees to give weight where needed. This is another compartmented composition, constructed on a series of rising diagonals that seem to allow a continuous ascent of the mountainside, even though none proceeds more than a short distance before it is broken off. One would not, in any event, wish to be hurried, since Lu provides so much entertainment along the way; unlike Wen Cheng-ming, he is not chary of human-interest embellishments.

At the bottom is a house overlooking the river, with the owner and a friend visible in the window. Above and to the right is the approach to a Buddhist temple; sedan chairs and donkeys have brought visitors and wait for them outside, and roadside stalls offer refreshment. Several gentlemen stand near the gate, and several more are seen in a courtyard over the wall. They have the air more of people on an outing than of pilgrims drawn by religious urges. Others sit on the bank of a rocky pool to the left, and two more are being borne up the steep path that continues up the mountain.

Although the figures suggest different ways of experiencing the scenery, this is not a painting that draws the viewer into it; hovering as it does between reality and poetry, insubstantial and devoid of rich textures, it delights the aesthetic sense without seriously engaging the tactile or spatial. Characteristic of Lu Chih's drawing of rocks and slopes is the multiplication of bent strokes, angular but never harsh, that cross and interweave to create flattening configurations of lozenge shapes.

Lu Chih's "Autumn Colors at Hsün-yang" (Pl. 121), dated 1554, is probably a later work. It illustrates the poem by Po Chü-i in which the poet tells of parting from a friend at the river shore and hearing the p'i-p'a song of the old courtesan; we have already seen a depiction of the same subject by Ch'iu Ying under the title "The Lute Song" (Color Pl. 9), and many other Wu-school artists did versions of it. Lu Chih's conveys better than any other its fragile sentiment, the awareness of the evanescence of human attachments, dispersing small and virtually weightless forms sparsely over an expanse of calm water. Stably planted on horizontal bases, his land masses do not interact dynamically, except through the slight tensions of intervening space. The

drawing is Lu's most delicate and refined and can hardly be matched, for these qualities, in Ming painting: the brush seems to have been lightly touched to the paper and nowhere impelled with any force. The red-leafed maple in the foreground, the light ruffling of the river and the green islets floating on it in the distance, create an aura of autumnal melancholy that echoes, across the centuries, the feeling that invests Po Chü-i's poem. The properly narrative materials of Lu Chih's picture, the boats and figures, play so small a part in its expression that the artist can reduce them to miniature scale and give them a place of so little prominence against the foreground shore that they can easily go unnoticed on one's first viewing of the scroll.

The model for some of the distinctive properties of the foregoing painting is Ni Tsan, whom Lu Chih admired and imitated throughout his life—not, like some others, by doing overtly "manner of Ni Tsan" pictures, but by adopting traits of Ni's style that he found congenial into works of a basically independent character. For "Autumn Colors" it is the sparse composition, its parts separated to evoke a feeling of loneliness, and the feather-soft touch of the brush. For the superb landscape in the Soochow Museum (Pl. 122), which is probably a late work of the artist, judging from its resemblance to a landscape dated 1564 in the Palace Museum, Taipei,[22] it is Ni's use of bent, angular strokes to construct multifaceted masses, endowing them with three-dimensional structure while preserving the transparency fundamental to the style. There is no color and no wash, unless the strokes of dilute ink sparingly applied to indicate depressions in the earth surfaces can be called that. The figures—a man standing on a bridge in the foreground, another in a boat farther back—are purely conventional, as are the houses; nothing of the specific or narrative has a place here.

The composition moves back from a foreground slope through a succession of carefully scaled forms, with precisely calculated repetitions and spacings. The means used for locking together the parts of the composition are those of Huang Kung-wang—for instance, the way the two curving movements of the ridges at the upper right fit together; and some of the terrain forms, such as flat-topped bluffs and slopes with squared outcroppings, along with such motifs as the tree that leans almost horizontal over the water, can be traced to sources in the Yüan master's works. But brushwork is sharper, the composition more complex, than in any surviving work of either Ni or Huang, and the whole effect of crystalline clarity all Lu Chih's own. Landscapes of this kind represent, among Lu Chih's works, his furthest excursions into the realm of abstract manipulations of pure form; they are few but significant contributions toward this important development in middle Ming painting.

Lu also experimented with the landscape in the tall, constricted format that was favored by Wen Cheng-ming. His most interesting use of this shape, more attenuated even than any of Wen's (the height is nearly four and a half times the width) is a late work, "Fisherman-Recluse at Hua-ch'i" of 1568 (Pl. 123). The title and part of the composition are taken from one of Wang Meng's masterworks (*Hills*, Pl. 52), which was known to the Soochow painters, being at this time in the collection of Hsiang Yüan-pien; copies must also have existed in some number, since two of them are still in the Palace Museum, Taipei, along with the original.

Lu Chih opens with an unmistakable reference to Wang's picture, placing the fisherman in his boat at the bottom, overhung by spreading trees. The top, with a steep mountain of distinctive shape rising from the river shore and low hills in the far distance, returns to the Wang Meng original to reproduce fairly literally its concluding passage. But the central section of Lu's painting, bracketed by these two borrowings, is not responsible either to Wang Meng or to nature; it would be difficult to understand it art-historically as anything but another move in an intricate game played by the Soochow painters among themselves. (One is tempted to add: and by the paintings, following Harold Rosenberg, who advises that the viewer of twentieth-century Occidental paintings must be aware "of what the paintings have been saying among them-

selves.'')[23] Like Wen Cheng-ming in his ''Thousand Cliffs'' of twenty years earlier, Lu Chih treats his composition in two halves, above and below a midpoint which he carefully leaves undefined so as not to create a feeling of disjunction. The lower section is constructed, again like Wen Cheng-ming's, as a rocky ravine on which overhanging cliffs press, making it into one of those grottoes that play so important a role in the landscape iconography of the school. A man is seated rather disconsolately on the bank at the base of the obligatory waterfall, with his servant. Above this is a spatially perplexing transition in which a vertically rising mass is abruptly transformed into a receding ridge, alongside which the river assumes its place, asserting more persuasively the new theme of flat recession. And so, after these curious sixteenth-century excursions, we rejoin Wang Meng in the distance.

Following the strangely ingrown course of Soochow landscape in this period, and familiar with the Yüan-dynasty or earlier styles and paintings that underlie some of it, we can under-stand and accept the ''rules of the game'' well enough to appreciate the special values involved in such a work as this. But if we step back for a moment and try to view it more objectively, less art-historically, as a picture, we are forced to acknowledge that it exhibits a dangerously esoteric character, a strong tendency to turn away from ordinary pictorial concerns; the aesthetic premises on which this stylistic direction is based seem to make a healthy continuation of it more and more difficult, since they drive the painter into more and more extreme and contrived solutions to increasingly artificial problems. Numerous other examples of this land-scape type, at once attenuated and compressed, could be adduced from the later sixteenth century; they would testify to the rapidity with which its somewhat forced fascination falls off when it is performed by the secondary masters, who understood less clearly the original goals of the game and play it with less élan and a lower level of proficiency.

WANG CH'UNG  Wen Cheng-ming and Lu Chih were prolific painters whose surviving works can be numbered in the dozens. Another of the most admired painters of early-sixteenth-century Soochow, by contrast, painted very little and is represented today by only a single major work. This is Wang Ch'ung (1494–1533). Although he came from a merchant family and was Wen Cheng-ming's junior by nearly a quarter-century, he was Wen's intimate friend. Like Wen, he failed repeatedly in the civil service examinations, the last time in 1531; two years later he died, not yet forty. Wen composed his epitaph. If he had lived longer, the critics said, he would have been the equal of Shen Chou and Wen himself. He was one of the best calligra-phers of his age, ranking only after Wen and Chu Yün-ming, and was also an accomplished poet. Wen Chia wrote on one of his few recorded paintings: ''Li-chi [Wang Ch'ung] was not known [chiefly] for his paintings. This work was one that he did casually, in a moment of exhilaration, 'following the brush' [sui-pi] with dots and washes. But it nonetheless captures profoundly the transcendental qualities of Huang Kung-wang and Ni Tsan. We can see from it that nothing is impossible to the mind of a noble man.''[24]

The landscape in the Soochow Museum which is Wang Ch'ung's only known and published painting (Pl. 124) is, as we would expect after reading Wen Chia's and other descriptions of his works, a translation of the Huang-Ni mode of the Yüan dynasty into a Ming idiom. It is ap-parent from the painting that even after Wen Cheng-ming's influence had swept through Soochow painting, it was not a clean sweep; in spite of Wang Ch'ung's close friendship with Wen, his painting adheres firmly to the older style of Shen Chou. Broad, blunt brushwork, perfectly controlled by the hand of a master calligrapher, invests this cool presentation of forms with a singular purity.

This much belongs to the tradition of Ni Tsan; the composition owes most to Huang Kung-wang, its architectural stability expressing the same impulse to order, with Shen Chou's re-working of this distinctive system of forms intervening. But Wang Ch'ung's proportioning and

placing of geometric shapes, with carefully spaced repetitions, are even more calculated than Shen Chou's, and his distribution of dark accents over a limited range of ink tones even more refined. The detail (Pl. 125) conveys, even in reproduction, some sense of the extraordinary brush-and-ink qualities of the painting, one of the most visually satisfying works of the whole Soochow school.

The stylistic direction that it represents is the one we have called abstract, using the term, of course, in a different sense from its common (and equally loose) application to some kinds of recent Occidental art that are otherwise termed nonobjective or nonfigural. The Chinese painters never arrived at a truly abstract art in that sense, since their works could always be seen, although at times only with difficulty, as images of natural or imaginary objects and scenes. We use the term rather to designate those varieties of Chinese painting in which the image is abstracted, i.e., divested of specific reference to time and place, of individually characterizing attributes, and of the close rendering of textures, light and shadow, or surface detail which, in paintings of other kinds, served to engage the senses more strongly. We mean to distinguish this abstract mode of landscape from particularized depictions of places and incidents and from paintings with literary and narrative themes or those in which the theme is the enjoyment of nature—scholars contemplating waterfalls or listening to the wind in the pines. These made up the bulk of Soochow painting throughout the Ming period. The abstract mode, as we will see, was to be powerfully asserted in both theory and practice by Tung Ch'i-ch'ang and his followers in the late Ming. Perhaps the distinction can best be stated as depending on whether it is the subject matter of the painting or its formal properties that dominate in determining its expression or (in the broadest sense) its meaning. This is, of course, a matter of relative weighting, since these wellsprings of expressive content are interdependent, not mutually exclusive.

CH'EN SHUN   Another excellent example of the abstract mode, and another indication of the persistence of Shen Chou's influence for some decades after his death, can be seen in a landscape by Ch'en Shun, the first leaf in an album dated 1540 (Pl. 126). Typical landscapes by this artist portray hills and trees in clouds, in a loose manner based on the style of the Sung master Mi Fu, his son Mi Yu-jen, and their Yüan-period followers. In this one the rocks and hills are more firmly bounded with broad, wet outlines that are scarcely darker than the washes. A row of roughly rectangular boulders stretches across the picture space at a slight diagonal, surmounted by leafy trees and echoed by a series of similar forms projecting from the hilltops. Houses are seen behind this middle-ground screen of rocks and trees, and through it streams pour into the foreground expanse of water that separates the whole scene from the viewer. The attraction of the picture is in the ease with which it can be apprehended, as a set of pleasing variations on a few simple motifs. The changing slope of the upper sides of the boulders, the rise and fall of the tree groups, the differing arrangements of the clusters of small rocks are descriptively inconsequential but formally significant events that occur as one reads the picture laterally, like a musical score. Even the spotting in the areas of ink wash, whether intended by the artist (who may have spattered the paper lightly with something that affected its absorbency) or accidental, add to the effect of rich variety within a simple scheme.

The artist, Ch'en Shun or Ch'en Tao-fu (1483–1544), is another of the Wen Cheng-ming circle of painters who like the others was born in the city, the son of an imperial censor named Ch'en Yü, and was well educated but never pursued a career as a bureaucrat. He probably made his living mostly as a painter and calligrapher—the scanty biographical accounts are typically silent on this question. Shen Chou may have been his painting teacher, and in any case he was one of Shen's young friends.

Wen Cheng-ming is often credited with having taught him painting, but (according to Wang Shih-chen) disclaimed that honor when questioned on the matter by one of his disciples: "Our

Tao-fu is himself an established teacher; in both calligraphy and painting he has his own school and goes his own way. He is not my pupil.'' Wang Shih-chen suggests that Wen's words contain some sense of dissatisfaction with Ch'en's accomplishments.

Wang also relates, and other sources repeat, that in his landscape style Ch'en Shun imitated the Yüan masters (presumably the usual models—Huang Kung-wang, Ni Tsan, and Wang Meng) in his early period, in works that were refined and skillful, but that he changed direction suddenly in his middle years and began doing sketchy pictures in the tradition of Mi Fu, Mi Yu-jen, and their Yüan-period follower Kao K'o-kung. This skeletal account of his career is gener-ally borne out by extant paintings, but we may add that he was apparently strongly influenced also by the works of artists active in Nanking a few decades earlier, such as Wu Wei, Shih Chung, and Kuo Hsü. Some other leaves in the 1540 landscape album use compositional types and motifs favored by those artists, such as the fisherman under the overhanging cliff. The Mi manner of landscape and the tradition of Kao K'o-kung, as we pointed out in an earlier chapter, played little part in the scholar-amateur current of painting in the Ming but were often adopted or adapted by academic artists and by the related group of unorthodox masters in and around Nanking, who endeavored to escape academicism by violating some of its rules while continuing to adhere to others. Ch'en Shun's affinities with this latter group are strong and help explain why his style was, in turn, so influential in the development of Hsü Wei's painting. Ch'en applies ink more liberally and with a richer range of values than do other Soochow artists, and his brushwork is looser, less restrained.

The best among Ch'en Shun's many flower pictures, such as the series in a handscroll in the Palace Museum, Taipei, dated 1538 (Pl. 127), are brilliant performances in brush and ink besides being penetrating portrayals of their subjects, combining these two kinds of excellence in a way that rivals, for instance, T'ang Yin's "Singing Bird" (Pl. 99–100). In particular, the techniques of allowing controlled suffusions of darker ink within a still-wet lighter area and loading the brush one-sidedly for shaded strokes are effectively exploited and developed to new heights of coloristic beauty by Ch'en Shun. They serve representationally to render shadows within the depths of a flower, or leaves turning at varying angles to the picture plane, and thus relieve the flatness of most earlier flower painting in ink as it was practiced by Shen Chou and others.

Wang Chih-teng writes of Ch'en's paintings of this kind: "In painting [flower subjects] from life, he did each flower and half-leaf in dilute ink, slanting and bold, spread out randomly and turned at oblique angles, seeming disordered and even upside down but wondrously pursuing the truth. He overturned [surpassed] the common crowd of painters. Their tricks of blue-greens distinguished and reds nicely calculated, petals separated and stamens and pistils divided—these are the cheap devices of the ordinary artisan and can't be spoken of in the same breath with the free-running styles of the upper-class artist.''

SHEN SHIH   As we learn more about the Soochow painting world in the sixteenth century, we begin to see in it a rich and elaborate fabric of interwoven styles and traditions, the product of a complex interaction of artists and patrons, collectors and dealers and connoisseurs. Styles were subject to class distinctions as people were. Those who wanted paintings approached particular artists with particular expectations, going to Ch'iu Ying for one kind of picture, T'ang Yin for another, Wen Cheng-ming for still another. One might assume that Ch'iu's and T'ang's styles had a broader appeal on different social and economic levels, while Wen's attracted a more exclusive circle of admiring collectors. That was doubtless true in the early decades of the century, but by Wen's later years the preponderance of taste seems to have shifted, and the somewhat exclusionist, "in-group" status that the scholar-amateurs' painting had held from the time of Liu Chüeh and the early period of Shen Chou was eroded by an increasing popularity.

That a number of Wen Cheng-ming's followers were semiprofessionals or outright professionals testifies to this change in the status of the school.

While these followers of Wen Cheng-ming dominated the scene, the styles of Ch'iu Ying and T'ang Yin, as we noted earlier, were scarcely carried on after their deaths except by minor masters. It was a time when a professional painter might have been well advised to learn and practice the "literary" styles, for mercenary reasons even if he did not share the general sense that these represented the progressive trend of the time. On the other hand, the demand for paintings in Sung-derived styles did not cease altogether, and collectors continued to pursue the works of old masters with a zeal that inspired forgers to augment the insufficient supply of genuinely antique works. (Besides being sold to the unwary as originals, forgeries were regularly used as more or less symbolic gifts, or bribes; it would have been ungrateful and unmannerly for the recipient of a "Sung" scroll to inquire too closely into the actual date of its execution.) A painter of sufficient skill and versatility, then, might combine the roles of a traditionalist adept in academic Sung styles, a copyist or forger of old paintings, a follower of T'ang and Ch'iu, an imitator of Shen and Wen—and, if his creative powers could survive all this, an original artist in his own right.

Just such a painter, it would appear, was the little known Soochow master Shen Shih, who adopted all these roles and others, including that of connoisseur. His birth and death dates are not recorded, but his period of activity can be placed provisionally at around 1540–80—his two dated paintings are 1543 and 1544, and he was the friend of the younger painter-collector Chan Ching-feng, who took his *chü-jen* degree in 1567 and was active in painting circles from around that time until the end of the century, with dated works in the 1590s.

Shen Shih was a native of Ch'ang-chou, the eastern sector of Soochow, but lived for some part of his life in Nanking. When he first determined to learn to paint, we are told by the *Ming-hua lu*, he worked at it for three years "without coming downstairs." He modeled his style on the Sung masters Li T'ang and Liu Sung-nien, as well as on Wu Chen of the Yüan, but also followed T'ang Yin and Ch'iu Ying. Several writers state that he excelled in copying old paintings. In Chan Ching-feng's *Tung-t'u hsüan-lan pien*, a miscellany probably written in the 1590s, Shen Shih is mentioned several times as a copyist of Sung and Yüan paintings. The implication is that he was engaged in the production of forgeries, although Chan Ching-feng does not say so plainly, nor do other writers. Chan also quotes Shen's opinions on old paintings, indicating that he had some standing as a connoisseur. This could also be a source of income, since it was normal for owners of paintings to pay in cash or gifts for opinions and authentications.

Filling in with imagination the spaces around these scraps of information, we can suppose Shen Shih to have been a man of wide acquaintance with all aspects of painting old and new, gained through study of collections in the Soochow and Nanking regions, who put his knowledge and talents to use in a variety of ways. His is not the only case of one who combined the activities of artist, forger, collector, connoisseur, and (quite likely) dealer; a distinguished example of that combination is widely known in our own time.

How many of Shen's copies and imitations pass today under more famous names we cannot say, but his original, signed works are rare. Apart from a fan painting in the style of Shen Chou, only two are presently known: a landscape handscroll, dated 1543,[25] and the work reproduced here, "Sunset in an Autumn Valley," dated 1544 (Pl. 128). The latter was painted in Nanking for a certain Mr. Chu-lin and bears poetic inscriptions by two other artists, Wen Cheng-ming's nephew Wen Po-jen and Shen Shih (unrelated to our painter, his given name written with a different character). It represents a wooded valley opening onto a broad river, probably the Yangtze. A man, presumably Chu-lin, is seated in the upper story of a house set among trees. The house is situated in the middle distance, set back from the foreground by a winding stream and seen through an opening in dense foliage. The use of graded ink tones to create the sunlit

hollow of space among the trees and to clarify spatial relationships is masterly; the brushwork is deft and sensitive, seeming unusually "painterly" for this age of more linear modes.

Although Shen Shih reveals a thorough awareness of the styles of Shen Chou and Wen Cheng-ming and could doubtless imitate them closely if he chose to, his chief models are in the Yüan dynasty, Wu Chen and even more Sheng Mou (cf. *Hills*, Pl. 21, 23, and Color Pl. 3). When an almost forgotten artist demonstrates such mastery of earlier styles as Shen Shih does here and in his 1543 handscroll and is, moreover, identified in literary sources as a professional copyist, we may be warned against any feeling of complacency in our judgments on the authenticity of old paintings, or at least against the common blunder of accepting a painting as genuine because of its high quality.

## 3. WEN'S DESCENDANTS AND FOLLOWERS IN THE LATER SIXTEENTH CENTURY

A number of Wen Cheng-ming's relatives and descendants were painters and calligraphers; as late as the mid-nineteenth century one of them, Wen Ting, was still carrying on the family tradition.[26] Only two others of the Wen family, however, both in the generation following Cheng-ming, were artists of any note. They were his second son Wen Chia (1501–83) and his nephew (brother's son) Wen Po-jen (1502–75).

WEN CHIA  Wen Chia served for a time as an instructor in a sub-prefectural school, probably a *ju-hsüeh*, or Confucian school, in Ho-chou in Anhui Province, but seems to have spent his later years back in Soochow. Through his aesthetic upbringing, his familiarity with the family collection, and his constant association with collectors in his father's circle of friends, he acquired effortlessly enough expertise as a connoisseur to undertake the judging and authentication of paintings and calligraphy in at least a semiprofessional capacity, as did his older brother Wen P'eng, who was an art adviser to the greatest collector of the time, Hsiang Yüan-pien. Inscriptions by Wen Chia, some in the form of poems, some offering art-historical judgments, are still to be seen on many important paintings; these were composed and inscribed, ordinarily, at the request of the owner of the scroll and were (like paintings by the scholar-amateurs) in theory done for pure friendship but in practice often for recompense of some kind (as noted already with respect to Shen Shih). When the Grand Secretary Yen Sung (1480–1565) fell from power and his collection of works of art, acquired as gifts from people who had sought favor with him, was confiscated, Wen Chia was employed in making a catalogue of the calligraphy and paintings.[27]

Wen Chia's immersion from childhood in an environment of the highest aesthetic refinement affected his painting just as deeply by instilling standards that prevented it from ever falling below that level of refinement, but also by virtually ruling out the kinds of originality and experimentation that risk lapses from good taste in the pursuit of greater goals than tastefulness. Wen Chia's paintings are exploratory only in moving into the further reaches of that unreal realm of poetic fancy in which Lu Chih was at home, and the only danger they court is preciosity. Whether or not they succumb to it is a question to be decided by personal judgment. Their subjects are often old poems, or local scenery, or traditional themes; their style offers some of the most fastidious and cultivated brushwork, the coolest coloring, the most rarefied transformations of tactile reality into expressively dilute images, in all of Ming painting.

A landscape dated 1555 (Pl. 129), more substantial than most of Wen Chia's others, is titled "Temples on Immortals' Mountains" and presumably represents, unless the scene is purely imaginary, some place in the environs of Soochow where a Taoist temple was situated on a

cliff, with some kind of cavern below. Whether or not the picture portrays any real place, the composition is in the main invented, or (to state the matter more accurately) derived by variation from the Wu-school formula for landscapes of this narrow shape. When we realize that it was painted just five years after Wen Cheng-ming's "Thousand Cliffs" (Pl. 116) and try to imagine the creative predicament of the painter working under the eye of his strong-willed and illustrious octogenarian father, a certain note of willful aberration becomes as understandable as in, say, a sonata by K. P. E. Bach. A less creative artist would simply have repeated the formula, a more creative one might have rejected it altogether; Wen Chia stretches it out of shape, almost but not quite to the breaking point.

The composition divides in the middle, like Wen Cheng-ming's; a pine tree, its height emphasized by the bareness of its trunk, acts as a skewer to help hold the two halves together. The grotto at the bottom, out of which a torrent of water pours, sets a theme that is taken up as the formal basis of the whole painting, which is built around a single long concave movement stretching from bottom to top. At the base, two gentlemen and their servants walk beside the stream, beneath an old tree that overhangs the water. The ropy vines with which it is entwined already inject a tone of slight eeriness, which deepens in the cavern, with its strangely uniform and pendulous stalactites, and turns to queasiness in the landscape above, on which the eye can take no firm hold—the paths slant steeply, the pilings of the buildings rest on no solid surface. The coloring is very cool, limited to blue-green and sallow yellow-brown tones instead of the slightly warmer greens and red-oranges of Lu Chih and others.

WEN PO-JEN    Wen Po-jen (1502–75), the nephew of Wen Cheng-ming, was one year younger than Wen Chia and must have grown up in much the same environment, but his was a personality of another kind: he was reportedly sulky and short-tempered, given to scolding people, and consequently disliked. While young he sued his famous uncle over some dispute, was sued in return, and ended up in jail. "There he fell ill and was nearly dying. Then in a dream he saw a man in golden armour who told him that in a previous life he had been a painter who always washed and purified himself before painting images of Kuanyin Bodhisattva. By this he had acquired merit and would escape further trouble in his present life."[28] He recovered from his illness, settled the lawsuit, and went on to become, we are told, the next most distinguished painter of the family tradition, called by many the equal of Wen Cheng-ming himself.

Few of his landscape compositions justify such an assessment; they are mostly exaggeratedly narrow in shape and crowded with details taken from the school repertory, compiled more than composed into assemblages that may impress the viewer by excess but can scarcely be comprehended as pictures at all. Compositions put together in this way, by accumulating small elements until they fill the available space through sheer numbers, were in fact common in Soochow painting around the third quarter of the sixteenth century; they are the unfortunate products of attempts to emulate those works of Wen Cheng-ming that similarly incorporated a multiplicity of elements into an elaborate whole, but in which the formally related materials were, by contrast, effectively organized into strong, clearly readable structures. Other works by Wen Po-jen, at an opposite extreme in effect but similar in their compositional extremism, are excessively empty, giving more of the area of the painting to an expanse of water and stretching the foreground and distant shores further apart than anyone had dared to do before.

Wen Po-jen's masterworks among surviving paintings, to which the negative aspects of the above characterization only partly apply, are four huge hanging scrolls in the Tokyo National Museum, painted in ink on paper and titled *Ssu-wan t'u* ("The Four Myriads"). All are inscribed by the artist with titles and signatures, and the last bears an additional inscription that supplies the date, 1551, and a dedication to Ju-ho, a friend of the artist whose proper name was Ku

Ts'ung-i. The word "myriad" (or "ten thousand") is used in Chinese in the sense of "innumerable." Each composition is based on the repetition of some motif in nature until it fills the picture space and extends beyond, by implication, into countlessness. The four make up, moreover, a set of the four seasons: the spring scene is "A Myriad Stalks of Bamboo in Mist and Rain"; summer (Pl. 130, 132), "A Myriad Ravines with Windblown Pines"; autumn (Pl. 131, 133), "A Myriad Hectares of Sunlit Waves"; and winter, "A Myriad Peaks with Flying Snow." Tung Ch'i-ch'ang, who inscribed each of the paintings, added still another dimension to them by suggesting (as Wen Po-jen may not have intended) that each is in the manner of some master of the past. One is expected, then, to view the paintings in relation to whatever understanding one may have of those old masters (and the relationships are not easy to discern, since Tung's suggestions are somewhat farfetched); to recognize and appreciate the underlying theme of "The Four Myriads," a conceit more poetic than pictorial, and the congruence of this with the seasonal aspect of the series; to see the paintings in the context of the Wen Cheng-ming school and as "moves" in the "game" referred to above; and—if this is still possible—to enjoy them as pictures.

In fact, for all their density of design, they are far easier to enjoy as pictures than most of Wen Po-jen's other works; they must represent the kind singled out by the author of the *Ming-hua lu* for special praise: "His landscapes are done in clean and supple brushwork. He follows the family manner but on occasion brings forth ingenious ideas of his own, in horizontal scrolls or large hanging scrolls full of heights and depths and fine detail; in these he is not inferior to Wen Cheng-ming."

Tung Ch'i-ch'ang's inscription on the "Myriad Ravines" (Pl. 130) reads: "This picture is in the manner of Ni Tsan. It is like 'Shih-heng suffering from an excess of literary talent'—[Wen Po-jen] is stronger even than Ni and cannot reduce himself [i.e., conceal his strength]. He unites the best skills of Lu Chih [with his own]." The allusion to Shih-heng, or Lu Chi (261–303), the author of the famous "Essay on Literature," refers to a remark made about him by his contemporary Chang Hua: where most people, Chang said, regret the paucity of their literary talents, Lu is troubled by the profusion of his.

Considering Tung's expressed disdain, on another occasion, for "recent painters" who "pile up small pieces to make a mountain," we may suspect that his effusive praise for Wen Po-jen, especially his ranking of him above Ni Tsan, is best understood as more or less obligatory enthusiasm for paintings that were owned by a friend, or by someone to whom Tung was somehow obliged. As we will see when we consider Tung as a painter, his stark, stripped-down style represents a reaction against just their proliferation of textural detail, which tends to obscure the clarity of structure on which Tung insisted.

But in fact, within the terms of this style, Wen Po-jen is remarkably successful in arranging his pines, rocks, and ridges according to an unobtrusively effective compositional scheme. A formal motif of bifurcation is announced at the base of the composition by two pine trees in the center that lean away from each other; a stream goes off diagonally to the left, a ridge to the right, and so forth, with successive diagonal elements diverging as we ascend and leading the eye upward and sideward from the central axis, which is marked at intervals by vertical trees, and along which are located the inconspicuous figures that people the ravine, seven of them in all. The skyline at the top departs from the standard "central mountain" formula to state the V-motif one last time. The drawing, dry and sensitive throughout, must account for Tung Ch'i-ch'ang's allusion to Ni Tsan; it is hard to see what else could.

It would be easier to associate the summer scene, "A Myriad Hectares of Sunlit Waves" (Pl. 131), with Ni Tsan, since the composition, at least, recalls Ni's spacious riverscapes; but this time it is Chao Meng-fu whom Tung invokes: "This picture follows Chao Meng-fu. It has the empty expansiveness of the sky over the [Great] Lake. The 'Water Village' picture [by Chao] in my collection is just like it." The "Water Village" (*Shui-ts'un t'u*) is a landscape handscroll

that Chao painted in 1302 (*Hills*, Pl. 13); it resembles Wen's picture in offering a limited number of delicately drawn forms spread sparsely over a ground plane that stretches to hills on a high horizon.

At the base of Wen Po-jen's composition, a boatman, identified by scrolls, books, and wine pot as a cultivated gentleman for whom this excursion on the lake is purely a mind-cleansing activity, is playing his flute (detail, Pl. 133). The ripples on the water continue its melancholy reverberations into far distance, where another boat serves as a faint echo. Only a flight of birds, skimming the surface, helps to carry the eye across the intervening expanse. The quality of fragile refinement in Wu-school painting here reaches an apogee from which the aftermath can only be descent: like some landscapes of the late Sung period, this seems to have reached the uttermost limit in its reduction of solid form, to have made the ultimate permissible demands on the viewer in its reliance on the pregnancy of space.

The later phases of Wu-school painting, from the late sixteenth century through the end of Ming, will be considered in a subsequent volume. We will end this one with two landscapes that lead in a different stylistic direction from that of the younger Wens, continuing the formalist or abstract trend noted earlier in several paintings of the school and anticipating the next truly decisive change in landscape style, which was to be accomplished by Tung Ch'i-ch'ang (1555–1636) around the turn of the century.

HOU MOU-KUNG   The first is an undated landscape by Hou Mou-kung (Pl. 134). Very little is known about the artist. He was a native of Soochow; his birth and death dates are unknown, and even his period of activity is problematic. His dated works fall between 1569 and 1604.[29] The *Ming-hua lu* describes his landscapes as "sparse and thin, pure and refined" and says that he studied painting under Ch'ien Ku (1508 to after 1574) who was a pupil and close follower of Wen Cheng-ming. Later, it goes on to relate, Hou turned to the styles of Huang Kung-wang and Wang Meng and gradually "entered the chambers of," or penetrated the methods of, these great Yüan-period masters, in works that were markedly different from his earlier ones. The landscape we reproduce would, in that case, belong to this later period, since it is, as Tung Ch'i-ch'ang notes in an inscription written at the upper right, "in the style of the late Yüan masters." It departs not only from the artist's earlier work but from Wu-school practice generally in being made up of earthy, soft-edged, volumetric forms arranged in a three-dimensional space.

This is not to say that Hou Mou-kung's picture is notably more realistic—the logic of this system of forms has no heavier debt to nature than one of Wen Cheng-ming's—but an effect of greater naturalism arises from the relatively unpatterned, informal treatment of trees and the rendering of the surfaces of earth masses more tactilely with dry, uneven applications of light ink. The visually compelling plasticity that results reminds us of the works of Huang Kung-wang, as it should, since they are the main sources of the style; the contrapuntal development of the rising mountain ridges also depends on Huang's formula (cf. *Hills*, Pl. 40), with the same three basic units recurring regularly: the triangular shape, the cluster of darker boulders, and the flat-topped mass, tilted toward the viewer and sometimes projecting sideward as a plateau or ledge.

The verticality of the composition and its dependence on a long, winding movement up the center, with subsidiary movements paralleling this at the sides, belongs to the sixteenth century, but the rest is new, or old: landscapes "in the manner of Huang Kung-wang" by Shen Chou, Wen Cheng-ming, and others had been flatter, more geometrically patterned, less earthy in substance. Hou Mou-kung's painting argues for direct contact with some work or works by Huang, and probably for a conscious reversion to the original source. In this, too, it anticipates the fundamentalist attitudes of Tung Ch'i-ch'ang.

CHü CHIEH   We conclude with a painting that not only is by another artist whose period of activity is problematic, but which is itself problematic in date, even in authenticity. But it is too fine and important a work to be ignored because we have not yet solved the problems associated with it. This is "Spring in Chiang-nan" signed by Chü Chieh and dated 1531 (Pl. 135). The artist was a native of Soochow who studied painting in his youth under Wen Chia; when Wen Cheng-ming saw his work he was surprised and delighted, and gave him personal instruction. Both his painting and his calligraphy came to resemble Wen's closely, and some considered him Wen's outstanding pupil. His success as a painter, at least until he attained some recognition in his own right, was doubtless based largely on his ability to imitate or even replicate Wen's works. Chü Chieh's family was connected with the imperial silk factory in Soochow, which was managed by a eunuch named Sun Lung (d. 1601, not to be confused with the fifteenth-century painter of the same name). Sun heard of Chü's ability as a painter and summoned him; Chü refused to come; Sun was furious, and brought about the financial ruin of Chü's family by accusing them of delaying tax payments. Chü Chieh built a small house in Nan-ts'un (Southern Village) at the foot of Tiger Hill and lived there in semipoverty and ill health for the rest of his life. "When he earned a bit of money with his brush, he would invite his friends in for feasting and drinking; when he ran out of food, he would get up early and do a picture of a lonely pine tree and far-off hills and send a boy out to trade it for some rice." So writes the *Ming-hua lu* and adds that he finally died of undernourishment when he was sixty.

The chronological problem raised by his dated works is that they seem to stretch over too long a period, from 1531 to 1583; a fifty-year active period as an artist is not impossible but is obviously incompatible with the information that he died at sixty. The 1531 "Spring in Chiang-nan," moreover, would seem on the basis of style to be a late work, surely postdating Wen Cheng-ming's well-known painting of 1547, which bears the same title and poem.[30] A few other works from the 1530s are recorded, and one painting dated 1534 bears his signature but is probably spurious.[31] Apart from these, Chü Chieh's extant dated works fall within a comfortable twenty-four year period, from 1559 to 1583.

The inscription and signature on the "Spring in Chiang-nan" do not themselves arouse suspicion, and the painting can be convincingly related to others by Chü Chieh. Only the date is difficult to accept. The possibility should be considered that we have here a case (like that of Watanabe Kazan in nineteenth-century Japan or de Chirico in our time) of an artist who, in his later period, puts early dates on his works in order to sell them. Perhaps by the Wan-li era (1573–1620), paintings from what must by then have been regarded as the golden age of the Wu school were valued far more highly than contemporary works, whoever the artist. It may be hard to believe such a trick of Chü Chieh, who was reportedly a person of the highest moral character, but the extreme poverty suggested by the statement that he died of malnutrition is surely sufficient excuse.

This is speculation; the painting is a reality and, whatever its date, represents a remarkable transformation of the earlier Wu-school style and of Wen Cheng-ming's own "Spring in Chiang-nan" into the geometricized, abstract mode that was to become dominant in the succeeding period. (Chü Chieh's interest, in his late years, in that new stylistic direction is indicated also by other paintings, especially certain leaves in two albums in the Palace Museum, Taipei.)[32]

Wen Cheng-ming's painting is made up of three land masses spaced by intervals of river, against which are silhouetted tall trees on the nearest promontory and smaller trees on the middle one. This much Chü Chieh retains. Most of Wen Cheng-ming's landscapes have figures in the foreground, providing the viewer with an easy ingress; in his "Spring in Chiang-nan" it is a man in a boat. Chü Chieh eliminates the figure and boat. Wen's picture is in his most delicate, insubstantial manner; the forms in it are defined by dotting, by the faintest of contours, and by washes of light color; scarcely anything is firmly bounded. Chü Chieh, who proves himself a master of this understated, poetic style in some of his other paintings, sacrifices delicacy to

clarity in this one; his forms are clear-cut, sharp-edged, essentially abstract. One is reminded of the transition from the Impressionists to Cézanne to the Cubists. Space is distorted by tilting the shorelines and, in the upper part, mismatching the angles of view between one side and the other; the river plane also seems to shift uneasily. The trees are less individualized and are treated rather as compositional units, their strictly triangular tops and straight trunks serving to break up and structure the water areas and enhance their function as active parts of the whole design. Where all the earth elements of Wen Cheng-ming's picture are stable, even static, those of Chü Chieh's are activated (like the forms of Hou Mou-kung's landscape) by the device of drawing them with slanting upper surfaces so that they point, or thrust, in one direction or the other, interacting dynamically. The instability of the composition is intensified by the weightiness of the upper part, which is also depicted in such a way that it seems to slip rightward.

The all but exclusive concern with problems of pure form that characterizes this landscape, and to a lesser extent Hou Mou-kung's, is untypical of later Wu-school painting, i.e., that of the late sixteenth and first half of the seventeenth centuries; it is taken up and exploited rather by the school of artists active in this same period in nearby Sung-chiang, above all by Tung Ch'i-ch'ang. Soochow painters working in the last phase of the Wu school would emphasize instead the poetic, narrative, and lyrical aspects of their tradition. But these are developments beyond the scope of our present subject. Chü Chieh's picture does not represent a total break with earlier phases of the Wu school, in which precedents can be found for some features of it: Shen Chou (cf. Pl. 29) for the topheavy composition, Lu Chih and others for the angularity of the forms, Wen Cheng-ming's "Spring Trees" (Pl. 111) for the slanting shorelines, and so forth. But they are used to new purpose in an essentially new style, one that augurs a new age in landscape painting. The characteristics of painting in this new age, and how it represents another revolution in painting style comparable to the one that took place at the beginning of the Yüan dynasty, are matters that will be considered in the next volume of this series, on painting of the late Ming period.

# Reference Matter

# Notes

References to publications are usually given below in abbreviated form, with only enough information to guide the reader to full entries in the Bibliography.

## CHAPTER 1

1. Biographical notes on Wang Li are to be found in *Ming-hua lu* (*Hua-shih ts'ung-shu* ed., ch. 2, p. 21), *Wu-sheng-shih shih* (ch. 1, p. 6), and *P'ei-wen-chai shu-hua p'u* (ch. 55, p. 40b) quoting from *Lieh-ch'ao shih-chi* by Ch'ien Chien-i (early Ch'ing period).

2. Wang's two essays are printed in *P'ei-wen-chai shu-hua p'u*, ch. 16. I am grateful to Thomas Lawton for giving me a copy of his draft translations of both; the renderings used here are, however, my own. For derogatory assessments of Ma Yüan and Hsia Kuei by Yüan-period writers, see the treatment of them by Chuang Su (*Hua-chi pu-i*) and T'ang Hou (*Hua chien*); both books are included in the bibliography for *Hills*.

3. The inscriptions in the album were first recorded in *T'ieh-wang shan-hu* (ca. 1600), where they make up most of ch. 6; if they all belong to a single album of paintings, it must have contained many more than the "forty-odd" leaves mentioned in *Wu-sheng-shih shih* and other seventeenth-century sources. The catalogue *Hua-yüan to-ying* (1955) states that eleven leaves survive in modern times, and that number of leaves were included in an album publication by Shen-chou Kuo-kuang She in 1929, in which the paintings were ascribed misleadingly to Fan K'uan. Five of these leaves were shown to me at the Shanghai Museum in 1973. However, three others, not among the eleven in the Shen-chou publication, were on view in the Palace Museum, Peking; and still others may be in storage there. The solution of numerous problems associated with this album must await the time when it is accessible for study.

4. Sheng Chu is represented today by two album leaves, one in the Palace Museum, Taipei (VA 7K), and the other in the Metropolitan Museum, New York (1973.121.14). Neither reveals any interesting departure from the manner of the Sheng Mou school. A signed album-leaf painting of "T'ao Yüan-ming Returning Home Drunk" in the Palace Museum, Taipei, seems to be the sole surviving work of Chou Wei.

5. MV 23; see *Ku-kung ming-hua*, vol. 7, pl. 9, and Cahill, *Chinese Painting*, pl. 120 (detail).

6. A landscape dated 1452, now known only in reproduction, would, if genuine, represent the "amateur" aspect of his painting; see *I-yüan chen-shang*, vol. 9.

7. The painting is unsigned, but Hsieh is identified as the artist in Yang Shih-ch'i's colophon. Another version of the painting, also ascribed to Hsieh, is in the Chen-chiang Museum in China (see *Wen-wu*, 1963, no. 4) but is reproduced so badly that no assessment of it is possible. A decision as to which is Hsieh Huan's genuine work—it is possible that both are—must be postponed until the scroll in China is accessible for study.

8. For the illustrations to *ku-shih*, see *Kokka* no. 283 (a pair) and *Tōyō bijutsu taikan*, 10. The handscrolls are the "Searching for Flowers" in the Hashimoto Collection, Takatsuki (Hashimoto cat. no. 2), mistakenly listed by Sirén (*Annotated Lists, Chinese Painting*, vol. VII, p. 232) as two paintings, and a recent acquisition of the Cleveland Museum of Art; see Sherman Lee, "Early Ming Painting," pp. 244–47. The other hanging

scroll, besides the one reproduced here, is in the Nezu Museum, Tokyo.

9. The complete scroll is reproduced in *Chung-kuo hua*, no. 13; a section in Sirén, *Chinese Painting*, vol. III, Pl. 271. No color reproduction has been published, but in studying the coloring and detail drawing of this painting I have used color slides that I was able to make from the original in 1973. The text of Hung-wu's colophon, written after the scroll was presented to the emperor by a mounter in 1375, is recorded in *P'ei-wen-chai*, ch. 84.

10. Liaoning Provincial Museum; see *Liaoning*, Pls. 8–14.

11. Many others, both earlier and later, could be cited. Especially interesting is a large, bizarre painting by Ma Shih in the Palace Museum, Taipei (MV 41, unpublished), in which an anomalous passage at the center right of Kuo Hsi's work, where the artist in an apparent change of plan opened a view into a seemingly subterranean world in order to overcome the excessive stability and weightiness of an earth slope, has been transferred and enlarged by Ma Shih so as to undermine his main central mass and negate its thickness: a curious case of a mistake become part of a tradition. The painting otherwise follows closely the style of Tai Chin, as seen, for example, in our Pl. 17.

12. Suzuki, *Mindai*, pp. 15–23, "The Biography of Tai Chin and Critical Comments on Him"; pp. 24–37, "The Works of Tai Chin and Their Style"; pp. 151–63, "Tai Chin's Influence Inside and Outside the Academy." I am indebted also to Howard Rogers, who composed a tentative chronology of Tai's career based largely on Ming sources cited by Suzuki, and Mary Ann Matteson, who used this chronology in a paper proposing a developmental sequence in Tai's works, for my seminar in Ming Academy Painting given in winter-spring, 1974; both have contributed to my treatment of Tai Chin.

13. *Ch'un-feng-t'ang sui-pi*, see Suzuki, *Mindai*, note 12. Ni Tuan's only work known to me, apart from a problematic picture in the Palace Museum, Taipei, is an unpublished painting in the Palace Museum, Peking, that fits very well the definition of the conservative Academy style outlined above.

14. Lang Ying states that Tai returned only after Hsieh Huan's death; but he goes on to say that one of Tai's patrons at the capital was Yang Shih-ch'i, who died in 1444, while Hsieh lived

for at least eight years after this. Even if we disbelieve the painting dated 1452 (see note 6—the reproduction is too indistinct to allow any firm judgment of its authenticity), we are still confronted with a reference in the "Veritable Records" of the emperor Ying-tsung, cited by Suzuki (note 217, p. 315) to Hsieh's promotion to the rank of Assistant Commander of the Guard in that same year, 1452. This chronological disparity is difficult to resolve; Lang Ying, writing a century or so after the events, must have had faulty information.

15. Cahill, *Chinese Painting*, p. 64. The pose of Tai Chin's figure is so close to that of the anonymous "Noble Scholar Under a Willow" (ibid., p. 63) as to suggest that Tai may have known that picture, or something based on it.

16. Palace Museum, Taipei (MV 33); see Sirén, *Chinese Painting*, VI, Pl. 145. See also Sherman Lee, "Early Ming Painting," where this interpretation is followed and both paintings are reproduced.

17. See Fontein and Hickman, no. 55.

18. They include "Autumn Colors on Mountain Peaks," attributed to Kao K'o-kung, in the Palace Museum, Taipei (YV 16), and "Taoist Temple in the Mountains," attributed to Tung Yüan, in the same collection (WV 10), which appears to be the work of some early Ming follower of Kao K'o-kung, possibly an Academy master.

19. Lee and Ho, pp. 26–62.

20. Sickman and Soper, Pl. 118.

21. Cited by Whitfield, p. 286.

22. By Chaoying Fang, pp. 30–32.

23. One is in the Palace Museum, Taipei (MV 40); see *Ku-kung shu-hua chi*, 43. The other is now in the Princeton Museum; see *Tōyō Bijutsu Taikan* 10.

24. See Li T'ien-ma, "Yen Tsung."

25. Standard late sources state that he was called to court, along with Lü Chi, in the Hung-chih era (1488–1506), and this statement is repeated in modern books. Recent Chinese scholarship, however, places him earlier, giving his birth and death dates as ca. 1416 to ca. 1480, and his main period of activity as the Ching-t'ai and T'ien-hsün eras (1450–64). See Li T'ien-ma, "Lin Liang"; also the note on him in *Ku-kung po-wu-yüan*, notes to no. 36.

26. Quoted in the entry on Lin Liang in *Hua-shih hui-yao*; see also Suzuki, *Mindai*, note 305.

## CHAPTER 2

1. Biographical material has been taken from the biography by Lee Hwa-chou in *Dictionary of Ming Biography*, pp. 1375–76.

2. *Chinese Art Treasures*, no. 91.

3. The serious reader is urged at this point to read the excellent essay by Frederick Mote, "A Millennium of Chinese Urban History."

4. As pointed out by Susan Bush, pp. 164–65, the tradition that became the "Northern school," from Li Ssu-hsün to Li T'ang and Ma Yüan, was spelled out as early as 1387 in *Ko-ku yao-lun*. Tu Ch'iung begins to introduce value judgments into this system, evidencing a leaning toward those artists who would later be assigned to the "Southern school." For the text of Tu Ch'iung's verses, see Yü Chien-hua, *Chung-kuo*, vol. I, p. 103.

5. For the Wu Chen scroll, see Sickman and Soper, Pl. 118. Yao Shou's copy of Chao Meng-fu's painting is now in the Peking Palace Museum (see *Chin T'ang Wu-tai*, Pl. 99).

6. Cahill, *Fantastics*, no. 13.

7. The chief biographical work on Shen Chou has been done by Richard Edwards, whose *Field of Stones* (1962) was, excepting a few early and abortive efforts by others, the first comprehensive study of an individual Chinese painter to be published in English. I have also made use of his more recent biography of Shen Chou for the *Dictionary of Ming Biography*, pp. 1173–77.

8. Both Edwards (*Field of Stones*, xxi) and Sirén (IV, 155) render this first line as "Mi is not Mi, Huang is not Huang." But this rendering, besides being meaningless, is grammatically impossible: *pu* ("does not") in the Chinese text (*Mi pu Mi, Huang pu Huang*) can only be followed by—and in this case also preceded by—a verb. So "Mi" here must be taken to mean "to be in the Mi style" or "to resemble Mi." (Any Chinese noun can in theory thus be pressed forcibly into service as a verb.) The cryptic quality of this line might be caught by "Mi won't Mi, Huang won't Huang," or even "To Mi or not to Mi . . ."

9. *Chinese Art Treasures*, no. 44.

10. The "Landscape of Mount Ling-yin" handscroll of 1471, mentioned above as having been painted on the same trip as Liu Chüeh's work of that year, would upset this account of Shen Chou's development if it were reliable. I am inclined, however, without having seen the original, to suspect it of being a copy or an imi-

tation by some later master, probably of the seventeenth century. See *Shen Shih-t'ien Ling-yin Shan t'u-chuan*, Shanghai, 1924.

11. Adapted from Edwards, *Field of Stones*, p. 91.

12. I have used the rendering of Edwards, *Field of Stones*, p. 57, for the opening lines, but have retranslated the remainder. Professor Wei-ming Tu gave me invaluable help in rendering and understanding the inscription.

13. Relevant here is the difficult but rewarding essay of Victoria Contag, "The Unique Characteristics of Chinese Landscape Pictures."

14. Edwards, *Field of Stones*, pp. 23–31; Cahill, *Chinese Painting*, pp. 128–29.

15. *Ch'ang-chou ch'ü t'u-chuan*, Peking, 1961.

16. Wang Shih-chen, *I-yüan chih-yen*, in *Ku-kung chou-k'an*, no. 77.

17. For an account of the grove and other depictions of it, see Tseng Yu-ho's "Seven Junipers." Until recently the Nanking Museum scroll was inaccessible for study in the original; there has thus been some uncertainty over which of the several versions of this painting is to be credited as Shen Chou's original. A viewing of the painting leaves no doubt; it is clearly superior not only to the other versions of the same composition but also to the several handscrolls of the same type ascribed to Wen Cheng-ming, including the much overpraised scroll in the Honolulu Academy of Art. A copy of Shen Chou's scroll in the Osaka Municipal Museum (see *Ōsaka Shiritsu Bijutsukan*, no. 79) has copies of the original inscriptions by Shen Chou (dated 1484 and 1492) and Wang Shih-chen, which are now missing from the original painting in Nanking.

## CHAPTER 3

1. The biographical account given here is pieced together from a variety of sources, of varying reliability. Again, I have depended on the material brought together by Suzuki; and I am indebted to Holly Holtz, on whose paper on Wu Wei, prepared for my seminar and later reworked into a master's thesis, I have drawn freely.

2. See, for example, Suzuki's *Ri Tō*. Here too, however, the qualitative level is untypically high. The bulk of the ordinary Che-school work remains unpublished.

3. For an excellent discussion of this scroll,

and of the fishermen theme in early Chinese literature and art, see Hay's article.

4. See Barnhart.

5. Barnhart, p. 178, quoting from *I-yüan chih-yen*.

6. Sirén, vol. III, Pl. 328.

7. *Dictionary of Ming Biography*, pp. 591–93.

8. *Tō Sō Gen Min meiga taikan*, Pl. 308–11. A landscape dated 1548 (*Shen-chou kuo-kuang chi*, vol. 19) must be rejected as spurious now that Chaoying Fang has established Hsü's death date a decade earlier.

9. *Pageant of Chinese Painting*, 536–39; *Sō Gen Min Shin*, Appendix 18–21.

10. Suzuki, *Mindai*, 297.

11. See the article on Wang E by Kawakami and also Suzuki's *Mindai*, pp. 184–85.

12. For biographical information and appraisals of Chung Li's position in the Che school, see Yonezawa's "Shō Rei" and Suzuki's *Mindai*, pp. 205–8.

13. Suzuki, *Ri Tō*, Pl. 81. This painting, the one reproduced here, and another "Gazing at a Waterfall" picture formerly in the Strehlneek Collection (*Collection E. A. Strehlneek*, auction catalogue, Tokyo Art Club, n.d., Pl. 147) are the only works published under Chung Li's name. However, two large paintings traditionally ascribed to Ma Yüan in the Palace Museum, Taipei, representing scholars on mountain terraces gazing at the moon and drinking wine, can be added to his extant oeuvre, one (SV 97) because it bears his signature and seal in the lower left corner, the other (SV 104) because of close correspondences in composition and style.

14. The date is from a seal that he used on several of his paintings, with the legend *hsin-yu cheng-shih*, or "Called to Court in the Hsin-yu Year" (1501).

15. See Suzuki, *Mindai*, pp. 4–7 and Chapter VI *passim* for discussions of these critical condemnations of the later Che-school artists.

16. The Li Chu painting is in the collection of Sueyoshi Hashimoto, Takatsuki; see Hashimoto catalogue, Pl. 8. The only other known work of the artist is a small landscape bearing his seal owned by Dr. Eugene Gaenslen, San Francisco, and kept at the University Art Museum, Berkeley.

17. Kuo Wei-ch'ü gives "1464–1538," and the same dates are used by Sirén, but without citing sources in either case.

18. *I-yüan chih-yen*; see *Ku-kung chou-k'an*, 78. The same story is told of Tai Chin in two later books, *Wu-tsa-tsu* and *Wu-sheng-shih shih*.

19. Sirén, III, Pl. 325.

20. Sickman and Soper, Pl. 32B.

21. Two figure-in-landscape paintings by Cheng Wen-lin are in the Hashimoto Collection, Takatsuki (Hashimoto catalogue, Pl. 15, 16), and another in the Ching Yüan Chai Collection (Suzuki, *Ri Tō*, Pl. 25). Other paintings can be tentatively added to his oeuvre on the basis of style, including a large, unsigned landscape with figures attributed to Tai Chin in the Palace Museum, Taipei, titled "Inebriated in Spring" (MV 355).

22. Cahill, "Yüan Chiang."

23. Suzuki, *Ri Tō*, Pl. 84. Two other paintings by Chu Pang are in the British Museum; see Whitfield, Pl. 11, 14.

CHAPTER 4

1. Wilson and Wong, p. 20.

2. Paintings of this school are treated by Shimada, "Lü Ching-fu's Painting." The survival of the school into the early Ch'ing period is indicated by a painting of lotuses in the *mo-ku* manner dated 1671 by T'ang Kuang (1626–90); see *Ku-kung po-wu-yüan*, Pl. 71.

3. See *Ku-kung shu-hua chi*, vol. 39; detail in Cahill, *Chinese Painting*, p. 120.

4. The *hakogaki* (box inscription) is for an undated landscape painted on paper. The third work of Yang Hsün presently known is a large winter landscape in the Tokyo National Museum. I am indebted to Professors Frederick Mote of Princeton and Gari Ledyard of Columbia, both of whom gave generously of their time and knowledge in the pursuit of the elusive Yang Hsün, without turning up any reference to a man of that name that matches exactly the information in the Japanese *hakogaki* or mentions that he was a painter. Two other Yang Hsüns are recorded; one was from Hsün-chou in Hupei Province and took his *chin-shih* degree in 1493; the other, noted chiefly for filial piety, took his *chü-jen* degree in 1597. Neither is recorded as having been a painter. The writer of the Japanese *hakogaki* of 1874, who signs "Rimpō Sanshō," cites two sources for his information: a seventeenth-century work called *Ming-chi hui-tsuan*, and the K'ang-hsi imperial encyclopedia *P'ei-wen-chai shu-hua p'u*. However, repeated perusals of both works have failed to produce a single mention of Yang Hsün. It is unlikely that Rimpō Sanshō invented the information or the sources; he may have somehow misidentified the latter; we record

provisionally the biographical data that he provides, in the hope that eventually it can either be confirmed or replaced with a firmer identification.

5. Shimada, "Ippin gafū."

6. Speiser and Franke.

7. The Ni Tsan bamboo painting, dated 1374, is in the Palace Museum, Taipei; see *National Palace Museum Quarterly*, vol. I, no. 3, pl. 19.

8. Sullivan, "Early Chinese Screen Painting."

9. See *P'ing-chin-kuan shu-hua chi*, pp. 35a–36a. The catalogue was written by Sun Hsing-yen (1753–1818) and published in 1841. The author comments on several depictions of the subject by other artists and mentions that in Tu Chin's, Fu Sheng is not shown holding a scroll (the *Shu-ching*), which is also the case in our plate.

10. Osaka Municipal Museum; see Sirén, III, Pl. 90; and Cahill, *Chinese Painting*, p. 18.

11. A thorough biography of Wang Wen, on which this account is based, was prepared by Lee Hwa-chou for the *Dictionary of Ming Biography* (pp. 1447–48.) The notes on Hsieh Shih-ch'en below are similarly based on the entry prepared for that project by the same author (*ibid.*, pp. 558–59.)

12. Adapted from the rendering in Sirén, IV, pp. 169–70.

13. Tseng Yu-ho, "A Study on Hsü Wei"; I-cheng Liang and L. Carrington Goodrich, biography for the *Dictionary of Ming Biography*, pp. 609–12; Faurot. Tseng and Faurot provide extensive translations from original sources.

14. Two of the *Four Cries* are translated by Faurot, who believes that one of them may actually have been composed late in his life. His essay on Southern drama has recently been translated and studied in another doctoral dissertation, by K. C. Leung.

15. Translation by Tseng, "Study," p. 249. Tseng notes that the wording is very obscure and speaks of her rendering as a tentative one.

16. Sirén, III, Pl. 368.

17. For instance, two leaves have recently been reproduced from an album by Tu Ta-ch'eng (*Liao-ning*, II, 20–21). His dates and period of activity are unknown, and no other work by him has been published. However, when we note that the paintings are of plants and insects in the loose "boneless" manner of Sun Lung and Kuo Hsü, it is not surprising to learn from literary sources that he was born and active in Nanking, was a poet and musician, and called himself Shan-

k'uang-sheng ("Master Mountain-crazy"). One almost feels ready to fill in, roughly, the remainder of his biography simply on the basis of his style. But that would push too far our argument about correlations.

## CHAPTER 5

1. One of the pictures also exists in two other versions, both in the Palace Museum, Taipei, ascribed to Li Sung (SV92) and Liu Sung-nien (SV86); both are superior to the Tōfuku-ji paintings, which suggests that these represent Ch'en Hsien only as a copyist, and should not be taken as his typical works.

2. Boston Museum of Fine Arts, *Portfolio*, I, Pl. 79.

3. For Ho's version, see his *Ssu-yu-chai hua-lun*, *Mei-shu ts'ung-shu* ed., p. 45. For Wang's, *I-yüan chih-yen*, in *Ku-kung chou-k'an* no. 75.

4. Complete translation in T. C. Lai, pp. 40–43; see also pp. 32–40 for a full account of the "bribery" affair. Another good treatment of his life, by Chu-tsing Li, is included in the same book, pp. 115–21. See also the series of articles by Chiang Chao-shen in the *National Palace Museum Quarterly*, II/4 through III/3, April 1968 to January 1969.

5. Wilson and Wong, pp. 72–75. The so-called *T'ang Liu-ju hua-p'u*, a compilation of excerpts from earlier writings on painting which circulates under the name of T'ang Yin, is actually a late-Ming reprint of a sixteenth-century work titled *Tu-shih hua-p'u* to which T'ang's name was falsely attached.

6. The 1501 painting is a figure-in-landscape composition with an inscription by Wen Cheng-ming dated to that year (see *Tō Sō*, Pl. 361); the 1504 work depicts the Weaving Maiden (see *I-lin ts'ung-pien*, 11.)

7. Sirén, vol. IV, p. 207, quoting Wang Chih-teng.

8. T. C. Lai, p. 100.

9. *T'ang Liu-ju hua-chi*, Pl. 22–25.

10. *Chinese Art Treasures*, no. 100.

11. The other two compositions include the portion covered by the right scroll of the Boston pair and another portion further to the right, which completes the horizontally extended branch and provides a view of the opposite shore of the river; they lack the left portion of the Boston pair, with vertical tree trunks and the cliff. The composition, and the screen shape, would seem to require still another section to the

left of the Boston portions, which has not survived in any version. Both of the other versions are inscribed with poems, almost identical in wording, signed by T'ang Yin, and the same poem was probably on the lost right section of the original work to which the Boston scrolls belong. See Chiang Chao-shen's article in the *National Palace Museum Quarterly*, vol. III, no. 3, January, 1969, Pl. XX-XXII, for all three. One of the two other versions (Chiang's Pl. XXI) is in a mainland Chinese collection, the other (Chiang's Pl. XX) in a private collection in Taipei. The former seems in reproduction to be distinctly the better of the two in both calligraphy and painting and may be a genuine work of T'ang Yin, who might, as Chiang suggests, have done the composition more than once. For another painting by T'ang Yin of a similar subject that may also have been mounted originally on a screen, see the catalogue of the Nanking Museum (*Nan-ching po-wu-yüan ts'ang-hua chi*), vol. I, Pl. 31; it is roughly 1.5 meters square.

12. For biographical information on Ch'iu Ying I have depended partly on the biography by Martie Young in the *Dictionary of Ming Biography* (pp. 255–57).

13. For an account of Hsiang Yüan-pien's life, see the biography by Ch'en Chih-mai in the *Dictionary of Ming Biography* (pp. 539–44).

14. The album is in the Palace Museum, Taipei (MA 12); the picture of narcissus and apricot flowers is in the Freer Gallery of Art, with a copy in the Palace Museum, Taipei (MV 453).

15. For a detail, see Cahill, *Chinese Painting*, p. 146; for a section of the "Spring Morning" scroll, *ibid.*, p. 145.

16. A possible exception to this statement is a handscroll by Ch'iu Ying formerly owned by Chang Ta-ch'ien, depicting Taoist Immortals in the *pai-miao* manner, with accompanying poems, apparently by Ch'iu Ying himself (see *Chin T'ang Wu-tai*, Pl. 153). I have not seen the original, and cannot judge its authenticity.

Another example of Ch'iu Ying's calligraphy is a letter published by Jean-Pierre Dubosc in "A Letter and Fan Painting by Ch'iu Ying." The letter is of considerable interest also as evidence of the manner in which Ch'iu accepted and fulfilled commissions for paintings.

17. *Wu-sheng-shih shih, Hua-shih ts'ung-shu* ed., III, 41. The rendering is Sirén's.

18. The version in the Palace Museum, Taipei, reproduced here and another formerly in the

Kuwana Collection, Kyoto (reproduced in *Tōyō bijutsu taikan*, vol. X), are so alike as to be all but indistinguishable in reproduction. The third version, also in the Palace Museum, is on paper and goes under a different title, *Yüan-chü t'u* ("Dwelling in the Garden").

19. Cahill, *Chinese Painting*, p. 141. A third picture, representing "Wang Hsi-chih Inscribing a Fan," has been said to belong to the same set, but the dimensions and proportions are not the same, and it is probably a separate work, unrelated to these two except in style. See *Chin T'ang Wu-tai*, Pl. 151.

### CHAPTER 6

1. The biographical notes that follow are based on Chiang Chao-shen's very detailed chronological biography (*nien-p'u*); see Bibliography. Also helpful was Richard Edwards' biography for the *Dictionary of Ming Biography*, pp. 1471–74. Three important publications on Wen Cheng-ming have appeared recently, and although my chapter was substantially completed before their publication, I gratefully acknowledge a debt to all of them. They are by Wilson and Wong, Anne Clapp, and Richard Edwards (*The Art of Wen Cheng-ming*, the catalogue of a major exhibition held in Ann Arbor, which also contains contributions by Anne Clapp and others). I am especially grateful to Anne Clapp for making a draft of her work, then in the form of a doctoral dissertation, available to me while I was writing.

2. The excerpt from Wen Lin's letter is from the biography of Wen Cheng-ming composed by his son Wen Chia; the translation is by Anne Clapp, p. 8. The letters from T'ang Yin are translated in Lai, pp. 48–50.

3. Tseng Yu-ho, "The Seven Junipers," pp. 22–23.

4. Chiang Chao-shen, Part I, pp. 66–67; the translation is taken, with minor changes, from Anne Clapp, p. 5. "Engendering movement through spirit resonance" (*ch'i-yün sheng-tung*) is of course the first of the Six Canons of Painting by Hsieh Ho of the fifth century.

5. See Edwards, *The Art of Wen Cheng-ming*, no. VIII; collection of Edward Binney, 3rd. Edwards discusses the problems associated with the painting and its inscription, finally accepting it as an early work, as does Anne Clapp.

6. Besides the work here reproduced, these include a "Winter Landscape in the Manner of Li Ch'eng" from the preceding year (Clapp, Fig.

4) and two handscrolls in the manner of Ni Tsan, one dating from around 1512 (Edwards, *Wen Cheng-ming*, no. XIII) and the other to around 1517–19 (*ibid.*, no. XIV). The last has especially close affinities in compositional method with the "Chih-p'ing Temple."

7. Clapp, p. 47. This was written when she knew the painting only from a photograph; later, seeing the original, she pronounced it to be a close copy. Richard Edwards holds the same opinion, one with which, needless to say, I disagree.

8. Edwards, *Wen Cheng-ming*, no. XVIII.

9. *Ssu-yu-chai ts'ung-shuo*, chapter 15; p. 125 in the Peking edition of 1959. Yao Ming-shan was Yao Lai (d. 1537), who entered the Han-lin Academy in the same year as Wen, 1523, after taking top place in the *chin-shih* examinations of that year; Yang Fang-ch'eng was Yang Wei-ts'ung (b. 1500), who had taken top honors in the examinations of 1521.

10. Anne Clapp, pp. 22–23.

11. Clapp, p. 2.

12. *Chin-ling so-shih*, 126b; repeated in *Wu-sheng-shih shih*, ch. 3.

13. *Ssu-yu-chai ts'ung-shuo*, chapter 29; p. 267 in the Peking edition of 1959.

14. Edwards, *Wen Cheng-ming*, no. XLI; the translation of the poem is by Ling-yün Shih Liu.

15. Clapp, p. 25.

16. Tai Ming-yüeh, inscription on a landscape; see Sirén, *Chinese Painting*, vol. VI, Pl. 308B.

17. *Chinese Calligraphy and Painting in the John M. Crawford, Jr., Collection*, New York, 1962, no. 14.

18. Translation by A. C. Graham, in Birch, p. 383.

19. Adapted from the rendering of Anne Clapp, p. 62. A companion picture titled "A Myriad Streams Contend in Flowing," dated 1550, is in the Nanking Museum; see *Nan-ching po-wu-yüan*, Pl. 27.

20. The 1549 painting is reproduced in Cahill, *Chinese Painting*, p. 130; the 1551 one in Sirén, VI, Pl. 211B.

21. Loehr, *Chinese Art*, p. 59.

22. A leaf in a collective album (VA 9K) titled "Visiting Plum Blossoms After Snow."

23. Harold Rosenberg, "A Risk for the Intelligence," *The New Yorker*, October 27, 1962, p. 152.

24. See *P'ei-wen-chai*, ch. 87, pp. 37b–38a.

25. The fan painting is in the Palace Museum, Taipei; see *Ku-kung chou-k'an* no. 64. The handscroll is in the Asian Art Museum of San Francisco, and is unpublished.

26. For a list of them and their genealogy, see Sirén, IV, p. 186, footnote 1.

27. *Chi'en-shan-t'ang shu-hua chi*; Wen Chia's postface is dated 1568. The larger inventory of Yen Sung's collection, *T'ien shui ping-shan lu*, literally "Heaven Reduces the Iceberg to Water," was published in 1728 by a descendant of Yen Sung from a manuscript in the family collection.

28. The story is told in *Wu-sheng-shih shih*, II, 29; the translation is Sirén's, IV, p. 187.

29. The Wilson and Wong book, in entry no. 26, written by Elizabeth Fulder Wilson, argues for an earlier period of activity, around 1540–80, but on insecure grounds. The landscape dated 1604 (*I-shu ts'ung-pien* 8), which the authors believe bears only a cyclical date and which they accordingly redate sixty years earlier to 1544, in fact bears an absolute date, Wan-li *chia-ch'en*, which can only be 1604. A copy of the painting (*T'ien-yin-t'ang ming-hua hsüan*, no. 33, Arthur M. Sackler, Jr., Collection) can be dismissed easily, but the version reproduced in *I-shu ts'ung-pien* appears, so far as one can judge in reproduction, to be a genuine work. The recorded handscroll by Hou Mou-kung with inscriptions by Wen Chia and Wen P'eng dated 1548, which Wilson and Wong adduce in favor of the earlier period of activity, is on the contrary unsafe evidence, both because the original scroll is not available for study and because the painting itself is undated—it was common, in the cases of scrolls devoted to someone's villa, as this one is, for the owner to collect inscriptions—essays on the villa, poems, etc.—and have the painting done later. Thus the Crawford painting of 1569 probably *is* the artist's earliest known dated work; it represents Hou's essay into the elongated composition divided at the middle (or "double-decked" in E. Wilson's term), of which we have discussed several examples by other artists. An unpublished album of landscapes in the C. C. Wang Collection, dated 1577, suggests that the undated landscape under discussion may belong around the same time, i.e., around the middle of the painter's active period.

30. *Chinese Art Treasures*, no. 97. Wen Cheng-ming's poem was based on one of the same title and theme by Ni Tsan, using the same rhyme words.

31. Kinjirō Harada, *Nihon genzai*, p. 165, an-

other painting dated 1531; Lu Hsin-yüan, *Jang-li-kuan*, ch. 20, p. 21, dated 1530; and *ibid*. supplement ch. 8, p. 5, dated 1537. A work with Chü Chieh's signature titled "Drinking Tea" in the Palace Museum, Taipei (MV 199), dated 1534, is a poor copy of a painting by Wen Cheng-ming in the same collection, and can be dismissed. I must here acknowledge a debt to Miss Cheng-chi Hsü, whose paper on Chü Chieh, delivered in my seminar on Wu-school painting just as this chapter was in final editing, led to some valuable emendations.

32. Palace Museum, Taipei: an album of eight leaves (MA 23) titled "Poetic Thoughts" and dated 1583, and a twelve-leaf album (MA 80), undated.

# Bibliography

Abe, Fusajirō. *Sōraikan Kinshō* 爽籟館欣賞 [Chinese Painting in the Abe Collection]. 6 vols., in 2 parts. Osaka, 1930–39.

Barnhart, Richard. "Survivals, Revivals, and the Classical Tradition of Chinese Figure Painting," *Proceedings of the International Symposium on Chinese Painting* (Taipei, 1970), pp. 143–210.

Birch, Cyril, ed. *Anthology of Chinese Literature from Early Times to the Fourteenth Century.* New York, 1965.

Bush, Susan. *The Chinese Literati on Painting: Su Shih (1037–1101) to Tung Ch'i-ch'ang (1555–1636).* Cambridge, Mass., 1971.

Cahill, James. *Chinese Painting.* Lausanne, 1960.

————. *Fantastics and Eccentrics in Chinese Painting.* New York, 1967.

————. *Hills Beyond a River: Chinese Painting of the Yüan Dynasty, 1279–1368.* New York and Tokyo, 1976.

————. "Yüan Chiang and His School," *Ars Orientalis*, V (1963), 259–72; VI (1966), 191–212.

Chan Ching-feng 詹景鳳. *Tung-t'u hsüan-lan-pien* 東圖玄覽編 (ca. 1600). In *Mei-shu ts'ung-shu* 美術叢書, V, 1.

Chang An-chih 張安治. *Wen Cheng-ming* 文徵明. Shanghai, 1959. (*Chung-kuo hua-chia ts'ung-shu* 中國畫家叢書 series).

Chao Ch'i-mei 趙琦美. *T'ieh-wang shan-hu* 鐵網珊瑚 (preface dated 1600).

Cheng Ping-shan 鄭秉珊. *Shen Shih-t'ien* 沈石田 (Shen Chou). Shanghai, 1958. (*Chung-kuo hua-chia ts'ung-shu* series).

Chiang, Chao-shen 江兆申. "Liu-ju chü-shih chih shen-shih" 六如居士之身世 (A Study of the Life of T'ang Yin), *Ku-kung chi-k'an* 故宮季刊 (National Palace Museum Quarterly), II, no. 4 (April, 1968), 15–32; "Liu-ju chü-shih chih shih-yu yü tsao-yü" 六如居士之師友與曹遇 (T'ang Yin: His Teachers, Friends and Personal Life), III, no. 1 (July, 1968) 33–60; "Liu-ju chü-shih chih yu-tsung yü shih-wen" 六如居士之遊縱與詩文 (T'ang Yin: His Travels and Literary Works), III, no. 2 (October, 1968), 31–71; "Liu-ju chü-shih chih shu-hua yü nien-p'u" 六如居士之書畫與年譜 (T'ang Yin's Calligraphy and Painting, and a Chronological Biography), III, no. 3, (January, 1969), 35–79.

————. "Wen Cheng-ming nien-p'u" 文徵明年譜 (The Life of Wen Cheng-ming), *Ku-kung chi-k'an*, V, no. 4 (1971), 39–88; VI, no. 1 (1972), 31–80; VI, no. 2 (1972), 45–75; VI, no. 3 (1972), 49–80; VI, no. 4 (1972), 67–109.

————. *Wu-p'ai hua chiu-shih nien chan* 吳派畫九十年展 (Ninety Years of Wu School Painting). Taipei, 1975.

Chiang Shao-shu 姜紹書. *Wu-sheng-shih shih* 無聲詩史 (postface dated 1720). In *Hua-shih ts'ung-shu* 畫史叢書.

*Chin T'ang Wu-tai Sung Yüan Ming Ch'ing ming-chia shu-hua chi* 晉唐五代宋元明清名家書畫集 (A Collection of Famous Painting and Calligraphy of the Chin, T'ang, Five Dynasties, Sung, Yüan, Ming, and Ch'ing Periods). Shanghai, 1943.

*Chinese Art Treasures: A Selected Group of Objects from the Chinese National Palace Museum and the Chinese National Central Museum, Taichung, Taiwan.* Geneva, 1961.

*Chin-ling so-shih*; see Chou Hui.

Chou Hui 周暉 (fl. ca. 1610). *Chin-ling so-shih* 金陵瑣事 (preface dated 1610), 2 vols. 1955 facsimile of original edition.

Chu Mou-yin 朱謀垔. *Hua-shih hui-yao* 畫史會要 (preface dated 1631).

Chuang Su 莊肅. *Hua-chi pu-i* 畫繼補遺 (completed 1298); reprinted with Teng Ch'un 鄧椿, *Hua-chi* 畫繼 (completed 1167). Peking, 1963.

*Chūgoku Min Shin bijutsu-ten mokuroku* 中國明清美術展目錄. Tokyo National Museum, 1963.

Clapp, Anne DeCoursey. *Wen Cheng-ming: The Ming Artist and Antiquity*. Ascona, 1975.

Contag, Victoria. "The Unique Characteristics of Chinese Landscape Pictures," *Archives of the Chinese Art Society of America*, VI (1952), 45–63.

Contag, Victoria and Wang Chi-ch'ien. *Seals of Chinese Painters and Collectors of the Ming and Ch'ing Periods*. Rev. ed., with supplement. Hong Kong, 1966.

*Dictionary of Ming Biography*; see Goodrich and Fang.

Dubosc, Jean-Pierre. *Great Chinese Painters of the Ming and Ch'ing Dynasties*. New York, 1949.

———. "A Letter and Fan Painting by Ch'iu Ying," *Archives of Asian Art*, XXVIII, 1974–75, pp. 108–12.

———. *Mostra d'arte cinese, Venezia: Settimo centenario di Marco Polo*. Venice, 1954.

Ecke, Gustav. *Chinese Painting in Hawaii*. 3 vols. Honolulu, 1965.

Edwards, Richard. *The Art of Wen Cheng-ming*. Ann Arbor, 1976.

———. *The Field of Stones: A Study of the Art of Shen Chou*. Washington, D.C., 1962.

*Exhibition of Paintings of the Ming and Ch'ing Periods*. City Museum and Art Gallery. Hong Kong, 1970.

Fang, Chaoying. "Some Notes on Porcelain of the Cheng-t'ung Period," *Archives of Asian Art*, XXVII (1973–74), 30–32.

Faurot, Jeanette Louise. *Four Cries of the Gibbon: A Tsa-chü Cycle by the Ming Dramatist Hsü Wei*. Unpublished doctoral dissertation, University of California, Berkeley, 1972.

Fontein, Jan and Money L. Hickman. *Zen Painting and Calligraphy*. Boston, 1970.

Goodrich, L. Carrington and Chaoying Fang, eds. *Dictionary of Ming Biography*. 2 vols. New York, 1976.

Harada, Kinjirō 原田謹次郎. *Nihon genzai shina meiga mokuroku* 日本現在支那名畫目錄. Tokyo, 1938.

Hashimoto, Sueyoshi 橋本末吉. *Hashimoto shūzō Min Shin ga mokuroku* 橋本收藏明清畫目錄 (Catalogue of Ming and Ch'ing Paintings in the Hashimoto Collection). Tokyo, 1972.

Hay, John. "Along the River During Winter's First Snow: A Tenth-Century Handscroll and Early Chinese Narrative," *Burlington Magazine* (May, 1972), 294–302.

Ho Liang-chün 何良俊 (1506–73). *Ssu-yu-chai ts'ung-shuo* 四友齋叢說 (preface dated 1569). Peking, 1959 reprint. Material on painting reprinted in *Mei-shu ts'ung-shu* III, 3 as: *Ssu-yu-chai hua-lun* 四友齋畫論.

Ho Lo-chih 何樂之. *Hsü Wei* 徐渭. Shanghai, 1959. (*Chung-kuo hua-chia ts'ung-shu* series).

Holtz, Holly. *Wu Wei and the Turning Point in Early Ming Painting*. Unpublished master's thesis, University of California, Berkeley, 1975.

Hsia Wen-yen 夏文彥. *T'u-hui pao-chien* 圖繪寶鑑 (preface dated 1365). Shanghai, 1936 reprint. Also *T'u-hui pao-chien hsü-pien* and *pu-i* compiled by Han Ang 韓昂 (1519) and *T'u-hui pao-chien hsü-tsuan* compiled by Mao Ta-lun 毛大倫 et. al. (late 17th century).

Hsieh Chao-che 謝肇淛 (ca. 1600). *Wu-tsa-tsu* 五雜俎. 2 vols. Shanghai, 1959.

Hsü Ch'in 徐沁. *Ming-hua lu* 明畫錄 (colophon dated 1673). In *Mei-shu ts'ung-shu* III, 7.

Hsü Lun 徐崙. *Hsü Wen-chang* 徐文長 (Hsü Wei). 1962.

*Hua-shih hui-yao*; see Chu Mou-yin.

*Hua-yüan to-ying* 畫苑掇英 (Gems of Chinese Painting). 3 vols. Shanghai, 1955.

*I-shu ts'ung-pien* 藝術叢編. 24 vols. Shanghai, 1906–10.

*I-yüan chen-shang* 藝苑眞賞. 10 vols. Shanghai, 1914–20.

Kao Lien 高濂 *Yen-hsien ch'ing-shang ch'ien* 燕閒清賞箋 (late 16th century). In *Mei-shu ts'ung-shu* III, 10.

Kawakami, Kei 川上輕. "Sō Minamoto Nagaharu kankoku shiga-kan to Ō Gaku" 送源永春還國詩畫卷と王諤 (The Scroll of Poems and Painting Given to Minamoto Nagaharu as a Farewell Gift on His Departure for Home from Ming, and the Life and Works of Wang E), *Bijutsu kenkyū*, no. 221 (March, 1962), 1–22.

Ku Ch'i-yüan 顧起元 (1565–1628). *K'o-tso chui-yü* 客座贅語 (postscript 1618).

*Ku-kung chou-k'an* 故宮週刊 (National Palace Museum Weekly), nos. 1–510, n.s. nos. 1–32, Peking, 1929–37.

*Ku-kung ming-hua* 故宮名畫 (Famous Paintings

in the Palace Museum). 10 vols. Taipei, 1965–69.

*Ku-kung po-wu-yüan ts'ang hua-niao-hua hsüan* 故宮博物院藏花鳥畫選 (Selected Flower and Bird Paintings from the Collection of the Palace Museum). Peking, 1965.

*Ku-kung shu-hua chi* 故宮書畫集 (Record of Painting and Calligraphy in the Palace Museum). 45 vols. Peking, 1930–36.

Kuo Wei-ch'ü 郭味蕖, ed. *Sung Yüan Ming Ch'ing shu-hua-chia nien-piao* 宋元明清書畫家年表 (A Chronology of Calligraphers and Painters of the Sung, Yüan, Ming and Ch'ing Periods). Peking, 1958.

Lai, T.C. *T'ang Yin, Poet-Painter.* Hong Kong, 1971.

Lawton, Thomas. *Chinese Figure Painting.* Freer Gallery of Art Fiftieth Anniversary Exhibition, II, Washington, D.C., 1973.

Lee, Sherman. "Early Ming Painting at the Imperial Court," *The Bulletin of the Cleveland Museum of Art*, October, 1975, pp. 243-59.

———. "Literati and Professionals: Four Ming Painters," *The Bulletin of the Cleveland Museum of Art*, III, no. 1 (1966), 2–25.

Lee, Sherman and Wai-kam Ho. *Chinese Art Under the Mongols: The Yüan Dynasty (1279–1368).* Cleveland, 1968.

Leung, K. C. *Hsü Wei as Dramatic Critic: A Critical Translation of the Nan-tz'u Hsü-lu.* Unpublished doctoral dissertation, University of California, Berkeley, 1974.

Li, Chu-tsing. *A Thousand Peaks and Myriad Ravines: Chinese Paintings in the Charles A. Drenowatz Collection.* 2 vols. Ascona, 1974.

Li T'ien-ma 李天馬. "Lin Liang nien-tai k'ao" 林良年代考 (On the Dates of Lin Liang), *I-lin ts'ung-lu* 藝林叢錄, III, 1962, 35–38.

———. "Yen Tsung nien-tai k'ao" 顏宗年代考 (On the Dates of Yen Tsung), *I-lin ts'ung-lu*, III, 1962, 38–39.

*Liao-ning-sheng po-wu-kuan ts'ang-hua chi* 遼寧省博物館藏畫集 (A Collection of Paintings from the Liaoning Provincial Museum). Peking, 1962.

Loehr, Max. *Chinese Art: Symbols and Images.* Wellesley, 1967.

———. "A Landscape Attributed to Wen Cheng-ming," *Artibus Asiae*, XXII (1959), 143–52.

Lu Hsin-yüan 陸心源. *Jang-li-kuan kuo-yen lu* (Catalogue of Paintings and Calligraphy in Lu's Collection). 1892.

*Min Shin no kaiga* 明清の繪画 (Paintings of the Ming and Ch'ing Dynasties). Tokyo, 1964.

*Ming-hua lu*; see Hsü Ch'in.

*Ming-jen ch'uan-chi tz'u-liao so-yin* 明人傳記資料索引 (Index of Ming Biographies). 2 vols. Taipei, 1965.

Mote, Frederick. "A Millennium of Chinese Urban History: Form, Time and Space Concepts in Soochow," *Rice University Studies*, vol. 59, no. 4 (Fall, 1973), 35–65.

*Nan-ching po-wu-yüan ts'ang-hua chi* 南京博物院藏畫集 (A Collection of Paintings from the Nanking Museum). 2 vols. Nanking, 1965.

*Ōsaka Shiritsu Bijutsukan zō Chūgoku kaiga* 大阪市立美術館藏中国繪画 (Chinese Painting in the Osaka Municipal Museum). 2 vols. Osaka, 1975.

*The Pageant of Chinese Painting* (*Chūgoku meiga hōkan* 中國名畫寶鑑). Kinjirō Harada, ed. Tokyo, 1936.

*P'ei-wen chai shu-hua p'u* 佩文齋書畫譜 (Imperial Encyclopedia of Calligraphy and Painting). 100 *chüan*. Compiled by Sun Yüeh, Wang Yüan-ch'i, et al. (completed 1708).

Shen Chou 沈周. *Shen Shih-t'ien ling-yin shan t'u-chuan.* Shanghai, 1924.

———. *Ts'ang-chou ch'ü t'u-chüan* 滄洲趣圖卷. Peking, 1961.

*Shen-chou kuo-kuang chi* 神州國光集. vols. 1–21. Shanghai, 1908–12.

Shimada, Shūjirō 島田修次郎. "Ippin gafū ni tsuite" 逸品畫風について. *Bijutsu kenkyū*, no. 161 (1950), 20–46. Translated by James Cahill as "Concerning the I-p'in Style of Painting," *Oriental Art* 7 (1961), 66–74; 8 (1962), 130–37; and 10 (1964), 19–26.

———. "Ro Keifu no sōchū-zu: Jōshū sōchūga ni tsuite" 呂甫甫の草蟲圖：常州草蟲畫について (Lü Ching-fu's Painting of Plants and Insects: Notes on the Ch'ang-chou [i.e. P'i-ling] Plants-and-Insects Painters), *Bijutsu kenkyū*, no. 150 (1948), 1–20.

Sickman, Laurence, ed. *Chinese Calligraphy and Painting in the Collection of John M. Crawford, Jr.* New York, 1962.

Sickman, Laurence and Alexander Soper. *The Art and Architecture of China.* Baltimore, 1956.

Sirén, Osvald. *Chinese Painting: Leading Masters and Principles.* 7 vols. London, 1956–58.

Smith, Bradley and Wan-go Weng. *China: A History in Art.* New York, 1972.

*Sō Gen Min Shin meiga taikan* 宋元明清名畫

大觀 (Painting Masterpieces of the Sung, Yüan, Ming, and Ch'ing Dynasties). 2 vols. Tokyo, 1931.

Speiser, Werner and Herbert Franke. "Eine Winterlandschaft des Shih Chung," *Ostasiatische Zeitschrift* (1936), 134–39.

Sullivan, Michael. "Notes on Early Chinese Screen Painting," *Artibus Asiae*, XXVII (1966), 239–54.

Sun Hsing-yen 孫星衍. *P'ing-chin-kuan chien-ts'ang shu-hua chi* 平津館鑑藏書畫記 (published 1841), 1 *chüan*.

Sun Tsu-po, comp. 孫祖白. *T'ang Liu-ju hua chi* 唐六如畫集 (Paintings by T'ang Yin). Shanghai, 1960.

Suzuki, Kei 鈴木敬. "Min no ga-in-sei ni tsuite" 明の畫院制について (Concerning the Organization of the Ming Painting Academy). *Bijutsu-shi* 美術史, no. 60 (1966), 95–106.

———. *Mindai kaigashi no kenkyū: Seppa* 明代絵画史の研究・浙派 (A Study of Ming Painting: The Che School). Tokyo, 1968.

———. *Ri Tō, Ba En, Ka Kei* 李唐馬遠夏珪 (Li T'ang, Ma Yüan, Hsia Kuei). *Suiboku bijutsu taikei*, vol. II. Tokyo, 1974.

T'ang Hou 湯垕. *Hua chien* 畫鑑 (written in 1329; completed by his friend Chang Yü). Peking, 1959 (annotated edition).

*T'ien shui ping-shan lu* 天水冰山錄 (published 1728). *Ts'ung-shu chi-ch'eng* 叢書集成 edition. Peking, 1937.

*T'ien-yin-t'ang ming-hua hsüan* 天隱堂名畫選 (T'ien Yin T'ang Collection; One Hundred Masterpieces of Chinese Painting). Tokyo, 1963.

Tomita, Kōjirō and Tseng Hsien-ch'i. *Portfolio of Chinese Paintings in the Museum: Yüan to Ch'ing Periods*. Museum of Fine Arts, Boston, 1961.

*Tō Sō Gen Min meiga taikan* 唐宋元明名畫大觀 (Painting Masterpieces of the T'ang, Sung, Yüan, and Ming Dynasties). 2 vols. Tokyo, 1929.

*Tōyō bijutsu taikan* 東洋美術大觀 (Art of the Far East). 12 vols. Tokyo, 1912.

Ts'ao Chao 曹昭. *Ko-ku yao-lun* 格古要論 (published 1387). 13 *chüan*. Translated by Sir Percival David: *Chinese Connoisseurship: The Ko Ku Yao Lun—the Essential Criteria of Antiquities*. New York, 1971.

Tseng Yu-ho. "'The Seven Junipers' of Wen Cheng-ming," *Archives of the Chinese Art Society of America*, VIII (1954), 22–30.

———. "A Study on Hsü Wei," *Ars Orientalis*, V (1963), 243–54.

Tung Ch'i-ch'ang 董其昌. *Hua-chih* 畫旨. In his *Jung-t'ai chi* 容臺集, *pieh-chi* 別集, ch. 4.

T'ung Chün 童寯. *Chiang-nan yüan-lin chih* 江南園林志 (Records of Chiang-nan Gardens). Peking, 1963.

Wang Chih-teng 王穉登. *Wu-chün tan-ch'ing chih* 吳郡丹青志 (preface dated 1563). 1 *chüan*. *Mei-shu ts'ung-shu*, II, 2.

Wang Li 王履. *Fan Chung-li hua-shan t'u* 范中立華山圖. Shanghai, 1929. (Eleven leaves of Wang Li's album of scenes of Hua-shan, with inscription, falsely ascribed to Fan K'uan).

Wang Shih-chen 王世貞. *I-yüan chih-yen* 藝苑厄言. Excerpts in *Ku-kung chou-kan*, nos. 68–78.

Wen Chao-t'ung 温肇桐. *Ming-tai ssu-ta-hua-chia* 明大四大畫家 (The Four Great Masters of the Ming Period). Hong Kong, 1960.

Wen Cheng-ming 文徵明. *Fu-t'ien chi* 甫田集 (The Writings of Wen Cheng-ming). 36 *chüan* (ca. 1574). Shanghai, 1910 reprint.

———. *Wen Cheng-ming hui-kao* 文徵明彙稿 (Compilation of Writings by and on Wen Cheng-ming). 2 vols. Shanghai, 1929.

Wen Chia 文嘉. *Ch'ien-shan-t'ang shu-hua chi* 鈐山堂書畫記 (Record of Calligraphy and Painting at the Ch'ien-shan-t'ang, 1569). In *Mei-shu ts'ung-shu*, II, 6, 39–64.

Weng, Wan-go H. C. *Gardens in Chinese Art*. New York, 1968.

Whitfield, Roderick. "Che School Paintings in the British Museum," *Burlington Magazine*, May, 1972, pp. 285-94.

Wilson, Marc and Kwan S. Wong. *Friends of Wen Cheng-ming: A View from the Crawford Collection*. New York, 1974.

*Wu-sheng-shih shih;* see Chiang Shao-shu

Yonezawa, Yoshiho 米澤嘉圃 ed. *Chūgoku bijutsu* 中國美術 (Arts of China). Vol. 3, Tokyo, 1970. Translation: *Arts of China: Paintings in Chinese Museums*. Tokyo, 1970.

———. *Painting in the Ming Dynasty*. Tokyo, 1956.

———. "Shō Rei hitsu kōshi kambaku-zu" 鐘禮筆高士觀瀑圖 (Scholar Gazing at a Waterfall by Chung Li). *Kokka*, no. 846 (September, 1962), 408–14.

Yü Chien-hua 兪劍華. *Chung-kuo hua-lun lei-pien* 中國畫論類編 (Anthology of Texts on Chinese Painting Theory). 2 vols. Peking, 1957.

———. *Wang Fu* 王紱. Shanghai, 1961. (*Chung-kuo hua-chia ts'ung-shu* series).

# Index

The "weathermark" identifies this book as a production of John Weatherhill, Inc., publishers of fine books on Asia and the Pacific. Editing, book design, and typography: Meredith Weatherby. Production supervisor: Mitsuo Okado. Composition: Samhwa, Seoul. Printing of the text: Toyo, Tokyo. Engraving and printing of the plates, in four-color offset and monochrome letterpress: Nissha, Kyoto. Binding: Makoto, Tokyo. The typeface used is Monotype Perpetua, with hand-set Perpetua for display.